Relics, Prayer, and Politics
in Medieval Venetia

RELICS, PRAYER, AND POLITICS IN MEDIEVAL VENETIA

Romanesque Painting in the Crypt of Aquileia Cathedral

Thomas E. A. Dale

PRINCETON UNIVERSITY PRESS

PRINCETON, NEW JERSEY

Copyright © 1997 by Princeton University Press
Published by Princeton University Press, 41 William Street,
Princeton, New Jersey 08540
In the United Kingdom: Princeton University Press, Chichester, West Sussex

Library of Congress Cataloging-in-Publication Data
Dale, Thomas E. A.
Relics, prayer, and politics in medieval Venetia : Romanesque painting in the
crypt of Aquileia Cathedral / Thomas E. A. Dale.
p. cm.
Includes bibliographical references and index.
ISBN 0-691-01175-3 (CL : acid-free paper)
1. Mural painting and decoration, Romanesque—Italy—Aquileia.
2. Mural painting and decoration, Italian—Italy—Aquileia. 3. Fortunatus,
Saint—Art. 4. Hermagoras, Saint—Art. 5. Bible. N.T.—Illusttrations.
6. Fortunatus, Saint—Relics—Italy—Aquileia. 7. Hermagoras, Saint—
Relics—Italy—Aquileia. 8. Art and religion—Italy—Aquileia. 9. Basilica
(Aquileia, Italy) I. Title.
ND2757.A75D35 1997
755'.63'0945391—dc21 97-386

This book has been composed in Janson

Princeton University Press books are printed on acid-free paper and meet
the guidelines for permanence and durability of the Committee on Production
Guidelines for Book Longevity of the Council on Library Resources

Printed in the United States of America

10 9 8 7 6 5 4 3 2 1

CONTENTS

v

ACKNOWLEDGMENTS

THE PRESENT BOOK is based on my Ph.D. dissertation, "The Crypt of the Basilica Patriarcale at Aquileia: Its Place in the Art and History of the Upper Adriatic," completed in 1990 under the direction of William Tronzo at the Johns Hopkins University in Baltimore. For their careful reading and criticism at that time, I am grateful to Professors Tronzo, Herbert L. Kessler, and Michael McCormick. In revising the thesis for publication, I have received invaluable counsel from Professors Carol Krinsky, Marcia Kupfer, and Anthony Cutler. At Princeton University Press, thanks are due to Timothy Wardell and Elizabeth Johnson, who shepherded the book through the publication process, and to Sharon Herson, who copyedited the manuscript. The final product is also greatly enhanced by the careful reconstruction drawings prepared by Pippa Murray and Jonathan Canning.

For financial support, I am indebted to the Department of History of Art at the Johns Hopkins University, Baltimore; the Charles S. Singleton Center for Italian Studies at the Villa Spelman, Florence; the Samuel H. Kress Foundation, New York City; the Gladys Krieble Delmas Foundation, New York City; Dumbarton Oaks, Washington, D.C.; the Department of Art History and Archaeology at Columbia University in New York; and William and Jane Dale of London, Canada.

The following libraries and photo archives kindly made their resources available to me: the Milton S. Eisenhower Library of the Johns Hopkins University, Baltimore, Maryland; the Museo Archeologico at Cividale, Friuli; the Biblioteca del Seminario Arcivescovile, Gorizia, Friuli; the Fototeca and library of the Kunsthistorisches Institut, Florence, Italy; Avery and Butler Libraries at Columbia University in New York; the Fototeca and library of the Biblioteca Hertziana, Rome; the Istituto Centrale per il Catalogo e la Documentazione, Rome; the Vatican Library, Rome; the Biblioteca del Seminario Arcivescovile, Udine; the Photo Archives of Osvaldo Böhm, Venice; the manuscript room of the Biblioteca Nazionale Marciana, Venice; the Byzantine Research Library, the Department of Byzantine Visual Resources, and the Princeton Index of Christian Art at Dumbarton Oaks, Washington, D.C. Permission to take photographs and explore normally inaccessible parts of the crypt was kindly granted by the Archbishop of Gorizia, by Dr. Luisa Bertacchi of the Soprintendenza per Beni Culturali, Artistici ed Ambientali per Friuli-Venezia-Giulia at Aquileia, and the *parroco* of Aquileia, Don Luigi Olivo.

I dedicate this book to the late Robert Deshman of the University of Toronto, who inspired me to pursue graduate studies in medieval art, and to my parents, Jane and William Dale, who have provided unfailing moral support.

LIST OF ILLUSTRATIONS

Abbreviations for Sources of Illustrations

Source is the author, unless otherwise specified.
Böhm: Osvaldo Böhm, Venice, Italy
Ciol: Elio Ciol, Cassarsa (Pordenone), Italy
DO: Copyright 1996, Dumbarton Oaks, Byzantine Visual Resources, Washington, D.C.
ICCD: Istituto Centrale per il Catalogo e la Documentazione (formerly the Gabinetto Fotografico Nazionale), Rome, Italy
NGA: National Gallery of Art, Washington, D.C.

Color Plates

Black and White Figures

ARCHITECTURE AND GENERAL VIEWS

INTERCESSORY HIERARCHY

ABBREVIATIONS

AASS: *Acta Sanctorum*

AnalBoll: *Analecta Bollandiana*

AntAltAdr: *Antichità Alto-Adriatiche*

AqN: *Aquileia Nostra*

ArchStorTrieste: *Archivio Storico per Trieste, l'Istria e il Trentino*

La Basilica: *La Basilica di Aquileia*. Bologna, 1933.

Brusin and Lorenzoni, *L'arte del Patriarcato*: D. dalla Barba Brusin and G. Lorenzoni. *L'arte del Patriarcato di Aquileia*. Padua, 1968.

CahArch: *Cahiers Archéologiques*

CompRendAcInscr: *Comptes rendus de l'Académie des Inscriptions*

CorsiRav: *Corsi di Cultura sull'arte Ravennate e Bizantina*

Dale, "Inventing a Sacred Past": T. Dale. "*Inventing* a Sacred Past: Pictorial Narratives of St. Mark the Evangelist in Aquileia and Venice, ca. 1000–1300." *DOP* 48 (1994): 53–104.

Demus, *The Church*: O. Demus. *The Church of San Marco in Venice. History—Architecture—Sculpture*. DOS, 6. Cambridge, Mass., 1960.

Demus, *Mosaics of San Marco*: O. Demus. *The Mosaics of San Marco in Venice*. 2 vols. Chicago, 1984.

Demus, *Norman Sicily*: O. Demus. *The Mosaics of Norman Sicily*. London, 1949.

Demus, *Romanesque Mural Painting*: O. Demus. *Romanesque Mural Painting*. Trans. Mary Whittall. London, 1970.

Der Dom: K. Lanckoronski, G. Neimann, and H. Swoboda. *Der Dom von Aquileia*. Vienna, 1906.

DOP: *Dumbarton Oaks Papers*

DOS: Dumbarton Oaks Studies

Egger, "Der heilige Hermagoras" (1947)/(1948): Rudolf Egger. "Der heilige Hermagoras: Eine kritische Untersuchung." *Zeitschrift für geschichtliche Landeskunde vom Kärnten (= Carinthia* I) 134 (1947): 16ff. and 137; (1948): 208ff.

Gioseffi and Belluno, *Aquileia*: D. Gioseffi and E. Belluno. *Aquileia. Gli Affreschi della Cripta*. Udine, 1976.

JBAA: *Journal of the British Archaeological Association*

JbAntChr: *Jahrbuch für Antike und Christentum*

JöB: *Jahrbuch der österreichischen Byzantinistik*

JöBG: *Jahrbuch der österreichisches Byzantinisches Gesellschaft*

JWAG: *Journal of the Walters Art Gallery*

JWCI: *Journal of the Warburg and Courtauld Institutes*

Kugler, "Die Kryptafresken": Johanna Kugler. "Die Kryptafresken der Basilika von Aquileia." Ph.D. diss. University of Vienna, 1969.

Kugler, "Byzantinisches und Westliches": "Byzantinisches und Westliches in den Kryptafresken von Aquileia," *Wiener Jahrbuch für Kunstgeschichte* 26 (1973): 7–31.

MemSocIstrArchStorPatr: *Atti e Memorie della Società Istriana di Archeologia e Storia Patria*

MemStorFor: *Memorie Storiche Forogiuliese*

MGH: *Monumenta Germaniae Historiae*

MittKhInstFlor: *Mitteilungen des Kunsthistorischen Instituts in Florenz*

Morgagni Schiffrer, "Gli affreschi medioevali": C. Morgagni Schiffrer. "Gli affreschi medioevali della Basilica Patriarcale." *AntAltAdr* 1 (1972): 323–48.

Morgagni Schiffrer, "Gli affreschi della cripta": C. Morgagni Schiffrer. "Gli affreschi della cripta di Aquileia." Tesi di laurea, Università degli Studi di Trieste, 1966–67.

PBSR: *Papers of the British School at Rome*

PG: *Patrologiae cursus completus, Series Graeca*, ed. J.-P. Migne. Paris, 1857–66.

PL: *Patrologiae cursus completus, Series Latina*, ed. J.-P. Migne. Paris, 1844–80.

Picard, *Souvenir*: J.-C. Picard. *Le Souvenir des évêques*. Rome, 1988.

REB: *Revue des études byzantines*

RivVen: *Rivista mensile della città di Venezia*

RJbK: *Römische Jahrbuch für Kunstgeschichte*

RQ: *Römische Quartalschrift für christliche Altertumskunde und Kirchengeschichte*

RSCI: *Rivista di storia della Chiesa in Italia*

Schiller, *Iconography*: G. Schiller. *Iconography of Christian Art*. Vols. 1 and 2. Trans. J. Seligman. New York, 1972.

Schiller, *Ikonographie*: G. Schiller. *Ikonographie der christlichen Kunst*. Vols. 3 and 4. Gütersloh, 1966 and 1980.

Toesca, "Gli affreschi": P. Toesca. "Gli affreschi del Duomo di Aquileia." *Dedalo* 6 (1925): 32–57.

Ughelli, *Italia Sacra*: F. Ughelli. *Italia Sacra*. 10 vols. Venice, 1720. Rpt. Leichtenstein, 1970.

Valland, *Aquilée*: R. Valland. *Aquilée et les origines Byzantines de la Renaissance*. Paris, 1963.

ZSav: *Zeitschrift der Savigny-Stiftung für Rechtsgeschichte*

Relics, Prayer, and Politics
in Medieval Venetia

 # INTRODUCTION

M ODERN TOURISTS who descend to the dimly lit crypt in the former cathedral of
Aquileia, near Venice, are drawn to the same objects that motivated their medieval
predecessors (figs. 1, 3). Displayed in glass cases beneath the glare of fluorescent lights
are glittering reliquaries containing carefully labeled bones of a second-century bishop
of Aquileia, Saint Hermagoras, and his deacon, Saint Fortunatus. While the twentieth-
century spectators' fascination most often stems from morbid curiosity, their medie-
val counterparts were attracted by a common belief, reinforced in the teachings of the
Church since late antiquity, that relics embodied the *praesentia* (physical presence) of the
saints.[1]

Addressing the monks of Cluny in the mid-twelfth century, Abbot Peter the Vener-
able affirmed that the martyr is divided by death into two parts "so that he may retain his
soul for himself among the mass of the blessed (in heaven), and give, with marvelous
largesse, the relics of his sacred body to be venerated by the faithful still in the living
flesh." Observing that Christ promises bodily resurrection to all his faithful servants, Peter
went on to admonish his monks: "[Y]ou should not feel contempt for the bones of the
present martyrs as if they were dry bones but should honor them now full of life as if they
were in their future incorruption."[2] As further proof that the "bodies of saints live" he
points to "innumerable miracles everywhere on earth . . . frequently experienced by those
who come to venerate their sepulchers with devout minds."

While Peter speaks of the spiritual and thaumaturgical benefits accrued from the
continuing *praesentia* of the saints, there was also a political dimension to their cult.[3]
Relics, suitably displayed in a lavish shrine or sculptural image of the saint, might enhance
the prestige and attract wealth to a cathedral or an abbey, as in the case of Sainte-Foy at
Conques.[4] Apostolic missionaries and episcopal saints such as James of Compostela, Mar-
tial of Limoges, and Cyrus of Pavia could justify the authority of a bishop and personify
the autonomy of the city in which their relics resided.[5]

At the reliquary-tomb, then, the spiritual and political potential of the saint co-
alesced. On site, the architecture of the shrine, pilgrimage and liturgy, textual and pictorial
narratives were all carefully orchestrated by ecclesiastical authorities to manifest those
powers to the patron saint's community and the outside world.[6]

The premise of this book is that the architecture and mural paintings of the Aqui-
leian crypt promoted the cult of the city's founding bishop, Saint Hermagoras. Although
his historical authenticity has long been hotly debated, it is an indisputable fact that Her-
magoras emerged from obscurity just as Aquileia was being revived as spiritual and politi-
cal capital of the Upper Adriatic mainland in the late eighth century. To consolidate his
hold on the newly conquered Lombard kingdom in Friuli and Istria, Charlemagne had the
abandoned Roman city rebuilt and installed his appointees in the venerable Aquileian See.

3

At the same time, Aquileia's founding bishop, Hermagoras, was cast as hero of a new myth tracing the origins of the Church back to Saint Mark the Evangelist.[7]

The burgeoning cult of Hermagoras and his deacon, Fortunatus, became a concrete reality when Charlemagne's appointee, Patriarch Maxentius, constructed the first relic crypt at the beginning of the ninth century. In a second phase, the architecture was modified to create the present three-aisled, apsidal hall crypt. As I shall later argue, these renovations were undertaken by Patriarch Poppo in the early eleventh century as part of the political renewal which led Aquileia to challenge the preeminence of Venice.

From the outset, the Aquileian crypt served a dual purpose. First, as the *memoria* housing the relics of the city's patrons Saints Hermagoras and Fortunatus, it was the premier *locus sanctorum* of the Upper Adriatic church—the focus of their ever-present interceding power. Second, because Hermagoras was the city's first bishop and was promoted as Saint Mark the Evangelist's chosen disciple, the relics provided tangible evidence for the foundation of the church in the apostolic era. This was, in turn, an essential argument designed to sustain the patriarchal title of the Aquileian Church and its primacy over the Upper Adriatic, including Venice. Both of these functions are reflected in the Romanesque mural paintings, probably added to the crypt at the end of the twelfth century under Patriarch Ulrich II (1161–82).

The program comprises four principal elements. In the central vault and spandrels, images of Christ and the saints form a carefully structured hierarchy (fig. 1:I1–I37; fig. 5). Four lunettes of the eastern hemicycle wall display an abbreviated feast cycle focusing on the Christ's Passion and the *Compassio* of the Virgin (fig. 1:F2–F5; fig. 4). Encircling the hierarchy of saints in the central vault, a highly detailed cycle narrates the foundation of the Church of Aquileia by Saint Mark and the *Passio* of the city's first bishop and deacon, Hermagoras and Fortunatus (fig. 1:H1–H24; fig. 4). Finally, in the socle zone, apparently secular scenes are drawn in outline on the undulating surface of a fictive curtain (fig. 1:S1–S9; fig. 4).

Past scholarship on the crypt has largely ignored the complexity of the ensemble, preferring to dwell upon stylistic and iconographic sources. The earliest discussions of the murals, dating from the late eighteenth century and the turn of the twentieth century, established a pattern for most future scholarship, calling attention to the Byzantine origins of their style.[8] More recent literature on Aquileia, still emphasizing ties with Byzantium, differs mainly in the precise dating—from the second quarter of the twelfth century to the beginning of the thirteenth—the presumed channel of Byzantine influence, and the emphasis placed on iconography. Pietro Toesca, writing in 1925, was the first scholar to recognize the role of Venice as a mediator of Byzantine style and iconography so clearly manifested in the feast cycle and the hierarchy of saints.[9] He also saw the dramatic realism in the Passion scenes as symptomatic of Veneto-Byzantine art around 1200. Taking up Toesca's lead, Rose Valland devoted an entire book to the Passion cycle, suggesting that the style and iconography of these scenes, though Byzantine in origin, revealed a more advanced illusion of space and a dramatic realism presaging Italian Renaissance art.[10] Chiara Morgagni Schiffrer and Johanna Kugler, in dissertations completed in 1967 and 1969, pursued a more balanced approach emphasizing equally the "Romanesque" and "Byzantine" elements of style and iconography.[11] These authors demonstrated systematically the Venetian role already

affirmed by Toesca and presented the first comprehensive discussion of iconographic sources.[12] They are further to be credited with relating the crypt to the political history of Aquileia, but they viewed this valuable context primarily as a dating tool. While Morgagni Schiffrer found political and economic rationales for dating the murals to the 1180s under Ulrich II, Kugler placed the decoration in the early decades of the thirteenth century under Patriarch Wolfger (1204–18).

In emphasizing the question of sources, isolating stylistic hands and iconographic motifs, previous writers have failed to grasp the significance of the program as a whole. Described and illustrated as individual scenes, the wall paintings appear much like miniatures that have been excised from their text pages, to be admired as independent objets d'art.

As more recent writers have emphasized, Romanesque mural painting is a highly visible and public art, which helps shape sacred space and potentially reveals much about the history, religious practices, and politics of the community for which it was designed.[13] To fully understand the painted decoration of a space, then, the primary patrons and users of the space and its intended functions must be determined. Once this contextual matrix is established, the painted program is susceptible to interpretation on a number of different levels.[14]

The very selection of narratives and single figures to be included in the program often says much about the function of the space and the identity of the local community. Thus, the individual iconic images of saints and their structure of presentation tend to relate to local litanies and calendars. Narratives are often chosen in order to reinforce a liturgical theme or to recount the titular saint's deeds and role in the local church.

To penetrate beyond this literal sense of the imagery, we need to determine prior pictorial traditions and the relationship between images and texts. On this basis, an examination can be made of the particular patterns of selection, the variations in narrative density, and the sequence within each component for visual cues that might reveal a thematic emphasis. Because monumental painting is experienced not at a glance, but through time and space, it is also of crucial importance to consider how the presentation of images relates to the viewer's changing position, and the order in which one experiences the imagery. Ultimately, the typological, spiritual, and political messages of the program are best understood when the interpreter takes into account the overall patterns of disposition of disparate elements within the architectural frame, as well as the thematic interrelationships established through juxtaposition and axial alignment.

The crypt of Aquileia offers a rare opportunity for such a contextual analysis of Romanesque mural painting. Not only does the decoration survive virtually intact, but also the saint whose relics it celebrates played a central role in the historiography of medieval Venetia—-a vast region encompassing Friuli, the Veneto, Istria, and Carinthia in South Austria.

THE RELICS of Saints Hermagoras and Fortunatus supply the raison d'être for the construction of the crypt and the formulation of the leading ideas of its decorative program. I therefore begin with a discussion of the history of the Church of Aquileia and its foundation legend. Chapter 2 sets the major phases of the crypt's construction within the context of the evolving cult of the founding bishop. Since no evaluation of the meaning of the

program can proceed without first establishing the artistic milieu and dating of the murals, I preface my interpretation of the mural paintings with a consideration of style in chapter 3. Going beyond the generic comparisons with Byzantine art made in the past, I search for concrete links—workshop traditions and jurisdictional ties—with mural painting and mosaics in the Upper Adriatic region and establish a relative chronology. Here, I also examine the potential meanings of distinct stylistic modes used within the program.

Chapters 4 through 8, which constitute the core of my interpretation, consider each of the four major divisions of the iconographic program. In Chapter 4, the hierarchy of saints is discussed both as a form of pictorial prayer and as a means of associating its founding bishop with the apostolic era. Chapter 5 examines how the hagiographic cycle reinforced the *praesentia* of the founding bishop and deacon at their tomb site and sustained the Aquileian Church's claim to primacy in medieval Venetia. Chapter 6 considers how the conventional Byzantine feast images are transformed into "Romanesque icons in space"—pictorial guides to meditation on the Passion of Christ and the *Compassio* or Comartyrdom of the Virgin. Chapter 7 assesses the meaning of the socle zone as a vehicle for allegory. Chapter 8 considers the role of ornament as a unifying formal element in the overall program, which also underlines the local church's foundation in the Roman past and the funerary function of the crypt.

As the Conclusion will suggest, the Aquileian crypt sheds light on crucial themes in medieval art. The central role of relics of the saints in the spirituality and politics of the Middle Ages is one theme which I emphasize. The other, more general theme emphasized here is the power of pictures as a form of persuasion or argument, both in the realm of private devotion and in the public sphere of civic history.

There are two appendixes. The first provides a complete iconographic catalogue, divided according to the plan in Figure 1. Here, the minutiae of identification, attributes, surviving inscriptions, and iconographic sources are discussed. The second provides an edition of and commentary on the earliest known description of the murals, a previously unpublished letter written by the local antiquarian Giandomenico Bertoli in April 1724.

CHAPTER ONE

History and Hagiography

Apostolic Mission and the Patriarchal Title in Medieval Venetia

B Y THE END of the twelfth century, when the decoration of the crypt was being completed, Aquileia's official history was inextricably bound to the legend of its patron saints. The patriarchal title, now recognized by pope and emperor, ranked the city in the highest echelon of the ecclesiastical hierarchy. It was Aquileia's apostolic pretensions that justified this lofty perch. According to the *Passio* of Saints Hermagoras and Fortunatus, Saint Peter himself sent Saint Mark the Evangelist to preach the gospel in pagan Aquileia and later consecrated the Evangelist's disciple, Hermagoras, as the first bishop of the Roman province of Venetia and Istria.[1] After organizing the church and converting most of the population, Hermagoras and his deacon, Fortunatus, were executed and buried outside the walls of the city.

The crypt and its decoration functioned with the relics of Hermagoras to validate Aquileia's foundation myth.[2] Thus, in order to establish the motivation for these artistic enterprises, it is necessary to trace the history of the Aquileian see and its devotion to Saints Mark and Hermagoras. Particularly important for our purposes is Aquileia's dispute with Venice and Grado, between the eighth and twelfth centuries, concerning the authority inherited from Mark and Hermagoras.

Mark's alleged mission to Aquileia, though possible, lacks any archaeological or documentary proof.[3] Apart from the list of bishops named in an eleventh-century episcopal catalogue, the history of the Aquileian Church remains obscure prior to the early fourth century.[4] At that time, Bishop Theodore (c. 308) constructed the double cathedral complex decorated with frescoes and refined mosaic pavements inscribed with his name.[5] The Church's increasing importance is manifested later in the same century by the expansion of the cathedral complex and by the residence of prominent theologians there, including Chromatius, Rufinus, Jerome, Ambrose, and Athanasius of Alexandria.[6]

The tradition connecting Mark with Hermagoras was probably formulated some time between the sixth and the late eighth centuries.[7] Like their rivals at Milan and Ravenna, the bishops of Aquileia wanted to trace their succession to apostolic times.[8] By selecting Peter's disciple Mark as patron, however, Aquileia went further to claim the unusual, suprametropolitan authority of a patriarchate.

Initially an honorific epithet, the title of patriarch came to be associated by the sixth

century with the suprametropolitan jurisdiction of the archbishops who presided over the five major cities of the late Roman empire: Rome, Alexandria, Antioch, Constantinople, and Jerusalem.[9] Although the papacy rejected the claims of Constantinople and Jerusalem to exercise true patriarchal authority because neither see was an apostolic or Petrine foundation, the five were eventually canonized as the "pentarchy" by Justinian I (527–65). While the pope was the only true patriarch in the West, toward the end of the same century the title was applied honorifically to a number of Western archbishoprics, including Arles, Besançon, Lyons, Bourges, Toledo, Milan, Ravenna, and Aquileia.[10]

What distinguished Aquileia from these churches was its alleged foundation by Mark. Economic and ecclesiastical relations between Aquileia and Alexandria in late antiquity may have fostered the choice of Mark.[11] But the most significant factor, as Guglielmo Biasutti has argued, must have been Aquileia's desire to express its allegiance to Peter and the papacy.[12] In light of Rome's insistence on Petrine authorization as the basis for true patriarchal authority, Aquileia's choice of Peter's disciple, Mark, provides a logical argument for its assumption of the higher dignity. Just as the Church of Alexandria was founded by the Evangelist at the behest of Peter, so Aquileia claimed that Mark had been sent by Peter to found another daughter church of the Apostolic See. Aquileia's argument was all the more plausible because it was known that Mark had spent time with Peter in Italy and had written his Gospel for the "Italians" in Rome.[13]

The historical moment at which Aquileia chose to vaunt its apostolic credentials continues to be debated. In 1948 Rudolf Egger articulated the now common view that the legend linking Mark with Hermagoras was composed toward the mid-sixth century to justify Aquileia's independence from Rome.[14] This move would have been prompted by the Council of Aquileia in 558, when Bishop Paulinus I (557–69) broke with the papacy in supporting the so-called "Three Chapters" condemned by Justinian in 543.[15] At that time, Egger reasoned, Paulinus would also have asserted his right to the title of patriarch of Venice and Istria. Indeed, Pope Pelagius I (556–60) condemned Paulinus for this presumption in a letter to the patrician John.[16]

The crucial passage in the pope's letter reads as follows:

> I question if one whom they claim to be patriarch of the Venices as well as Istria has ever been present at, or sent legates to, the general synods which we venerate. Whereas if this can be demonstrated neither by false testimonies nor by reason of these matters, they should learn at some point that not only is (the Aquileian Church) not a general church, but also it cannot even be said to be part of a general one, unless reunited with the foundation of the Apostolic Sees, (and) thus freed from the desiccation caused by cutting itself off (from the universal church), it begins to count itself among the members of Christ.[17]

While Aquileian pretensions to the patriarchal title are clear in this passage, neither the pope's letter nor any other sources prior to the late eighth century mention an apostolic foundation as supporting evidence.[18] Indeed, Pelagius charges that Aquileia has not even provided falsifications in support of its presumed authority. Aquileia's apostolic tradition seems instead to be the product of the seventh-century schism and the advent of the Franks to political ascendancy in North Italy a century later.

Seeds of disunity had been sewn within the Upper Adriatic province as early as the sixth century in the aftermath of the Lombard invasion.[19] When Aquileia fell to the Lombards in 568, Bishop Paulinus I moved his church to the neighboring island of Grado, then a Byzantine protectorate. The Aquileian clergy remained there until the death of Bishop Severus in 610, when the election of his successor provoked an internal schism over the "Three Chapters." Subsequently, one faction reestablished the bishopric at Aquileia with Lombard support, while the other remained at Grado with the backing of the Byzantine exarch. For the next two centuries the rival bishoprics coexisted relatively peacefully, each exercising authority within the respective boundaries of the Lombard and Byzantine administrations. But at the end of the eighth century, Frankish conquests in North Italy and Istria upset the political equilibrium.

Charlemagne, following his army's occupation of Friuli in the early 780s, strengthened the authority of the Aquileian See under his appointees, Paulinus II (787–802), Ursus (802–11) and Maxentius (811–37). Recognizing Aquileia's political significance, Charlemagne promoted its patriarchal title and the extension of the metropolitan's authority into Istrian territory occupied by his troops in 788. He further granted Maxentius funds to rebuild the city and its cathedral, which had been abandoned in the seventh century in favor of Cormons and Cividale.[20]

It is during this period that official documents and chronicles first consistently record the patriarchal title after a long hiatus.[21] Likewise, Mark's apostolic mission—the canonical basis for the title—is first outlined by Paul the Deacon in his *Liber de Episcopis Mettensibus*, a work commissioned between 783 and 786 by Bishop Angilram of Metz and Charlemagne.[22] In his introduction to the episcopal list, Paul mentions a series of bishoprics founded at the behest of Saint Peter to set the stage for the narration of the foundation of the See of Metz by the apostle's disciple Clement. In this context, Paul records that Mark, the most distinguished of Peter's disciples, was sent to Aquileia and prior to returning to Peter and setting off for Alexandria, he selected Hermagoras to officiate in his place.[23] Here, *in nuccia*, is the apostolic succession of the Aquileian bishopric—from Peter to Mark to Hermagoras.[24]

At the Synod of Mantua in 827, the legend itself was successfully adduced as evidence for Aquileia's primacy over the province of Venice and Istria.[25] With papal sanction of Aquileia's claim, Grado would have been reduced to a mere parish, had it not been for the intervention of Venice.

Recently established as the seat of Byzantium's *Dux militiae* in the Upper Adriatic, Venice found herself caught between Byzantine and Carolingian forces vying for control of the region.[26] After a period of internal unrest and shifting allegiances, the city increased its autonomy from Byzantium under the Partecipaci doges, Agnellus and Justinian (810–29), and reasserted its authority over the islands and coast of the Upper Adriatic and the episcopate of Grado. It was therefore unwilling to tolerate ecclesiastical interference from Aquileia and responded within a year of the synod by acquiring the relics of Saint Mark from Alexandria.[27] By substituting this "Italian" patron for the Eastern warrior saint, Theodore, Venice simultaneously undermined the basis of Aquileian apostolicity and forged a new identity, independent of both Carolingians and Byzantines.[28]

During the next four centuries the papacy vacillated, succumbing alternately to pressure from the imperial sponsors of Aquileia and the powerful Venetian state backing Grado. Aquileia regained papal approval during two crucial political renascences under Patriarchs Poppo (1019–42) and Ulrich II (1161–82). Both patriarchs used architecture and pictorial cycles at the Basilica Patriarcale to reinforce the case for Aquileian primacy (see below, chaps. 2 and 5).

The German-born patriarch Poppo was appointed to his office by Emperor Henry II (1014–24). Only five years after his succession, he took advantage of the temporary exile of Patriarch Ursus of Grado and Doge Orseolo of Venice to subjugate Grado by military force. Initially, Venice persuaded Pope John XIX to take Grado's part, but three years later at the Lateran Synod of 1027, the pope upheld the decision pronounced in favor of Aquileia at Mantua two hundred years earlier. Grado was once more to be reduced to a parish of Aquileia and the elder see was restored as "capud et metropolim tocius Venecie (head and metropolitan of all Venetia)."[29]

In his military campaign against Grado, Poppo intended to bend the rival see to his own authority, but he also seized the opportunity to reclaim the relics of Hermagoras and Fortunatus, which had been in the custody of Grado since the Lombard invasion of 568.[30] By this action he countered the translation of Saint Mark's relics to Venice in the ninth century. If Venice had enjoyed the patronage of the region's apostle displayed in its government church, Aquileia could now claim the authority of the region's first bishop, whose relics served to reconsecrate Poppo's new cathedral in 1031.

The cult of Hermagoras and Fortunatus was also enhanced in the liturgy of the Church of Aquileia under Poppo. The first evidence of a full-fledged feast dedicated to the patrons comes from this period,[31] and in 1028, four years after the recovery of the relics from Grado, the Acts of the Chapter of Aquileia record the earliest known endowment of an altar dedicated to Hermagoras.[32] The church as a whole was consecrated on the festival of Hermagoras and Fortunatus on July 12 with the support of Pope John XIX, who, according to a fourteenth-century inscription, issued indulgences for the observance of the feast and its octave.[33] The inclusion of an octave indicates the newly elevated status of the patron saint's feast, placing it on the same level as the feasts of John the Baptist, Peter, and Paul. Saint Mark the Evangelist, on the other hand, is not even included in the dedicatory inscription composed for the consecration. This fact, together with the institution of devotions at the altar dedicated to Hermagoras and Fortunatus in the crypt on the feast of Saint Mark,[34] suggests that the cult of the local founders had been intentionally orchestrated at the expense of the evangelist.

Poppo's military and political successes were short-lived. In 1044, two years after his death, Venetian forces successfully repulsed the Aquileian invaders from Grado. Subsequently, Pope Benedict IX recognized Ursus of Grado as "patriarch of the Church of Grado, the New Aquileia," and reduced the Aquileian prelate to bishop of Friuli.[35] In his "Constitutions" of 1053, Leo IX further recognized Grado as the "head and metropolitan of all (the province of) Venetia and Istria," and this state of affairs prevailed until the 1180s.[36]

The last champion of Aquileia's cause, Ulrich II, was elevated to the patriarchate in

1161.[37] His career will be discussed more fully in connection with the hagiographic cycle in chapter 5. Suffice it to say here that through his diplomatic efforts, Venice-Grado agreed in a treaty of 1180 to renounce any claims to Aquileia's patriarchal title or jurisdiction. Aquileia theoretically gained ecclesiastical primacy in Venetia and Istria, but Venice wielded the real economic and military power in the region. Virtual control over church matters was soon to follow. By the end of the century, both patriarchs resided in Venice. The See of Grado, whose patriarchs had been selected from the ranks of Venetian clergy since the ninth century, was finally suppressed in 1451, and its jurisdiction passed into the hands of the bishops of Castello. Aquileia was gradually eclipsed in the course of the fourteenth century by Venice, and from 1430 until its suppression in 1751 was a satellite of Venice, much as Grado had been from the ninth century on.[38]

To summarize: the origins of the Church of Aquileia remain obscure. While episcopal catalogues lead us to believe that the bishopric was established under Saint Hermagoras in the second century, its existence is firmly documented only at the beginning of the fourth century. The legend making Saint Mark the founder of the Aquileian Church and teacher of Saint Hermagoras was apparently not formulated until the Carolingian period, when ecclesiastical and imperial authorities collaborated to promote the see's patriarchal jurisdiction in Venetia and Istria. Aquileia gained official recognition of its patriarchal title at three points in its history: under Maxentius, at the Synod of Mantua in 827; under Poppo, at the Lateran Synod of 1027; and under Ulrich II in 1180, when the treaty was negotiated between Aquileia and Grado. In each case, the cult of the founding bishop was an instrument of ecclesiastical political policy, designed to counter the claims of Grado and Venice. Architectural innovation highlighted possession of the founding bishop's relics and thus legitimized ecclesiastical claims made in the first two periods; similarly, the Romanesque murals proclaimed Aquileia's primacy over the Venices at the end of the twelfth century.

CHAPTER TWO

The Architectural Setting of the Relics

THE CRYPT was designed to amplify both religious and political functions of the relics. As *memoria* of the patron saints of Aquileia, Hermagoras and Fortunatus, it perpetuated the memory of their careers and martyrdoms in Aquileia and served as a continuing channel for their intercessory power. It was also a special chapel in which the canons of the cathedral could regularly celebrate the mass. At the same time, like other manifestations of the cult of the founding bishop, the crypt and its decoration played a crucial role in the ecclesiastical politics of Aquileia and Venice. This chapter outlines the building phases of the crypt and explains how the architecture fulfilled these functions.

Building History of the Crypt

Viewed from the nave, the crypt boldly advertises the physical presence of the saints beneath the high altar. It rises four meters above the nave floor and projects from the central apse halfway into the crossing to provide a podium for the choir (figs. 2, 6). Its elegant marble facade, dating from the fifteenth century, forms a harmonious tripartite composition. An elaborate *fenestella confessionis* at its center originally offered a view to the relics within; adjacent flights of stairs communicate with the sanctuary above; and Corinthian pilasters frame twin entrances to the crypt on each flank.

The medieval fabric of the interior remains largely uncompromised by this later intervention (pl. I; fig. 7). Access is afforded by two L-shaped stairways aligned with the side aisles of the nave. Constructed in part from antique funerary slabs, both passages are barrel-vaulted and lead to square groin-vaulted landings and thence, down three more steps into the west aisle of the crypt. Each stairway also communicates with a small, groin-vaulted room flanking the *fenestella*.

Inscribed within a square perimeter, the crypt is a three-aisled apsidal hall, four bays in length, with an absidiole in its central western bay, pierced by the *fenestella confessionis* (figs. 2, 3). The walls are divided into round-arched bays by engaged columns with simple impost capitals. Together with the six free-standing columns flanking the central aisle, they support three parallel barrel vaults on the east–west axis. The capitals of the free-standing columns are blocky, shallowly carved renditions of the Corinthian order, ringed with an arcade motif at the echinus (fig. 4). Their shafts, which were originally plastered over, are roughly shaped from Roman funerary slabs. The stone floor is similarly composed of spolia.[1]

The building history of the crypt spans an entire millennium from the fifth to the fifteenth century. The present church occupies the site of the southern *aula* of the double

cathedral constructed at the beginning of the fourth century under Bishop Theodore.[2] This first church, excavated by Niemann and Gnirs between 1893 and 1915, was a simple three-aisled, rectangular hall, lavishly decorated with figured mosaic pavements and murals. Its fifth-century successor, known as the south "post-Theodoran" basilica,[3] was likewise a three-aisled hall, but it was wider and extended farther east (fig. 9). Much of this structure is visible in the present church. The bases of the piers remain beneath the present nave colonnades. The external walls and short buttresses of the nave and choir survive up to seven meters above ground in the present fabric. Finally, parts of the pavement have been discovered in the area of the modern high altar at the crossing.

This church must have been almost entirely destroyed by the invading Lombards a century later and remained derelict until the beginning of the ninth century.[4] In the spirit of "renovatio," Aquileia's first Carolingian patriarch, Paulinus II (792–802), wrote a poem lamenting the ruinous state of the ancient city.[5] But it was apparently left to his successor, Maxentius (811–32), to rebuild the city and its churches. In a diploma issued at Aachen on 21 December 811, Charlemagne granted him the hereditary properties of the former Lombard duke, Rotgaud, and his two brothers to restore the city to its former dignity.[6] The document further specifies that funds are being provided so that Maxentius may complete the reconstruction of the church and its appurtenances.[7]

The new Carolingian cathedral, though incorporating most of the lower walls of the post-Theodoran church, boasted a number of innovations: the porch and catechumens' church ("Chiesa dei Pagani") connecting the basilica with its baptistery, the transept with north and south apses, the raised presbytery, and the hall crypt beneath it (fig. 10).[8]

Of greatest significance for this discussion are the outer east wall and the interior hemicycle wall of the crypt. As Luisa Bertacchi confirmed in her excavations of 1970, the east wall of the fifth-century church is almost entirely preserved in the outer wall of the Carolingian crypt (figs. 7, 9, 11).[9] The latter was reduced in width, and new side walls were constructed to enclose a square choir. At the same time, the crypt was excavated beneath the original presbytery pavement.

While there is no question that the hemicycle of the crypt postdates the fifth-century exterior wall, there is considerable debate over the date of its insertion. Many still believe that the apsidal wall was constructed together with the vaulting during the Carolingian phase.[10] However, I adopt the theory first formulated by Toesca that the present interior arrangement belongs to Patriarch Poppo's building campaign in the early eleventh century.[11]

The Carolingian dating of the crypt interior is based on the following elements: the plan and vaulting; the relationship between the hemicycle and the presumed Carolingian apse of the presbytery above; the design of the crypt's capitals; and finally, the underpainting visible on the hemicycle wall.

Starting with the plan, Tavano insists that the horseshoe configuration of the eastern hemicycle is a peculiarly Carolingian feature (fig. 7).[12] The eighth-century crypt of San Salvatore in Brescia certainly conforms to this pattern; however, this typology is shared in crypts constructed from the tenth to late eleventh centuries.[13] Furthermore, the size of the apsidal hall at Aquileia, the articulation of its elevation into clearly defined bay units, and

the configuration of its west end, with entrances from the side and a central reliquary niche can only be paralleled in fully evolved "First-Romanesque" hall crypts of the early eleventh century, such as that of San Pietro at Agliate in Lombardy (fig. 8).[14] Likewise, the Aquileian system of parallel barrel vaults supported on spandrels and intermittent groins (figs. 3, 4, 5), though quite rare, can be found in late-tenth- and early-eleventh-century crypts.[15]

A second argument stems from the assumption that the Carolingian choir was endowed with a semicircular apse, for which the crypt provided the foundation. The principal evidence is Swoboda's discovery of an "earlier" blocked window adjacent to the north window of the Popponian apse and the presumed Carolingian floor mosaic in the apse.[16] Because he did not record whether the blocked window was visible from the interior and conformed to the curvature of the apse, it cannot be proven that the window was part of an earlier apsidal wall rather than the flat exterior wall.[17] As far as the mosaic pavement is concerned, Xavier Barral i Altet has demonstrated that its design and combination of *opus sectile* and *opus musivum* techniques place it amongst a group of Romanesque pavements found close by at San Zaccharia and San Marco in Venice, and at the Abbey of Pomposa.[18]

The Carolingian dating of the six free-standing capitals can be confirmed by comparisons with ninth-century capitals in the Cappella della Pietà of San Satiro in Milan and the abbey of San Baronto near Empoli in Tuscany.[19] Nevertheless, the capitals can provide only a *terminus post quem* for the dating of the crypt interior, since it is likely that they are spolia. This is suggested by the uniform discrepancy in scale between the free-standing columns and those engaged to the hemicycle. Furthermore, both Carolingian and Roman spolia are used elsewhere in the eleventh-century phase of the cathedral: in the exterior buttresses of the south aisle, the episcopal throne, some of the capitals of the transept and sanctuary, and the campanile.[20]

Brusin voices a fourth argument, that the lower layer of intonaco on the hemicycle wall is Carolingian.[21] She bases her argument on the unproven assumption that it is contemporary with the corresponding layer in the left apse of the upper church. On the contrary, an inscription discovered by Swoboda on the lower intonaco layer of the crypt in the northernmost bay of the hemicycle provides compelling evidence that it belongs to an aborted decorative scheme begun under Patriarch Poppo at the beginning of the eleventh century (fig. 1:F1; fig. 12).[22] Executed in gold letters, the fragment reads as follows: ". . . OPON(I?)E REVEREN[]ISSIMO PATHA . . . / ORTVNA[?]IARGHIABIAN MARTI MAI . . ." Swoboda reconstructed the inscription as follows: "O PON(T)I?(FIC)E REVEREN-(D)ISSIMO PAT(RIARC)HA . . . / (FO)RTVNATI ARCH(IDIACONI?), FABIANI (OR TACIANI) MART(YRV)M A(QVILEIENSIVM) . . ."[23]

The most interesting part of the inscription is the first line referring to the "most reverend patriarch." Swoboda laments the absence of further letters to enable the identification of the patriarch responsible for the decoration, but it is more likely that the name appeared before the title rather than after it, as he had assumed. Instead of transcribing the second word as "PONTIFICE" for which the existing letters present a very unusual abbreviation, I propose to read the first cluster as "(P)OP(P)ONE," the ablative form of Poppo.[24] His

name appears in a similar formula in the painted inscription of the apse: ". . . DOMINO POPPO(NE) VENERABILI PAT(RIARC)HA AQ(VI)LEGIE(N)SI"[25] and again at the end of an act of the chapter of Aquileia of July 1033 recording the reconsecration of the church: ". . . Domini Popponis Reverendissimi Patriarchae. . . ."[26]

If my reading of the inscription is accepted, then it provides another manifestation of Poppo's ambitious program of sculptural and painted decoration. The inscription and marbling of the columns (lower layer) would have been executed after the translation of relics from Grado by the workshop responsible for the apse of the upper church. The relatively flat, smooth surface of the vaulting which is so congenial to figural murals may well have been chosen with this task in mind. In the end, the project was probably aborted because of Poppo's premature death during the siege of Grado in 1042.

The three-aisled apsidal hall with its western reliquary niche and twin entrance bays thus seem to be the product of Poppo's building campaign in the 1030s. The Carolingian crypt on the same site must have been a considerably simpler, square-plan room defined by the present exterior walls.

Clues to its illumination are visible in the masonry of the east wall (fig. 11). Starting at the height of 4.56 meters above sea level, one finds a series of four apertures, approximately 0.8 × 1.5 meters, that have been walled in with rough rubble masonry; at the height of 5.46 meters, there is a series of four narrow arched embrasures, measuring 0.1 (exterior)/0.3 (interior) × 1.0 meters still open on the exterior. In addition, on the interior of the north, east, and south walls, there is evidence of regularly spaced engaged piers which Bertacchi has reasonably presumed to articulate a system of support for the ceiling of a rectangular-plan room antedating the insertion of the hemicycle wall. Both sets of windows are spaced at regular intervals between the five engaged piers, suggesting that the rectangular chamber was divided into four aisles (fig. 7). Bertacchi has attributed the embrasures to the post-Theodoran phase of the east wall and the larger blocked windows to the Carolingian phase. It seems more logical, however, to assume precedence for the larger openings, since embrasures are hardly appropriate illumination for a fifth-century presbytery. Indeed, a similar hierarchy of window types can be seen in the ninth-century central apse of the Abbey of Pomposa: three generously sized arched windows pierce the apse of the upper church, while narrow embrasures mark the perimeter of the crypt.[27]

In sum, the Carolingian crypt was a four-aisled rectangular hall illuminated at the east by the four surviving embrasures.[28] This space was entirely reworked under Poppo in the 1030s to form the standard Romanesque hall crypt evident today. From that time, the interior of the crypt has remained largely intact, with the exception of two significant interventions.

In 1348 the basilica suffered grave damage from an earthquake. While attempts to repair it were made in the course of the next decade, a serious campaign of structural renovation was not undertaken until the patriarchates of Lodovico della Torre (1360–65) and Marquardus of Randeck (1365–81).[29] At this time the present nave arcades, clerestory walls, crossing arches, and wooden vaults were constructed. In order to support the eastern crossing arch, substantial octagonal piers were inserted in the crypt adjacent to the

landings of the entrance stairs. Concurrently, the east walls of the landings were filled in to be flush with the piers, thus concealing the twelfth-century decoration.[30]

A second campaign of a more cosmetic nature was initiated by the Venetian patriarch, Marco Barbo (1467–91; fig. 2).[31] In keeping with the current fashion of his native city, Barbo commissioned Antonio da Venezia and Gasperino de Matendellis da Lugano to execute an elaborate, classicizing frame for the *fenestella confessionis*, and marble revetment framed by Corinthian pilasters for the flanking facades. Inside the crypt, a new sarcophagus was commissioned for the relics of Hermagoras and Fortunatus and placed in the central aisle (fig. 13).[32] In 1490 a wooden armoire was constructed on a platform above the sarcophagus to contain the treasury; and it was probably at this time that the free-standing columns were enclosed with an iron fence.[33] Finally, a new altar, dedicated to Hermagoras and Fortunatus, was installed to the west of the enclosed treasury in 1494.[34] The two pilasters marking the opening of the absidiole (fig. 3) must also have been added at this time, since they correspond well to the style and execution of the simple fluted order of pilasters on the nave facade of the crypt.

Still visible in early twentieth-century photographs (fig. 13), these interior furnishings were removed when the crypt was restored in 1946–47.[35] Happily, this permits us to experience the decoration as a whole, which for five hundred years was so brutally compromised by the iron screen. It also permits us to experience the spatial flow which originally facilitated the viewing of the relics and participation in regular masses.

Religious Functions: Memoria, Dedication, and Oratory

The Romanesque hall crypt united within a single structure the disparate functions that were fulfilled separately in Early Christian architecture by suburban martyria and urban parish churches or cathedrals. It was here that the relics were placed during the initial dedication of the church and were venerated thereafter by the faithful. In many cases the crypt also provided space for the burial of bishops as well as prominent laymen, and the perpetuation of their memory in votive masses at its various altars.[36] At the same time the crypt provided a platform for the daily celebration of the eucharist at the high altar, which continually evoked the memory of the patron saints immediately below.

The plan of Aquileia's crypt explains much about how it was used (fig. 7). Dual western entrances facilitate the movement of visitors along the western aisle of the crypt to view the relics of Hermagoras and Fortunatus. Much like earlier corridor crypts in Carolingian Rome, for which the Gregorian *confessio* of Old Saint Peter's in Rome provided the model, the Aquileian hall crypt type permits a rational flow of traffic allowing pilgrims to view the relics without disturbing the regular liturgy in the choir.[37]

Like most "First Romanesque" hall crypts, that at Aquileia must originally have contained a *memoria* for the relics in the western absidiole, directly beneath the high altar (figs. 3, 6).[38] The relics were made visible there from the nave through a medieval predecessor of the current *fenestella* (fig. 2). At the same time, the obvious axial relationship between the high altar and the relic altar of the crypt would have reinforced the symbolic link between the relics of martyrs and the eucharistic relics of Christ.

Theological justification for this association originates with Saint Paul. In Romans 6:3–6, he argues that those who are baptized into Jesus Christ are also baptized into his death and those who are planted together with him in the likeness of his death shall also be in the likeness of his resurrection. Elsewhere, in II Corinthians 1:7 and Galatians 5:24 he emphasizes that the disciples literally participate in the Passion of Christ: they are glorified in the cross of their master and are crucified with him.

While Paul cast all followers of Christ in the model of his Passion, patristic writers emphasized the particular role of martyrs as imitators of Christ who suffer physically and die for their faith.[39] It is on these grounds that Paulinus of Nola justifies the collocation of ashes of martyrs with a relic of the True Cross in the church of Saint Felix at Nola in the early fifth century: "How well the bones of saints are combined with the wood of the cross, so that those who were killed for the cross find rest on the cross."[40]

A passage from the Apocalypse contributed to the concrete expression of this idea. At the opening of the fifth seal John "saw under the altar the souls of those who had been slain for the word of God and for the witness they had born . . ." (Rev. 6:9).[41] By the end of the fourth century, it became accepted practice to consecrate churches by placing the relics of saints in or beneath the altar.[42] When in 380 Saint Ambrose of Milan enshrined the newly discovered relics of Gervase and Protase in a *confessio* beneath the altar of his basilica apostolorum,[43] he deemed it "proper that martyrs, themselves triumphant victims, should be placed beneath the altar where Christ is offered as the eucharistic host."[44] What is significant for Aquileia is the special place that Ambrose accorded to episcopal burial: he justified his own tomb *ad sanctos* beneath the altar on the grounds that even in death the bishop might continue to make the eucharistic offering on behalf of his people.[45]

Although consecrating churches with relics was officially approved as early as the fifth century at the Sixth Council of Carthage in 401, the strong push to do so came only at the end of the eighth century.[46] In Western Europe, councils of 801 and 813 required that all altars lacking relics be destroyed.[47] The consecration of altars and churches with both relics of the saints and eucharistic particles—a further extension of the parallelism between the martyrs and Christ—appears to have been another product of the Carolingian reform. First mandated at the Council of Chelsea in 816, the practice continued to be the norm up to the thirteenth century.[48] Indeed, the liturgy of dedication in both the tenth-century Romano-German pontifical and the twelfth-century Roman pontifical alludes to the traditional scriptural justification of the practice from Apocalypse 6:26. When the relics are introduced into the *confessio*, the priest sings the antiphon: "You have accepted your places beneath the altar; intercede upon our behalf with the Lord who has chosen you."[49]

By the early eleventh century, then, when the Aquileian crypt assumed its present configuration, the relics of martyrs "subtus altare" were bound to the eucharistic relics of Christ above. That architectural relationship was initially activated through the liturgy of dedication in the act of depositing the relics beneath the eucharistic altar, then through the annual feasts in honor of the martyrs and the church's anniversary, and further through the daily celebration of the eucharist both at the high altar and in the crypt itself.

The dual role of the Aquileian crypt as martyrium and place of dedication was em-

phasized in the local liturgical calendar. In the thirteenth-century Processional now in Gorizia, the rubrics mention a procession to the altar of Hermagoras in the crypt at the second hour of vespers on his feast day, July 12.[50] The antiphons and prayers recited in the crypt *ad sanctum* Hermachoram are drawn both from the *Passio* recounting the death and martyrdom of Hermagoras and from the standard dedication ritual. That liturgy's emphasis on the relationship between the terrestrial church building and the heavenly Jerusalem, and on the power of the local martyrs to intercede at their burial place to bridge the two realms, is also reinforced by the pictorial program (see chap. 4).

Although most written sources on Aquileia are silent about pilgrimage, the papal indulgences proclaimed by John XIX to those who would visit the shrine of Hermagoras and Fortunatus must have provided an important impetus within the province of Aquileia.[51] Similarly, although no *Miracula* collection survives, miracles performed by the relics are mentioned in a diploma of Emperor Henry IV addressed to Aquileia.[52]

Beyond its primary dedicatory and reliquary functions, the Aquileian crypt also provided ample space to serve as an oratory. This regular liturgical usage of the crypt is highlighted by the inclusion of a second altar, independent of the *memoria* altar. Conforming to the pattern of most European crypts from the Carolingian period on, the second altar was probably dedicated to Mary.[53] This was particularly appropriate at Aquileia, because the *Genetrix Dei* preceded the local patron saints as primary patron of the cathedral, a fact that is reinforced pictorially in the apse of the upper church and the hierarchy of saints in the central vault of the crypt.

Today there is only a single, small altar table in the western niche where the *memoria* housing the relics was once located (fig. 3). In the original scheme, there would have been a free-standing altar in the central aisle. This arrangement was perpetuated in the Renaissance renovations of the crypt and survived up until the early twentieth century (fig. 13). Judging from extant altars in contemporary hall crypts (cf. fig. 8), however, the Aquileian altar must originally have been located farther east, between the last pair of free-standing columns. This provides ampler space for an eastward-facing congregation to participate in regular celebrations of the eucharist, and we shall demonstrate that it accords with the disposition of intercessory images on the central vault of the crypt. Suffice it to mention here that the orant image of the founding bishop, Hermagoras, is situated over the presumed altar site (figs. 3, 23), facing the viewer in such a way that he serves both as an appropriate backdrop to the altar and as a prototype for his medieval successors who would stretch out their arms in a similar fashion to celebrate the eucharist at the altar below.

As Rutishauser has suggested, the increasing popularity of the private mass may also have contributed to the expansion of liturgical functions in hall crypts.[54] The *missa privata* or private mass, first institutionalized in the Carolingian period, was a simple eucharist said by the priest alone or in the company of only one or two congregants.[55] It often served as a votive mass, requested to commemorate the deceased shortly after death and on subsequent anniversaries, or to benefit a living individual. At the same time it could fulfill the needs of the regular clergy and canons to celebrate the mass daily. There was a steady increase in the number of altars consecrated in the main church as well as in crypts

from the eighth to twelfth centuries, because while the urban clergy were officially en-
couraged to celebrate at least two or three masses per day, they could not celebrate a mass
at an altar that was used by the bishop on the same day and could perform that function
only twice a day at any given altar.[56]

Both forms of private mass must have been performed in the Aquileian crypt. As far
as votive masses are concerned, the Acts of the Chapter of Aquileia mention the offering
of private funds by Abbot Ossiach for the furnishings of the altar of Saint Hermagoras in
1028,[57] and the dedication of the same altar is recorded in the Necrologium Aquileiense
on Saint Mark's day together with obituaries of private individuals.[58] Although there were
no burials in the crypt itself, the concentration of episcopal tombs *ad sanctos* in the crossing
and eastern section of the nave immediately in front of the crypt suggests that a major
function of the masses celebrated there was to have the founding bishop intercede on
behalf of the souls of his medieval successors.[59]

The dual function of the crypt as *memoria* and oratory insured that the crypt was
used each day. It also meant that the future decoration of the church would serve diverse
audiences—pilgrims to the tomb, participants in the eucharist, the patriarch and canons of
the cathedral. Future chapters (4–7) illustrate how these spiritual needs were addressed in
the structure and content of the painted decoration.

The Crypt as a Function of Ecclesiastical Politics

Apart from its religious functions, the crypt amplified the political function of the relics.
As we have seen, the medieval crypt is primarily the product of two campaigns: the first
under the patriarch Maxentius (811–37), the second, under Poppo (1019–42). The particu-
lar historical circumstances outlined in chapter 1 suggest that these patriarchs employed
architecture to further their propaganda war against Venice.

The inclusion of the crypt in the ninth-century rebuilding of the Basilica Patriarcale
represents the most substantial functional change in the cathedral complex since its incep-
tion in the fourth century. This innovation may reflect official Carolingian policy pro-
claimed at the Synods of Frankfurt (774) and Mainz (813), requiring saints' relics for the
consecration of churches. It is also in keeping with the general trend toward shifting relics
intra muros to protect them and make their shrines more visible to the urban population.[60]
Foremost in Patriarch Maxentius's mind must have been the desire to create a new *locus
sanctus* for the patron saints in their native city. By restoring the city of Aquileia and
returning his ecclesiastical administration there, he reaffirmed the importance of the his-
toric metropolitan city for his own apostolic succession. The construction of the crypt of
the founders of the see, no less than the redaction of their *Passio*, contributed to his cam-
paign for the primacy of Aquileia over Grado and Venice. So powerful were these argu-
ments that the papacy recognized Aquileia's metropolitan authority over the Roman prov-
ince of "Venetia and Hestria" at the Synod of Mantua in 827, subjecting to it the Venetian
metropolitan See of Grado.

When the Venetians stole the relics of Saint Mark in 828 and dedicated a new ducal
chapel in his honor, they undercut Aquileian authority and appropriated Mark as their

own patron.[61] Patriarch Poppo's reconstruction of the Aquileian crypt and his plans for its decoration are entirely consistent with his vigorous campaign to restore the greatness of his metropolitan see.[62] The importance of the dual patrons of the church, hitherto included only sporadically as part of the dedication in official documents, was repeatedly emphasized by Poppo in order to strengthen the legitimacy of Aquileia's authority vis-à-vis Grado, whence the relics had recently been stolen.[63] For this reason the newly structured sanctuary and crypt were consecrated on the festival of Hermagoras and Fortunatus, 12 July 1031.

To these arguments emphasizing the authoritative presence of the founding bishop at Aquileia, Poppo added two pictorial ones: the architecture of his new cathedral and the decoration of the apse. As Hans Buchwald has pointed out, the selection of Corinthian capitals for the nave arcades, based on antique spolia employed in the transept, and particular details of the ground plan of the renovated church—the projecting transept and the nonstructural colonnades screening off the ends of the transept—allude to the early Christian basilica of Saint Peter's in Rome (figs. 2, 10). Buchwald concludes that "Poppo wanted to stress his spiritual affinity to the papacy. . . . The church could serve as a visual demonstration underlining the fact that his patriarchy had (supposedly) been founded by the Apostle Mark as the papacy had been founded by the Apostle Peter."[64]

The apostolic succession of Aquileia is emphasized again in the decoration of the apse (figs. 14, 15).[65] The two key positions on either side of the Theophany, normally occupied by Peter and Paul in Roman apse compositions and their derivatives, are granted here to Mark and Hermagoras on the *dexter* and *sinister* sides, respectively. The next two positions are occupied by Hermagoras's immediate successor Hilary, and his deacon, Fortunatus. Then follow Tatian, the deacon of Hilary, and Euphemia, the adopted Aquileian female martyr, connected in local tradition with Hermagoras.[66]

Like his predecessor Maxentius, Poppo was initially successful in restoring the apostolic authority claimed for Aquileia in the *Passio* of Hermagoras and Fortunatus, but Venice once again was prompt to respond. Military force, diplomatic means, new redactions of history, and architecture were used in turn to counter the success of Aquileia. The culmination of the Venetian response was the construction of the present basilica of San Marco under Domenico Contarini (1042–71) and his immediate successors in the second half of the century. While Poppo had modeled his new church on the apostolic basilicas of Rome, the doges of Venice enhanced their own status by choosing a Byzantine imperial model for their ducal chapel, the Church of the Holy Apostles in Constantinople.[67] An essential modification of the Byzantine model was the inclusion of a Western-style hall crypt, much larger than the Popponian crypt of Aquileia, providing a suitable setting for the newly recovered relics of Saint Mark, confirming the validity of the translation that had provided the raison d'être for the first church of San Marco.[68]

CHAPTER THREE

Byzantine and Romanesque

Painting Styles, Dating, and Meaning

Studied in photographic isolation, scenes such as the frequently reproduced Deposition of Christ (pls. III, IV) project an air of sublime pathos that has led many writers to define a distinct artistic personality, a Byzantine painter or his Venetian disciple, dubbed the "Maestro della Passione."[1] In the scholarly literature, this grand master towers over the anonymous "Romanesque" painters to whom the rest of the decoration has been attributed (pls. II, V, VI, VII). Also Romanesque in feel are the proliferation of ornament, crowding the figural imagery of the ceiling, and garish palette (pls. I, VIII). Yet the disposition of figural imagery within its architectural frame does not readily conform to conventional definitions of either Romanesque or Byzantine (pl. I; figs. 1, 4).[2] The crypt presents a somewhat awkward setting with limited wall space, and this has forced the designer to accommodate most of the figural imagery in the superstructure. In the absence of dome or apse, the theophanic visions of Christ and the *Genetrix Dei*, together with the civic saints interceding before them, occupy the three core panels of the middle aisle vault (figs. 5, 17). The spandrels, ideal fields for single figures, are given over to the lower echelons of the hierarchy of saints. The remaining vaults are unconventionally articulated as a sequence of rectangular panels with scenes from the hagiographic legend, each oriented along the longitudinal axis towards the viewer at the west end of the crypt. By contrast, the Passion scenes in the lunettes of the hemicycle are framed individually by the physical architecture of the vaults and semicolumns (pl. I; fig. 4). Finally, the socle zone, set apart by an ornamental mask frieze, is rendered as a fictive curtain or *velum*, illusionistically suspended on rings before the wall (pls. I, VI).

There is no documentary evidence to date the wall paintings, apart from graffiti on the hemicycle which provide a *terminus ante quem* of 1217 for the upper layer.[3] The recent consensus of opinion, led by Chiara Morgagni Schiffrer and Johanna Kugler, holds that the murals were completed toward the end of the twelfth century or in the early decades of the thirteenth by Venetian painters familiar with the late Comnenian style of contemporary Byzantine art.[4] To "Romanesque" assistants have been ascribed most of the scenes of the hagiographic cycle and the fictive curtain.

Morgagni Schiffrer seems correct in narrowing the dating to the 1180s. Both stylistic evidence and circumstances of patronage to be discussed later in chapter 5 stand in her favor. I further assume that there was a local Aquileian workshop that was perhaps trained in Venice but brought together for the crypt project and later deployed elsewhere in the

patriarchate. Instead of viewing stylistic discrepancies in terms of different artists or sources of influence as most previous authors have presumed, I propose that different stylistic modes were adapted to the function of each distinct iconographic division of the program.

Overview

Consistent with Romanesque and Byzantine practice between the eleventh and thirteenth centuries,[5] the Aquileian murals are only partially executed in the fresco technique. The main elements of the composition, sketched in red ocher on the intonaco, and the color fields of the background are painted *a fresco*; draperies and flesh areas with highlights and shadows are painted in the final stage *a secco*.

Two well-preserved panels characterize prevailing compositional principles and figure style: the Consecration of Hermagoras (pl. II) and the Deposition of Christ from the Cross (pl. III). The dramatis personae may be summarized briefly. In the Consecration scene, Saint Peter strides in from the left to bestow the crozier and his blessing upon Saint Hermagoras, already vested as bishop in the middle of the scene. Saint Mark stands as witness at right. In the Deposition, the Virgin stands slightly to the left of the empty cross, holding her son's limp torso close to her breast. Joseph of Arimathaea helps carry the body from behind, while Nicodemus kneels at the foot of the cross to remove the nails from Christ's feet. Four women who accompanied the Virgin at the Crucifixion stand in a tight group to the left while a disproportionately large figure of John the Evangelist weeps at right. Finally, two bust-length angels appear above the arms of the cross.

Each scene is divided into three color zones. A narrow ground line in green or ocher defines a limited foreground stage on which the figures stand. An ultramarine blue zone (now largely vanished) is set within a dark green background field to represent the sky and form a foil for the figures.[6] Compositions tend towards bilateral symmetry. The main action takes place parallel to the picture plane and is directed inward by the glances of participants.

In contrast to the planar conception of the Consecration, the Deposition and other feast scenes such as the Crucifixion (fig. 84) reveal a spatial tension. The oblique arrangement of heads to the left and right of the cross, the outward curve of the body of Christ, and the perspective of the pavilion behind Saint John seem to project the action forward into the viewer's space. This impression is reinforced by the transgression of the image's boundaries: the mound of Golgotha touches the lower frame; Nicodemus's left foot actually overlaps it; and the top of the cross protrudes above the upper border.

Although previous writers have tried to separate Romanesque and Byzantine participation according to the iconographic divisions of the program, comparison of the Deposition and Consecration panels reveals a remarkable consistency in figure style. Figures are tall and agile, their apparent weight enhanced by billowing vestments.[7] A three-tone, chiaroscuro system is employed to cast the draperies into relief. The darkest tone of a given hue is used for outlines or shadows, a pale tone for the intermediate zones of drapery, and an overlay of white pigment for highlights. A fragmented view of anatomy is

conveyed by a recurrent scheme of highlights and contours. For example, in the figures of Peter (Consecration) and Joseph (Deposition), broad, angular patches of white undercut by triangular shadows and nested V-folds indicate the places where the cloth is pulled tightly over the knees. Nested V-folds mark cloth flowing between the legs. In figures such as Hermagoras (Consecration) and the mourning women (Deposition), undergarments are fitted closely to the forearms and modeled with repeating hairpin folds.

Distinct from these conventions are the insistent linear patterns which enliven the drapery. Long, cascading folds falling from shoulders, arms, and waist are delineated with continuous parallel white lines, interrupted occasionally by triplet groups of horizontal highlights (e.g., Peter and Mark; Joseph and John). Frequently, the forward knee of toga-clad figures is marked by a distinctive teardrop highlight over the kneecap with a series of lines radiating from it (e.g., John).[8] For certain figures, a strong curvilinear element is introduced in the highlights marking joints at the hip, elbow, or shoulder (Peter; John). In other cases, the drapery seems to take on a life of its own: the agitated meandering hems and tubular trumpet folds of the garments is partly motivated by the movement of the figures—Joseph of Arimathaea lifting Christ from the Cross, Peter consecrating Hermagoras—but it is also used to capture emotional states of a character like John in the Deposition.

Modeling of flesh follows a common color scheme throughout. A pale ocher provides the principal flesh tone (pls. IV, V). External contours and internal features are delineated in red, with shadows beneath eyes, mouth, and chin executed in broad strokes of olive green close to the red contours. Concentric red and white lines frequently enhance the modeling of the neck. For the faces, the artists juxtapose linear highlights with broader patches of white. As many as five parallel strokes of different colors outline the nose, including the base flesh tone, a white highlight, and shadows in pink, red, and olive green. The forward side of the face is usually marked with a red spot on the cheek and a white, hairpin highlight opening toward the nose. Broader white patches highlight forehead and chin, and a distinctive white spot appears frequently at the outer corner of the lower eyelid. Hands are delineated with long, slender fingers and modeled with the same linear pattern of white highlights.

The *velum*, or curtain, illusionistically suspended before the socle, differs in mode from the rest of the program (pls. I, VI). Resembling embroideries like the Bayeux Tapestry,[9] its figures are executed as colored outline drawings, with red ocher as the primary pigment for design, yellow ocher or pink for shading, and the white linen medium serving for flesh and background. Despite its distinct technique, the curtain need not be seen as the product of an independent "Romanesque" master.[10] Its impressive draftsmanship essentially duplicates the underdrawings in the rest of the decoration.[11] The tunic-clad figures in the pilgrim scene find close relatives in the executioner from the Martyrdom of Hermagoras and Fortunatus (figs. 80, 99). Common conventions include the application of curvilinear patterns outlining the tunic around the elbows and shoulders, the Z-pattern of lines around the lower arms and cuffs of the tunic, and the treatment of the belly as an oval with V-folds nested beneath it between the legs. Likewise, the naked torsos of the crazed Vices (fig. 90) reveal the same scheme employed for Christ in the Deposition (fig.

86). This technical relationship between the socle designs and the underdrawings of the narratives above has ramifications for the meaning of the curtain as a distinct mode for allegory (see chap. 7).

Byzantine and Romanesque in Aquileian Painting

Aquileia has long been hailed as a monument of Byzantine art on Italian soil. While the earliest commentators on the crypt from the eighteenth century condemned the "maniera greca" as a negative influence, more recent writers have seen Byzantium as an engine of stylistic change which revitalized Western painting in a succession of "waves" in the late eleventh and twelfth centuries.[12] Aquileia is most closely associated with the "Dynamic Style" of the late Comnenian period in Byzantine art.[13] Characterized by an increasing emotionalism, agile figures whose movements animate billowing draperies, and bold linear modeling of the flesh and draperies, this style is presumed to have emanated from the Byzantine capital in the 1140s. An artistic koiné of the Orthodox world, it evolved in complexity until the Latin conquest in 1204.

The murals of Saint Panteleimon at Nerezi in Macedonia, executed for Prince Alexios Comnenos around 1164 (figs. 102, 103), are frequently evoked as models for the pronounced pathos of the Deposition and Threnos at Aquileia (figs. 86, 87; pls. III, IV).[14] The similarities are closest, however, where style and iconography are hard to separate: in the gestures of despair and in the pathetic, tear-stained faces with the narrow, angular eyes and furrowed brows. By contrast, the modeling of flesh and drapery in the Aquileian scenes appears much more linear and schematized: the proliferation of schematic highlights there is a world apart from the broad, smooth highlights and coloristic modeling seen at Nerezi. On this basis, Aquileia may better be associated with a later phase of Comnenian art manifested throughout the Orthodox world during the last quarter of the twelfth century from Bačkovo in Bulgaria to Monreale in Norman Sicily and Novgorod in north Russia.[15]

The search for "sources" in Byzantine art has obscured the fact that the Aquileian murals were executed by local artists. The obvious linguistic difference of the Latin inscriptions betrays a more profound discrepancy in formal language. The brightly colored fields set one within the other to serve as a foil rather than an ambient for the figures are quintessentially Romanesque. Likewise, the garish marbled columns and decorative application of ornament compete with the figural imagery for the viewer's attention and thereby depart from the classic restraint of Byzantine art (pls. I, VIII). Even the carefully studied late Comnenian mannerisms of drapery folds and linear flesh highlights appear more Latin in their application. Contours are strengthened, billowing draperies are petrified in midair (e.g., John; pl. III), and emphatic surface patterns often disguise willful distortions (Christ; pl. III) or an inadequate understanding of anatomy (Peter's lower body; pl. II). To define Aquileia's style and date more precisely, it is necessary to examine the state of Romanesque painting in the region around Aquileia itself.

The extensive remains of wall painting from the eleventh and twelfth centuries in churches under the patriarchal jurisdiction of Aquileia prompt one to question whether

Aquileia itself might have been the font of a thriving local tradition of painting.[16] Connections may be established with four sites in Friuli and the Veneto: the Abbey of Santa Maria at Summaga, near Portogruaro; the Abbey of Santa Maria de Silvis at Sesto al Reghena; the former Abbey of Sonnenburg (Castelbadia) in the Alto Adige; and the baptistery of San Marco in Venice.

The small domed *sacellum* at the base of the present campanile is all that remains of a church in Summaga that was destroyed by earthquake and rebuilt under Abbot Richerius in 1211 (fig. 104).[17] Both the decorative system and the color range of the Summaga murals correspond well to those at Aquileia. In both churches, the Byzantinizing images of the upper zone are distinguished from the socle which is conceived as a fictive curtain decorated with fluid outline drawings. The best-preserved elements of the decoration are the Crucifixion on the south wall (fig. 105), a scene with two Benedictine monks on the west wall (fig. 106), the figures of Eve and Abraham on the intrados of the north arch (figs. 108, 109), and the fictive curtain (figs. 110–13).

The duplication of subject immediately prompts comparison of the two versions of the Crucifixion (figs. 84, 104, 105). Here, as at Aquileia, the action is set close to the foreground plane, framed by pavilions. The emaciated corpse of Christ and the slumped head with narrowed eyes and deep shadows on the lower lids enhance the mood of pathos. The body itself is modeled as a series of linear patterns. Ribs are highlighted in parallel white lines, his breast and pectoral muscles are firmly outlined in swelling black contours, and oval highlights divide the arms into discrete compartments. While the Christ figure is close in style and mood to his Aquileian counterpart, the handling of architecture and space reveals a decidedly more Romanesque temperament. At Summaga, the architectural props stand adjacent to rather than behind the figures and are positioned parallel to the picture plane, with front and side rendered from the same frontal viewpoint. The sophisticated perspectival composition of figures and architecture in the Passion scenes of Aquileia is entirely absent; on this basis, the Summaga Crucifixion may better be associated with the compositional tendencies manifested in the hagiographic cycle at Aquileia (e.g., figs. 68, 75, 78), where the mural surface remains largely unchallenged.

The willowy figure of Eve (fig. 108) parallels Christ in the Aquileia Deposition (pl. III), both in its slender, elongated proportions and in the system of sharply delineated highlights used to depict the bone structure and musculature of limbs and torso. Again, both cycles reveal a Romanesque tendency to interpret Byzantine highlight schemes as a more pronounced pattern that divides the anatomy into compartments.

For the modeling of male heads, the closest parallels may be drawn between the two monks on the west wall at Summaga and the heads of unbearded deacons at Aquileia such as Saint Fortunatus (figs. 106, 107; pl. V). In both cases, the face is a squat, flattened oval shape, truncated by a straight hairline. The nose, which is drawn as an extension of the eyebrows, is modeled in parallel strokes of white, pink, olive, and green. The wide-open eyes, more almond-shaped in the case of Summaga, are set in deep sockets with dark shadows marking the upper and lower lids. The closed mouths form a drawn-out, gently undulating "m" with fleshy lips thickening toward the center, highlighted by white above, shaded by red below. Broad patches of white and pink convey highlights or shadows on the

forehead, cheeks, and chin. A circular pink spot adds flush to the cheeks, while a smaller white one provides a distinctive highlight at the lower outer corner of the eye socket. Finally, the side of the face turned from the viewer is shaded in each case with contiguous strokes of pink, red, and green.

Summaga and Aquileia also betray strong affinities in the handling of draperies. The sharp triangular highlights over the knees of Abraham (fig. 109) resemble those in the figure of Ulfius from the Baptism of Athaulf (fig. 58, right). The treatment of the cloth around the waist and the pleated folds falling from the left shoulder finds close relatives in the figure of Mark from the Healing of Athaulf (fig. 58, left).

Perhaps the most striking point of contact between Summaga and Aquileia is the *velum* in the socle zone. As at Aquileia, the curtain is executed in white with a series of nested V-folds indicated in greenish gray. As a small fragment above the scene of Samson or David Wrestling the Lion reveals (fig. 110), the entire curtain was originally bordered at the top by a comparable medallion frieze. Like their Aquileian counterparts, the Summaga figures are executed both in red and black outline drawing with some shading in yellow ocher; the illusionistic folds of the background curtain show through them. Drapery patterns and hair style of the two youths engaged in armed combat at Summaga (fig. 112) closely resemble those of the knight and seated ruler in the Pilgrim scene at Aquileia (fig. 99).

Many writers ascribe the Summaga frescoes to the late eleventh century,[18] but a technical detail shared with Aquileia assures a late-twelfth-century date. The personification of Temperantia (fig. 113, far right), the two long-haired youths engaged in combat (fig. 112) at Summaga, and the Western knight at Aquileia (fig. 98) all hold a particular variant of the kite shield: its straight top and sides, and the prominent boss protruding from the center are documented on seals from around 1150 to the beginning of the thirteenth century.[19]

The rebuilding of the main church in 1211 establishes a *terminus ante quem* for the *sacellum* decoration. At this time, the floor in the chapel was raised above the level of the socle and new openings connected the chapel to the nave and south side aisle, destroying parts of the original decoration. The central and north apses of the new church were decorated by a distinctly different workshop, although it still manifests regional traditions in the disposition and iconography of the decoration (fig. 114).[20] It is clear that the provincial thirteenth-century painters could not have belonged to the same generation as those of the chapel workshop: their style is distinguished from that of the chapel by stocky figures, disproportionately large heads, heavy dark contours, rather clumsy modeling of draperies, and a darker palette. The linear schemes of late Comnenian modeling employed at Aquileia and in the first campaign at Summaga are absent in this thirteenth-century phase.[21] Patronage connections further strengthen the case for dating the paintings of the *sacellum* in the last quarter of the twelfth century. An auspicious moment is defined between 1188 and 1192 by a series of privileges granted to Summaga by Bishop Romulus of Concordia and Patriarch Godfrey of Aquileia.[22]

Patriarch Godfrey may have been responsible for the decoration of a second Aquileian dependency, the Benedictine abbey at Sesto al Reghena, located within 10 kilometers

of Summaga and Concordia.[23] It was here that Godfrey served as abbot between 1176 and 1182. The imprint of the Aquileian painters is evident in the Chapel of the Archangel Michael (fig. 115). Only a fragment of the original program survives—the head and wings of an archangel on the east wall of the oratory which forms an enclosed gallery over the entrance court to the abbey. Enough evidence remains, though, to establish artistic connections with the crypt of Aquileia and the *sacellum* of Summaga. At Sesto, we find the same decorative structure in which the wall is articulated as a series of picture fields bounded by red borders. The typology of the archangel's head likewise compares favorably with that of his counterpart at Aquileia (fig. 20): a gently sloping bottle-shaped neck, an egg-shaped face with a pointed forehead, a long straight nose joined to high-arched brows, a mop of hair piled high behind the forehead, and boldly arched wings framing the face. Specific details of modeling correspond closely to other figures in the crypt: for example, the pronounced dark shadows above and below the eyes, the distinct triangular one above the nose, and the concentric lines of shadow and highlight on the neck find close parallels in the face of Saint Chrysogonus (fig. 116). The body of the archangel is destroyed with the exception of his right arm which emerges from the mantel to grasp a labarum. While the drapery itself is hard to read, the summary, rather heavy treatment of the jeweled collar parallels the handling of the same detail for the princely figure in the Election of Hermagoras (fig. 60).

The decoration of a third Benedictine abbey under Aquileia's jurisdiction may be connected with the crypt, the former convent dedicated to Saint Mary at Sonnenburg (Castelbadia) in Sud Tirol (Alto Adige).[24] The crypt of Saint Nicholas, constructed in the third decade of the eleventh century under Bishop Ulrich II of Trent at the time of the abbey's foundation, is similar in configuration to the crypt of Aquileia. It follows a three-aisled apsidal plan with four free-standing columns. Two layers of wall painting survive in fragmentary form: the first, comprising simple consecration crosses and part of a dedicatory inscription, belongs to the eleventh century; the second layer, which concerns us, is ascribed to c. 1200 and includes part of a fictive curtain decorated with sea creatures—a whale (only its tail survives), a dolphin (fig. 117), and a siren for which the inscription alone survives (fig. 118)—and part of a scene identified as the Nativity of Saint Nicholas (fig. 119).

The curtain fragment displays the same medallion border (fig. 118) and technique of tinted outline drawing found at Aquileia (fig. 97) and Summaga (fig. 110), but the metallic rendition of the boldly projecting folds and meandering hem of the curtain are most closely paralleled at Summaga. The figures from the lunette panel, identified as the Nativity of Saint Nicholas (fig. 119), display particularly hard, dark contours and rigid angular or curvilinear patterns which represent an exaggerated version of the more "Romanesque" style of the Aquileian painter who executed the figure of Discordia in the south entrance bay (fig. 16); but the metallic quality of the draperies and the absence of conventional systems of highlight and shadow for internal modeling of draperies and flesh distinguish Sonnenburg from Aquileia. These differences might simply indicate the presence of a different artist—perhaps from Tirol itself—absent from the other projects in the south, or they could be interpreted as a change within the workshop tradition, moving away from Byzantinizing models toward the more abstract indigenous style rooted in Ottonian art.

The Ascension painted on the north wall of the current baptistery of San Marco represents a chance survival of twelfth-century mural painting in Venice (figs. 120, 121).[25] Executed as decoration for an open porch on the south side of the basilica, it was concealed from view first by the enclosure of the porch to form the baptistery in the early thirteenth century and then by marble revetment and mosaics commissioned by Doge Andrea Dandolo (1343–54). Of the original three-register composition, only part of the central one was recovered in 1962. Here, the orant Virgin stands frontally on the central axis, flanked by a pair of angels and the twelve apostles, who gesticulate and lift their heads to the now lost vision of the ascending Christ above them.

A single dark blue field provides the only background, but otherwise, the decorative system conforms closely to that of the crypt. Red bands outlined in white frame the pictorial zones, and an ornamental band, fulfilling the function of the mask frieze at Aquileia, separates the lower zone of the figural composition from the dado, which was originally covered with a fictive curtain.

The figure style of the baptistery painting so closely resembles that of certain figures at Aquileia that Lorenzoni and Brusin have attributed it to the same artists.[26] The two basic apostolic facial types—Petrine and Iohannine—established in the region by the second decade of the twelfth century in the mosaics of San Marco in Venice and the Basilica Ursiana of Ravenna have been overlaid with the same late Comnenian highlight systems employed in the crypt of Aquileia. Peter compares favorably with his counterparts in the hierarchy of saints and in the hagiographic narrative. The youthful apostle behind Peter corresponds closely to Philip at Aquileia (fig. 34). In the better-preserved heads of the Virgin and angel to her right, precise analogies for specific modeling patterns employed in the crypt can be found: the hairpin highlight opening toward the nose, the highlight patch with fine rays emanating from it at the corner of the eye, the forked highlight and triangular shadow at the top of the nose, the heavy olive green shadow along the chin, and the arched shadow beneath the mouth (figs. 20, 116). The heaviness of the shadows beneath the chin and eyes, the broad necks, and egg-shaped faces link these two figures with Saint Fortunatus at Aquileia (fig. 107).

Drapery style is harder to measure since only the Virgin Mary remains intact and much of the original modeling has been lost; but what does remain reveals clear points of contact with Aquileia. The economic modeling of the drapery over the legs with only a few nested folds below the knees is replicated in the portrayal of the Virgin in the Deposition (fig. 86), while the slinglike folds of the mantel falling to the waist are paralleled in the figure of the woman who raises her arms in despair in the Threnos (fig. 87).

Close correspondences among the murals of Aquileia, Summaga, Sonnenburg, Venice, and Sesto al Reghena suggest that all five projects were executed within a limited time period, spanning the last two decades of the twelfth century. Of these comparanda, only Summaga offers the possibility of documentary evidence for dating. Because the style of its murals is less self-consciously Byzantine than that of Aquileia—Comnenian "Baroque" highlight schemes and billowing draperies are absent—and its handling of the fictive curtain reveals a tendency to harden contours that is accentuated in the other related Ro-

manesque paintings in the region, I am inclined to date Summaga somewhat later than Aquileia. If my dating of Summaga between 1188 and 1192 is accepted, it strengthens the case for dating the Aquileian murals in the 1180s. This hypothesis also accords with political arguments to be presented in chapter 5. It suffices to say here that the hagiographic cycle of the crypt, which conveys so forcefully the apostolic roots of Aquileia's patriarchal authority, celebrates the definitive recognition in 1181 of Aquileian primacy in the region by Pope Alexander III, Emperor Frederick Barbarossa, and Enrico Dandolo, the rival Venetian patriarch of Grado.

Aquileia and Mosaics of the Upper Adriatic

It remains a moot point as to whether the painters of the crypt originated in the Aquileian hinterland or in Venice. Patronage and ecclesiastical connections to the patriarch of Aquileia would favor the theory that the original workshop was brought together at Aquileia itself and later dispersed to dependencies within the patriarchate or to urban centers such as Venice.[27] There is little doubt, however, that the strong Byzantinizing cast of the Aquileian painting style was mediated by mosaic decoration in the region. An ongoing laboratory involving both Byzantine and native Italian mosaicists was available close at hand in the basilica of San Marco in Venice.

The Ascension Workshop comes closest to the dynamic phase of late Comnenian art manifested at Aquileia.[28] To this atelier may be assigned the Ascension of Christ and the Virtues in the central dome of San Marco, the Passion scenes on the western arch of the crossing, and the *Passio* cycles of the apostles on the vault of the south aisle. These mosaics were probably initiated in the last third of the twelfth century under the patronage of Doge Pietro Ziani. Scenes such as the Arrest and Mocking of Christ (fig. 122) reveal the same emphatic curvilinear patterns marking elbows, shoulders, and stomachs found at Aquileia in the figure of the executioner in the Martyrdom of Hermagoras and Fortunatus (fig. 80). The drawing of the profile heads of the same figures recalls the head of one of the half-naked vices depicted on the fictive curtain (fig. 92), while the expression of the emotion in their faces by means of narrow deep-set eyes in wedge-shaped sockets brings to mind the faces of the mourning women in the Passion scenes of the crypt (fig. 85).

What complicates matters is that Aquileia has also been compared frequently to four mosaic cycles attributed to the first half of the twelfth century: the apse of the Basilica Ursiana at Ravenna, the hemicycle of the central apse of San Marco, the left apse of the cathedral of San Giusto at Trieste, and the Anastasis on the west wall of the former Cathedral of Torcello.

Of these four mosaic programs, only one is securely dated. The apse of the Basilica Ursiana, dated by inscription to 1112, was destroyed in 1741.[29] The original decoration is known from Gianfrancesco Buonamici's engraving and six fragments preserved in the Museo Arcivescovile of Ravenna. Lorenzoni and Brusin first connected the heads of Peter and John (figs. 125, 127) from the Ravenna mosaics and those of Peter in the Consecration of Hermagoras (fig. 124) and Pontianus in the Entombment of Hermagoras and Fortunatus in the crypt of Aquileia (fig. 126).[30] They observed a remarkable consonance in

the design of the two pairs of heads. In both mosaics the artist treats hair and beard as a series of parallel strands. In the faces, a red patch marks the forward cheek, masklike shadows appear above and below the eyes, a triangular patch shades the top of the nose, and Y-shaped highlights model the outstretched neck. Peter in both cases is distinguished from the youthful type by his furrowed brow.

Equally compelling comparisons can be found amongst the early-twelfth-century mosaics executed by the Ravenna workshop for the apse of San Marco in Venice.[31] The Aquileian figure of Nicholas replicates his mosaic counterpart except for the few changes made to the Venetian figure's lower body by later restoration (figs. 51, 127). The head of Peter in San Marco manifests the same typology and modeling scheme as his counterparts in Aquileia and Ravenna (figs. 123, 124, 129).

Lorenzoni and Brusin also linked a mosaic fragment of the Deposition on the south tetrapylon of the San Marco choir (now in the Museo di San Marco) with Aquileia.[32] There is no doubt that the four mourning women (fig. 130) are models for their counterparts at Aquileia (figs. 86, 131). The mourners form the same tight, pyramidal group and, with eyes narrowed and draperies held to the face, represent precisely the same four variations of grief. A second fragment from the same composition, which Lorenzoni does not mention, depicts a group of angels from above the left arm of the cross (fig. 132). In this case, not the entire group, but individuals in it are reproduced at Aquileia; the angel propping his chin on one arm appears in reverse above the right arm of the cross in the Aquileia Deposition (figs. 86, 133), while the incredulous angel with outstretched arms is reversed in the adjacent Threnos (fig. 87, at upper right).

Precise correspondences of the same order can be found in the north central apse of San Giusto in Trieste. Compelling technical resemblances with the Ravenna mosaics favor an early or mid-twelfth-century date.[33] The entire figures of Paul, John, Bartholomew, and Philip (figs. 134, 135)—including specific drapery patterns—are duplicated by the Aquileian apostles (figs. 25, 28, 29, 34).

On the basis of these comparisons alone it would be tempting to accept Lorenzoni and Brusin's dating of the Aquileian murals to the early or mid twelfth century, but, as we have already seen, Aquileia's agile figures and rich linear modeling patterns bear the imprint of late Comnenian art that was assimilated both by the mosaicists of San Marco and the regional mural painters at the end of the twelfth century. That there is a wide chronological gap between Aquileia's paintings and the mosaics that provided models for certain figures is confirmed when one shifts from comparisons of generic heads or figure types to more strictly measurable stylistic features such as the handling of contour and the fall of light and shadow on the draped body.

The heavy-set figures in the apse of San Marco (figs. 128, 129) stand in sharp contrast to the slender, slightly tapered apostles at Aquileia (figs. 28, 29). Metallic, monochromatic swaths of drapery, sparsely outlined in rigid contours, are replaced at Aquileia by energetic draperies modeled in carefully modulated shades and highlights, and animated by a plethora of linear surface patterns. The Aquileian apostles exhibit closer affinities with their counterparts in Trieste as far as proportions and drapery conventions are concerned. Nevertheless, the draperies are less supple, the figures less agile, and the con-

tours harder in the latter. These differences go beyond the discrepancies of handling in the two different media. The Aquileian style is infused with a dynamic spirit that the early-twelfth-century mosaics lack.

That individual figures or heads in the crypt replicate so closely details of disparate mosaic cycles from the same region but executed at different points in the twelfth century may be explained by recourse to model books.[34] These loose collections of drawings of different subjects copy both entire compositions and individual motifs for eventual use in other works of art, often in different media or overlaid with a more recent style.[35] Because they were rarely systematic and served both as copies of existing works of art and sources for newer works over a long period of time, model books complicate questions of dating. More interesting, but equally elusive, is the motivation for the choice of these and other models.

Style and Meaning

Medievalists habitually speak of stylistic "influence," assuming the passive absorption of ideas from outside "sources" in a dominant neighboring culture.[36] However, in a recent essay on the "maniera greca," Anthony Cutler encourages us to reconsider the artistic relationship between East and West in terms of cultural appropriation.[37] According to Cutler, Byzantine style had no single, fixed meaning for Italians but did have an enduring prestige that fostered its continual appropriation for a variety of different reasons. In the case of panel painting, the appropriation of Byzantine objects or models evoked a sense of authenticity, since most of the authoritative portraits of Christ, his mother, and the saints were connected with the East.[38] By contrast, Leo of Ostia makes it clear that by employing Byzantine artists to revive the arts at Montecassino, Abbot Desiderius valued their works primarily for their aesthetic properties and high quality of craftsmanship.[39]

Other examples betray a political agenda. In appropriating the archaic, five-domed plan of Justinian's Apostoleion in Constantinople for their own apostle's church of San Marco, the Venetians proclaimed their inheritance of the authority wielded over the Upper Adriatic by the sixth-century Byzantine emperor.[40] In later centuries, Venice continued to stress the political prestige of Byzantium by calling upon Byzantine artists to decorate the interior of the church.

Analogous politics of style may be proposed for Aquileia. The Byzantine veneer that has been universally recognized in the Passion scenes and certain parts of the hagiographic cycle should probably be seen not so much as emulating the power and authority of Byzantium directly, but rather as imitating the sumptuous mosaic decoration then under way in the competitor's principal church of San Marco. Although Aquileia lacked the resources to produce mosaics of its own, the patrons could at least give the appearance of the more prestigious medium by including precise, recognizable excerpts from the major mosaic cycles of the Upper Adriatic. By adopting the Byzantinizing style of its political rivals, it proclaimed its own elevated status as the sole patriarchate of Venetia. Aquileia's preoccupation, noted above, with the prestige of its patriarchal title in connection with the cult of relics and the architecture of the crypt also plays a major role in the iconographic program of the murals.

While the "Byzantinizing" rubric may generally be applied to the upper parts of the decoration, closer examination suggests that each of the four main elements of the iconographic program constitutes a distinct stylistic mode.[41] Derived ultimately from ancient musical theory, the concept of modes has been extended to the sister arts of poetry, rhetoric, and the visual arts to define the stylistic/formal means that convey distinctions in content.[42] While no medieval text associates modes of pictorial style with particular iconographic genres or responses, analogies may be drawn with rhetorical theory.[43] Drawing inspiration from Cicero and the *Rhetorica ad Herennium*, a work commonly misattributed to him, medieval writers on rhetoric distinguished three stylistic modes, in ascending order of importance: *humilis*, or lowly; *mediocris*, or middle; and *gravis*, the lofty or sublime style.[44] While ancient and early medieval writers differentiated these modes primarily in terms of quality of elocution, rhetoricians of the twelfth and thirteenth centuries had begun to define modes in terms closer to our own modern definitions according to subject. Geoffrey of Vinsauf, John of Garland, and Thierry of Chartres all argue that style should be varied according to a hierarchy of subject matter directly linked to the social class or status of the person depicted; just as the status differed, so should the vocabulary used to describe their actions, costumes, and settings.[45] In this hierarchical scheme each mode was associated with one of the masterworks of Virgil: the lowly style with the *Eclogues*, the middle style with the *Georgics*, and the sublime with the *Aeneid*.[46]

Meyer Schapiro may be the first modern scholar to have applied the concept of modes to medieval art, initially in his 1944 review of Charles Rufus Morey's *Early Christian Art* and later in his influential essay on style in 1962.[47] Criticizing Morey's characterization of the polarity between neo-Attic and Alexandrian styles as a matter of historical or regional differences, Schapiro argues that different "'modes' (were) practiced by the same artist or school of artists according to the content to be expressed."

One of Schapiro's examples, the fifth-century mosaic decoration of Santa Maria Maggiore in Rome, is particularly relevant to the case of Aquileia, because it entails the selection of stylistic variations according to the iconographic genre of distinct cycles within a larger unified program. Schapiro characterizes the mode of the New Testament scenes on the triumphal arch as "a solemn, deliberated, 'Byzantine' manner with symmetrical compositions set against a neutral background." The majority of scenes in the Old Testament cycle, on the other hand, are represented in an alternative "picturesque mode" in which figures are grouped more informally within natural landscape backgrounds rendered with impressionistic details. Style is thus used to bring out essential distinctions in content:

> If the large impression of the two cycles is of a contrast of two styles, it is because the Old Testament was interpreted chiefly as history or action and the New Testament as the source of dogmas and rites; but wherever the latter were implied in the Old Testament scenes, these too were cast in the expressive mode of the New Testament subjects.

Ernst Kitzinger has elaborated on Schapiro's analysis of Santa Maria Maggiore in his *Byzantine Art in The Making*.[48] Characterizing the Old Testament cycle as an "epic mode," stylistically related to illustrated manuscripts of Virgil and Homer, he argues that it represents "a conscious and programmatic appropriation of the past": executed at a time when

the papacy had replaced the emperor as the chief authority in Rome, the assimilation of the epic mode suggests that the biblical history of the church has supplanted its pagan counterpart. The Epiphanies of Christ on the triumphal arch, by contrast, are rendered in an abstract or "transcendental" style to convey "subjects that have do with ceremony, with power, and with the proclamation of eternal verities."

For both Schapiro and Kitzinger, then, stylistic differentiation is meaningful. Modes may operate in concert with the architectural frame to distinguish formally a hierarchy of being or to highlight different narrative functions. For Kitzinger, in addition, they may allude to disparate cultures or eras for ideological purposes.

While these general hermeneutical principles remain valid for twelfth-century church decoration, the dialectic contrast between classical and abstract modes no longer applies. At Aquileia, the complex interpenetration of four distinct narrative and iconic components within an irregular architectural frame prompts us to consider a more subtle, nuanced interpretation. The most obvious formal and iconographic distinctions may be drawn between the simulated embroideries representing ostensibly profane subjects in the lowest zone and the sacred narratives and icons executed in full color above, but each of the upper three divisions also speaks a slightly different pictorial language dependent on its setting within the architectural frame (pl. I; figs. 4, 5).

The hierarchy of saints, which occupies the central aisle vault and all of the supporting spandrels, appropriately presents the most hieratic or "iconic" mode (pl. VII; fig. 5). Figures are displayed primarily in frontal, inactive poses, unless they are ancillary figures in a multifigure group, and they are set against abstract backgrounds with minimal suggestions of space.[49] In the absence of narrative, these images confront the viewer head-on to foster direct visual transmission of prayer and intercession. They are animated by the viewer's movement from west to east, looking from ceiling to spandrels and then from central aisle to periphery in a descending hierarchy of importance.

The Passion and hagiographic cycles, by contrast, exemplify closely allied narrative modes in which active figures are portrayed in profile or three-quarter position, moving within a shallow foreground space (pl. I). The two narrative cycles also differ from one another in their handling of space within the frame and their relationship to the surrounding architectural setting (pls. II, III; fig. 4). While the episodes of the saint's life tend to be composed on a series of planes parallel to the surface of the image, the architectural props and the oblique composition of figures in the feast scenes project the action forward toward the viewer's space. Moreover, the perception of two distinct modes is enhanced by the different ways in which the images are inscribed within the actual architecture of the crypt. The Christological scenes in the lunettes become an extension of the barrel-vaulted space of the aisle (pl. III), directly framed by the physical curve of the vault: they thus correspond to what Otto Demus has aptly characterized as "icons in space" in Middle Byzantine church decoration.[50] The hagiographic scenes, by contrast, are flattened against the vault as a vertical sequence framed by decorative borders (pls. I, VIII). As if to appropriate the *auctoritas* of the written word, these packed narrative panels seem consciously to imitate the miniatures on a manuscript page.[51]

The most obvious distinctions are those between lunette and socle zones (pls. I, III,

VI). Here one is immediately struck by the contrast between the seemingly Byzantine Passion scenes of the lunettes and the seemingly Romanesque images of knights in combat, drawn in outline on the curtain. These two modes separate the sacred realm of feast icons from the terrestrial subjects below. But the meaning of this modal distinction is enriched by the change in medium. In the fictive textile, we have the representation of an image within a larger complex of images. Much like the literary *ekphrasis* of textiles and other works of art within a larger narrative—Baudri de Bourgueil's famous poem describing a tapestry in Countess Adele's bedchamber comes to mind—the painted textile here presents itself as paranarrative commentary, which glosses the biblical narratives above it.[52] Within the ecclesiastical context, the very medium of the curtain takes on a particular significance as a symbol of the allegorical genre of scenes represented upon it (see chap. 7 below).

Summary

In this chapter, the analysis of style has served the conventional purpose of setting the decorative program within its chronological and geographical contexts. I have confirmed what previous commentators have long observed, that Aquileia assimilated Byzantine culture largely through the intermediary of mosaic art in the Veneto, but I have also argued that Aquileia was the font of a thriving regional tradition of mural painting that was active throughout the patriarchate in the last decades of the twelfth century. By analyzing relationships with better-documented programs of painting in places such as Summaga, I have been able to narrow the dating of the Aquileian murals to the 1180s. Beyond questions of dating and attribution, I have argued that the hybrid of Byzantine and Romanesque forms manifested in the Aquileian murals should be explained not so much by influences or by independent artistic personalities, but as the result of a deliberate choice of stylistic modes. It is these modes that enhance the distinctive levels or functions of narrative within the larger program which are considered in the subsequent four chapters.

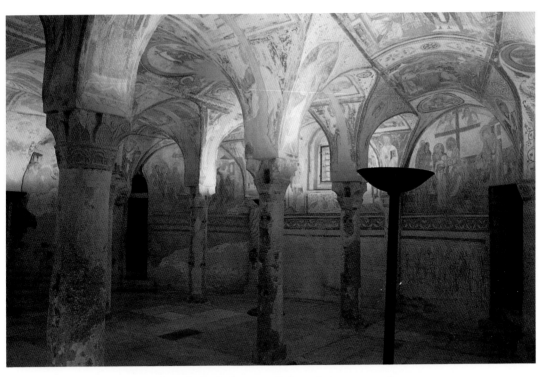

I. Aquileia Cathedral, general view of crypt to southeast

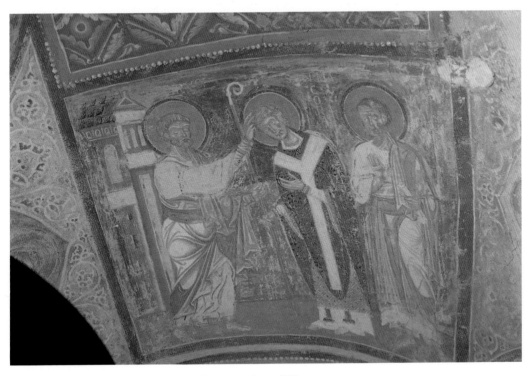

II. Consecration of Hermagoras

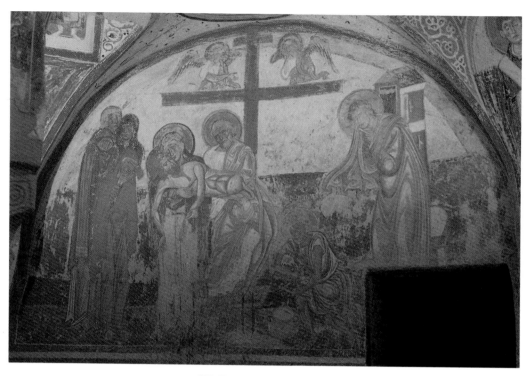

III. Deposition of Christ

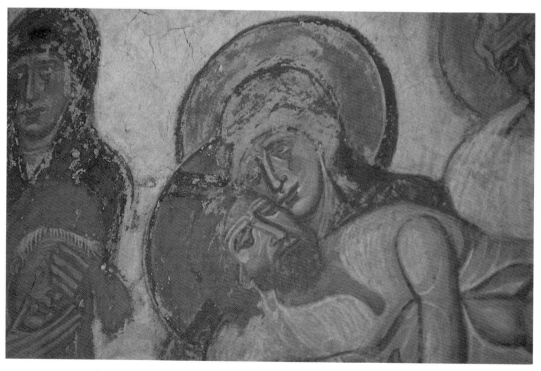

IV. Detail of plate III: Mary holding Christ

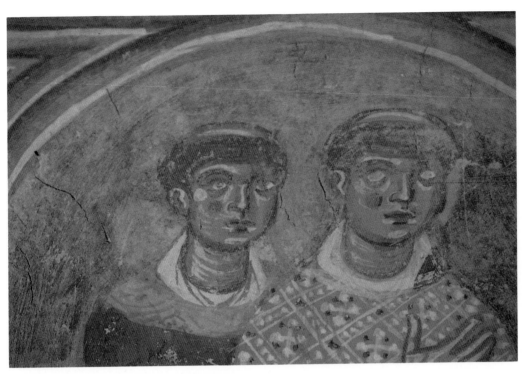

V. Detail of Baptism of Pontianus

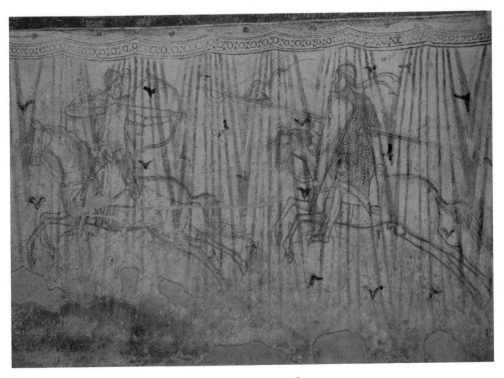

VI. Crusader pursuing Saracen

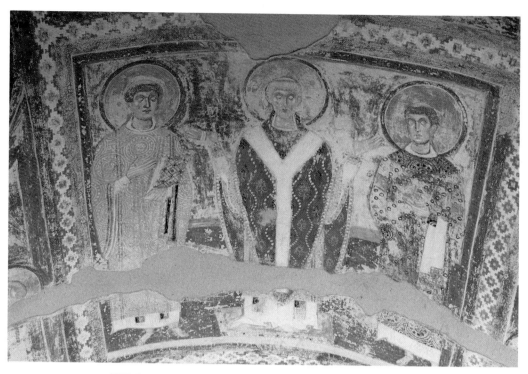

VII. St. Hermagoras orant with Sts. Fortunatus and Cyrus

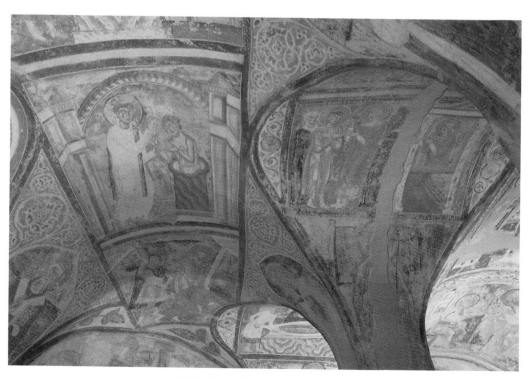

VIII. General view of north vault

CHAPTER FOUR

The Intercessory Program

O F THE FOUR major elements of the iconographic program, the iconic images of Christ and the saints occupy the highest position (fig. 1:I1–I37; fig. 5). Displayed in the three central panels of the middle aisle vault and on the thirty supporting spandrels, these images confront the viewer directly at every position within the crypt, evoking the multitude of the blessed in heaven. Collectively, they convey the central message of the relics emphasized in the dedication liturgy: they are the powerful intercessory channel bridging heaven and earth, present time and a future end of time at the Last Judgment.

The Founding Bishop as Intercessor before Christ

Visual priority is naturally given to the theophanies and the patron saints whose relics are hallowed in the crypt (fig. 17). They appear on the central axis of the crypt in the uppermost position on the vault. As one stands at the west end of the central aisle, in front of the original reliquary niche, the three core panels of the hierarchy appear upright along the length of the vault, in descending order of importance from west to east (fig. 1:I1–I3). The first panel depicts Christ enthroned between two archangels (fig. 18). He sits on an elaborate lyre-backed throne with turned legs and diaper-patterned upholstery. Following Byzantine convention he holds a book on his left knee while raising his right hand in benediction, and his feet rest on a suppedaneum. Each of the flanking archangels, clad in court costume, extends one arm in intercession and holds a staff in the other. Complementing this panel are *imagines clipeatae* of the archangels occupying soffits above five of the lunettes of the hemicycle wall (fig. 1:A; figs. 19–21). In each case, a bust-length, nimbed archangel holds an orb or scepter and extends the right hand in intercession.

Placed at the head of the hierarchy of saints, the image of the enthroned Christ functions as an apse or cupola. Similar compositions are common in Middle Byzantine apse programs in Cappadocia,[1] but as early as the mid seventh century, a half-length Christ flanked by interceding angels appears in the apse of the oratory of San Venanzio in the Lateran Baptistery.[2] More than mere guardians to the throne, then, the Aquileian angels through their gestures and positions form part of the larger hierarchy of intercessors before Christ. That the image functions less as a *Maiestas* than as a form of visual prayer or *Deesis* is demonstrated by the fact that this same trio is featured in a series of Middle Byzantine ivory triptychs, where they stand at the head of comprehensive "carved litanies" designed for private devotion.[3]

The next panel follows a rare iconographic formula copied from the eleventh-century apse fresco in the sanctuary of Aquileia Cathedral (fig. 1:I2; figs. 14, 22).[4] The

Virgin sits with the Christ child in her lap on a lyre-backed throne inscribed within a star-studded aureole of light and surrounded by the winged beasts representing the Four Evangelists. The core of this image conforms to one of the oldest and most important icon types of the Virgin, the *Hodegetria*.[5] Holding the Christ child in her left arm, she extends her right in intercession, demonstrating her special status as *coredemptrix*, warranted first by her role in the Incarnation, later by her *Compassio* with Christ at Calvary, and finally through her Assumption and Coronation as Bride of Christ and symbol of *Ecclesia*.[6] More unusual is the inclusion of the four Living Creatures of the Apocalypse. These attributes together with the mandorla appear to cast the Virgin in the role of intercessor at the throne of the Last Judgment, represented in the preceding panel. Thus, the *Pantocrator* and *Theotokos* of the first two panels work together much like dome and apse do in Byzantine church programs or conch and hemicycle in their Western counterparts in South Italy and Norman Sicily.[7]

The third panel of the central vault (fig. 1:I3; fig. 23; pl. VII) features the frontal figure of Saint Hermagoras standing on a jeweled *suppedaneum* between Saints Fortunatus and Cyrus of Pavia. Fully vested as patriarch and celebrant in alb, dalmatic, chasuble, and Y-shaped patriarchal pallium, the founding bishop stretches his arms out in the traditional orant gesture. Fortunatus, who appears at the favored right hand of Hermagoras, and Cyrus of Pavia are vested as assisting deacons in alb and dalmatic. Both carry necessary liturgical objects for the mass: Fortunatus holds the gospel book, Cyrus a thurible and pyx. Turned slightly toward the center, each also extends one arm in intercession.

This three-figure image resembles in form and function the "Angel Deesis" in the first panel. The gestures of the figures and the inscription affirm the central role of Hermagoras as chief intercessor for his people: "He exhorts Christ to save his people."[8] The image of Hermagoras was doubtless intended to be seen in connection with the images of Christ and Mary in the preceding panels "above." But the image also functions specifically in conjunction with the relics and altar.

Each time the eucharist was celebrated at the altar beneath the image, the participants facing east would tangibly be reminded that the bishop interceded on behalf of his community, both in life as he celebrated the eucharist and in death through the presence of his relics.[9] At the founding bishop's tomb, the potential power of his intercession for the local community was greatest, and here the reigning patriarch was most effectively cast in the authoritative image of the founding bishop.[10]

It is not surprising to find Hermagoras's closest follower and designated successor, Fortunatus, at his right hand: his martyrdom with Hermagoras and the collocation of his relics in the crypt earn him a prominent place among Aquileia's intercessors. Less obvious is the choice of Cyrus. The first bishop of Pavia is not commemorated in any of the Aquileian liturgical texts from the twelfth and thirteenth centuries; nor is he mentioned by name in the *Passio* text among the disciples ordained by Hermagoras. However, the ninth-century *Vitae SS. Syri et Euventi* affirms that Cyrus was consecrated by Hermagoras, and it was through Aquileia that the Pavian See could be connected with Peter.[11] The invention and translation of Cyrus's relics to the cathedral within the walls of Pavia and the nearly

contemporaneous redaction of the *Vitae* appear to have been employed to support that city's claim for autonomy from the metropolitan see of Milan.[12]

Although existing twelfth- and thirteenth-century liturgical codices of Aquileia make no mention of any particular devotion to the Pavian protobishop, a chapel dedicated to Cyrus at Aquileia is recorded in the maps of 1693 and 1735.[13] Located a short distance from the walls in the northwest quarter of the city, it appears to have been constructed in the second half of the twelfth century. It is first mentioned in a papal bull of 1177 in which Alexander III confirms the possessions of the Veronese monastery of Santa Maria in Organo.[14] The Aquileian clergy undoubtedly promoted the cult of Cyrus as evidence for the primacy of its own proto-episcopus, Hermagoras, who consecrated bishops to evangelize the province of Italy.[15]

Pillars of Ecclesia: The Saints in the Spandrels

The intercessory hierarchy continues with three classes of single saints in the spandrels surmounting each of the free-standing and engaged columns of the crypt. Seeming physically to support the ceiling, they beautifully illustrate the theological metaphor of the saints as "columns" of the spiritual church edifice.[16] Once again a hierarchy of viewing governs their disposition. Peter and Paul lead the apostles in the spandrels above the two easternmost free-standing columns facing the central aisle, immediately beneath Hermagoras orant (fig. 1:I4–I15; figs. 5, 24–35). The other ten apostles occupy the remaining spandrels facing west and inward toward the central aisle. The second level of the hierarchy, the martyrs of Aquileia and the Upper Adriatic Church, fill the spandrels facing east and away from the central aisle (fig. 1:I16–I27; figs. 36–47). Finally, the confessors appear in the spandrels over the engaged columns of the perimeter walls (fig. 1:I28–I35; figs. 48–54).

The favoring of Peter and Paul at the head of the apostolic ranks follows a long-standing Roman tradition (figs. 24, 25).[17] Then follow in pairs across the central aisle Andrew and Matthew (figs. 26, 27), John and Bartholomew (figs. 28, 29), James the Less and James Major (figs. 30, 31), two unidentified apostles (figs. 32, 33), and Philip and Thomas (figs. 34, 35). The first eight are identified by Latin inscriptions.[18] Philip and Thomas, on the other hand, correspond to figure types found in the mosaics of the left apse in San Giusto, Trieste (figs. 134, 135). Because the Aquileian artists copied a number of figures directly from San Giusto and the selection of inscribed apostles corresponds perfectly to that of Trieste, the remaining pair probably also followed the Trieste apse and represented Simon and Matthias.[19]

Turning westward from the far east end, the hierarchy continues with three pairs of Byzantine martyrs long venerated in the northern Adriatic (fig. 1:I16–I21): Sergius and Bacchus (figs. 36, 37), Cosmas and Damian (figs. 38, 39), Theodore and George (figs. 40, 41).[20] Breaking with the pattern of pairing saints in spandrels across the central aisle from each other, the two military saints appear on contiguous east and north faces of the same column. This provides a logical transition to the saints on the spandrels facing out toward

the side aisles, which cannot be viewed together as pairs with their counterparts on opposite sides of the central aisle.

Two unidentified, clean-shaven patricians holding crosses form a natural pair on the remaining spandrels of the north aisle (figs. 42, 43). Along the opposite side of the central aisle follow the martyrs of the patriarchate of Aquileia. Hermogenes, the Early Christian martyr of Pannonia and a deacon, probably his companion Fortunatus (fig. 1:124, 125; figs. 44, 45), occupy the contiguous west and south faces of the westernmost column of the right aisle. In the last two spandrels of the free-standing columns appear Chrysogonus (fig. 46), an Aquileian martyr whose cult was later transplanted to Rome,[21] and Tatian (fig. 47), the deacon of the second bishop of Aquileia, Saint Hilary, portrayed across the aisle on the hemicycle wall.[22]

The remaining eight spandrels surmounting the engaged columns of the perimeter walls are devoted to confessors (fig. 1:128–135). Only four can be identified with certainty according to their inscriptions: Martin (fig. 49), Martial (fig. 50), Nicholas (fig. 51), and Hilary (fig. 52), second bishop of Aquileia.

The selection of Martin, Hilary, and Nicholas is not surprising. Martin of Tours was universally venerated in the Western Church as its champion against Arianism.[23] As second bishop of Aquileia and the immediate successor of Hermagoras, Hilary was an important local saint. There was an octagonal church of fourth-century origins dedicated to him at the entrance to the Roman forum.[24] He also appears with his deacon Tatian in the Popponian apse of the upper church (figs. 14, 15). The Venetians venerated Nicholas from the end of the eleventh century when his relics were translated to San Marco,[25] and Aquileian calendars of the eleventh and twelfth centuries commemorate him.[26] He was thus a local saint, albeit of recent importation.

Saint Martial of Limoges, however, is not recorded in Aquileia's liturgical calendar.[27] His only connection with the region is a church dedication in Venice recorded in the twelfth century.[28] It seems justified—as in the case of Cyrus of Pavia—to rationalize his presence here on the basis of the overall program of the decoration and the city's desire to demonstrate its legitimacy as an Apostolic See. Aquileia's apostolic foundation seems to be emphasized within the hierarchy of saints by the insertion of Hermagoras among the ranks of apostles and founding bishops of the apostolic era. Martial fits in well with this theme because, like Hermagoras, he was the founding bishop of his own see, and by the twelfth-century he was being promoted as a missionary sent out by Christ himself.[29]

The remaining two confessors of the hemicycle wall and those flanking the reliquary niche are poorly preserved (fig. 1:134, 135; figs. 48, 53, 54) but it may be presumed that they filled out the hierarchy with regional bishop saints. A fragmentary inscription on the spandrel to the left of the absidiole suggests that it represented St. Voldoricus (= Ulrich), a bishop saint included in Aquileia's twelfth-century calendar. If this identification is correct, his selection may be related to the patronage of the crypt decoration, for it was his namesake, Patriarch Ulrich II, who restored Aquileia's fortunes after the Peace of Venice in 1177.

Viewed as an ensemble, the saints constitute a carefully ordered pictorial prayer that largely corresponds in its structure and selection to the local twelfth-century litany.[30] That

text begins by beseeching Christ the Savior and Mary, the "Sancta Dei Genetrix," thus paralleling the first two panels in the central vault. Then follow the archangels and angels, John the Baptist, the patriarchs and prophets, the twelve apostles, the four evangelists, martyrs of the universal church, local martyrs, including Hermagoras and Fortunatus, Hilary, Tatian, and Chrysogonus, the confessors or bishops, including Martin, Nicholas, and Voldoricus, and finally, virgin martyrs.

Naturally it would have been impossible to depict the complete list of saints in the textual litany, which enumerates well over one hundred names. However, the overall sequence and organization into major classifications are generally followed. Two significant anomalies are readily explained by the specific needs of the pictorial program. In keeping with the identity of the crypt with the patrons of Aquileia and their relics, Hermagoras and his two disciples occupy a favored place close to Christ and the Virgin, and before the apostles. At the same time, even though Aquileia boasted five prominent female martyrs, all the saints except the Virgin Mary are male. Again, the intent seems to have been to reinforce the dual role of the founding bishop within the ranks of Early Christian martyrs and bishops. Both political and spiritual functions of the hierarchy of saints would have been activated liturgically each day for the litany itself was recited during each mass celebrated there.

A Dedication Portrait: Charlemagne and His Heir?

The pictorial hierarchy of the saints is further adapted to local use by the inclusion of a dedication portrait in the spandrel over the south terminal pier of the hemicycle wall (fig. 1:136; figs. 55, 56). As the orant Virgin Mary turns slightly to the left and looks up to the *Dextera Manus Dei* extending from the arc of heaven above, she is approached by a smaller-scale nimbed donor dressed as a ruler.

The Aquileian composition exemplifies a special class of portraiture which fulfills two functions: to record the dedication of the church building and its decoration, and to provide a vehicle of prayer on behalf of the donor. The particular configuration of the Aquileia donor portrait, in which the Virgin serves as primary intercessor to Christ, finds close analogies in two twelfth-century dedication mosaics executed by Byzantine artists for patrons in Norman Sicily: one showing Admiral George of Antioch at the Martorana in Palermo and the other, King William II at Monreale Cathedral.[31] The contrast between the two mosaics is instructive. The Martorana mosaic conforms to Byzantine images of the interceding Virgin known as the *Paraklesis*. The donor, George of Antioch, prostrates himself before the Virgin, who extends one hand to receive him and holds a scroll in the other, inscribed with the petition addressed to Christ. A bust-length figure of Christ appears in the upper right corner. In the Monreale mosaic, King William II approaches the enthroned Virgin with head slightly inclined and offers the model of the church he has dedicated to her. The hand of God issues from the sky together with two angels to accept the offering. Although an enthroned figure of the Virgin is substituted for the standing figure, this panel is closer to the Aquileian image: the posture of the donor, the depiction of the hand instead of the bust of Christ, and the inclusion of angels.[32]

What distinguishes the Aquileian donor from other such portraits in Western church decoration is his dual status as king and saint. Since Western monarchs are not normally nimbed, the Aquileian donor must be a ruler saint.[33] Charlemagne is the most likely candidate. In the second half of the twelfth century when the crypt was decorated, Frederick I Barbarossa actively promoted him as the model Christian emperor to legitimize his own authority over Church and State.[34] As early as 1154, he referred to his illustrious predecessor as "Sanctissimus" in a diploma for Bishop Hartwig of Bremen-Hamburg and seven years later had him canonized by the antipope Victor IV.[35] In the canonization proceedings Frederick himself argued that Charlemagne had suffered as a true martyr in his defense of the Church and expansion of the Christian faith.[36]

The Church of Aquileia had particular reasons to commemorate Charlemagne in the crypt. After all, he refounded Aquileia two centuries after it had been abandoned to the Lombards. He financed the rebuilding of the city and its cathedral, including the first crypt,[37] and supported the church's patriarchal title which extended its territorial jurisdiction to the churches of Istria. The commemoration of Charlemagne in the twelfth-century decoration would have been motivated not only by his role as founder of the new cathedral, then, but also as a local patron saint and protector of the patriarchate.

If a retrospective dedication portrait of Charlemagne is unusual, it is certainly not unprecedented.[38] The early-twelfth-century gilded copper cover of the *Liber Aureus* of Prüm (Trier, Stadtbibliothek, Cod. 1709) is engraved with portraits of Pippin, Charlemagne, and his immediate successors as donors before Christ.[39] Pippin, the founder of the abbey, holds a model church; Charlemagne holds the gospel book that he donated to the abbey; his successors, Louis the Pious, Lothar, Louis the German, and Charles the Bald hold charters of privileges granted to the abbey. The cover of the *Liber Aureus* was itself the gift of Henry IV, who is portrayed with his wife on an inserted folio as part of a series which includes his predecessors Conrad II, Henry III, Henry IV, and his heir, Henry V. In this way, the imperial donor is included in the succession of august patrons of the past, and the abbey documents visually the history of its royal privileges as part of its own pedigree.

A second retrospective donor portrait of Charlemagne provides a closer parallel for the Aquileian iconography: the dedication image on the Shrine of Charlemagne, executed around 1200 to preserve the relics of the newly canonized saint.[40] Charlemagne, like the Aquileian donor, is dressed in a secular tunic and boasts both crown and nimbus. In this case, the dove replaces the *Dextera Manus Dei* and the Madonna and Child are substituted for the orant Virgin, but the path of intercession is the same: from sainted ruler to Christ through the mediation of the Virgin.

A third example dates from Charlemagne's own lifetime. The heavily restored mosaic in the apse of the Lateran Triclinium, better documented by sixteenth- and seventeenth-century drawings, incorporates two double dedication images on the spandrels flanking the conch. On the left, Pope Silvester receives the keys and Constantine the Great the vexillum from Christ; on the right, Peter bestows the pallium upon Pope Leo III and the vexillum upon Charlemagne.[41] In this way Charlemagne is portrayed as a second Constantine, the divinely sanctioned successor of the first Christian emperor.

A similar juxtaposition might have been planned in the crypt. The decoration of the opposite spandrel is destroyed, but it may have depicted the emperor, Frederick Barbarossa. This would have been in keeping with Barbarossa's well publicized self-identification as the "new Charlemagne."[42] Indeed, in the case of Aquileia, the twelfth-century emperor could claim that he, like Charlemagne, had restored the Aquileian See to its former grandeur, since he and Pope Alexander III definitively recognized Aquileian jurisdiction over the Istrian bishoprics in 1181. Moreover, his generous donations of property to Aquileia at the time also paralleled those of Charlemagne and would have helped finance the new decoration of the crypt.[43]

The representation of Charlemagne proposed here suits the function of the hagiographic cycle outlined in the next chapter: together, they reinforce the authority of the patriarchal see. As a retrospective portrait of the patriarchate's greatest imperial benefactor in the past, it would also provide tangible evidence of Frederick I's self-conscious emulation of his illustrious predecessor.[44]

Regardless of the donor's identity, this image is important because it reinforces the primary spiritual and political functions of the space, made tangible in the larger hierarchy of iconic images to which it belongs. The next chapter shows how the same roles are performed in a narrative mode.

CHAPTER FIVE

The Hagiographic Cycle and Ecclesiastical Politics

WHILE the hierarchy of saints underlines the founding bishop's role as Aquileia's primary intercessor in the heavenly communion, the complementary narrative cycle records his past role in the history of the terrestrial church as first bishop and martyr of Aquileia. Originally comprising up to twenty-six scenes with Latin tituli,[1] the narrative encircles the hieratic panels of the central vault, starting at the east end and moving clockwise around the ceiling back to its starting point (fig. 1:H1–H25; fig. 4). Like the theophanies of the central aisle, most of the narrative is oriented to the viewer standing at the west end of the crypt; thus one can read these scenes without straying further east than the first pair of columns. Two further episodes relating the translation of relics may have been represented in the western lunettes flanking the reliquary niche (fig. 1:H26, H27).

In keeping with the reliquary function of the crypt, this cycle affirms the continuing physical presence of the patron saints and demonstrates how their mission and martyrdom established Aquileia as the premier *locus sanctorum* in medieval Venetia. Besides highlighting the physical remains that consecrate the physical church building, the cycle also advances particular arguments regarding the institution of the local church and its special status as a patriarchal see. What is more, it can be demonstrated that the Aquileian cycle participates in the larger ecclesiastical/political debate with Venice, played out in the pictorial narratives of the rival churches.

Text and Image: An Overview of the Hagiographic Cycle

The narrative sequence in the crypt conforms closely to the *Passio* of Hermagoras and Fortunatus preserved in a twelfth-century manuscript of the *Vitae Sanctorum* in the Bibliothèque de la Ville of Namur (Codex 53) and a contemporary liturgical version, contained in the Aquileian breviary in the Museo Civico Archeologico at Cividale (Codex 91).[2] According to these texts, Peter sent Mark to Aquileia to preach the new Christian gospel. Upon his arrival at the city gate, the evangelist healed a leper named Athaulf and then baptized him with his whole family. After preaching there for several years, Mark desired to return to Rome to see Peter again. Before his departure, the people pleaded with him to provide them with a successor. With Mark's blessing they elected his disciple Hermagoras as their new bishop, and Mark took him to Rome to be consecrated by Peter. Soon after his return to Aquileia, Hermagoras began preaching and ordaining priests, thus incurring the wrath of the pagan priests. He was brought before the Roman prefect Sevastus to be reprimanded. During a long trial the saint refused to pay homage to the images of the emperor or pagan gods and continued to sing praises to God. Consequently, the prefect submitted

the bishop to a series of gruesome tortures. When these failed to break the bishop's will, Sevastus had him thrown into jail, but throngs of Aquileians flocked to his cell to hear him preach. His new converts included the jailer, Pontianus, and the family of Gregory, whose demoniac son Hermagoras miraculously cured. In order to insure the apostolic succession, Hermagoras ordained Fortunatus as his deacon. As the last act of his mission, Hermagoras healed the blind woman Alexandria and had her baptized by Fortunatus. Angered by reports of this recent conversion, the pagan priests demanded that Sevastus put an end to Hermagoras's mission. The prefect responded by sending a soldier to execute the bishop and his deacon in the middle of the night. Later, his followers—Pontianus, Alexandria, and Gregory—wrapped the bodies in linen and buried them outside the walls of the city.

While the pictorial version follows this basic plot quite closely, certain anomalies reflect a desire to cast the narrative in the mold of standard episcopal saints and martyrs, thereby enhancing its apparent credibility. At the same time it exhibits certain patterns of selection and display, designed to emphasize the text's underlying political agenda.

Aquileia's alleged apostolic foundation is proclaimed in the easternmost panel of the central vault and the lunette below it (figs. 57, 58). The titulus of the first panel affirms Mark's role as the city's first patron saint: "City of Aquileia, behold the good patron is sent to you."[3] Peter, enthroned before the cityscape of Rome, hands Mark his *baculum*, or pastoral staff, thereby commissioning him to preach his gospel to Aquileia. Mark, already carrying the gospel in a satchel strung across one shoulder, reaches out to claim his symbol of office.

In the lunette below (fig. 58), Mark heals the leper, Athaulf, outside the walls of Aquileia and baptizes him in the presence of his family. Although the text specifies that Athaulf and his family were baptized at the western gate of the city, the latter is set before a ciborium, the standard pictorial shorthand for the sanctuary of the church. In borrowing this pictorial topos, the artist underlines the significance of this first baptism as the initial act of instituting the Aquileian Church. Certainly it is no accident that these episodes interrupt the Christological cycle on the central axis: in this way the apostolic foundation of the Aquileian Church visibly stands out from the rest of the hagiographic cycle.

The right aisle vault (fig. 1:H4–H11; fig. 4) documents in a dense narrative sequence how the metropolitan see was established at Aquileia. Seven scenes illustrate a mere twelve lines of the *Passio* text.[4] Having heard of Mark's intent to depart for Rome, four patricians of Aquileia ask him to provide them with a "pastor" to take his place (fig. 1:H4; fig. 59). They elect the reluctant Hermagoras as his successor in the presence of a princely official, elegantly attired in bejeweled tunic, chlamys, and dappled stockings (fig. 1:H5; fig. 60). As if to grant his consent to the election, the latter draws Hermagoras by the arm before Saint Mark to receive his blessing. Once elected by the people, Hermagoras journeys with Mark to Rome (fig. 1:H6; fig. 61) to be consecrated as protobishop of the "province of Italy."

The Consecration is so crucial for Aquileia's ecclesiastical claims that it is given special prominence by its scale, its elaborate ornamental borders, and the monumentality of its conception (fig. 1:H7; fig. 62; pl. II). Peter strides forward to bestow the same baculum upon Hermagoras that he earlier conveyed to Mark, but now Hermagoras is fully vested as an archbishop, clad in alb, dalmatic, chasuble, and pallium. Mark stands behind his disciple as official witness to his election.

One detail of Hermagoras's attire—the pallium—furnishes crucial evidence of Aquileia's patriarchal title. The pallium, which could be bestowed only by the pope, was granted at the time of confirmation and was generally conceived as a prerequisite to the archbishop's consecration. More important is the fact that it symbolized his ecclesiastical authority: numerous documents from the early twelfth century on confirm that he could not legally exercise his authority until he had received the pallium. Thus, the section "De consecratione" of the *Decretum* of Gratian dictates that "neither archbishop, nor primate, nor patriarch may consecrate bishops before he has received the pallium."[5] Paschal II is more precise: "With the pallium, the fullness of the episcopal office is granted, since according to the custom of the Apostolic See and of all Europe, before he has received the pallium, a metropolitan is not allowed to consecrate bishops or to hold a synod."[6] Finally, Innocent III went one step further to ensure papal control over the archiepiscopal office, declaring that the metropolitan who had not yet received the pallium, had no right to either the "plenitudo officii ponitificalis" or the title "archiepiscopus."[7]

Aquileia seems to have acquired official recognition of its metropolitan jurisdiction only during the sixth to eighth centuries. The *Passio* text quite accurately calls Hermagoras "episcopus provinciae Italiae."[8] The breviary text used at Aquileia, on the other hand, emphasizes the see's primacy by designating Hermagoras "prothon episcopus provincie italie" and the city "ex civitatibus italiae prima." Thus liturgical and pictorial versions add a contemporary gloss to the legend intended to reinforce Aquileia's side of the ecclesiastical battle with Venice-Grado. The fact that Hermagoras has made the journey to Rome and has already received his pallium also confirms that the papal prerogative to bestow metropolitan authority has been respected.

In the subsequent panel (fig. 1:H8; fig. 63), Hermagoras is received at Aquileia by a procession of clergy and people, who hail him at the city gate with olive branches and incense. Although this episode is not specifically mentioned in the *Passio*, it conforms to a pictorial topos in episcopal *vitae* and again serves to confirm his canonical election by clergy and people.[9]

The *Passio* text tells us that "after returning to the city of Aquileia, (Hermagoras) formed the government of his church and he ordained priests whom he sent to the city of Trieste and through other cities." This brief statement is the basis for the next two scenes. Set in a Christian sanctuary delimited by a marble enclosure, altar platform, and ciborium, both show the new bishop exercising his authority. In the first panel Hermagoras stands before the altar in the midst of four or five tonsured deacons either to preach the gospel or instruct his clergy (fig. 1:H9; fig. 64). In the fragmentary second scene,[10] Hermagoras strides forward from the chancel steps to ordain a priest or bishop, a scene which must be connected with the missions to Trieste and other cities mentioned in the *Passio* (fig. 1:H10; figs. 65, 66). This pictorial emphasis on Hermagoras's role in the foundation of other bishoprics may have been extended to a third, almost completely destroyed panel on the vault of the south entrance bay (fig. 1:H11; fig. 67).

The third part of the *vita*, displayed at the west end of the ceiling, is an abbreviated *Passio* of Hermagoras. The first of three scenes depicts his trial before the Roman prefect, Sevastus, who has been alerted to Hermagoras's preaching by indignant pagan priests (fig.

1:H12; figs. 68, 69). In this typical trial scene, the saint stands opposite the enthroned prefect while a pagan courtier accuses him. Perhaps to give Aquileia's copatron greater prominence, Fortunatus appears anachronistically at Hermagoras's side.

In the second scene (fig. 1:H13; figs. 70, 71), Sevastus, infuriated by the bishop's consistent refusals to worship the pagan idols, has the prostrate saint flagellated with rawhide whips. The third panel (fig. 1:H14, figs. 72, 73) is devoted to further tortures: Sevastus has glowing irons applied to the sides of Hermagoras as he hangs on a crosslike rack.

The final "chapter" focuses on the ministry of Hermagoras and his follower, Fortunatus: a series of conversions and baptisms which lead the pagans to abandon their temples (fig. 13). Since all the tortures have failed to break the spirit of Hermagoras, Sevastus has him imprisoned. First, Hermagoras is shown preaching from the window of his jail, a classical, tetrastyle pedimented structure (fig. 1:H16; fig. 74). The guard Pontianus and another laymen, drawn there in the night by a glowing light and a sweet fragrance, listen to the preacher with outstretched arms. In the subsequent panel (fig. 1:H17; fig. 75), a clean-shaven, nimbed cleric baptizes Pontianus in the presence of two other clergy. Although not specifically mentioned at this point in the text, it appears that Hermagoras's disciple Fortunatus has again been interpolated into the narrative to give the copatron of the crypt greater prominence.

The pictorial narrative skips over the events immediately following the baptism of Pontianus—the ecstatic speech of Pontianus which drew great crowds and the condemnation of Hermagoras by the priests before Sevastus—to present a second diptych of conversion and baptism. In one panel, Hermagoras heals the demoniac son of a soldier named Gregory (fig. 1:H18; fig. 76). Simultaneously a ray descends from the arc of heaven to convert the boy. In the second panel, Hermagoras baptizes the entire family of Gregory (fig. 1:H19; fig. 77): all appear naked in a single font as Hermagoras blesses them and a ray descends upon them from the dome of heaven to signify their acceptance. A third convert, the blind woman Alexandria, appears initially as witness to the ordination of Fortunatus as successor to Hermagoras (fig. 1:H20; fig. 78). Then she reappears in the adjacent scene (fig. 1:H21) at the window of Hermagoras's jail cell to be healed and converted. In a third scene, Fortunatus baptizes her beneath an archway (fig. 1:H22; fig. 79).

Accused of driving so many pagans to apostasy, the two clerics are blindfolded and decapitated by one of the prefect's henchmen in the middle of the night (fig. 1:H23; fig. 80). In this, the most gruesome of all the episodes, Hermagoras's severed head spins off in midair as blood spurts out from the neck. Meanwhile, the executioner raises his sword against Fortunatus, and a ray of light descends from heaven to confirm their "apotheosis." Because of its importance in demonstrating the origins of Aquileia's principal relics, this episode is made particularly tangible to the viewer, both through the violence of action and by its spatial relationship to the viewer. In contrast to all other episodes, there is no distinct ground line and the figures overlap the frame, apparently hurtling themselves forward into the viewer's space.

The ceiling cycle culminates in the burial of Hermagoras and Fortunatus outside the walls of the city (fig. 1:H24; fig. 81). As a priest fumigates the bodies with incense, three recent converts participate in the entombment. Pontianus and Gregory lower the bodies, wrapped

in shrouds, into the sarcophagus; Alexandria holds the two severed heads. The inscription emphasizes the lament of the bishop's followers at the tomb: "The Christians grieve where they bury the relics of the father."[11] At first glance, it seems curious that the inscription is oriented in the opposite direction to the image, i.e., facing west instead of east. But it makes sense when it is realized that the relics themselves could have been viewed in conjunction with the inscription at the west end of the crypt. The connection between the historical entombment and the later deposition of relics in the crypt is emphasized by the use of the liturgical term "recondo," normally applied to relics, for "burial" in the inscription.[12]

If my reconstruction of the scenes in the western lunettes is correct, the first burial *extra muros* would also have been pictorially connected with the later deposition of the relics in the crypt after their return from Grado under Poppo in 1041 (fig. 1:H25, H26; fig. 82). Only a fragment of the panel on the south side survives, but enough is visible to indicate a crowd scene involving at least one cleric and a number of laymen dressed in tunics and capes. These figures cannot have belonged to a Christological feast scene but would be appropriate for a translation scene. It is possible that the south panel portrayed the initial translation of relics from Aquileia to Grado at the time of the Lombard invasion, and the second, the return of the relics to Aquileia under Poppo. An alternative scenario would have two scenes involving the translation to Aquileia itself: the translation from Grado in the first and the actual *collocatio* of the relics in the new crypt in the second. The representation of the translation here would have visually highlighted the *loculus* of the relics in the adjacent niche.[13]

Viewed as a whole, the program of the hagiographic narrative reveals a clear ecclesiological message. It vaunts Aquileia's apostolic pretensions on the visually prominent, central axis of the eastern hemicycle. On the south aisle vault, it then documents with legal precision how Mark and Hermagoras instituted the ecclesiastical hierarchy of the Church of Venetia. After the brief but obligatory sequence of trials and tortures that establishes Hermagoras's credentials as a true martyr for the faith, the cycle demonstrates the renewal of the Aquileian *civitas* through a series of conversions and baptisms. Finally, the scenes of death, burial, and translation highlight the continuing, authorizing presence of the patron saints at Aquileia in the form of their relics.

Hagiography and Convention

Much of this story has a familiar ring to it. As recent studies of hagiographic texts and pictures have recognized, medieval writers made a virtue of convention in their composition.[14] Particularly in the case of recently invented narratives, they employed familiar topoi to lend an air of authenticity and emphasize certain universal themes.[15] For every saint was a bridge between Christ's terrestrial ministry and the present community of the "body of Christ"—at once an imitator of Christ's life and an example for the local church.[16] Gregory of Tours sums it up nicely in his *Vitae Patrum*: "Some ask whether we should say the life of the saints or lives of the saints"; he prefers the singular designation "because, though there may be some differences in their merits and virtues, yet the life of one body nourished them all in the world."[17]

Although the Aquileian cycle shares individual elements with earlier versions of the Marcian legend in Venice, most of the narrative appears to have been created ad hoc for the crypt, drawing inspiration from three established pictorial sources. The first part of the narrative, which documents so precisely the establishment of the Aquileian See, conforms to a pattern found in other episcopal saints' lives (figs. 57–66).[18] For example, both the details of individual liturgical props and vestments, and the sequence of events leading up to Hermagoras's return to Aquileia as bishop—the request for a bishop, the election, the journey to Rome, the consecration and bestowal of the pallium—are closely paralleled in a roughly contemporary set of enamels depicting the life of the bishop-saint Heribert of Deutz.[19]

The episodes of trial and torture at the west end of the crypt, and the repetitive sequence of conversions and baptisms follow the pictorial conventions of apostolic cycles. Three scenes, which show Hermagoras preaching from his prison cell in a classical, pedimented structure (figs. 74, 76, 78), seem to draw inspiration specifically from illustrations of Saint Paul preaching from prison.[20] The trial of Hermagoras and his disciple Fortunatus before Sevastus (fig. 68), which departs from the text by including the deacon saint with his bishop and dressing both in apostolic robes, seems likewise to follow an apostolic composition such as the confrontation of Peter and Paul with Simon Magus as shown in the late-twelfth-century mosaic in Monreale Cathedral.[21]

Finally, Christological types seem to have inspired two scenes in the Aquileian cycle. The Healing of the Leper Athaulf by Mark naturally recalls illustrations of Christ's more famous miracle, seen, for example, in the transept of Monreale Cathedral.[22] Similarly, Hermagoras is cast in the mold of the Crucified Christ in the second torture scene (fig. 72). While the text refers to Hermagoras hanging on a "rack" as his chest is scraped with claws and white-hot iron plates and burning lamps are applied to his flesh, the mural shows Hermagoras with arms stretched out on a cross. In addition, the two torturers, symmetrically flanking the cross, resemble the Roman soldiers who pierce Christ's side and offer vinegar on a lance in the Crucifixion narrative.

Johanna Kugler, the only scholar to comment on the iconography of the hagiographic scenes in any detail, attempted to find a more specific model for the Aquileian cycle in a lost Venetian source.[23] She proposed that the crypt cycle was based directly on an early-twelfth-century mosaic or fresco cycle in San Marco, which was replaced by the current mosaics of the choir chapels. She further postulated an earlier eleventh-century Venetian manuscript as the ultimate source for the "core" scenes shared with the Pala d'Oro and the mosaics of the Cappella San Pietro: the Mission of Mark, the Conversion and Baptism of Athaulf, Mark taking Hermagoras to Rome, and the Consecration of Hermagoras. The remaining scenes would have been invented ad hoc from hagiographic topoi. The hypothetical model, reflecting more closely the Pala d'Oro than the mosaic cycles, would have included the Alexandrian mission and translation cycle absent from the Aquileia cycle.

Careful examination of these three twelfth-century cycles below argues against the existence of a single, common model. There are few direct iconographic correspondences, not a single inscription contains the same wording, and the Aquileia cycle includes almost twenty scenes that are absent from the Venetian cycles. It is also doubtful that a complete

illustrated *libellus* existed either at Aquileia or Venice in the Carolingian period. The legend had just been formulated shortly before the Council of Mantua in 827 and, as far as one can tell from the *Acta*, it did not describe the careers of Hermagoras and Fortunatus after the protobishop's consecration. The complete story is told only in *Passio* and breviary texts from the twelfth century, and none of these is illustrated.

Rather than merely copying a preexisting cycle in manuscript illumination, then, it appears that the Aquileia murals were invented ad hoc for the crypt, relying on more general conventions to authenticate their content, and at least in certain cases, laying emphasis on the apostolic connection through architectural and compositional references. Paradoxically, these monumental paintings are displayed in a manner that resembles miniatures—in a vertical sequence, framed by elaborate borders. If my reading is correct, this indicates not so much a specific manuscript source for the cycle, but rather an attempt once again to suggest the authenticity of the account by evoking the aura of authority embodied in a codex and its miniatures.[24]

Hagiographic Invention and Ecclesiastical Politics

The assumption of a single manuscript source for the Aquileian cycle and its Venetian relatives actually runs contrary to the dynamic process of hagiographic invention that emerges when one studies different pictorial versions of a common narrative over time.[25] Just as the communal memory of the saint was constantly revised or reinvented in texts, so pictorial images could serve to adapt the "memoria" of the saint to the changing exigencies of the cult over time.[26] Aquileia and Venice produced at least seven different variations of Mark's alleged mission to the region between the eleventh and thirteenth centuries. In contrast to other saints in Western Europe for whom pictorial *vitae* were produced during the same period exclusively as illustrations to texts in manuscripts, the Adriatic versions of Mark's legend are found primarily in the monumental art of the two rival *loca sancta* of the region: the Basilica Patriarcale of Aquileia, and the Basilica Ducale of San Marco in Venice.

In comparing the Aquileian cycle with two prior Venetian versions of the narrative on the Pala d'Oro and choir chapels of San Marco, it becomes clear that the two cities manipulated a common pictorial narrative to buttress independent claims on Mark and ecclesiastical primacy in the region. Thus each new version of the legend served as an independent argument that responded both to previous pictorial cycles and to the changing political landscape.

Although the essential core of the Aquileian mission—the passing of the gospel from Peter to Mark to Hermagoras—is already acted out in the single figures of the apse of San Marco, the earliest surviving Venetian narrative cycle is found in the lower section of the Pala d'Oro, commissioned as an antependium for the high altar of San Marco by Doge Ordelaffo Falier in 1105 (figs. 136–39).[27] Ten scenes from the Marcian legend are included: the commission of Mark by Peter; the baptism of Hermagoras;[28] the presentation of Hermagoras to Peter in Rome by Mark; the Healing of Anianus by Mark at Alexandria; the destruction of an idol at Alexandria; Christ's appearance to Mark in prison; the martyr-

dom of Mark; his entombment; the translation of his relics by ship to Venice; and their reception by the patriarch of Grado and Venetian clergy. This cycle emphasizes the role of Mark in the foundation of the Church of Aquileia—the "Venetia Vetus"—at the expense of Hermagoras. Mark is given the *baculum* of apostolic authority by Peter (fig. 137), while Hermagoras is merely presented to him as a candidate for ordination, still dressed in the vestments of a deacon with the stole over one shoulder (fig. 138). The Aquileia scene of his consecration as protobishop of Aquileia is absent. At the same time this series of enamels, which was designed for the altar over the tomb of Saint Mark, appropriately emphasizes the history of the evangelist's relics: his mission, martyrdom, and entombment in Alexandria, and the translation of the relics to Venice.[29]

A second version of the Marcian legend was executed some decades later on the vaults and upper walls of the two chapels flanking the choir (fig. 140). Demus, who originally dated the mosaics to the early decades of the thirteenth century, more recently placed them in the first half of the twelfth century.[30] I have argued elsewhere on iconographic grounds that a date between 1155 and 1180 is more likely.[31]

The legend is divided into four unequal sections containing a combined total of fifteen scenes (fig. 141). The first section recounts the Aquileian mission of Mark and Hermagoras. In the upper register of the eastern half of the barrel vault in the Cappella di San Pietro, Peter commissions the evangelist; Mark heals and baptizes the leper Athaulf. Below, Peter consecrates Hermagoras bishop in the presence of Mark, and Hermagoras baptizes an unspecified youth. The second section summarizes Mark's mission to Pentapolis in two (heavily restored) generic scenes of preaching and baptizing in the upper register of the western half of the vault (fig. 142). The third section, covering the evangelist's career and death in Alexandria, is represented in the lower register of the western vault and on the north wall of the chapel (figs. 143, 144). On the vault, an angel urges Mark on his voyage to Egypt and Mark heals the cobbler Anianus at Alexandria. In the lunette, two pagans tie a rope around the saint's neck as he celebrates mass, and later Mark is buried at his first martyrium in Alexandria. The decoration of this chapel thus corresponds to the liturgical commemoration of the Feast of Mark, celebrated on April 25, when the *Passio* of the saint would be recited.[32] At the same time, it is a succinct statement of the jurisdictional claims of the Venetian Church, and the foundation for the myth of the Venetian state.[33]

The first phase of the Venetian myth is enacted in Aquileia, known in eleventh-century Venetian historiography as the first "Venetia." It explains how Christianity came to the Upper Adriatic region through the mission of Mark at the behest of Peter. The subsequent episodes in the same chapel merely fill in the narrative gap between Aquileia and Venice, tracing the evangelist's career in Pentapolis and Alexandria, his final resting place. As a footnote to this pre-Venetian phase of the legend, Pope Pelagius II and Patriarch Helias of Grado appear on either side of the arch opening into the choir.[34] They embody the second major phase in the Venetian acquisition of Mark's patronage: the alleged transfer of the metropolitan See of Aquileia to Grado in 579 (figs. 145, 146). The inscription on Pelagius's scroll reads as follows: "Because we cannot deny your just petitions, Venerable Father, we confirm through the content of our privilege that the castrum

of Grado is the metropolitan of all Venice, Istria and Dalmatia."³⁵ The inscriptions above each figure summarize this exchange. Helias petitions to the pope, "I request, Father, that Grado be made the Metropolitan of the Venetians," and Pelagius responds, "So be it (the Metropolitan) of the Venetian, Istrian and Dalmatian peoples."³⁶

The cycle of seven scenes in the Cappella di San Clemente is entirely devoted to the Translation of Mark to Venice in 828. It is only natural that this part of the legend should receive such inordinate attention in the overall program, for this is the very act by which Venice usurped the patronage of Mark the Evangelist from Aquileia and the second of three principal Marcian feasts, celebrated on January 31.³⁷ The story begins in the upper register of the west vault with the removal of the relics from the tomb and their transfer in baskets of pork to the ship (fig. 147). Following closely the *Translatio* text, the two merchants Tribunus and Rusticus are assisted by two Orthodox custodians, Theodore Presbyter and the monk Stauricus.³⁸ Their presence helps justify the Venetian theft: after much discussion with Tribunus and Rusticus, the custodians agree to assist the Venetians in removing the relics to Venice in order to save them from profanation by the Saracens.³⁹

The two custodians appear again in the lower register where they stand guard as the Moslem officials inspect the Venetian ship (fig. 148) but are repelled by the sight of unclean meat. The narrative continues around the corner in the south lunette with the departure of the ship from Alexandria (fig. 149). Then, instead of proceeding across the lunette on the other side of the window, the story resumes in the top register of the west side of the vault (fig. 150). A single episode, not included in the Pala d'Oro, fills the entire space: Mark saving the Venetians from shipwreck. Thus, in parallel to the divinely sanctioned journey to Alexandria, the saint himself authorizes the translation of his relics back to Italy. Here we see in embryo a Venetian predilection for divine sanction which evolved into the *Praedestinatio* myth of the thirteenth century.⁴⁰

The last and most impressive of all the images in the cycle is the Reception of the relics in Venice (figs. 151, 152). On the north wall, the relic ship has arrived in port, sails furled in preparation for disembarkation. The Venetian merchants and their Greek collaborators raise their arms to salute the dignitaries on shore. The relics, the presence of which is only implied, are received across the actual space of the corner of the chapel by a solemn procession of Venetian dignitaries, named in the inscription as pontiffs, clergy, the people, and the Doge.⁴¹ Tightly packed in the left half of this register, this group of figures has evidently just moved out of the palace to receive the relics arriving from the south, leaving a wide empty space between themselves and the palace.⁴²

This mosaic cycle shares the same basic tripartite structure of the Pala d'Oro narrative: the initial Aquileian mission establishes Mark's link with the Upper Adriatic, later to be inherited by Venice through Grado; the second part documents the evangelist's Egyptian career leading up to his martyrdom there; and the third part records the translation of Mark's relics to Venice, where they are revered as a civic palladium in the new ducal chapel.

All three cycles share the crucial first episode of the Aquileian legend: the Commission of Mark by Peter. The enamel panel from the Pala d'Oro (fig. 137) and the crypt

painting (fig. 57) are almost identical in iconography. Both show Peter enthroned at left, bestowing a pastoral staff upon Mark, who, like Peter, is dressed as an apostle. In the Cappella San Pietro, on the other hand, the commission of an apostle has been transformed into the consecration of an archbishop. In conformity with representations of the Consecration of Hermagoras later in the same cycle at San Marco and in the Aquileia cycle, Mark is fully vested with pallium, dalmatic, and miter as he receives the pontifical *baculum* and papal blessing from Peter. The discrepancy in the meaning of the two scenes is confirmed by the accompanying inscriptions: the Aquileia inscription records that Mark is sent as the "Patronus" to the people of Aquileia, while that in San Marco, "MARCVS SACRATVR," documents the consecration of the evangelist. Demus found no textual basis for this anomaly, but this usurpation of the first position in the episcopal succession by Mark is already suggested in the *Chronicon Gradense* from the mid-eleventh century.[43] This interpolation into the legend enhances the status of Venice's patron at the expense of Hermagoras, now demoted to second place in the episcopal succession. The episcopal primacy of Mark over Hermagoras—and thence, Venice-Grado over Aquileia—is further emphasized by the axial placement of the scene of his consecration above that of Hermagoras in the lower register of the same vault.

The next two episodes in the Aquileian cycle, the Healing and Baptism of Athaulf, are also included in the mosaics of the Cappella San Pietro. However, apart from the outstretched arms of the leper in the first scene, there are no significant iconographical correlations between the two versions (figs. 58, 141). In contrast to Aquileia, Mark affects his healing by a blessing gesture rather than physically grasping the leper by the arm. The Venetian version of the baptism bears even less a resemblance to its Aquileian counterpart, probably due to restoration work executed in the nineteenth century: the mosaic omits Athaulf's family, and rather than standing in a font, the neophyte kneels before the evangelist to receive the laying on of hands.

The fourth episode that the two cycles share, the Consecration of Hermagoras, conforms to a generic three-figure composition commonly used in episcopal *vitae* (figs. 62, 141). In the presence of Mark, Peter bestows the baculum, or crosier, upon Hermagoras who is fully vested in his episcopal attire, complete with the pallium. However, even here there are discrepancies: whereas in the fresco, Hermagoras is still bareheaded but already holds the crosier in one hand, in the Venetian mosaic, Hermagoras wears a miter, and Peter alone holds the crosier, thereby indicating that the full power vested in it has not yet been transferred.

Despite their drawing upon a common textual tradition, then, the Aquileian and Venetian pictorial narratives are too different to sustain the theory that they stem from a single source. Instead, these very public statements appear to supply independent pictorial arguments that sustain the shifting claims on Mark made by Aquileia and Venice in the ongoing dispute over ecclesiastical authority in the region.

Apart from the specific iconographic discrepancies already noted, further arguments are conveyed by the very selection of episodes. Within the common core of the Marcian mission, the Aquileian cycle includes additional episodes to authenticate Hermagoras's position as protobishop of Venetia et Histria. Three episodes lead up to his consecration:

the people confront Mark to request a new pastor upon his departure; they elect Her-
magoras in the presence of Mark; Hermagoras journeys to Rome to receive the pallium
and *baculum* of his metropolitan office from Peter himself; and he is officially accepted by
the people of Aquileia at the gates of the city upon his return.

Within this dense narrative sequence establishing the apostolic succession of Aqui-
leia from Mark, the election scene is particularly significant (fig. 60). Though absent from
the Venetian cycles, it is essential for the Aquileian version of the legend because it estab-
lishes the canonical basis for Hermagoras's consecration as bishop. No mention is made of
a prince in the textual sources, and this may be interpreted as an allusion to the role of the
Western emperor in the investiture of clerics. The Chapter of Aquileia was granted free
episcopal election under Charlemagne,[44] but the imperial authorities from the north con-
tinued to exercise the right to propose their own candidates. The Aquileian Church for its
part consistently elected partisans of the German emperor and supported his papal candi-
dates up until the late 1160s when Patriarch Ulrich II restored communion with the
official pope, Alexander III. Even after Frederick Barbarossa made his peace with Alex-
ander at Venice in 1177, he insisted on the right to confirm episcopal elections, and this
state of affairs is reflected in the Aquileian mural of the Election of Hermagoras (fig. 60).[45]
The overseeing authority of the church, however, is also represented by Mark. Serving as
an official witness here, he conveys the candidate to Rome in the subsequent scene for his
consecration by Peter (figs. 61, 62).

Equally important for Aquileian claims is the expansion of the narrative following
Hermagoras's election and consecration. While the San Marco cycle summarizes the mis-
sion of Hermagoras in one generic scene of baptism and the text of the legend jumps
ahead to the trial of Hermagoras, the crypt cycle gives a detailed account of the expansion
of the Church to justify Aquileia's later metropolitan authority.

Two crucial events in the course of the long ecclesiastical dispute shaped these differ-
ent pictorial versions of local Church history: the subjection of the archbishopric of Zara
to the patriarch of Grado in 1155 and the Peace of Venice in 1177.

The first is reflected in the Venetian mosaics. In a pictorial footnote to the pre-
Venetian phase of the legend in the Cappella San Clemente, Pope Pelagius appears oppo-
site Patriarch Helias on the arch opening from the presbytery into the side chapel to
confer a charter approving the transfer of the metropolitan See of Aquileia to Grado in
579 (figs. 145, 146). The text of the papal writ, abbreviated in the scroll held by Pelagius, is
a forgery which dates back as far as the Carolingian period. It is already mentioned in the
Acts of the Council of Mantua (827) as evidence adduced by Grado to support its metro-
politan claims.[46] Significantly, it is also cited in the prologue of the tenth-century Venetian
Translatio text to prepare the ground for the appropriation of Aquileia's founding
apostle.[47]

During the eleventh century, the theory of the permanent translation of the see to
"Nova Aquileia" was elaborated in a series of Venetian-Gradese sources. According to the
Chronicon Venetum of John the Deacon, completed in 1008, Patriarch Paulinus I trans-
ferred the see and the relics of its patron saints to Grado following the Lombard invasion
of 568, naming the island "Aquileia Nova." Later, in 579, the chronicler asserts, Paulinus's

successor Helias gained the approval of Pope Pelagius II to institute Grado as the metropolitan see of all Venetia at a synod of twenty bishops from the region.[48] As further recognition of Grado's new status, the chronicler records the donation of the cathedrae of Mark and Hermagoras by the Byzantine emperor, Heraclius (610–41).[49] The Grado Synod and the letter of confirmation by Pelagius are also mentioned in two later Gradese sources of the mid-eleventh century, both of which interpolate Grado's claim over the Istrian bishoprics into the earlier forgery: the *Chronica de Singulis Patriarchis Nove Aquileie* and the *Chronicum Gradense*.[50]

The Synodal *Acta* and Pope Pelagius II's letter survive only in fourteenth-century manuscripts, but Lenel has convincingly traced their exemplars to the early eleventh century.[51] The letter is particularly important for our understanding of the mosaic of Pelagius in San Marco, for it uses the same language employed in the inscription. Thus, in the forged letter, Pelagius grants the request of the synod: "Therefore, because you have petitioned us, . . . with the consent of your suffragan bishops, that the castrum of Grado should become the metropolitan of all Venetia and indeed of Istria, namely to govern the church . . . we confirm in perpetuity that the above-mentioned castrum of Grado is made metropolitan of all Venice and Istria with all the appurtenances of your church. . . ."[52] Similarly, we read in the mosaic document held by Pelagius: "Because we cannot deny your just petitions, Venerable Father, we confirm through the content of our privilege that the castrum of Grado is the metropolitan of all Venice, Istria, and Dalmatia."

It is the inclusion of Dalmatia under Grado's jurisdiction that differentiates the mosaic inscriptions from the forged letter of Pelagius and the eleventh-century chronicles. Otto Demus has explained this as an interpolation of the early twelfth century, reflecting Venetian aspirations to bring about a new ecclesiastical order in territories already under its political control.[53] Venetian involvement in Dalmatia had begun as early as 1000 when Pietro II Orseolo led a military expedition there and was honored with the title *Dux Dalmatiae*. Venetian control of parts of the Byzantine province was realized sporadically between 1069 and 1165 and again, more permanently, from 1202 on.[54] But it was only toward the end of the first period, between 1115 and 1165, that Venice firmly established its political authority over Zara and four smaller Dalmatian cities—Arbe, Veglia, Cherso, and Ossero—while Spalato, Trau, and Ragusa were absorbed into the Hungarian empire. This political division of Dalmatia resulted in the separation of the bishops in the Venetian territory from their metropolitan see in Spalato. Consequently, Anastasius IV exempted Zara from the jurisdiction of Spalato in October 1154 and established it as a new metropolitan to preside over Ossero, Veglia, Arbe, and Lesina. By reorganizing the Dalmatian Church within the Venetian territory under a single metropolitan, Anastasius prepared the ground for the ecclesiastical subjection of Dalmatia to Venice. In a series of three diplomas issued between February 1155 and June 1157, Anastasius IV and his successor Hadrian IV subjected the newly erected archbishopric of Zara to the authority of the Venetian-controlled See of Grado.[55]

The significance of these last events for the genesis of the choir mosaics has not been adequately assessed. By placing Zara under the jurisdiction of the patriarch of Grado, the pope did not merely add territory to the Venetian metropolitan province. Anastasius and

Hadrian explicitly state in these diplomas that they are elevating the dignity of Grado "ex brevitate patriarchatum inferior" by conceding it "primacy . . . over the archiepiscopal See of Zara and its bishoprics."[56] As Steindorff and Dusa have rightly emphasized, this move was calculated to enhance the juridical status of the Venetian-based patriarchate of Grado vis-à-vis its rival at Aquileia.[57] Contrary to canonical tradition, Anastasius placed one metropolitan directly under the authority of another: Grado, which had heretofore exercised ordinary metropolitan authority over other bishoprics, now gained supra-metropolitan status and the prerogative to consecrate the archbishops of Zara.

This interpretation is confirmed by a letter of Innocent III to the doge and people of Venice in 1206, renewing the privilege granted by Anastasius: "The metropolitan dignity was conceded to them by the Apostolic See particularly on account of your honor, so that your Church would clearly possess the patriarchal dignity not only in name but also in full (legal) right, when the metropolitan of Zara was subjected to it."[58] Such an unprecedented action was probably motivated by two factors: the papacy wanted to reward the Venetians for assisting it against the Normans and to punish the patriarchs of Aquileia for adhering to the German-sponsored antipopes throughout the twelfth century. It represented another major about-face in papal policy concerning the age-long ecclesiastical battle between Aquileia and Venice-Grado. As recently as 1132, Aquileia's authority over the Istrian bishoprics had been confirmed by Pope Innocent II.[59] Now, only two decades later Anastasius IV was returning them to Venetian tutelage and enhancing the rival patriarchate with suprametropolitan authority in Dalmatia. As Innocent III's letter suggests, Grado alone could legally claim both title and real authority of a patriarch, since that office was, by definition, ranked above other metropolitans.

By including Istria and Dalmatia, the Pelagian donation mosaic in the Cappella San Clemente visually documents this redistribution of ecclesiastical power between 1155 and 1157.[60] That the mosaics were actually executed around the same time is confirmed by other evidence. Although these mosaics are difficult to place on stylistic grounds alone because of their rather "provincial" character and poor state of preservation,[61] certain well-preserved figures reveal strong affinities with mid-twelfth-century Byzantine frescoes.[62] This dating would also be in keeping with the inscription in the Cappella San Clemente which appears to record the initiation of the marble revetment there by a certain Petrus in 1159.[63]

The elevation of the Venetian patriarchate to true suprametropolitan authority in the region is reflected in a second portrait image within the same cycle: the Reception of the Relics of Saint Mark in Venice (fig. 152). This version strikes a remarkable contrast to the conventional translation image of the Pala d'Oro (fig. 139). On the enamel, a group of clergy, headed by a deacon thurifer and Bishop Ursus holding a processional cross, stands in front of a church to receive the reliquary chest from the three merchants. In the mosaic, we see instead the contemporary Venetian governing class, comprising both clergy and laity standing before an abbreviated image of the city. While the enamel, like the text of the *Translatio*, records only Bishop Ursus of Olivolo-Castello receiving the relics from the merchants, the mosaic depicts the doge with his councillors and no less than seven bishops. As Demus has rightly pointed out, the central bishop must, anachronistically, be

identified as the patriarch of Grado together with the six bishops under his tutelage in the Venetian lagoon.[64] But while he identifies the seventh bishop as the *primicerius* of San Marco, the text of the donation of Pope Pelagius in the Cappella San Clemente suggests that the supernumerary should be identified as the archbishop of Zara, newly subjected to the Venetian patriarch of Grado.

The interpolation of such a complex political message at this point in the narrative of the translation is commensurate with the significance of Mark's relics in the reinvention of Venetian history. Once Venice had dedicated itself to Saint Mark, the possession of his relics came to justify both the spiritual authority of the patriarch of Grado and the temporal authority the doge. From the eleventh century on, the doge was invested with his office in the name of Mark at the high altar of the basilica hallowing his relics.[65] After the mid-twelfth century, Mark's posthumous presence there also sanctioned the transfer of apostolic authority from his old see at Aquileia to the new patriarchate of Venice-Grado. Taken as a whole, the mosaic program of the choir chapels proclaims the recent papal vindication of Venetian control over the Church of Venetia and Istria, as well as Dalmatia.

The pictorial narrative in the crypt culminates Aquileia's concerted response to this jurisdictional setback. Only a year after his consecration, Patriarch Ulrich II (= Voldoricus) of Treffen (1161–82) attempted to subject Grado by military force.[66] Although he suffered a humiliating defeat at the hands of the Venetians, his diplomatic efforts did eventually bear fruit. After the death of the antipope, Victor IV, he returned his schismatic church to communion with Pope Alexander III from whom he received the pallium and the office of papal legate.[67] Exploiting his unique position as confidant of both pope and emperor, Ulrich succeeded in restoring Church unity and the status of his own see.[68] Frederick Barbarossa rewarded him by extending the secular jurisdiction of the patriarchate previously granted by Emperor Otto III.[69] Alexander III confirmed the Aquileian patriarch's right to wear the pallium—symbol of the exercise of metropolitan authority—and his jurisdiction over sixteen bishoprics, including those contested in Istria.[70]

The basis for these special rights in Aquileia's apostolic tradition is established in the preamble of the papal bull of 1177:

> Granted that the love of all the apostles is equal, and all accepted the same power of binding and loosening, yet according to the word of the blessed Leo, just as a certain distinction of dignity is preserved among them, so it is granted to one to preside over the other. And certainly in the same way, the Church of God is made in the dignity and diversity of its offices, and for the manifestation of more important ministries are established more important people, both so that they might be distinguished by the privilege of their dignity and might have broader care than others. Truly it is agreed that the Church of Aquileia is one of the worthier and nobler Western churches to have existed since ancient times, and which has shone forth in the excellence of its dignity and is known to adhere faithfully and with devotion to the Holy Roman Church. And thus the Apostolic See has always very carefully preserved the rights and dignities of the same (Aquileian) Church, and has favorably honored the prelates of the same, and it is accustomed to admit most willingly their just requests. Therefore, Venerable Brother in Christ, Patriarch of Aquileia, to you, and through you to the Holy Church of Aquileia, . . .

we concede, following the example of our predecessor of blessed memory, Hadrian, the power over sixteen bishoprics . . . with Metropolitan authority.[71]

In this passage, Alexander III establishes the legitimacy of his own position and that of other privileged metropolitans such as Aquilcia on the basis of their apostolic foundation. He cites as authority his venerable fifth-century predecessor, Leo the Great, who adumbrated the principle that ecclesiastical authority should be dictated not so much by the political importance of a given city but by its connection with an apostle.[72] Rome stood at the top of the hierarchy, consecrated by the preaching and martyrdom of Peter there. Alexandria, whose church was founded by Mark the evangelist at the behest of Peter, and Antioch, another foundation by Peter himself, were ranked highest among the metropolitans of the Eastern Church.

That Alexander III should emphasize the apostolicity of Aquileia and its fidelity to Rome is instructive, because relations between the two sees had been strained for almost a century.[73] Now the papacy seemed to recognize definitively Aquileia's long-disputed patriarchal title and granted the see substantial benefits. Alexander III's bull of 1177 returned to the patriarchs of Aquileia the jurisdiction over the Istrian bishoprics, which had been ceded to Grado by Anastasius IV along with the see of Zara only twenty years before.[74] Furthermore, Alexander now reinforced the special status of the see, recalling the special dignities it had enjoyed from ancient times and placing it directly under the protection of Peter and the Apostolic See. The greatest of all rewards, however, came three years later with the official resolution of the age-old jurisdictional conflict with the Church of Venice-Grado in Aquileia's favor. The patriarch of Grado, Enrico Dandolo, in the presence of Alexander III and Ulrich II of Aquileia, formally renounced the claims of his Church over the Istrian bishoprics as well as the relics and treasures which had been taken from Grado by Poppo at the beginning of the eleventh century.[75]

The historical moment for the decoration of the crypt can hardly have been more propitious than these last years of Ulrich II's patriarchate. As Morgagni Schiffrer has pointed out, the lavish decoration of the crypt would have been made possible by the generous territorial privileges granted by both pope and emperor; furthermore, the accessibility to the Venetian craftsmen who must have worked in the crypt would have been facilitated by the recent rapprochement between Aquileia and Venice.[76] More important, however, is the motivation of the iconographic program in recent historical events. With its particular emphasis on the historical ties between Aquileia and Rome and the legitimacy of its succession, the pictorial narrative confirms Aquileia's return to the orthodox fold and the restoration of its ancient metropolitan authority. In response to the Venetian elevation of Mark at the expense of Hermagoras, the crypt murals carefully distinguish the roles of apostle-patronus performed by Mark and that of founding bishop fulfilled in the person of Saint Hermagoras. Venetian possession of the apostle's relics is not denied, but merely omitted. For it is the miracles and preaching of Mark at Aquileia, and the mission and death of the founding bishop Hermagoras that consecrate Aquileia as the patriarchate of medieval Venetia.

CHAPTER SIX

Christ's Passion and the *Compassio* of the Virgin

Romanesque Icons in Space

W HILE the hagiographic cycle functions largely as an extension of ecclesiastical politics, the parallel narrative running along the eastern hemicycle reinforces the more universal spiritual themes associated with relics: martyrdom and intercession. Displayed in the four grand lunettes flanking the central aisle,[1] the Dormition of the Virgin, Crucifixion, Deposition, and Threnos constitute an abbreviated "feast cycle" (fig. 1:F2– F5).[2] The apparent adherence to Byzantine convention goes beyond iconography and choice of individual scenes. Their mode of presentation, already described, bridges the depicted realm with that of the spectator in a way that recalls Byzantine "icons in space" (pl. I; fig. 4).[3]

Otto Demus coined this felicitous expression fifty years ago to describe monumental images in which Christ, the saints, and individual participants in narrative feast scenes interact across the actual space of a Middle Byzantine church to establish a tangible link with the spectator. Instead of encouraging a serial reading of narrative along the picture plane of a flat basilican wall as Romanesque nave cycles do, Middle Byzantine churches display centralized compositions within separate spatial units framed by the architecture. Narrative is stripped to essentials and individual actors project themselves into the viewer's space. Granting these mosaics an affective function, Demus argues that "the Byzantine church itself is the 'picture-space' of the icons. . . . the beholder is bodily enclosed in the grand icon of the church . . . and takes part in the events he sees."[4]

While Byzantine art has long been recognized as a source for the style and iconography of Italian Romanesque wall painting, no one has ever asked if there might also be a functional relationship. Hans Belting has demonstrated that Italian panel painters assimilated Byzantine icon types to create new devotional images of the Passion in the late-thirteenth and fourteenth centuries and Anne Derbes has recently explored how the narratives of the Passion in Italian Dugento painting were enriched by Byzantine material to complement Franciscan meditational exercises.[5] But the four feast scenes in Aquileia's crypt show how twelfth-century mural painters adapted the format as well as the style and iconography of Byzantine art to create a distinct mode of devotional narrative. At Aquileia, the Passion is transformed into devotional images of the *Compassio*, the spiritual martyrdom which makes the Virgin the ideal surrogate for the spectator who meditates on the death of Christ.[6]

Christ's Passion and the Dormition of the Virgin are visually privileged by their large

scale and by their close proximity to the spectator (pls. I, III; fig. 4). They are also the images that elicit the greatest empathy. The viewer is first drawn into the scenes by their high emotional tenor. At the same time, a spatial continuum is established between viewer and image by the tilted ground plane rising back at eye level and by the V-shaped composition which appears to project the central protagonists in front of the picture plane. Whereas the saint's life is presented like a filmstrip in a dense narrative sequence along the length of the aisle vaults, the feast cycle comprises two distinct pairs of centralized, self-contained compositions, each framed as a separate lunette by the vaults. Mary's Dormition and the Crucifixion form one pair at left of the central aisle (fig. 1:F2, F3; figs. 83, 84); the Deposition of Christ and the Threnos form a second pair at right (fig. 1:F4, F5; figs. 85, 86), focusing on the intimate relationship between mother and son.

The Dormition of the Virgin (fig. 83),[7] conforming to Middle Byzantine iconography, shows Mary asleep on her bed in the foreground, her head propped up at left. She is attended by symmetrical groupings of grief-stricken apostles and three Orthodox bishops, holding veiled arms to their faces. Peter swings a thurible in the foreground to fumigate the body. Christ himself appears immediately behind her on the central axis beneath the dome of heaven. Glancing directly at her, he holds her mummylike soul aloft to be received by two angels.

The contiguous lunette to the right of the Dormition depicts the Crucifixion (fig. 84). Set within a shallow foreground precinct, the scene is dominated by the dead body of Christ on the cross. In keeping with the Byzantine feast image for Good Friday adopted in Italy by the mid-twelfth century, Christ is clad only in a perizonium and is slumped in a broad S-curve; his eyes are closed, and his head rests on his right shoulder. Blood springs from the wounds in his hands, feet, and side. Mary, looking up to Christ, stands with four mourning women at left while John the Evangelist bows his head in grief beside the centurion at right. Above the cross hover the sun and moon and two grieving angels.

The Aquileian image departs from the Middle Byzantine type in its emphasis on the Virgin's sorrow. Here tears visibly stream from her narrow reddened eyes as she looks directly at her son, holding a handkerchief to her chin. Her emotional state is also amplified by the expanded entourage of women (fig. 85). Three women stand weeping behind her, one of them covering her eyes with her left hand. A fourth companion even turns her back on Christ to comfort his mother; holding Mary's right hand in her own, she elicits the spectator's sympathy.

The feast cycle is conspicuously interrupted in the central lunette by two episodes from Mark's mission which trumpet Aquileia's apostolic authority (figs. 5, 58). The second pair of Passion scenes on the opposite side underlines the relationship of the suffering mother to her son in unusually explicit terms.

In the Deposition (pl. III; fig. 86), the cross, though shifted slightly to the left of center to allow for the doorway, again defines the principal vertical axis of the composition. Christ's limp body is twisted away from the base of the cross in a bold curve to the left. In keeping with the biblical accounts, Joseph of Arimathaea and Nicodemus remove the body from the cross. While Joseph lifts Christ from behind, Nicodemus pries the nails from Christ's bleeding feet.

The Virgin and John the Evangelist have been imported from the Crucifixion narrative, as they do not figure in the biblical texts. Their presence reflects in part the evolution of a symmetrical Byzantine feast image around the turn of the tenth century, based on the Crucifixion which it sometimes supplanted in feast cycles. More specific to the twelfth century, however, is the central role played by the Virgin in the Deposition (pl. IV). Instead of passively taking in the scene from one side, Mary now stands in the middle of the composition behind Christ with her face pressed against his, her right arm supporting his torso from beneath, and her left arm holding his left. As in the Crucifixion her grief is amplified by four mourning women (fig. 131); here fused into a single, columnar group, they take her place as the compositional counterbalance to John. With the focus of the visual and emotive force of the composition on the juxtaposed heads of grieving mother and dead son, an important step is taken toward the development of the pietà (pl. IV), which was later to be excerpted from its original narrative context.[8]

The fourth surviving lunette, depicting the *Threnos* or Bewailing of Christ, again focuses on the emotionally charged juxtaposition of the faces of Christ and his mother (fig. 87). Like the Deposition, this image goes beyond the terse biblical accounts which mention Joseph and Nicodemus placing the body in the rich man's tomb. While Joseph and Nicodemus are relegated to the feet of the dead Christ, Mary becomes the primary actor, tenderly embracing Christ's upper body and holding his head up to hers with one arm wrapped in his shroud and the other grasping his right arm. To the right, Joseph of Arimathaea kneels down to hold Christ's feet. Reflecting his prominent position at the Virgin's side in the *Koimesis*, John the Evangelist appears here to imitate the grieving of the Virgin herself: he stoops and grasps Christ's left arm to kiss the hand. The Virgin's four attendants also appear again to amplify the expression of her grief: the first shown in profile, the second with arms flung in the air in despair, the third turning away from the scene, the fourth holding her mantle up to her face.

Both the Deposition and the *Threnos* exhibit a heightened pathos typical of late Comnenian art. Close parallels for both images have long been recognized in the celebrated murals at Saint Panteleimon in Nerezi, Macedonia, dating from 1164 (figs. 102, 103). As at Aquileia, this Byzantine Deposition is based on the symmetrical composition of the Crucifixion and focuses on the tender embrace of Mary and Christ. The Aquileia image, however, integrates Mary more fully into the central axis, placing her behind Christ to help lift the body. The two images of the *Threnos* are even closer in conception, both showing the procession to the tomb arrested so that the Virgin can embrace the body while others such as Nicodemus and John caress his limbs.

Kurt Weitzmann and Henry Maguire uncovered the origins of these extra-biblical themes in ninth- and tenth-century Byzantine sermons and liturgical hymns for the Passion.[9] The tender embrace is described in a late-ninth-century sermon by George of Nicomedia. In this text, the Virgin speaks of "holding and embracing the body . . . (and) kissing the motionless and wounded limbs of him who cures the incurable wounds of nature . . . the voiceless mouth and silent lips . . . (and) the closed eyes of him who invented the operation of sight."[10] Her active participation in the lifting of Christ from the cross is also recorded in a late-tenth-century Lament of the Virgin attributed to Symeon

Metaphrastes. The author has the Virgin ruefully address her dead son: "Nicodemus alone
. . . placed you painfully in my arms, which even lately lifted you joyfully as an in-
fant. . . ."[11] Hans Belting further suggests that the time lag between texts and images
which fully realize this new concept of the Virgin's role in the Passion is due to the fact
that these texts became current in the Byzantine Good Friday liturgy only during the
eleventh and twelfth centuries.[12] The new Byzantine images of the Passion on which the
Aquileian murals were modeled thus responded directly to changes in the liturgical com-
memoration of the Passion.

The *Compassio* of the Virgin in Medieval Literature

Merely to identify iconographic sources is to neglect the more central questions as to why
Byzantine models were sought for this part of the Aquileian program and why such em-
phasis was placed on Mary's role in the Passion. The answer to both questions lies in the
rise of the *Compassio* of the Virgin as a major theme in meditational literature, sermons,
and liturgical hymns of the twelfth century.

The *Compassio* derives ultimately from Simeon's prophecy to the Virgin in the Tem-
ple: "and a sword shall pierce your soul . . ." (Lk. 2:35).[13] While early church fathers such
as Augustine and Ambrose already interpreted the sword as the grief inflicted upon the
Virgin at the Crucifixion, they emphasized that she accepted the fate of her son stoically,
knowing Christ's death was necessary for redemption.[14] A striking shift in patristic opin-
ion is evident by the mid-ninth century in Paschasius Radpertus's tract on the Assumption
of the Virgin.[15] For this theologian, the Virgin's incomparable love for her son dictated
that her grief at the Crucifixion should surpass physical martyrdom; thus arose the notion
of the Virgin's *Compassio* as a spiritual equivalent to the physical pain inflicted upon Christ
through the Passion. It remained for writers of the late eleventh and twelfth centuries to
translate this theological statement into concrete images.

Saint Anselm of Bec's *Oratio ad Christum* (c. 1085) marks a watershed in the medieval
conception of the *Compassio*.[16] Lamenting that his soul cannot experience the same "sword
of grief" which has pierced that of Mary, Anselm describes more explicitly than any pre-
vious commentator the outward signs of the Virgin's grief:

> Why, O my soul, were you not there to be pierced by a sword of bitter sorrow when you
> could not bear the piercing of the side of your Savior with a Lance? . . . Why did you
> not share the sufferings of the most pure virgin, his worthy mother and your gentle
> lady? My most merciful Lady, what can I say about the fountains that flowed from your
> most pure eyes when you saw your only son before you, bound, beaten, and hurt? What
> do I know of the flood that drenched your matchless face when you beheld your son,
> your Lord, and your God, stretched on the cross without guilt, when the flesh of your
> flesh was cruelly butchered by wicked men? How can I judge what sobs troubled your
> most pure breast when you heard, "Woman, behold your son," and the disciple, "Be-
> hold, your mother," when you received as a son the disciple in place of the master, the
> servant for the Lord.[17]

What is striking about this text is that the Virgin becomes an intermediary for contemplating Christ's suffering and a model of the spiritual "imitatio Christi" which joins the faithful to Christ. Just as the pictorial images of the crypt enhance an intimate experience of Passion and *Compassio*, so Anselm challenges the reader to confront the dead Christ and to share the mother's most acute grief, her floods of tears and troubled breast.[18]

Sandro Sticca has traced Anselm's impact in a series of meditations and sermons on the Passion composed from around the middle of the twelfth century principally by Cistercians and Victorines.[19] The theme of the Virgin's *Compassio* surpassing martyrdom, announced as early as the ninth century by Paschasius Radpertus, is elaborated by Richard of Saint-Victor (1105–1173), Arnauld Bonnaevallis (d.1160) and Bernard of Clairvaux (1091–1153). Richard of Saint Victor describes Mary's sorrow at the foot of the cross as a more intense martyrdom than that suffered by the martyrs of the Christian faith:

> Beyond these things, she was adorned with martyrdom. For a sword, not of matter but of grief, pierced her soul. The martyrdom by which she suffered was more painful than iron. . . . Among the martyrs, the greatness of their love alleviated the pain of their suffering, but the more the Virgin loved, the more she suffered.[20]

Similarly, in his *De laudibus Beatae Mariae Virginis*, Arnaud justifies Mary's role as coredemptrix by virtue of her shared sacrifice with Christ at the time of the Passion:

> Mary sacrifices herself in spirit for Christ and makes entreaties for the salvation of the world, the Son intercedes, the Father grants pardon. . . . For the affection of Mary moved him, and at that time there was in all a single will of Christ and Mary, and likewise they both offered a single sacrifice to God: she, in the blood of the heart, he in the blood of the flesh.[21]

Bernard of Clairvaux gives a particularly poignant description of the inward, spiritual martyrdom of the Virgin in his Sermon on the Assumption of Mary:

> Truly, O blessed mother, a sword has pierced your soul. . . . And certainly after your Jesus . . . gave up the ghost, the cruel lance which opened his side clearly did not touch his soul, but certainly pierced your soul. Undoubtedly, in that case, his soul was not yours; but clearly on the other hand, your (soul) could not be plucked out. The force of grief, then, pierced your soul, so that it is not unmerited that we proclaim as more than a martyr the one in whom a feeling of the corporeal passion has produced the effect of compassion.[22]

While all of these texts embrace an internalized conception of the Virgin's *compassio*, two meditations on the Passion composed in the last decades of the twelfth century present close narrative parallels for the outward emotional drama reenacted in the Aquileian images of the Passion. The *Liber de Passione Domini*, once ascribed to Saint Bernard of Clairvaux, and the *Dialogus Mariae et Anselmi de Passione Domini*, connected by its title to Anselm, are now generally believed to have formed part of the *De Laudibus Sanctae Dei Genitricis*, composed by a North Italian monk, Ogerius of Locedio, prior to his elevation as abbot in 1205.[23]

Initially addressed to the Virgin Mary, the *Liber de Passione Domini* is written mostly in first person, alternating between the Virgin and author, thereby providing a parallel for the intimate dialogue between image and viewer facilitated by the pictorial images of the crypt.[24] The entourage of women accompanying the Virgin in the Aquileian cycle is recalled at the outset when the Virgin speaks of "my sisters and many women, bewailing him with me as one." Seeing the stripped body on the cross and the blood flowing from the four wounds, the Virgin is speechless, overcome by grief. Then follows a monologue in which the Virgin pleads with Christ to let her die; he responds by commending her to John the Evangelist, who, like the Virgin, is "continuously shedding tears."

In contrast to the terse gospel narrative of Joseph of Arimathaea and Nicodemus removing the body to the tomb, Ogerius vividly portrays a scene much like the Aquileian painting of the Deposition:

> Mary stood, raising up her arms, in order to draw both Christ's head and dangling hand to her own breast. As long as she had the strength to touch him, she could not be satisfied with kisses and embraces, collapsing on account of him, her beloved (son), even though he was dead. While this body was deposited from the cross on the ground, she stood over him, as if she were dead, collapsing on account of the incontinence of her grief and the immensity of her love.[25]

Similarly, the Entombment narrative is arrested by the Virgin's pleas with Joseph and Nicodemus not to lay him in the tomb so that she might embrace the body again. The men, moved by her grief, participate in a lamentation for the Virgin herself.

> Do not deliver him to the tomb so quickly; give him to his miserable mother, so that I may hold him with me, even his dead body, or if you put him in the tomb, deposit wretched me with him; this I would prefer, because after this, he will outlive me. They placed Christ in the tomb and she pulled him back to her. She wanted to keep him; they wanted to take him to the sepulchre, and thus came about this holy strife and lamentable controversy amongst them. . . . They saw the mother enter (the tomb) forsaken by every solace. And they poured over her a greater lament than over her deceased son, our Lord. Greater was the grief of the mother for them than the grief which came from the death of her Lord. Therefore they all wept, sighing with miserable sorrow, and handed over the Lord of Life for the burial of death.[26]

The second of Ogerius's meditations on the Passion, *Dialogus de Passione Domini*, comprises a series of questions put to the Virgin by Saint Anselm. The responses frame biblical excerpts within the context of the Virgin's personal reaction to events. Here again, the Virgin complains throughout of her immense maternal grief. She holds and embraces the corpse once it has been removed from the cross, impeding the entombment and begging the bystanders to bury her with her son. But here, as in the pictorial composition, responses from other individuals echo the Virgin's lament at the entombment:

> And I, receiving his head in my bosom, bitterly began to cry, saying: Alas, sweet son, what consolation have I that I behold my dead son with my own eyes? Then John the Evangelist, drawing near, fell upon the breast of Jesus, crying and saying, Alas, alas, from this breast I drank the sweet words yesterday; today, sad and lamentable things.

Then Peter came; and . . . he began to cry bitterly; then Mary Magdalen, more than everyone, began to cry over her Lord. [27]

While these meditations were directed initially to a monastic audience, the *Compassio* was diffused to a wider public through liturgical hymns and Passion plays.[28] In the earliest extant text of a Passion play, copied in a mid-twelfth-century manuscript in the library of Montecassino, the Virgin's lament, significantly distinguished from the main part of the play by its vernacular language, follows the account of Christ commending Mary and John to each other. In response, Mary, still standing with John and the other women at the base of the cross, shows to Christ her womb; recalling that she has borne him in her womb, she beseeches him to remember her in his kingdom: "To whom do you leave me, O grieving me, I who carried you in my womb. As I watch you dying now, remember me in your kingdom."[29]

Although this *Planctus* has sometimes been viewed as the kernel of later liturgical drama, Sticca has recently demonstrated that the *Planctus* originated as an independent liturgical chant, inspired by the Byzantine *Staurotheotokia* for Good Friday, and was only later added to enrich the texts of Passion plays.[30] In the course of the twelfth century the *Planctus* also became very popular as an independent genre of devotional hymn to be sung on Good Friday during the Adoration of the Cross. Significantly, this practice is documented in the diocese of Aquileia at least as early as the fourteenth century.[31]

One late-twelfth-century version by Adam of Saint-Victor, *Maestae parentis Christi*, resembles particularly closely the meditations of Ogerius discussed above.[32] It opens with the Virgin dejected and full of tears as she meditates on the wounds and blood, the taunts and indignities suffered by Christ. Then follows an extensive lament in the first person. The most poignant passage presents the Virgin's state of mind as she waits for the body to be removed from the cross:

> thus stands the desolate mother, now no longer a mother, but a woman bereaved of her sweet son. She laments, cries, and waits until the body is taken down from the cross. O mournful one upon whom I have gazed! She sits, appearing half dead and holds the spoils of the dead corpse in her bosom. She looks over all the cuts and the bloody places of the nails and also the individual wounds. . . . O grievous sorrow and lament! The limbs of her son, formerly handsome and now black and blue, the mother holds between her tender hands. She embraces and kisses the (limbs) now pallid on account of the hardships and harsh wounds. Stretching out her hands, she exclaimed and inundated the body with her weeping, shedding tears like streams.[33]

The *Planctus* concludes with a collective appeal to the Virgin that the faithful "may cry with you and pierce our heart with the sword of compassion." Thus, as in Anselm's meditation and in the Aquileian paintings, the spectator is explicitly drawn to contemplate and suffer Christ's Passion through the intermediary of his mother.

The concrete expression of the Virgin's *Compassio* in twelfth-century meditations and hymns such as these helps explain why the designers of the crypt program were so receptive to the tone and iconography of Byzantine icons of the Passion. At the same time, the theme of *Compassio* justifies the limited scope of the Aquileian cycle: all four episodes unite Christ with his mother in death.

Although the Dormition of the Virgin is not mentioned in any of these texts, its inclusion in the Aquileian cycle is nonetheless related to the *Compassio* theme. Its juxtaposition with the Crucifixion is a visual cue to the comparison made between the death of the son of God and that of his mother as necessary events in the scheme of salvation. The anachronistic placement of the Dormition prior to the Crucifixion and Passion cycle not only announces the Marian emphasis of the subsequent scenes but also enhances an important contemporary argument concerning the apocryphal Assumption of the Virgin. It is precisely because of the Virgin's role as *Theotokos* and her cosuffering with Christ in the Passion that she was deemed worthy above all other mortals to have her body and soul ascend into heaven to join Christ immediately after her death.[34] Together with the image of the *Theotokos/Maiestas* in the central vault (fig. 22), the three Passion lunettes thus provide pictorial proofs or justifications for the Assumption, initiated by Christ at the Virgin's deathbed.

Compositionally and conceptually, the Dormition also forms a pair with the *Threnos* on the opposite side of the central axis (figs. 83, 87). The bodies of the deceased in both cases are laid out parallel to the picture plane with the head to the left and are surrounded by a throng of mourners. More important, the intimate bond between Christ and his mother is manifested in their proximity and actions. In the *Threnos*, the Virgin kneels down to hold her deceased son from behind, drawing his head upwards to embrace it; in the Dormition, Christ leans over from behind the bier to establish eye contact with his mother in the flesh, while cradling her soul in his arms to convey it to heaven. One action seems to warrant the other; just as the Virgin has borne Christ both as a living child and a dead man, Christ now takes the Virgin as both bride and daughter.[35]

Within the larger program, these pictorial "meditations" on Christ's Passion and the Virgin's *Compassio* extend through narrative the intercessory message presented in the terse iconic language of the hierarchy of saints. There too, the Virgin is the primary intermediary before Christ by virtue of her motherhood. The attention given to the death of Christ and his mother also underlines the funerary function of the crypt as burial chamber of the local martyrs. To this extent, Aquileia's program follows that of the crypt of Hosios Lukas in Phocis, the only Byzantine crypt to survive with a comparable form of decoration.[36] But in a church that was dedicated to the Virgin, the Marian emphasis of the cycle was clearly intended to strengthen her central role in the scheme of universal and local salvation.

Mary's *compassio* also functions typologically in relationship to the hagiographic cycle as a model of "imitatio Christi." While the Virgin suffers in the likeness of Christ through her spiritual "martyrdom" at the Passion, Hermagoras and Fortunatus are assimilated to the body of Christ through their mission and physical martyrdom for the faith (see above, chap. 5). It seems no accident, then, that the Execution of Hermagoras and Fortunatus is placed on the ceiling immediately adjacent to both the Dormition and the Crucifixion (fig. 1:H23, F2, F3; fig. 13, far left). But Mary, more than the martyrs, provided a model for the viewer's spiritual "imitatio Christi." In the twelfth century, as Giles Constable has shown, religious and laymen alike increasingly sought to imitate the human body of Christ both by physical mortification of the flesh and by meditating internally on all the details of the

Passion narrative.[37] Images provided pictorial guides to internal visualization, and as texts by Anselm and Ogerius cited above suggest, Mary became the principal surrogate through whom one could vicariously experience the Passion.

Icons in Space

Drawing upon meditation literature, sermons, and liturgical texts, I have argued that the selection and content of the feast images in the crypt were designed to enhance the role of the Virgin as cosufferer with Christ and mediator of his Passion for the spectator. As I emphasized at the outset, the designer of the program also deliberately appropriated the formal language of Byzantine "icons in space" to enhance the mediating role of mural paintings as devotional guides.

That monumental paintings should function in this way seems to run counter to the conventional perception of church decoration as a kind of static, pictorial counterpart to texts. Yet, there is abundant archaeological and textual evidence from the Carolingian period on that wall paintings did serve the devotional functions usually associated with panel painting. An unusually rich collection of wall icons, including a narrative Crucifixion, survives from as early as the eighth century in the church of Santa Maria Antiqua in Rome.[38] Each of these images, independently framed and sometimes inset within the thickness of the wall, corresponds precisely to types found on contemporary panel paintings from the East, and in certain cases, metal fittings provide for hanging lamps or censers.

Eric Palazzo has assembled a series of hagiographic texts that indicate precisely how these mural images could be used in both private and communal devotion.[39] Particularly pertinent is an eleventh-century text concerning private devotion in a crypt found in Andrew of Fleury's biography of Gauzlin, abbot of Saint-Benoît-sur-Loire. Here we learn that the abbot, sensing his own imminent death, descended to the crypt in the church of Châtillon and there prostrated himself on the floor to pray and confess himself before an ensemble of images including a wooden Majesty of the Virgin and Child and a painted *Maiestas Domini* in the apse: "and there, as if he were already before the tribunal of the stern Judge, stretched out on the floor, he commended himself by his prayers to Jesus Christ. . . ."[40] While Andrew of Fleury records the dynamic participation of mural painting in a dying man's last prayers, the more routine devotional usage of wall paintings is testified in a poem composed around 1000 by the monk Purchard in honor of Abbot Witigowo of Reichenau. According to Purchard, "the monks habitually liked to gather together and worship at this altar, placed in front of the fresco that represented the Virgin and Child, which they caressed with their eyes and their prayers."[41]

It is this tactile, physical contact with Mary and the body of Christ that is projected so forcefully by the form and content of the Passion and *Compassio* in the Aquileian crypt. These arrested narratives, focusing on the Virgin embracing her son and Christ embracing his mother, are no less "visual prayers" than the hierarchy of the saints. Placed at eye level behind the altar, they too enhance the "liturgical memory" celebrated both privately and communally in the crypt.[42]

CHAPTER SEVEN

The Fictive Curtain as Allegorical Veil

O CCUPYING the lowest zone of the pictorial hierarchy, the socle is immediately distinguished from the sacred narratives above it by its mode representing a white linen textile, embroidered with ostensibly secular themes (pls. I, VI). With the exception of the two entrance bays where simulated marble panels appear, the entire socle is hung with a *velum* or curtain, illusionistically suspended from rings to fall gently in nested V-folds before the wall plane. Human figures and beasts are executed on the surface in red-ocher outline drawings.

Despite their poor state of conservation, the subjects of the seven panels on the eastern hemicycle can be identified with reasonable confidence (fig. 1:S1–S7).[1] Proceeding clockwise from the northwest end, we encounter in the first bay a striped tiger and a spotted panther flanking a tree (fig. 1:S1; figs. 88, 89).

In the second panel (fig. 1:S2; figs. 90–92) is a group of two or three half-naked louts with flaming hair at left, and toward the center, a seated woman wearing a crown, who turns abruptly to the right to face another lout, bound with rope, who falls at the feet of a lion. The subject is difficult to determine, but it may represent Vices in combat. A similar cast of figures tumbles chaotically around Superbia, the queen of Vices, in an eleventh-century illustration of Hatigarius's *Treatise on the Eight Vices* at Moissac (fig. 153).[2]

In the surviving fragment of the third panel (fig. 1:S3; figs. 93, 94), a figure stands at left before a faldistorium throne, ornamented with beast heads. Below him to the right, a child lies asleep or dead, and further along the top border, a man in secular dress watches a knight—perhaps Saint George—raise his sword to slay a dragon.

In the central bay, David plays his lyre in the pacific company of birds and animals (fig. 1:S4; figs. 95, 96). The central section retains the shadowy outlines of the youth, seated on a throne decorated with a Corinthian pilaster. Most of the original animals and birds are difficult to see, but the clearest examples give an indication of the variety of fauna. At David's feet sits a small dog; just above his head, a serpent confronts a mouse. In the upper left corner, an owl perches on a tree branch. A lion slumbers in the lower left corner. Finally, on the upper right side are a stag and a camel. This is an image of harmony that contrasts with the images of conflict that dominate the socle zone on either side.

Best preserved of all, the fifth panel depicts a Christian knight pursuing a Saracen archer (pl. VI; fig. 1:S5; figs. 97, 98). The latter typically sports long unkempt hair and beard, and following contemporary accounts of the Crusades, he turns in his saddle to fire upon his enemy while feigning retreat.[3]

The sixth panel (fig. 1:S6; figs. 99, 100) features a troop of four disheveled men led by a knight who presents what appears to be a reliquary to a seated ruler. Behind him

stands a long-legged seabird—a crane or an ibis—with a fish in its beak. Dressed in animal skins and carrying long spiral staves, the four figures at left may be identified as pilgrims. Finally, in the seventh panel (fig. 1:S7; fig. 101), at the south end of the hemicycle, a troop of mounted knights gallops off to do battle.

The scenes on the Aquileian curtain evoke a poorly understood genre of Romanesque marginalia which Bernard of Clairvaux describes eloquently in his oft-cited *Apologia* to Abbot William of Saint-Thierry:

> To what purpose are those unclean apes, those fierce lions, those monstrous centaurs, those half-men, those striped tigers, those fighting knights, those hunters winding their horns? Many bodies are there seen under one head, or again many heads to a single body. . . . In short, so many and so marvelous are the varieties of shapes on every hand, that we are more tempted to read in the marble than in our books, and to spend the whole day wondering at these things rather than in meditating the law of God.[4]

Although Bernard rails against the distraction of the monks by these carved cloister capitals, he succinctly catalogues the quasi-profane repertoire to be found both in Romanesque sculpture and in the socle zone of Romanesque painting.

Taking their cue from Bernard, most scholars of Romanesque art have dismissed the possibility of a religious interpretation of the genre. The leading authority on Romanesque wall painting, Otto Demus, affirms that

> fantastic scenes, fabulous monsters, Atlantean figures . . . are more often figments of the artist's imagination than illustrations of a work of literature . . . drawn or painted on the curtain, usually in the loosest possible order or disorder. The dado is the only area in mural painting where free rein is given to the grotesque, fantastic and profane elements which play so prominent a role in manuscript illumination and stone carving.[5]

Demus presses the point further to argue that the very mode of representation undermines any notion of serious intent in this marginal zone:

> the fantastic and irrational elements . . . were confined in mural painting to a strictly delimited marginal area, and often painted to represent the pattern of a "curtain" along the dado; this formal convention shows that they were not intended to be taken very seriously. . . . Those lighter moments of mural painting frequently allow of no significant interpretation and have nothing to do with the programme of the rest of the church.[6]

Demus's view reflects the aesthetic theory championed by Meyer Schapiro twenty years earlier in his article "On the Aesthetic Attitude in Romanesque Art."[7] Examining Saint Bernard's diatribe, Schapiro argued that

> Bernard does not attack religious art, but profane images of an unbridled, often irrational fantasy, themes of force in which he admits only a satisfaction of idle curiosity. . . . These cloister sculptures are wholly without didactic meaning or religious symbolism. . . . (They exemplify) a pagan life-attitude which will ultimately compete with the Christian, an attitude of spontaneous enjoyment and curiosity about the world, expressed through images that stir the senses and the profane imagination.[8]

Schapiro was correct in finding an aesthetic appreciation for profane imagery in the writings of Bernard and his contemporaries, and he rightly emphasized the visual attraction of such "curiosities." Indeed, the pictorial catalogues of wild beasts and monstrous races in Romanesque cloister capitals reflect the heightened interest in natural history and marvels evinced in contemporary bestiaries, travel literature, and *mappaemundi*. However, more recent scholars of marginal imagery in a variety of media and contexts suggest that it may contain "didactic meaning or religious symbolism." Lillian Randall and Michael Camille, focusing on Gothic manuscript illumination, have forcefully argued that marginalia should be seen not so much as an outlet of free and random artistic expression, but as part of a conscious dialectic within Christian art between the sacred biblical and hagiographic narratives, and contemporary experience conveyed through allegory and fabliaux.[9] Similarly, recent studies of medieval *mappaemundi* and illustrated accounts of natural history have emphasized that fantastic creatures and monstrous races relegated to the margins of the created world were conceived both as examples of man's fallen nature and vices, and as targets for redemption offered by the advent of Christ.[10]

In the official realm of church decoration, governed by ecclesiastical patrons, it seems even less plausible to divorce ostensibly profane imagery from the religious content of a program. Indeed, recent studies of socle decoration and mosaic pavements confirm that these terrestrial zones within the church were exploited to convey the fallen world and concrete examples of the Christian struggle for its redemption.[11] By activating the terrestrial realm, designers of Romanesque wall painting and mosaic pavements, like those of contemporary *mappaemundi*, could map out in space a universal history comprising biblical and historical events, sacred and profane figures, the fallen world and the promise of redemption.[12] It is within this allegorical framework that I wish to interpret the Aquileia *velum*. Rather than imposing a consistent narrative structure on the *velum*, as past writers have unsuccessfully attempted, I propose that each episode is a discrete *exemplum*, distilling the moral of spiritual combat represented above in the Passion of Christ and the *Passio* of the local martyrs, Hermagoras and Fortunatus.

The *Velum* as an Allegory of Spiritual Warfare

Previous writers on the crypt have regarded the socle as a continuous narrative strip, but they do not account for the heterogeneous subjects or the absence of narrative continuity.[13] Comparisons with other fictive curtains and floor mosaics suggest instead that the Aquileian curtain constitutes a collection of variations on the theme of *Psychomachia*, or "the battle of the Soul."[14] The fifth-century writer Prudentius, in his allegorical poem of this name, conceives the Christian soul as embattled by sin from which it is delivered by the grace of the Crucifixion. The inner battle of the spirit takes the form of physical combat involving seven pairs of Virtues and Vices. It is commonly illustrated by knights or female personifications engaged in battle and by examples from biblical history, but the theme was freely interpreted to include a broad range of animal and human combat images in Romanesque art.[15] Thus, like the *exempla* collections compiled for sermons in

increasing numbers during the twelfth century, pictorial cycles drew from a diversity of texts—natural science, history, ancient myth, biblical literature, and fables—to illustrate the spiritual struggle and the vagaries of human behavior in the fallen world.[16]

None of more than twenty Romanesque figured *vela* documented in North Italy and adjacent provinces depicts a continuous narrative of the kind proposed for Aquileia.[17] In every case, the subject matter encompasses a diverse range of combat scenes, animals or birds and related fabliaux, mythological figures, personifications of Virtues and Vices, popular legends such as the *Alexander Romance* and the *Chanson de Roland*, individual Old Testament heroes such as David and military saints like George, who serve as models for the Christian knight.

A well-preserved painted *velum* in the south chapel of the abbey of Summaga is particularly instructive for understanding the structure and meaning of the Aquileian series. We have seen that Summaga was a dependency of Aquileia, and its paintings were executed by artists closely related to those of the crypt in the early 1190s.[18] The west wall originally displayed at least four paired figures of Virtues personified by knights or women, triumphing over recumbent Vices: Generosity (Largitas) and Avarice; Humility and Vainglory; Hope and Despair; and Temperance with Intemperance (fig. 113).[19] These emblematic pairs are ultimately based on *Psychomachia* illustrations found as early as the ninth century in manuscripts and ivories,[20] and endlessly repeated in Romanesque sculpture, metalwork, and painting.[21]

Diverse forms of combat figure prominently on the other walls of the chapel at Summaga. To the left of the eastern apse, a barefooted youth with a cloak about his shoulders wrestles a lion from behind (fig. 110): in the absence of inscriptions or distinctive attributes, he may be identified as David or Samson. The hemicycle of the apse is occupied by a youth slaying a dragon or griffin with bow and arrow, a youth confronting a giant in combat— perhaps David and Goliath—and a falconer on horseback (fig. 111). Finally, on the south wall, a plump, bearded man carries off eggs in a cloth from a bird-filled hut at left, and at right, two men are engaged in what appears to be trial by combat in the presence of an official, holding a staff (fig. 112).[22] The Summaga curtain is not arranged according to a single sequential narrative, but like Aquileia's displays distinct *exempla* or variations on a theme. The labeled Prudentian pairs of Virtues and Vices on the west wall and the Old Testament lion-slaying and dragon combat on the east wall leave no doubt as to the general interpretation of the *velum's* program as an allegory of spiritual warfare.

The theme of *Psychomachia* is most readily recognized at Aquileia in the panel depicting Superbia with the Vices (fig. 1:S3) and the dragon-slaying (fig. 1:S4), but the other scenes of the *velum* may likewise constitute *exempla* of spiritual warfare, shown, for example, by moralized animal fables and acts of pilgrimage and holy war.[23]

The two feline beasts flanking a tree in the first panel (fig. 89) seem not to be a heraldic textile design, since two different wild animals confront each other. Instead the Aquileian composition is more likely to be a moralizing contrast of diverse human natures.[24] W. von Blankenburg has demonstrated that similar compositions in Romanesque sculpture constitute zoomorphic variations on the *Psychomachia*.[25] One of his examples is a

capital in the church of Hamersleben depicting a lion confronting a dragon on either side of a tree. Bestiaries interpret the lion as a symbol of Christ, the dragon as Satan, and the tree as the salutary Tree of Life or the Church.[26] A similar interpretation may be proffered for the Aquileian curtain. Once again, in the bestiaries, we read that "Christ is the true Panther, who has freed us from the power of Satan."[27] The tiger, on the other hand, is associated with the malevolent forces of Satan lurking in the forests.[28]

The second panel depicts the battle for the soul in a more direct fashion through the personifications of Vices assembled around Pride (fig. 90). These hurtling figures are the descendants of the allegorical combatants first outlined by Prudentius in the fifth century and elaborated by later authors. In this case, rather than depicting the more usual one-on-one combat of Virtues and Vices, the composition focuses on the discord amongst the Vices themselves caused by the queen of Vices, Superbia.

The subsequent panel presents the classic theme of the dragon-slaying (fig. 93). Whether the horseman represents Saint George or another of the numerous exemplary knights, he clearly embodies the chivalric virtue of fortitude, the force of Christian Good.[29] The dragon, as we have already seen, was associated with Satan in bestiary tradition of the later Middle Ages.[30] Scriptural authority for this is found in Apocalypse 12:9, wherein Saint Michael slays "the great dragon . . . that old serpent, called the Devil, and Satan." Early church fathers ranging from Augustine to Bede reinforced this interpretation, and from their biblical exegesis it passed to hagiography and romance literature as a topos of malevolent forces threatening Christianity. With the importation of the cult of Saint George to the West in the eleventh century, the dragon-slayer became the model for the Christian knight and even a partipant in some accounts of the Crusades.[31]

Leaving aside the central panel of David, the last three panels would have been associated by contemporary viewers with Crusade and pilgrimage (figs. 97–101). The two phenomena were closely related. Crusaders were considered both "milites" and "per-egrini,"[32] and just as pilgrimage was traditionally promoted as a form of penance, so the Crusades came to be linked in the twelfth-century crusading literature with individual salvation.[33]

Bernard of Clairvaux was one of the most ardent promoters of the Crusades as spiritual warfare. In his letter of 1146 to the eastern Franks and the Bavarians, he wrote of the Crusade as a test and opportunity for the sinner to save his soul:

> But I say to you that the Lord is putting you to the test. He is looking down on the children of men to see if there be any that understand and seek him and grieve over his plight. For the Lord has pity on his people and is providing a saving remedy for the gravely fallen. . . . He does not desire your death, but that you should turn from your way and live, because this is his way of offering you a favorable opportunity not of destruction but of salvation.[34]

Likewise, Guibert de Nogent in his account of the Crusades states that "God has instituted a holy manner of warfare, so that knights and the common people . . . have found a new way of winning salvation."[35] Bernard further stresses the relationship between the

condition of a man's soul and the results of his terrestrial battles in a treatise dedicated to the crusading order of the Templars, *De laude novae militiae ad milites Templi*. He affirms that the "knight who puts the breastplate of faith on his soul in the same way as he puts a breastplate of iron on his body is truly intrepid and safe from everything. Undoubtedly defended by both kinds of armor, he fears neither demon nor man."[36] Later in the same treatise he observes that "it is not from the accident of war but from the disposition of the heart that either peril or victory is allotted to the Christian."[37] Thus the man who fights the good fight will be gloriously rewarded in victory or blessed as a martyr if he dies in battle. On the other hand, the man who kills another in response to the vices of pride or anger will suffer the death of his own soul.

The use of armed combat as a metaphor for *psychomachia* or spiritual warfare is also common in the *chansons de geste*. For example, in the *Pseudo-Turpin*, Charlemagne's conquest of Spain is likened to a battle between Virtues and Vices: "Just as Charles's warriors made ready their weapons before battle, so should we prepare our weapons, that is, our virtues before we undertake the battle against vice. . . . Just as Charles's knights died in war for faith, so ought we to 'die to vice' and live with holy virtues in the world that we may deserve the flourishing palm of triumph in the celestial kingdom."[38] In all these texts, it is clear that the struggle of the individual's soul is integrally connected with the universal struggle of the Christian church.

David, the enthroned musician charming the wild beasts, seems initially to be at odds with the theme of spiritual warfare. However, his roles as central harmony figure and model of virtuous conduct[39] become clear through analogous compositions in contemporary floor mosaics and psalter illustrations.

Floor mosaics exhibit close affinities with painted curtains in terms of their position within the pictorial hierarchy, their distinct technique—usually monochrome or of limited color range—and the scope of subject matter.[40] What is more, certain mosaic programs reveal a structure comparable to that of the Aquileian curtain. Just as David dominates the central axis of the curtain, so a cosmological harmony figure, Annus, occupies the focus around which are disposed the cycle of months and/or a loose collection of narrative images of combat and wild beasts,[41] in late-twelfth-century pavements from North Italy, such as those of Cremona and Aosta Cathedrals, and the abbey of San Savino in Piacenza.[42] Furthermore, the enthroned musician, David, is the central figure in at least three extant mosaic pavements and two others recorded in texts.[43] In the former choir pavement of Saint Gereon at Cologne, executed between 1151 and 1156, he appears as an Old Testament hero, the model king and warrior, flanked by combat narratives from his own life and that of Samson.[44] In the mosaic floor completed in 1109 for the abbey of Saint Bertin at Saint-Omer, David is depicted twice in portrait rondels as king and psalmist, framed by the twelve zodiac symbols.[45] Closest in conception to the Aquileia curtain is a third mosaic floor formerly in the choir of Santa Maria Maggiore in Vercelli.[46] Here, a two-register composition depicting David enthroned amidst musicians was combined with the Old Testament narrative of Judith slaying Holofernes, episodes of knightly combat, possibly derived from the *Chanson de Roland*, and combat in the animal world derived from

the fable of Renard the Fox. Amidst these images of strife, David embodies the concept of harmony, a theme which gains particular resonance from its location in the choir, where the singing of the daily office (including recitations from the Psalms) perpetually calls to mind the celestial harmonies.[47]

David's role within the context of the images of struggle and combat on the fictive curtain of Aquileia can be defined more precisely by analogy with certain illustrations from the psalter (fig. 158). The *Beatus* initial of the Saint Albans Psalter depicts what is a fairly common image of David as author of the Psalms.[48] Seated upon a throne, he plays his lyre with one hand while holding the text of his psalms in the other; the source of his inspiration is represented by the Dove of the Holy Spirit, singing into his ear. More novel in this context is the inclusion of two armed knights on horseback engaged in fierce combat in the upper border.[49] This is the earliest extant example of a series of *Beatus* miniatures containing knightly combat in the margins; the theme is particularly popular in thirteenth-century French manuscripts.[50]

The explanatory gloss on the margins of the Saint Albans miniature describes the knights in combat as an allegory of spiritual warfare.[51] Just as the two knights must arm themselves with swords, helmets, and shields, so the Christian must defend himself with the spiritual armor of virtue in the face of the pressures of sinful vices. According to the gloss, "We need every art which these two warriors provide for their bodies to set in order our spirits." David through his psalms is said to inform the faithful of the way to salvation;[52] the sound of his lyre is the voice of the Church, and his psalter signifies the wisdom of the prophets. Thus the "spirituales"—those who adhere to the monastic life—love the psalter and desire its divine doctrine.

The ideas expressed in the gloss are far from novel. Saint Paul, in his Epistle to the Ephesians, urges the faithful to "put on the whole armor of God, that (they) may be able to stand against the wiles of the devil" (6:11). He extends the metaphor to specify a series of spiritual weapons: the "shield of faith," the "helmet of salvation," and the "breastplate of righteousness." Otto Pächt has traced the specific application of spiritual warfare to the monastic vocation back to the Pseudo-Basilean text *Admonitio ad filium spiritualem*, but the theme's currency in early-twelfth-century exegesis is demonstrated by the *Similitudo militis* of the Pseudo-Anselm and the crusading sermons of Bernard of Clairvaux.[53]

The imagery of the curtain then, like that of the *Beatus* miniatures, furnishes an allegory of spiritual combat, a path to salvation. Furthermore, like the textual gloss on the margins of the main text, it serves as a pictorial gloss or commentary on the models of salvation provided in the upper part of the decoration by the martyrdom of the saints and the Passion of Christ.[54] Through his mission on earth, his death and triumph over death on the Cross, Christ establishes the promise of salvation. Hermagoras and Fortunatus, through their mission to the pagans and their martyrdoms, imitate Christ and are rewarded with the eternal salvation of their souls. They become at the same time intercessors and *exempla* for the local Church.

The curtain is an application of salvation history that sets a course of spiritual conduct for the viewer. David the Psalmist's central role in the curtain allegory parallels the position ascribed to him by contemporary twelfth-century exegetes such as Honorius Au-

gustodunensis: "There is no Holy Scripture except that written for the sons of God, for whom the mother Church opens all closed things through the key of David."[55]

Allegorical Veils: The Meaning of Fictive Curtains

Once it is established that the content of the fictive embroideries is meaningful, the question arises whether the medium itself is significant. In concluding this chapter, I will briefly explore how simulated textiles, like their real counterparts, transcend an ostensibly decorative function to define a distinctive mode for allegory within Romanesque painting.

There can be little doubt that the curtain genre of Romanesque painting originates in the decorative conventions of ancient Roman painting. Examples survive in painted decoration of houses and temples from the first-century B.C. at Pompeii and Brescia, in the marble revetment of the fourth-century Basilica of Junius Bassus in Rome, and after a hiatus of some three hundred years they appear again frequently in painted church programs in Rome and Central Italy during the eighth and ninth centuries.[56] Apart from the rondel of the Nativity on the socle in the presbytery of Santa Maria Antiqua, none of the numerous examples recently catalogued by John Osborne contains narrative scenes: the repertoire is largely confined to isolated birds, animals, and ornamental motifs.[57]

Osborne has observed that the early medieval church decoration in Rome did not merely revive a Roman convention for socle decoration; it also drew on the designs of actual embroidered textiles, recorded in the *Liber Pontificalis* as donations to various churches in Rome.[58] During the pontificates between Hadrian I (772–95) and Leo IV (847–55), hundreds of textiles were donated for use as altar hangings, sanctuary curtains, ciborium curtains, and hangings suspended between the columns of nave and presbytery.[59] Certain birds, beasts, and foliate designs mentioned in the *Liber Pontificalis* appear both on surviving textiles from the Eastern Mediterranean and their painted counterparts. The same source also inventories a broad range of narrative subjects including the *vitae* of titular saints of the churches, such as Peter, Paul, and Lawrence, as well as scenes from the Old and New Testaments, but no parallels can be found in extant painted curtains.

Although few Romanesque textiles survive, the allegorical function of the Aquileian curtain—if not the specific content— parallels that of actual textiles destined for display in churches.[60] The best-preserved example is a tapestry commissioned between 1186 and 1203 by Abbess Agnes of Quedlinburg as a gift for the pope. Fragments depict the concord between Church and State, represented by an enthroned monarch and bishop among personifications of the Virtues, and a complex Christian allegory based on episodes from the Marriage of Mercury and Philology by Martianus Capella.[61]

Our knowledge of the repertoire of religious allegory on tapestries is greatly expanded by literary sources.[62] Hermann de Lerbeke records a tapestry presented to the Cathedral of Minden in 1158 illustrating one of the Epistles of Saint Paul with "many axioms and proverbs of masters and poets magisterially worked into it," exhorting the viewer to "follow in the steps of the philosophers . . . to act rightly and shun vices. . . ."[63] At Liège, a local abbot composed a tapestry program with an allegory and harmonization of the two Testaments of the Bible.[64] Finally, the Renaissance chronicler Wilhelm Witt-

wer (1449–1512) provides a detailed record of Romanesque hangings in the abbey of Augsburg.[65] Amongst a series of Lenten embroideries commissioned and designed by Abbot Udalscalc (1126–49), Wittwer mentions one representing the transition from Old Testament to the New and another with eight panels devoted to the Crucifixion and Resurrection as well as to moralizations.

The content of these textiles is consonant with the allegorical interpretation proposed for the Aquileia socle paintings. The fact that the sources so frequently associate their display with the Lenten season highlights the function of *vela*—actual or fictive—as a medium for allegory, based on the exegesis of the *vela* in the Temple of Jerusalem. In this light, the curtain medium itself appears to work in concert with the allegorical content to invest the socle—previously relegated to a decorative role—with a new significance.

The root of the Christian tradition of allegorical veils or curtains is found in the Epistles of Saint Paul.[66] Commenting in II Corinthians 3:14 on the veiling of Moses' face after the second giving of the commandments (Exodus 34:33), Paul describes this covenant as a veil before the New Covenant established by Christ:

> Yes, to this day whenever Moses is read a veil lies over their (the Jews') minds; but when a man turns to the Lord the veil is removed. . . . And even if our gospel is veiled, it is veiled only to those who are perishing.

From this passage comes the idea of the Old Testament as an allegory for the New, whose true message is veiled or concealed from the Jews and revealed to the faithful in Christ. In his Epistle to the Hebrews, Paul discusses the same theme with respect to the actual veils or curtains which screened off the Holy of Holies from the people in the Temple of Jerusalem. According to the apostle, "We have confidence to enter the sanctuary by the blood of Jesus, by the new and living way which he opened for us through the curtain, that is, through his flesh . . ." (10:20). Here, the curtain of the Hebrew temple, veiling the place where God is made manifest to the priests, fulfills in Christian allegory the opposite function of revelation. It is through the veil of flesh in Christ that God has manifested himself to the faithful.

By the twelfth century, the veil or curtain was firmly embedded in the vocabulary of exegesis. It was discussed most frequently in commentaries on the curtains in the Temple described in Exodus. For the Italian commentator Bruno of Segni, the Temple *velum* is an allegory for the message of the gospels:

> This *velum* then, which preaches thus, admonishes thus, teaches thus, or persuades thus, is the preaching of the gospel. And whence, it is said to hang before the four columns, by which we understand the four evangelists. . . . Before them, then, hangs this *velum*, since by them it is embroidered [*pingitur*], by them variously related, by them preached, by them sustained and carried.[67]

In his *Gemma Animae*, Honorius Augustodunensis applies the curtain metaphor to actual curtains used in medieval churches during Lent:

> And because the mystery of Scripture at this time [of Lent] is veiled from us, therefore the velum is extended before our eyes in these days. And the priest and few others enter

behind the *velum*, because such mysteries of Scriptures are opened to few teachers. At Easter, the velum is lifted . . . because all things will be laid bare and open at the Resurrection, where the blessed will see the King, resplendent in his glory. . . . Indeed, rising from the dead, he has pulled away the curtain, and at the same time he has opened its sense so that they might know the Scriptures and he has revealed heaven to the believers.[68]

Writing a century later, William Durandus discusses the use of the Lenten veils in more concrete terms that seem particularly relevant to the position and meaning of the Aquileian fictive curtains. In Book I, speaking of the Lenten season as a time when "the understanding of the Holy Scriptures . . . was veiled, hidden, and obscure," Durandus records three veils corresponding to those of the Temple, all of which are pierced at the time of Christ's Passion to reveal the mystery of his death and resurrection.[69] The first appears around the altar, the second separates the sanctuary from the Clergy, and the third, the clergy from the laity. This third veil is of particular interest because it is linked specifically with a chancel enclosure and thence the fictive curtains encompassing the perimeter of a church:

> The third kind of veil originates from this, because in the early church, the *peribolus*, or wall which surrounds the choir, was raised only as high as the elevation of the sanctuary platform (*appodiationem*), (and this) may still be seen today in some churches. This was done so that the people, seeing the clergy singing Psalms, might follow their good example. But at this time, a veil or wall is suspended or interposed between the clergy and laity, so that they may not look at each other, as if to say: Avert your eyes, lest they behold vanity.[70]

This chancel enclosure may correspond to existing *scholae cantorum* at San Clemente and Santa Maria in Cosmedin in Rome, where low parapet walls delimit the choir without impeding the view of a standing congregation.[71] What is not clear is whether the Lenten curtains were simply hung over such chancel *plutei* or between intercolumniations of a proper templon. The latter alternative is easier to imagine for sanctuaries with a Byzantine-style templon, but the arrangement of the *schola cantorum* in the two Roman churches already mentioned supports the theory that curtains were actually hung at the lower level, corresponding to the position of the fictive curtains.

This disposition is envisaged in two illustrations of the Temple from the late-twelfth-century *Hortus Deliciarum* (fig. 155).[72] Here, the central *velum* appears at socle level, suspended from rods by rings in undulating folds much like the painted curtain of Aquileia. The perspective of this miniature allows us to see the curtain both as a symbolic barrier and as a form of revelation. In accordance with Paul's exegesis, the Christian viewer—unlike Moses who was veiled when he received the law—sees the Almighty in a vision amidst the cherubim over the ark of the covenant. The image of the curtained Temple thus becomes the prototype for the Christian sanctuary, in which God is revealed through the eucharistic image of Christ.[73]

The Aquileian fictive *velum* seems to have performed this symbolic role, both defining the perimeter of the crypt as a sanctuary in the image of the Temple and serving as an appropriate medium for its message. Its allegorical function may also have been inten-

tionally underlined by the execution of the figural imagery in the red ocher preparatory drawings used in the upper zones of the crypt program.[74] Their contrast with the highly finished paintings of the upper zones evokes the pictorial metaphor first adduced by Saint Paul to affirm the allegorical function of the Old Testament with respect to the New. In Hebrews 10:1, he contrasts the Old Testament law as a shadow (*umbra*) of things to come with the true image (*imago*) of things in the New Testament.[75] In his commentary on Hebrews, Alcuin makes the pictorial metaphor more explicit, affirming that the Old Testament is not truth itself, but merely the shadowy outlines (*lineamenta*) of the image of truth, painted in with colors in the New Testament.[76] Similarly, a later medieval commentator on Hebrews, Walfrid Strabo of Fulda, affirms that the Old Testament is not the true image (*imago*), but only the preparatory drawing (*substratio*) prior to the application of the colors.[77] Finally, in the twelfth century, William of Tyre applies the same metaphor more generally to the process of history writing: he affirms that he was like an unskilled painter who could prepare only the underdrawings (*lineamenta*) for wiser hands who would complete the beauty of the work by adding the nobler colors.[78]

Applying the exegetical metaphors of the veil and the underdrawing to the Aquileian crypt, it is possible to integrate the iconography of the socle zone into the program of sacred imagery above it. Instead of representing autonomous expressions of artistic freedom, the discrete *exempla* of *Psychomachia* function as allegorical veils that reveal in the imperfect sketches of terrestrial struggle the essential promise of redemption offered above them by the full-color images of Christ's Passion, the *Compassio* of the Virgin, the martyrdoms of the local saints, and the hierarchy of saints of the universal church.

CHAPTER EIGHT

Ornament as Decoration, Frame, and Bearer of Meaning

ONCE IT IS accepted that an ostensibly decorative convention like the fictive curtain reinforces the allegorical message of the socle zone, then we are prompted to question the contribution of the entire ornamental repertoire to the meaning of the crypt. In dealing with ornament, both as a general topic and within the particular field of Romanesque painting, there is a tendency simply to catalogue motifs and their sources or to treat it as a "merely" decorative element for which no interpretation is necessary.[1]

A decorative sense is certainly enhanced by the ways in which the ornament is displayed in the crypt. While many of the individual ornamental motifs are inspired by Roman and Byzantine exemplars, the application of ornament to fill all available surfaces of vaults and walls between figural scenes is thoroughly Romanesque in spirit. A primary motivation for this proliferation of ornament undoubtedly lies in the complexity of the architectural structure and the need to fill awkward corners around regularized figural panels.[2] This *horror vacui* is symptomatic of Romanesque programs set in vaulted spaces such as the crypt of Anagni and the Panteón de Los Reyes at León.[3] Also in keeping with this decorative mentality is the extension of ornament to structural members: the garish marbling of columns and the painting of the low-relief capitals.[4]

To be sure, ornament serves to embellish the crypt,[5] enhancing the value and visual attraction of the ensemble and the prized relics.[6] But ornament may also contribute to the meaning generated by the function of the space and its iconographic program. Beyond its decorative function, ornament in the crypt of Aquileia serves as an organizing frame for the narrative and iconic figural imagery, as a form of antiquarian quotation, and as a symbol of the principles of death and regeneration embodied in all medieval funerary spaces.

Ornament as Decoration and Organizing Principle

The decorative function of the ornament is clear from the sheer variety of motifs and by their display on every surface surrounding the figural panels (pls. I, VIII; figs. 4, 17). The greatest concentration of ornament is on the ceiling and its supporting spandrels. Simple geometric step and cross patterns enrich the red borders of the iconic panels featuring Christ and the saints in the central aisle vault, distinguishing them from the single figures of apostles in the spandrels below. In the side aisle vaults, more elaborate forms—including rinceaux, rosettes, volutes and acanthus—are framed as independent panels by gold borders and white pearl friezes (pl. II; fig. 4). These framed ornaments, which resemble the headpieces of manuscript pages, separate the narrative panels of the saint's life in

the right aisle. They disappear from later parts of the narrative, perhaps because of poor planning. There may be a less mundane reason, though: these panels of rich ornament draw attention to episodes that are crucial to Aquileia's jurisdictional claims: the Election of Hermagoras as first bishop of Aquileia and his Consecration by Saint Peter in Rome.[7]

A simplified scallop-shell motif fills the upper and lower frame for four additional narrative panels of the ceiling: the Reception of Hermagoras at Aquileia (fig. 17); the Trial of Hermagoras and Fortunatus (fig. 68); the Torture/Crucifixion of Hermagoras (fig. 72), and the Conversion and Baptism of Pontianus (fig. 75). In this case, because the scenes do not form part of a continuous barrel vault but are fitted on the segments of vault within the intercolumniations, the framing motifs serve less to arrest the beholder's eye at a significant point in the narrative than to fill awkward spaces between the curving groins of the vault and the square borders of the narrative.

A distinctive architectural form of ornament is used to frame the martyrs, bishops, and deacons of the side aisles (pl. I, figs. 4, 46, 47, 49, 52). Brightly colored, inlaid vine scrolls decorate golden, ogee-arched baldachins over the heads of these saints. Reminiscent of actual sculptural frames for Byzantine mural icons such as that of Saint Panteleimon at Nerezi (1164),[8] this device may be intended to mark the local saints of the diocese and to link across the aisle figures that were closely associated with one another as in the case of Saints Hilary and Tatian (figs. 47, 52).

The remaining ornament in the upper zone comprises primarily vegetal motifs designed to fill the awkward interstices between the oblong frames of the figural panels and the curving borders of the vaults where they meet the supporting spandrels and hemicycle wall. Two palm trees, entwined with grape vines flank the central lunette (fig. 58). In the two adjacent bays to the left appear pairs of stylized trees with broad leaf-shaped clusters of branches paired about a twisting trunk (figs. 83, 84). On the opposite side of the hemicycle, vine scrolls wrapped around a central stock inhabited by blue birds are combined with acanthus (figs. 86, 87). Finally, in the southernmost terminal of the hemicycle, a fragment of a more complex composition survives, comprising acanthus leaves, volutes, a rosette, and a double-handled vase from which more foliage emerges (fig. 156).

The ornamentation of the walls and supports in the crypt falls into three categories: individually framed decorative panels with foliate designs comparable to those in the ceiling, a continuous horizontal frieze, and a series of simulated precious materials. To the first category belong two panels of luxuriant foliage on the jambs of the door which cuts the lower right corner of the Deposition (fig. 157). The panel to the left is an elegant candelabra-like arrangement of acanthus and vines in a symmetrical design. The right jamb of the same door is filled with a vine scroll, inhabited with birds eating grapes (fig. 158). A third panel of this type fills the space beneath the window separating the Conversion and Baptism of Athaulf by Saint Mark in the central bay (fig. 58). Here, two peacocks flank a basket filled with fruit, from which vines and branches laden with fruit stem.

One constant element that binds the entire perimeter of the crypt is the horizontal frieze running between socle and lunettes (pl. I; figs. 86, 159). This classicizing architectural ornament comprises a repeating pattern of bearded heads linked by acanthus swags and alternating with poppies and plants resembling daisies or sunflowers. This frieze per-

forms a crucial architectonic function, marking the boundary between two distinct elements of the iconographic and pictorial hierarchy: the feast scenes in the lunettes, set illusionistically behind the picture plane, and the allegorical images of the socle, rendered as fictive embroidered textiles projected in front of the wall surface.

Finally, the supporting zones are rendered to simulate precious materials—textiles and marbles (pl. I). Although most of the free-standing columns have been denuded of their plaster and painted decoration, all of the free-standing and engaged columns were once decorated with simulated marbles. A pattern of wavy red and white lines is best preserved on the engaged column to the left of the Deposition. In addition, the capitals were decorated with a stylized Corinthian design; even the carved capitals of the free-standing columns were plastered over and painted with fictive carvings, presumably to harmonize the Carolingian spolia with the impost capitals of the hemicycle wall. Similarly, fictive columns, distinguished as a form of dark blue stone speckled with red, are imposed upon the plain piers which mark the termini of the hemicycle wall to blend with the real semicolumns.

The socle zone too is a form of simulated precious material. While the main part of the crypt is consistently draped with fictive textiles embroidered with figural designs, the entrance bays are distinguished by the application of simulated veined marbles in the same zone. Given the association of the curtain with the sanctuary of the Temple, the absence of "veils" in the socle of the entrance bays may distinguish between the utilitarian function of passageways and the sanctity of the sanctuary containing the relics. Ornament in the socle zone that emphasizes functional distinctions is found earlier in the ninth-century tower chapel at Torba near Castelseprio in Lombardy. In this case, fictive curtains define a sanctuary space around the altar, while the remaining socle zone in the "nave" space was decorated with imitation marbles.[9]

Sources and Meaning

The repertoire of motifs suggests to a great extent the same artistic provenance as the style of the figural imagery. Many of the motifs, though ultimately Byzantine or antique in origin, have more immediate prototypes in the decoration of San Marco in Venice and other churches of the Upper Adriatic region.[10]

The refined rinceaux panel on the left jamb of the door cut into the Deposition lunette is paralleled in the spandrel zone of the Emmanuel cupola of San Marco and on the intrados of the north central apse in the Cathedral of Trieste.[11] The Byzantinizing tree types in the arches framing the lunettes of the Dormition and the Crucifixion—slender twisting trunks, a series of truncated branches, and a flourishing tri- or bilobate top—probably made their way to Aquileia via the Ascension Workshop of San Marco.[12]

The panel of alternating rosettes and heart-shaped tendrils (fig. 60) separating the Consecration and Election of Hermagoras in the south aisle vault corresponds in its general scheme to the soffit of a window in the Ascension cupola of San Marco.[13] A precise parallel for the multicolored petals of the rosettes is found in the upper border of the Ascension fresco in the Baptistery (fig. 120), a painting close in style to those of Aquileia.

The border between the Consecration of Hermagoras and Hermagoras Ordaining Priests also appears to be derived from manuscript illumination (fig. 62). The repeating series of acanthus leaves shaped in diamonds around a central knob with birds and pairs of leaves between them belongs to the same genre of geometric foliage pattern found in San Marco on the jambs of the window between the peoples of Pontus and Cappadocia and the window below the orant John the Evangelist in the north dome.[14] Variations of the geometric border of trapezoids inscribed in circles below Christ enthroned in the crypt (fig. 17) can be found in the window jambs of the eastern cupola at San Marco.[15] Another geometric ornament, the multicolored step pattern, which marks out the panels of the central aisle of the crypt (pl. VII; figs. 5, 17), seems derived from manuscript illumination, although it too is common in Byzantine church decoration and appears in San Marco at the base of the Ascension dome.[16]

The scallop shell, which appears above the window in the central lunette (fig. 58) and frames certain narrative scenes (fig. 75), is used in a repeating pattern as part of a decorative medallion at the apex of the north transept vault in San Marco.[17] As Kugler points out, the original function of the motif as an honorific canopy in antique and early medieval art has been lost in the later examples and its shape has been simplified to transform it into multicolored decorative motifs, more in keeping with Romanesque taste.[18]

Kugler has rightly emphasized that many motifs originate in antique models such as sculptural reliefs at Aquileia itself.[19] The distinguished mask frieze (fig. 159) running between the socle and the lunette panels relates closely to three sets of Roman reliefs preserved in medieval churches in Rome—in the Chapel of the Sacrament at Santa Prassede, in the cloister of the Santi Quattro Coronati, and in the apse of Santi Nereo e Achille— and the fragment of an architrave, possibly from a sepulchral monument, now in the Lapidary of the Temple of Roma and Augustus in Pola (fig. 160).[20] This last example, which corresponds best in individual details such as the flowers, is of particular importance because it comes from the Aquileia region. Likewise, the decoration of one of the spandrels comprising a delicate pattern of foliage and an amphora with volute handles (fig. 157) has its prototype in regional antique sculpture: one related relief is preserved in the Concordia Museum and two others stand at the entrance to an Early Christian mausoleum behind the Basilica Apostolorum there.[21]

Two further motifs may be cited that belong specifically to the Early Christian repertoire: the palm trees flanking the central lunette and the peacocks flanking a basket of grapes in the panel beneath the window of the central lunette (fig. 58). Palm trees are associated with the victory of martyrs in Early Christian art.[22] Peacocks flanking a fruit basket appear in a fourth-century tomb painting at Nicaea, in contemporary Roman catacombs, and on fifth- to sixth-century sarcophagi at Ravenna.[23]

Aquileia's debt to contemporary Byzantine and Veneto-Byzantine style and iconography is paralleled to a certain extent in the realm of ornament. While the individual borders already described in connection with San Marco can be found in Byzantine manuscripts throughout the eleventh and twelfth centuries,[24] the delicate rinceaux-filled arcades framing the saints of the side aisles seem characteristically late Comnenian (pl. I; fig. 47). The single images of saints under foliate arcades can be found in the painted arches

over the prothesis and diaconicon niches in the church of Saint George at Kurbinovo and in the painted frames of the prophets in the dome of Saint George at Staraya Ladoga.[25] The particular pattern of the Aquileia rinceaux—executed in white against a gold background with enamel-like nodes of bright colors, and organized into a strict geometric pattern—is closest to such late Comnenian examples as the Episkopi at Mesa Mani in the Peloponnesus and the Evangelistria at Geraki.[26]

The catholic appropriation of Byzantine, Veneto-Byzantine, Early Christian, and late antique models is in keeping with the general character of ornament in Italian Romanesque mural painting. The large number of Byzantine motifs is probably due to the formation of the workshop in Veneto-Byzantine culture. Here, as in the case of style and iconography, the Aquileian painters may simply have tried to imitate the more prestigious medium of mosaic represented in the most important church of the region, San Marco in Venice.

The concentration of specific late antique and Early Christian motifs, on the other hand, suggests self-conscious antiquarianism. The frieze of bearded heads and foliage, the elegant rinceaux on door jambs and soffits of arches seem to evoke models from architectural sculpture accessible in the ruins of ancient Aquileia and other nearby cities (figs. 159, 160). Some models may even have been funerary monuments of which the inscription panels were reused in the floor and column shafts of the crypt. Part of the appeal of this ornament, then, was its evocation of Aquileia's great Roman past, and more specifically, the apostolic era in which the Church of Aquileia was instituted.[27]

More precise in meaning are the ornamental panels of the central bay of the hemicycle (fig. 58). Both the paired palm trees and the peacocks flanking the fruit basket are paradisiacal themes commonly associated with resurrection in Early Christian funerary art. Moreover, palm trees are specifically associated with the victory of martyrs over death and their reception into Paradise.[28] It is hardly fortuitous that these elements appear in the central bay at the beginning and conclusion of the narrative of the local martyrs, close to the image of their apotheosis in the central vault. Furthermore, these motifs frame the Healing and Baptism of Athaulf, the crucial episodes marking the death of pagan Aquileia and the birth of its Christian Church under Mark. The universal message of baptism as a symbol of death and resurrection is thus reinforced by the ornamental frame.

More than mere decoration, then, ornament enhances the essential themes of the program which stem from the crypt's function as reliquary of its founding bishop, Saint Hermagoras, and his deacon and comartyr, Fortunatus. The ubiquitous vegetal imagery not only suggests the promise of resurrection and renewal at the burial site of the city's martyrs; it also proclaims the ecclesiastical renewal of the patriarchate, ushered in by the Peace of Venice and Aquileia's subsequent agreements with papacy and empire.[29] In adopting Veneto-Byzantine and ancient sources for individual motifs, the crypt displays a dual purpose: to emulate the grandeur of mosaic decoration embodied in San Marco, the seat of Aquileia's Venetian rivals, and to underscore the roots of the patriarchate's own authority in its Roman past.

CONCLUSION

IT IS A GREAT paradox of medieval Christianity that the powers ascribed to the dead saint by far outstripped those of the living. Ever present through his relics and images, the saint became a vehicle of supernatural power, transcending distinctions of time and space. Focusing on the crypt of Aquileia Cathedral, I have argued that architecture and mural painting complemented the relics of the founding bishop to proclaim his authority in the prayer and politics of his native city.

Documentary and archaeological evidence indicate that the first crypt was constructed at the beginning of the ninth century, shortly after the Carolingians captured North Italy from the Lombards and promoted Aquileia's claims to the patriarchal title of Venetia and Istria. It was reconstructed in its present form (with the exception of external revetments) under Patriarch Poppo at the beginning of the eleventh century to celebrate the repatriation of the relics from the rival See of Grado and the momentary subjection of the Venetian Church to Aquileia's patriarchal jurisdiction.

The architecture highlighted the saint's presence by raising the emplacement of his relics above the nave on axis with the high altar. More than a mere tomb site, the space of the crypt facilitated continuous contact with the saint through the pilgrimage to his relics and regular masses at the altars there. This constant use of the crypt activated the powers of relics and images.

The current program of decoration was probably executed for Patriarch Ulrich II (1161–82) shortly after his diplomatic successes during the reunion of Pope Alexander III and Emperor Frederick Barbarossa at Venice in 1177. Evoking in their overall style and iconographic models the prestige of Veneto-Byzantine mosaics in the late Comnenian style, the mural paintings were a pictorial response to the claims made in the mosaics of San Marco in Venice. At the same time, each of the four main elements of the Aquileian program was designed in a distinct stylistic mode to distinguish functions of images as intercessory icons, documentary narratives, devotional narratives, and allegory.

The iconic hierarchy of saints reinforces the continuing presence of the patron saints through their relics, promising intercession both in the present and at the end of time before the enthroned Judge (figs. 5, 17, 23). Its presentation conforms to conventional hierarchies of liturgical prayer. The founding bishop flanked by his deacons is prominently displayed in the vault over the central aisle with arms outstretched in prayer to highlight his intercession in each mass celebrated at the altar beneath. His insertion amongst the ranks of the apostles and later bishops and martyrs of the local church also underlines the continuous chain of authority embodied in the apostolic succession from Hermagoras to the reigning patriarch.

While the hierarchy of saints emphasizes the founding bishop's role on the vertical axis of time and space, intervening between the terrestrial present and the heavenly Judg-

ment at the end of time, the surrounding narrative relates his terrestrial time-bound existence (figs. 17, 57–82). Here the connection between the relics and the origins of the local Church is explicitly documented in a dense, booklike narrative of Hermagoras's mission and *Passio* with his deacon, Fortunatus. The political function of the crypt as memorial of Aquileia's founding bishop and proof of its apostolic succession clearly emerges from the particular selection and disposition of episodes in the early part of the *Passio*. The apostolic foundation of the see, the essential proof of its claim to the suprametropolitan dignity of a patriarchate, is prominently displayed on the central axis of the crypt, where the Commission of Mark by Peter and the Healing and Baptism of the first convert at Aquileia interrupt the Christological narrative (fig. 58). The subsequent establishment of the episcopate and its suprametropolitan authority under Hermagoras is documented with legal precision in the scenes of the right aisle, including the election of Hermagoras, his journey to Rome to receive the pallium and be consecrated by Peter, his return to Aquileia to be received by the people and clergy, and his later commission of bishops to found neighboring churches in the Upper Adriatic (figs. 59–66). The remainder of the cycle, by contrast, conforms to the more widespread imagery of the trials, tortures, miracles, martyrdoms, and translations (figs. 68–82). Through these scenes, Aquileia is established as the preeminent *locus sanctus* of Venetia, the permanent resting place of the founding bishop of the regional Church.

The feast cycle, which boasts the most prominent display surfaces in the lunettes of the hemicycle wall, reinforces the theme of martyrdom in a typological way (figs. 83–87). All four scenes focus on physical death, the first depicting the Dormition and Assumption of the Virgin, and the remaining lunettes, the death and entombment of Christ. The juxtaposition of Christ's Passion with the *Passio* of the local patron saints reflects the ancient theme of *imitatio Christi*, reinforced by the very rites of consecration with which the deposition of relics is intimately associated. The Dormition is included in part because Mary was the primary patron of the cathedral, but it also points to a new theme, the *Compassio* of the Virgin. Her own physical death is anticipated by her spiritual martyrdom—her suffering at the base of the cross, her bearing the burden of her son's dead body at the Deposition and Threnos. She thus becomes a model for imitation by the saints in their own struggle to imitate Christ. On another level, these "icons in space" are vehicles for meditation, allowing the medieval spectator to experience the suffering of Christ vicariously through the Virgin.

The fictive curtain, placed at the lower margin of the decorative program, provides an allegorical gloss on the theme of spiritual combat already present in the sacred narratives of the Passion and *Passio* of the saints (pl. I; figs. 88–101). Here images of Virtues battling Vices, Crusaders and Saracens, military saints and beasts provide concrete examples for the continuing struggle to perfect life on earth through prayer and meditation. The mode of outline drawings suggests the state of incompleteness or imperfection embodied in this terrestrial conflict. The medium of the curtain—a potent metaphor for revelation and concealment—reinforces the allegorical message of the drawings.

Even the ornamental repertoire plays a role in shaping the meaning of the overall program. Beyond its primary decorative function, it articulates the walls and vaults into

different iconographic zones. In the choice of marbles for the socle in the entrance bays and curtains for the socle of the main hall of the crypt, it distinguishes utilitarian space from the sanctuary of the relics. Specific motifs such as the palm trees, the peacocks flanking the basket of fruit in the central bay, and the mask frieze reinforce the sepulchral function of the crypt. Finally, the persistent recourse to models from late antique and Early Christian art celebrates the ancient roots of Aquileia's ecclesio-political power in the apostolic era.

APART FROM their local significance within the artistic, religious and political life of medieval Venetia, the Romanesque murals in the crypt of of Aquileia Cathedral have broader implications for our understanding of the spiritual and propagandistic functions of medieval pictorial narrative.

On a purely spiritual level, I have suggested that the *Compassio* theme of the feast cycle presented the Virgin as model for the spectator's own inward experience of and belief in the reality of Christ's Passion—a pictorial equivalent to contemporary meditation literature. Similarly, I argued that the hagiographic and allegorical narratives could be construed as *exempla* for the behavior of the contemporary spectator.

The eleventh-century English biographer Goscelin confirms this affective power of mural painting in his *Vita S. Edithae* when he records that Edith had the monk Benno of Trier paint all the walls of her church at Wilton with the Passion of Christ "so that what the images demonstrated would be depicted in her heart."[1]

While Paulinus of Nola (353/4–431) had already articulated the view that murals in churches could have an impact on the moral behavior of its viewers,[2] more influential in the later Middle Ages were the two letters of Gregory the Great to the iconoclastic Bishop Serenus of Marseilles. In the second letter the Pope asserted that "a picture offers to the ignorant who look at it . . . what they ought to follow."[3] Gregory's proclamations, which were originally conceived "as clever gambits in a sophisticated strategy to convert barbarian Gaul,"[4] were still current in the period of Aquileia's Romanesque narratives. The artist of the Saint Albans Psalter, for example, prefaced his miniatures of the Life of Christ with a paraphrase of Gregory's second letter: "For it is one thing to venerate a picture and another to learn the story it depicts, which is to be venerated. The picture is for simple men what writing is for those who can read, for those who cannot read see and learn from the picture the model they should follow."[5]

A more political aspect of medieval narrative is suggested by the hagiographic cycle at Aquileia, where local history is cast in the mold of contemporary institutional politics. Marcia Kupfer defines a comparable "politics of narrative" in her interpretation of Romanesque painting in central France.[6] Sacred histories from the Bible or the lives of the saints, she argues, are selected and rearranged to reflect current values and issues of the local community to whom the program is addressed.

This power of Romanesque painting as a form of political argument or propaganda is again corroborated by medieval writers. Particularly noteworthy is a late-twelfth-century account of a celebrated painting of Emperor Lothar III as suppliant before Innocent II.[7] In his paraphrase of the Deeds of Frederick Barbarossa, Gunther of Pairis complains that

the wall painting in the Lateran Palace was the work of a lying painter, and was being used together with written documents by the contemporary pope, Hadrian IV, to promote certain papal prerogatives over the imperial office. He urged that both the offensive text and the image be removed.

Whether they were designed primarily to guide the spectator's spiritual life through sacred models or to project a particular political argument onto history, what gave medieval pictorial narratives their enduring power was the authority ascribed to the sense of sight. As Karl Morrison has emphasized, history writers of the twelfth century, like their ancient forebears, conceived themselves as painters; their goal was to "renew past events through a narrative so knowing and vividly representational that readers could see them before their very eyes."[8]

Such was the authority of pictorial narrative that Peter Comestor (d. 1178) used wall paintings as evidence in theological arguments about the Gospel narratives.[9] Concerning the inclusion of the ox and ass at the Nativity, he argued that although they are not mentioned in the Gospels, some authority for their presence could be found "in pictures in churches, which are as the books of the laity."[10] Likewise, in discussing the question of the nature of Christ's body during the Transfiguration, he observed that depictions of the Transfiguration in wall paintings of churches support the position that the splendor witnessed by the disciples emanated not from the Lord's body but in the air surrounding him.[11]

The role of pictures in authenticating the lives of the saints may be demonstrated by two texts of the Romanesque period. In his *Epistola de apostolatu Sancti Martialis*, Adhémar de Chabannes (d.1034) cites pictures as proof that Saint Martial, the founding bishop of Limoges, was a disciple of Christ. Adhémar recounts how he convinced a doubter by showing him "faded pictures of great antiquity. . . . Seeing Martial ministering to the Lord at the Last Supper, and other pictures, as one reads in his *Vita*, he (the doubter) . . . confessed his sin."[12]

The second example comes from Venice itself and concerns a Venetian addendum to the hagiographic legend that originated in Aquileia. In his account of the Translation of Saint Mark's relics to Venice, the thirteenth-century chronicler Martino da Canal cites the mosaics on the facade of the church both to confirm the veracity of his narrative and to justify the basilica's continual embellishment. "And if any one of you wishes to verify that events transpired as I have recounted them to you, come and see the beautiful church of San Marco at Venice and look at the front of the beautiful church, because this story is recorded there just as I have recounted it. . . ."[13]

The power of the pictorial narratives in the crypt of Aquileia Cathedral and the relics whose presence they manifest is still palpable at the end of the second millennium. This local tradition endures despite the long decline of the Aquileian patriarchate between 1521 and 1915 when the city formed part of the Holy Roman Empire. Already mutilated in the fifteenth century by the construction of the treasury, the murals were neglected to the extent that in 1724, Giandomenico Bertoli, the noted antiquarian, was incapable of discerning the crucial episodes of local history.[14] Moreover, the crypt was deprived of its very raison d'être after the patriarchal title was suppressed in July 1751 and when the relics of Saints Hermagoras and Fortunatus were removed to Gorizia a year later.

The revival of Aquileia's medieval past began after Italian troops took the city from the Austrians in 1915. In a climate of growing nationalism during the 1920s and 1930s, Pietro Toesca and Antonio Morassi provided the first systematic studies of the crypt and its murals, including the earliest photographic documentation. More importantly, the relics, which give the entire program its meaning, were returned to the crypt on the Feast of Saint Mark the Evangelist in 1968.[15] Finally, within the last decade, Pope John Paul II has appointed a titular bishop of Aquileia. Although the former "basilica patriarcale" remains a parish church and the episcopal title is honorific, the pope's restoration of a ceremonial head of the ancient see vindicates in part the argument which the pictorial narrative of the crypt was designed to sustain eight centuries ago.

APPENDIX I

Iconographic Catalogue

THIS CATALOGUE, keyed to the schematic plan (fig. 1), briefly describes each figural panel, its condition, iconography, and inscriptions. The hagiographic section also includes excerpts from the *Passio* of Saints Hermagoras and Fortunatus.

I. Entrance Chambers (fig. 16)

The two entrance chambers, from which one descends to the crypt at the west end, contain fragments of decoration contemporary with the second layer in the main body of the crypt.[1] In both chambers, the walls are delineated into lunette panels and dados by means of the red borders used throughout the crypt, but here the mask frieze is omitted.

On the south wall of the south chamber, the right arm and shoulder survive from an orant figure standing in the center of the lunette; the dado is decorated with a simple pattern of vertical parallel lines. The east wall is broken in the lunette zone by a large square window which appears to be modern (fig. 16). To the right of the window, there is a prostrate male figure, leaning on one elbow and with head turned upward; the tail end of two lines of inscription appear directly above the man's head: ". . . R(?)DIA" in the upper line and ". . . D(?)IA" in the lower line. An extremely vague fragment higher up seems to indicate the presence of another figure, standing above the first one. A wavy marble pattern decorates the left half of the dado; a herring bone pattern with a central post occupies the right half.[2]

Enough survives of the lunette to suggest a tentative identification. The standing figure who tramples a prostrate one underfoot recalls a long-standing convention used for personifications of Virtues triumphing over Vices. The recumbent figure of one the Vices in the dado of the *sacellum* at Summaga (fig. 113) provides a striking parallel.

The fragmentary inscription suggests that the pair of figures should be labeled Concordia and Discordia.[3] The same pair is represented on the early-twelfth-century ivory book cover of the Melisenda Psalter in the British Museum.[4]

Much less survives from the north entrance chamber. Of the eastern lunette, only fragments of the left and lower red border survive. On the north wall, fragments of the socle display illusionistic marble patterns similar to those found at the south entrance.

II. Intercessory Hierarchy

Christ, Angels, the Virgin, and Patron Saints

I1. Christ enthroned between two angels (fig. 18)

This panel is badly damaged. The insertion of the iron fence in the fifteenth century cut a horizontal swath across the middle of the panel, and the head of Christ was removed at an uncertain time. A fragment now on display at the back of the crypt has been identified as the missing head, but its dimensions do not correspond, and its style belongs to the Trecento.

Christ is seated frontally on a high-backed throne with turned legs and diaper-patterned upholstery. He holds a book on his left knee and raises his right hand in benediction. Two archangels turn in toward Christ from the flanks. Each is dressed in the imperial loros and holds a staff, or labarum, in one hand, while extending the other in intercession.

The full-length Pantocrator seated on a high-backed throne belongs to a Middle Byzantine type found in coinage beginning with Basil I (869–79) and in apse and cupola compositions.[5] Examples of this so-called Angel-Deesis are legion in Byzantine ivory triptychs, where they stand at the head of "carved litanies" designed for private devotion.[6]

IA. Busts of angels (figs. 19–21)

Complementing the "Angel Deesis" of the central aisle are five bust-length angels within medallions on the soffits of arches that frame five of the seven lunettes on the hemicycle wall. While only faint outlines of the circular clipeus are visible for the two busts above the westernmost lunettes, those over the Koimesis, Deposition, and Threnos are intact. All of the angel busts are set against a celestial blue background within a broad clipeus. Although they follow a common youthful and slightly feminine facial type, sporting long hair adorned with a jeweled diadem, each angel exhibits a different variation in costume and attributes. The angel above the Dormition (fig. 19) wears a green toga with gold-embroidered decoration over neck and shoulders and a red toga draped over his left shoulder. He rests his empty left hand on the base of the clipeus, while extending the right in intercession. The angel over the Deposition (fig. 20) is more richly attired in the imperial loros. Like the previous angel, he intercedes with his right hand, but in his left he holds an orb. Finally, the third intact angel (fig. 21) wears a gold-embroidered tunic and toga like the first but holds a jeweled scepter in his right hand and an orb in his left.

Entirely Byzantine in conception, these angel busts find close parallels in iconography and disposition in Middle Byzantine programs such as those of St. Hierotheos at Megara in the central dome, the Nea Moni at Chios, and Cappadocian cave churches.[7]

I2. The Virgin and Child enthroned amidst the Four Evangelists (fig. 22)

Clad in a maroon chiton and maphorion, the Virgin sits frontally on a jewel-studded, lyre-backed throne. Following the Byzantine *Hodegetria* type, she holds Christ in her lap with her left arm while raising her right hand in a gesture of intercession. The Christ child, fully frontal like his mother, holds a scroll in his left hand and raises his right in benediction.

The throne is set within a multicolored aureole of light. The deep blue pigment of its interior has all but been lost, but the tricolored (olive green, pink, and maroon) star-spangled frame is intact. The evangelist symbols, set against a dark green ground, occupy the four corners of the panel. Each bust-length winged beast holds a gospel book and is inscribed with the name of the gospel writer: the eagle, "s. IOH(ANNES)" in the upper left; the angel, "(s. MA)THEVS" in the upper right; the bull, "s. LVCAS" in the lower right; and finally, the lion, "s. MARCVS" in the lower left.[8]

This rare image, which ascribes to the Madonna and Child the lyre-backed throne type, the aureole, and four evangelist symbols normally reserved for the *Maiestas Domini*, was popular within the patriarchate of Aquileia. It appears in the apse of the upper church (fig. 14) and is later taken up in the early-thirteenth-century decoration of the central apse of Summaga Abbey, an Aquileian dependency.[9]

The origins of this composition may be traced in early Christian apse compositions.[10] The core of the Aquileian composition—the *Theotokos* seated on a lyre-backed throne within a mandorla—appears as early as a sixth-century apse mosaic in the Panagia Kanakaria at Lythrankomi, on the island of Cyprus.[11] Both the throne and aureole seem to have been transferred from the *Maiestas Domini* to the Virgin in honor of her role in the Incarnation. Anthony Cutler sees

the lyre-backed throne as originally signifying the role of Christ incarnate as a harmonizing figure.[12] Grabar explains the innovation of the mandorla as an expression of Christ's divinity from the moment of his birth; in this way, the iconography of Christ's first epiphany is assimilated with the theophanies of Old Testament prophecies, the revelation of John, and the Transfiguration.[13]

A different source for the composition as a whole is found in a miniature from a tenth-century Byzantine gospel book in the Biblioteca Comunale of Brescia.[14] On folio 2 recto, the bust-length Madonna and Child appear within a clipeus, framed by four smaller medallions containing the four evangelist symbols. Robert Nelson sees this merely as a variation of the *Maiestas Domini* which so frequently serves as the preface illustration to the gospel text in Byzantine manuscripts from the tenth century.[15] However, as George Galavaris has observed, the substitution of the Virgin and Child for the usual enthroned Christ alludes to the Virgin's role in the Incarnation, a theme emphasized in the prefatory text attributed to Epiphanios. This image bridges the gap between the earlier Byzantine apse mosaic from Cyprus, in which the Virgin and Child are contained in a mandorla without the evangelist symbols, and the fully developed *Maiestas* images first found in the West in the eleventh-century apse of Aquileia.

I3. Hermagoras orant with Fortunatus and Cyrus (pl. VII; fig. 23)

This three-figure composition is set on a green ground with a blue field within it representing the atmosphere. Hermagoras, inscribed "HERMACHORAS," stands frontally on a jeweled *suppedaneum* at center with his arms extended in the orant gesture. He is portrayed as a mature man with gray hair and beard and is fully vested in archiepiscopal attire, including the metropolitan pallium, an elaborately embroidered cope and dalmatic, as well as an alb with jeweled cuffs and stole.

Two deacon saints turn in toward him from the flanks. Both are clean-shaven and wear elaborate dalmatics over albs. Although the inscription no longer survives, the figure at Hermagoras's right hand, holding the gospel book, must be identified as Fortunatus, who was his copatron and successor. Cyrus, who holds a thurible and a pyx on the opposite side, is inscribed "SYRVS."[16] The titulus running along the lower border has been accurately transcribed by Kugler as "EXOR(A)T XP(ISTV)M POP(V)LV(M) CONSERVET VT ISTVM" (He exhorts Christ to save his people).[17]

Apostles

I4. Peter, S. PE/TRVS (fig. 24)

Peter stands in contrapposto and extends his right hand to display the keys on a ring; only the ring around his thumb survives. The left hand has been lost altogether due to the vertical swath cut into the fresco when the iron fence was installed in the fifteenth century to protect the treasury at the center of the crypt. Peter's face conforms to a standard type with a full head of gray hair and beard and somewhat gaunt cheeks. He wears a white toga with an ocher himation.

I5. Paul, S. PAU/LVS (fig. 25)

Paul faces Peter across the aisle, but turns his head toward the spectator approaching from the west. Clad in a white toga with a green himation, he holds a book in his left arm while raising the right in an intercessory gesture. Badly damaged by the installation of the fence, only one side of Paul's bearded, bald head is visible.

Paul conforms to the standard Middle Byzantine type,[18] but he seems more directly based on his counterpart in the left apse of San Giusto in Trieste (fig. 135).

I6. Andrew, S. AN/DREAS (fig. 26)

Andrew's head and most of his body have been destroyed, but he is clearly identified by inscription and by the attribute of the cross-staff held in his left hand. He wears an olive green

himation over his white toga and raises his right hand in benediction. The same bushy haired, bearded type, holding the cross-staff, appears in mid-twelfth-century mosaics at Palermo, Cefalù, Monreale, and Trieste.[19]

I7. Matthew, s. MAT/THEVS (fig. 27)

This apostle is likewise badly damaged along the central axis of the spandrel. He wears a red himation over his toga and blesses with his right hand.

I8. John, s. IO/H(AN)ES (fig. 28)

The boldly modeled John the Evangelist is amongst the best-preserved apostles. He is depicted as the mature evangelist rather than the youthful disciple: he displays gray hair and beard, a furrowed brow, and a high forehead. He raises his right hand in benediction from a slinglike swath of his green himation, and with his left he holds a bejeweled gospel book. A golden layer of paint has been applied over the olive green himation to shaded areas beneath the right knee and on both shoulders.

John is another example who copies precisely the iconography and modeling conventions of his counterpart in the mosaics of the left-hand apse of San Giusto in Trieste (fig. 134). An earlier version of the same facial type is found in the narthex of San Marco in Venice.[20]

I9. Bartholomew, [s.] BAR(THOL)O(MEVS) (fig. 29)

This apostle is clean-shaven with ruddy cheeks. Like Paul on the same side of the aisle, he turns his head toward the viewer approaching from the west. Clad in white toga and pink himation, he varies the pattern of the previous apostles by holding a scroll in his left hand while holding his other hand at his side.

I10. James the Less, s. IA/COBVS (fig. 30)

James the Less is distinguished from his namesake across the aisle by his youthful brown hair and beard, and by central parting of his hair. Clad in toga and pink himation, he raises his right hand in benediction. He may have held an attribute in his left hand but this was obliterated when the iron fence was installed.

I11. James Major, s. IA/(COBVS) (fig. 31)

The elder James has a gray beard and hair. In this figural variation, arms are extended from the body; he holds a scroll in his left arm while displaying the right open palm in the conventional orant gesture. The distinct facial types for the two apostles named James are found in the apse of San Giusto in Trieste (fig. 135).

I12. Simon? SI? . . . (fig. 32)

This bearded apostle's identity is not certain, but faint remnants of the inscription at left seem to form "SI . . ." for "SIMONVS." He resembles closely the physiognomic type found in Trieste (fig. 135).

I13. Mathias? (fig. 33)

If the identification of I12 is correct, Mathias is his likely counterpart, for he appears with Simon in the left apse of San Giusto in Trieste (fig. 135). Badly damaged, this apostle appears to be bald and bearded. He wears a red toga with a bright green himation and raises his right hand in blessing.

I14. Philip (fig. 34)

Amongst the remaining unnamed apostles, the youthful, clean- shaven physiognomy displayed in one of two spandrels facing west at the east end of the central aisle can only belong to Philip or Thomas.[21] The scales are tipped in favor of Philip for the northern apostle of the pair,

because this figure reproduces precisely the stance, physiognomy, and gestures of Saint Philip in the left-hand apse of San Giusto in Trieste (fig. 134). Both figures conform to the youthful, beardless type; both display a pronounced contrapposto and turn their heads to our right at a 45-degree angle; both hold the right arm in a sling of drapery while holding out a scroll in the left. They even reveal the same patterns of modeling: for example the curvilinear highlight on the drapery at the elbow and the Y-shaped muscles straining at the neck.

115. Thomas (fig. 35)

The last apostle conforms closely to the type of Philip, and despite the absence of an inscription, must be identified as Thomas, the only other youthful apostle remaining in the Trieste series (fig. 135) to which Aquileia so closely adheres. Like Philip, he holds his right arm in a sling of drapery, but in contrast to his mosaic counterpart, he holds the scroll close to his body.

Martyrs

116. Sergius, se(r)/givs (fig. 36)

Sergius appears in patrician dress: a maroon chlamys fastened by a pearl-studded brooch and a long pink tunic decorated with gold-embroidered segmenta, shoulder and neck bands, and cuffs. He holds a staff inset with pearls and jewels in his right hand and a sword in his left. He has a youthful, almost feminine, face with a luxuriant mop of curly hair piled high above his forehead.

Byzantine examples of the same costume type are found in the eleventh-century frescoes of the "Five Saints" in the northwest chapel of the Catholicon of Hosios Lukas, the contemporary mosaics of the Nea Moni on Chios, and the late Comnenian (c. 1164–70) frescoes of Artemesios and a companion on the entrance wall of St. Panteleimon at Nerezi.[22]

117. Bacchus, s. bac(c)h/vs (fig. 37)

Bacchus is clad in the same patrician dress as Sergius, and like him, holds a sword at his left side while raising a jeweled staff in his right hand.

118. Cosmas, s. c(os)/mas (fig. 38)

Saint Cosmas has suffered severe damage to the face as a result of the insertion of the metal screen. Like Sergius and Bacchus, he is dressed in patrician costume, comprised of a long green tunic and golden chlamys. As an attribute of his medical profession, he holds a pyx in one hand.

119. Damian, s. dam/ianvs (fig. 39)

Saint Damian, like his counterpart on the opposite side of the aisle, is badly damaged in the face. His attire is nearly identical to that of his fellow physician, Cosmas, but instead of a pyx, he carries what appears to be a swath of bandage.

120. Theodore, (th)heo/dorvs (fig. 40)

This military saint wears Byzantine lamellar armor over a white tunic; a cloak draped over his shoulders hangs down to his waist. With his left hand, he holds the drapery at his hip, and in his right he holds a lance out from his side. His head and feet have been almost entirely destroyed.

121. George, ge(o)/rgivs (fig. 41)

Saint George wears lamellar armor over his shoulders and waist, scale armor over his breast, and a chlamys. He holds a lance on a diagonal with his right hand, while his left rests at his side. The armor displayed by both George and Theodore, based on Byzantine convention, contrasts with the simple chain mail shirts which protect the Western knights portrayed in the fictive curtain of the crypt.[23]

I22. Martyr: Vitalis? s.v. . . . (fig. 42)

This clean-shaven martyr is attired in a patrician tunic with embroidered shoulder pieces and hem, and a chlamys. He displays the open palm of his left hand while holding a cross in the right. Without justifying his identification, Swoboda labeled this figure Saint Diomedes.[24] However, the very faint remains of inscription set against the blue background suggest the possibility of Vitalis, a local Adriatic martyr venerated at Ravenna.

Both this saint and I23 conform to a type current in Byzantine art of the eleventh and twelfth centuries,[25] but the immediate model was likely a Venetian one.[26]

I23. Anastasi(a/us), s. ANA?/STA?(SIVS) (fig. 43)

Forming a pair with I22, this similarly attired clean-shaven martyr holds a cross in one hand and part of his transparent chlamys in the other. Swoboda's identification of the figure as Anastasia is based on remains of an inscription.[27] Anastasia, a martyr from Pannonia, is a likely candidate for representation in the crypt because she was venerated from an early period in Aquileia and her relics are listed in the earliest surviving inventory of the Aquileian treasury made between 1358 and 1378.[28] The saint, however, is attired in precisely the same costume as other patrician male martyrs in the crypt, and in contrast to representations of patrician female saints in contemporary Venetian mosaics—for example, Saint Dorothea—the Aquileian figure's hair does not reach down to the neck and is not covered by an appropriate headdress.[29] The inscription's ending could be male or female, but it is more likely that the male saint Anastasius is represented.

I24. Hermogenes, H(ERM)/OG(ENES) (fig. 44)

Hermogenes is dressed in the same patrician costume as Cosmas and Damian, a long tunic with embroidered decoration and a chlamys. He extends his right arm in prayer and holds a martyr's crown and palm in the other.

I25. Fortunatus? (fig. 45)

This deacon saint conforms to the same facial type as Saint Fortunatus in I3 and wears an almost identical costume: a richly embroidered green dalmatic over an alb.[30] He holds a gospel book and stole in his left hand and swings a thurible with his right. The proposed identification as Fortunatus is based on the fact that the Pannonian martyr Hermogenes had a companion of that name.[31]

I26. Chrysogonus, s. C(H)R(Y)SO/GONV(S) (fig. 46)

Saint Chrysogonus wears the same patrician costume as Cosmas and Damian and like I22 and I23, holds a simple cross in his right hand. His youthful face corresponds to the type used for Sergius, Bacchus, and Vitalis. Perhaps in reference to the Greek root of his name, his tunic and chlamys are golden in color.

I27. Tatian, s. TA(T)/(I)AN(VS) (fig. 47)

The deacon Tatian conforms to the type used for the two Fortunati. Tonsured and clean-shaven, he wears an alb, a gold dalmatic embroidered with a pattern of circles, and a stole over one shoulder. He displays the open palm of his right hand to the viewer while holding a chalice in his left.

Confessors/Bishops

I28. Apollinaris? (fig. 48)

Bearded and tonsured, this bishop saint stands frontally with arms outstretched in prayer. Although most of the pigment has been lost, the underdrawing shows that he wore the full regalia of

a metropolitan, vested for mass: an alb, dalmatic, cope, and Y-shaped pallium inscribed with crosses. No trace of an inscription survives, but it is possible that he portrayed Apollinaris, the founding bishop of Ravenna, as a pendant to the martyr of the same city, Vitalis (I22). This and all subsequent bishops, with the exception of Nicholas, conform to Western iconography—both in terms of the episcopal costume and the standard bearded and tonsured "patriarchal" physiognomy. Particularly close parallels are seen in the figures of Ambrose and Augustine in the twelfth-century mosaics of the north cupola of San Marco.[32]

I29. Martin, MA(R)/T(I)N?VS) (fig. 49)

Swoboda's identification of this bishop as Saint Martin is confirmed by remnants of the inscription.[33] Following the standard type for Martin, he is tonsured and displays white hair, moustache, and beard. Here the full episcopal regalia is well preserved: an alb, a gold-embroidered stole and dalmatic, a speckled maroon chasuble, and a white pallium. Befitting his status as missionary to Merovingian Gaul, he holds a gospel book in his left hand. With his right hand he bestows a blessing, using the standard Latin gesture. The veneration of Martin was strong throughout the Roman Church, and Martin is customarily included in the calendars of Aquileian liturgical manuscripts. It is possible that he was intentionally paired with another French missionary, Saint Martial of Limoges, who appears in the subsequent spandrel to the right of the Crucifixion.

I30. Martial, s. MAR/TIALIS (fig. 50)

Saint Martial of Limoges is the best preserved of all the confessors. He exhibits a full head of shoulder-length gray hair and a full beard and moustache. Though both arms are outstretched in the orant position, his right hand holds a crozier. Like the three previous figures, he wears the full episcopal regalia. In this case, the chasuble is particularly lavish in its decoration: framed by pearl- and jewel-studded borders, the silk is embroidered with delicate foliate designs and rondels containing griffins—patterns recognizably based on Byzantine textiles.[34] In contrast to those of the other bishops represented here, Martial's T-shaped golden pallium, sewn with pearls and jewels, is part of the cope itself.

I31. Nicholas, s. NICHO/LAVS (fig. 51)

Nicholas of Myra, adopted as patron of Venice at the end of the eleventh century, is based directly on the design of his counterpart in the central apse of San Marco (fig. 127).[35] His face conforms to the distinctive Byzantine type with a high forehead, gray hair and beard, and hollow cheeks. Unlike the other confessors in the crypt, Nicholas displays the attire of a Byzantine hierarch—a himation over the alb rather than dalmatic and chasuble. He also wears a white, Y-shaped pallium or ormophorion.

I32. Hilary, s. HELA/RVS (fig. 52)

Hilary, the immediate successor to Hermagoras as bishop of Aquileia, is clean-shaven and tonsured. He conforms to the convention of episcopal attire manifested in the previous Western bishops. Like Nicholas and Martin, he holds a gospel book in his left hand while blessing with the right.

I33. Bishop (fig. 53)

The orant bishop to the right of the *Threnos* is almost identical in pose and costume to the figure that I have tentatively identified as Apollinaris on the opposite side of the hemicycle (I28). While the upper half of the figure is poorly preserved except for the underdrawing, the lower half reveals the usual alb, stole, embroidered dalmatic, and cope. In this case, the pallium conforms to the tau-shaped version common in northern Europe.

Given his position near the end of the hierarchy of saints, and his close proximity to Hilary at left and Chrysogonus on the opposite side of the south aisle, it seems likely that he represents a local Aquileian saint. Chrysogonus II, fourth bishop of Aquileia, is a probable candidate, since his two predecessors are represented on adjacent spandrels. Saints Chromatius (388–407/8) and Paulinus (787–802) are two other Aquileian bishops particularly prominent in the local church calendar.

I34. Voldoricus? s. vo?. (fig. 54)

The bishop saint to the left of the western absidiole is badly damaged: only the upper part of the head, the left arm, and part of the lower body still exist. Enough survives, however, to indicate that, like I33, he was an orant bishop, clad in Western episcopal vestments. On the basis of the first faint letters of the inscription, he may tentatively be identified as Voldoricus (a Latin form of Ulrich). This name appears in the litanies and commemorative prayers of two twelfth-century Aquileian manuscripts.[36] Since all the stylistic and iconographic evidence points to a dating for the crypt decoration during the patriarchate of Ulrich II (1161–82), the patron's namesake would have been a logical choice for the favored position adjacent the relic niche.

I35. Bishop

Nothing of the fresco or its underlying plaster remains, but there is little doubt that the spandrel to the right of the western absidiole also contained a bishop saint, balancing I34.

Dedication Portraits

I36. Dedication portrait: St. Charlemagne? before the Virgin Mary (figs. 55, 56)

Illusionistic columns of dark blue marble, speckled in red, mark the termini of the hemicycle wall, and above each are the remains of previously unpublished figural decoration, uncovered in the most recent restoration campaign of 1973.[37] While much of the pigment has been lost, the extant underdrawings on the south spandrel are sufficiently clear to make out three figures. At left, a large, nimbed orant turns slightly to the left toward the *Dextera Manus Dei* emerging from the upper corner of the spandrel. The figure's head no longer survives. The dual patrons of the basilica, the Virgin Mary and Hermagoras, are the most likely candidates for the orant, but Mary is more plausible on the basis of costume. There is no sign of the ecclesiastical vestments which Hermagoras would be expected to wear, and gentle undulating curves below the arms indicate the lower edge of a mantle of the type worn by the Virgin in the Ascension in the Baptistery of San Marco (fig. 121).

A bearded male donor, executed on a smaller scale, approaches the orant with veiled arms. Though nimbed, the figure is attired in secular garb: an ocher tunic with a broad border at the hem, falling just above the knee, and a pink cloak which coalesces with the drapery covering the figure's hands. The donor also wears a simple crown, comprising a narrow ring around the head surmounted by a knob and possibly a cross. A similar crown may be seen in the portrait of Charlemagne on the twelfth-century tapestry in the treasury of Halberstadt Cathedral.[38] An angel, whose head is missing, emerges from the clouds at the upper right to sanction his coronation. The group closely resembles Byzantine imperial portraits where the angel hovers over the ruler and reaches down to touch the crown on his head.[39]

There is a long pictorial tradition of lay donors beseeching orant saints in monumental art ranging back at least as far as the sixth century, when the first mosaics are believed to have been executed for the nave of Saint Demetrios in Thessaloniki.[40] In one of these votive panels, an entire family approaches the patron. Like the Aquileian donor, each figure is executed on a smaller scale than Demetrios and approaches the saint reverently with veiled hands. Similarly, in the mid-eighth-century fresco program of the Theodotus Chapel at Santa Maria Antiqua in Rome, the donor

appears alone or together with his family before the Virgin Orant and Saints Quiricus and Julitta no less than three times.[41]

The particular configuration of the Aquileia donor portrait with the Virgin as the primary intercessor to Christ on behalf of a layman finds close analogies in Middle Byzantine art, including a tenth-century miniature from the Leo Bible[42] and a series of monumental and miniature representations of the Virgin as *Paraklesis*, dating from the eleventh century on.[43] Among the closest parallels in church decoration are the mosaic panels in the Martorana of Palermo and Monreale Cathedral, both works that were executed by Byzantine craftsmen for Norman rulers emulating the Eastern emperors.[44]

I37. Dedication portrait?

The spandrel above the north column has lost most of its original decoration. Only an arched frame at the top and drapery, possibly from the arm of a figure survive. The resemblance of the arch fragment to the elegant ogival arcades framing the saints in the other spandrels of the side aisle suggests that another confessor was depicted here. The drapery fragment, however, does not belong to a clerical costume, and following the usual symmetry of the crypt program, one would expect a composition relating to the dedication portrait on the opposite spandrel.

III. Hagiographic Cycle

Twenty-six episodes of the hagiographic narrative appear on the ceiling and three lunettes of the supporting wall, including the central bay of the eastern hemicycle (H2, H3) and the two western bays flanking the reliquary niche (H25, H26). Unless otherwise specified, all quotations are from the Latin *Passio* of Hermagoras and Fortunatus recorded in the twelfth-century Passional, Namur (Belgium), Bibliothèque de la Ville, Codex 53 (published in *AnalBoll* 2 [1883]: 311ff.).

H1. Peter commissions Mark as apostle of Aquileia (fig. 57)

> In illo tempore, cum esset beatus Petrus apostolus in urbe Roma, dixit ad Marcum discipulum suum: . . . Surge et perge ad urbem que vocatur Aquileia Ystriae provinciae, ad praedicandum verbum Domini. Tunc accipiens beatus Marcus primam sortem et baculum pontifcatus, iter arripuit . . . (311, ll. 21–25).

> [At that time, when the blessed apostle Peter was in the city (of) Rome, he said to his disciple Mark: ". . . Arise and hasten to the city which is called Aquileia, in the province of Istria, to preach the word of the Lord." Then the blessed Mark, accepting this distinguished duty and the pastoral staff, started on his journey. . . .]

The painting represents the text in a straightforward fashion. Peter, clad in a gold toga and white pallium, is enthroned at left before a twin-towered cityscape representing Rome. He raises his right hand to bestow the baculum upon Mark the Evangelist and holds a scroll in his left. His name appears in an badly effaced inscription, "(PE)TRVS," above his head. Mark, wearing a shoulder bag for his gospel, stoops to receive the "baculum pontificatus" from Peter with his right hand and extends the other in a conversational gesture. He is identified by a vertical inscription, "S. MARCVS."

The text at the base of the panel, legible in its negative image on an older photograph from the Istituto Centrale per il Catalogo e la Documentazione in Rome (C10339) reads: "VRBS AQ(V)ILEIA BONVS TIBI MITTITVR ECCE PATRONVS" (City of Aquileia: Behold the good patron is sent to you). Programmatic rather than merely descriptive, the inscription makes clear the role of Saint Mark as the spiritual patron, or "patronus," of Aquileia, distinct from the role of Hermagoras as founder of the patriarchate.[45]

Two previous representations of this episode may be cited. The earliest surviving example is an enamel from the 1105 section of the Pala d'Oro, executed for Doge Ordelaffo Falier (fig. 137).[46] As in the Aquileia version, Peter, enthroned at left, commissions Mark with the pastoral staff. Both figures are labelled with Latin inscriptions, "s(an)c(tv)s petrvs" and "s(an)c(tv)s marcvs" but there is no explanatory titulus for the scene as a whole. The city portrait conforms to a different convention, a towered gateway, which gives the enamel a more "Romanesque" appearance than the Aquileia panel. The throne type and Peter's pose are also different. In the enamel, Peter, his lower body in a frontal position, sits on a solid throne of the type frequently used for Christ himself. At Aquileia, on the other hand, Peter is shown from the side, seated on a stool with turned legs of the type commonly seen in Byzantine evangelist portraits.

Another iconographic change is more significant: the substitution of the gospel book in the satchel for the rather inconspicuous scroll. In this way Peter's role in the commission of the gospel of Mark is brought to the fore. The gospel of Mark, not only the symbol of Mark's evangelization of Venetia, was also a prized relic whose custody was claimed by Aquileia.[47]

Different again in iconographic details is the representation of the same episode in the mid-twelfth-century choir mosaics of San Marco in Venice (fig. 141, upper left).[48] Here, as the inscription "marcvs sacratvr" makes clear, the commission has been transformed into a consecration of Mark as the first bishop of Aquileia. In keeping with this new meaning, Peter stands to bless Mark and hand him the crozier of his episcopal office; Mark himself wears the full episcopal regalia including miter, pallium, cope, and dalmatic.

The composition of these two images may also have been based on a more general model, a pictorial topos in hagiographic cycles. The sending out of Silas and Timothy by Saint Paul, illustrated in the late-twelfth-century mosaics of Monreale Cathedral, conforms to the same compositional genre.[49]

H2. Healing the leper Athaulf (fig. 58, left)

> . . . et veniens in praedictam civitatem (Aquileiam) invenit ibi juvenem nomine At-
> aulfum, filium Ulfii . . . , qui magna detinebatur infirmitate. A quo interrogatus de qua
> provincia adveniret, enarravit ei eo quod christianus esset et medicus ad omnes ae-
> gritudines curandas. Audiens juvenis hujuscemodi sermones, ad pedes ejus provolutus,
> rogabat ut infirmitatem ejus depelleret. Tunc beatus Marcus apprehensa manu et bra-
> chio ejus mundavit eum a lepra (311, ll. 25–32).

> [. . . and coming to the aforementioned city (Aquileia), (Mark) came upon a youth there
> named Athaulf, son of Ulfius . . . , who was hindered by a great infirmity. Questioned by
> him as to which province he had come from, (Mark) told him that he was a Christian
> and a physician for the healing of all afflictions. Hearing such remarks, the youth,
> prostrated at (Mark's) feet, prayed that he might take away his infirmity. Then the
> blessed Mark, having grasped his hand and arm, cured him of leprosy.]

In the left panel of the central lunette, Mark, standing at left, prepares to cure the leper. In keeping with the textual account, he grasps Athaulf's right arm near the wrist and raises his own right arm in benediction. Athaulf, clad in a loin cloth and a cloak draped over his shoulder, reveals the sores of leprosy on his upper body and legs. Standing before a cityscape comparable to that in the previous scene, he stretches out his arms in acceptance of the new faith.

The only other extant representation of this episode is the mosaic in the chapel of San Pietro in San Marco (fig. 141, upper middle). Inscribed "lepram sanat," this scene shows the same two-figure composition with certain discrepancies in costume and attitudes of the leper, which may be

due in part to later restorations of the mosaic.[50] A much closer resemblance to the Aquileia panel is actually seen in a Christological scene, Christ Healing the Leper, in Monreale Cathedral.[51]

H3. Baptism of Athaulf (fig. 58, right)

> At juvenis, videns haec mirabilia, citius cucurrit ad patrem suum Ulfium et omnia indicavit ei quae illi beatus Marcus fecisset. Celerius ergo cum magna turba veniens Ulfius inveniensque beatum Marcum ad portam occidentalem residentem, vidensque mirabilia Dei in sanitate filii sui luce clarius apparentia . . . baptizatus est ipse et filius ejus et omnis familia ejus et multitudo populi (311, l. 32–312, l. 3).

> [Moreover, the youth, seeing these wonders, ran very quickly to his father Ulfius and told him all the things that blessed Mark had done there. Rapidly then, and with a great crowd, Ulfius coming and finding Saint Mark residing at the western gate, and seeing the wonders of God in the healing of his son, that appeared clearer than sunlight . . . was baptized himself together with his son and all his household and a multitude of the people.]

Although the text calls for the baptism to take place at the gate of the city, the painting includes the standard liturgical setting for baptism: a circular font raised on a platform and a ciborium behind to designate the sanctuary of a church. In the right half of the central lunette, Mark strides from the left toward the baptismal font, a stout marble vessel with a quatrefoil plan set on a two-step platform in front of a ciborium. Raising his right arm in benediction, Mark places his left hand on one shoulder of Athaulf, who stands naked and waist-deep in the font with arms crossed over his chest. Behind him to the right are gathered his father, Ulfius, and other members of the family. The descent of the Holy Spirit confirms the leper's conversion with rays extending from the arc of heaven to the catechumen's head.

This episode has been heavily restored in the mosaic cycle of the San Pietro Chapel in San Marco, a fact that may explain why the composition bears so little resemblance to that of Aquileia (fig. 141, upper right).[52] In this abbreviated scene, Mark places his hands on the head of the kneeling leper to baptize him. The font and ciborium are absent, and Athaulf is fully clothed—a striking anomaly for a baptism.

Closer comparanda for the Aquileia composition are found elsewhere in San Marco: Matthew baptizing the king of Ethiopia in the south aisle and Mark baptizing in one of the enamels of the Pala d'Oro.[53] The second example displays the same quatrefoil-plan font. The thesis that the Aquileia scene was invented ad hoc on the basis of standard apostolic scenes is reinforced by a third example, the Baptism of Paul in the mosaics of Monreale,[54] where there are two significant details absent from other comparanda: the ciborium, which provides a strictly liturgical setting for the event, and the descent of the Holy Spirit, in the form of a ray extending from the arc of heaven to the head of the baptized.

H4. Mark confronted by the citizens of Aquileia (fig. 59)

> Cumque beatus Marcus praedicaret per annos aliquot, desiderio videndi beatum Petrum cor ejus succensum est, voluitque occulte dimittere populum Romamque contendere. Cujus conatui occurentes populi, querebantur de abscessu ejus et querulis vocibus haec verba ei ingeminabant: . . . "Quid peccavimus, quia absentia tua filios tuos contristas . . . ? Da nobis pastorem." (312, ll. 3–9).

> [And when Saint Mark had preached for several years, his heart was inflamed by the



desire to see blessed Peter, and he wanted secretly to leave the people and hasten to Rome. When his (Mark's) attempt was confronted by the people, they complained about his departure and repeated these words to him with clamoring voices: . . . "How have we sinned, that you would sadden your sons with your departure . . . ? Give us a pastor."]

Mark, inscribed "s. MARCVS," gestures with one arm as he discusses his imminent departure with a group of four citizens facing him. Only a fragment of the titulus can be deciphered: "MA(RCVS)? N..VOB.TV . . ."

This relatively insignificant episode is not represented in the other early cycles. Again, it can be demonstrated that the ultimate source of the composition is a generic model—an apostle confronting a crowd—derived from another saint's life or Christ's ministry.[55]

H5. Hermagoras elected bishop of Aquileia (fig. 60)

Tunc Marcus proposuit eis ut eligerent quemcumque vellent christiana fidelitate potentem. At illi elegerant sibi elegantem personam nomine Hermagoram (312, ll. 9–11).

[Then Mark proposed to them, that whomsoever they chose, they should elect a man powerful in Christian faithfulness. Thus, they had elected there for themselves an elegant person named Hermagoras.]

Hermagoras is elected by the people in the presence of Saint Mark. The action takes place on a narrow plot of ground sewn with flowers. Behind the figures appear a second ground line in ocher and a rather confused architectural backdrop which combines two obliquely placed pavilions of the type found in the Crucifixion and Deposition with a low wall and an arched cornice running parallel to the picture plane. The cornice self-consciously reproduces a classical egg-and-dart motif design, but it is curiously isolated from its normal context within a larger entablature. The fragmentary titulus, "NVT(V?) . . ." (populi nutu?) may refer to the election of Hermagoras by the will of the people.

A man dressed in princely costume, wearing a cape, embroidered tunic, dappled stockings, and skull cap, would seem at first glance to be the "elegant" Hermagoras, but it is the bearded man behind him who is inscribed "s. HERMACHORAS." The saint is tonsured like his companions and wears a long cassock with a cape hanging over his front. Apparently reluctant to take up this high office, Hermagoras is drawn out from the crowd by the princely figure, grasping his left arm. Mark, inscribed "s. MARCVS," holds his pastoral staff with his left hand and raises his right hand in benediction, apparently signifying his approval of the election.

H6. Mark and Hermagoras journey to Rome (fig. 61)

(Hermagoras) iter faciens cum beato Marco ad urbem Romam, a beato Petro accepto baculo pontificatus et velamine sacramenti, factus est episcopus Provinciae Italiae (312, ll. 12–13).

[(Hermagoras), making the journey to Rome with Saint Mark, was made bishop of the province of Italy, through the pontifical baculum (crozier) received from Saint Peter and the sacramental garment.][56]

This scene, like H4, fills a rather confined panel within a narrow intercolumniation. Perhaps due to lack of space and in order to improve its visibility, it has been placed perpendicular to the other scenes, oriented toward the viewer standing in the right aisle.

The journey is portrayed in a straightforward manner. Mark, inscribed "(M)AR(C)VS," proceeds to the left, turning around to engage his successor in conversation. Mark has exchanged his tau-shaped staff for a crozier, and Hermagoras, inscribed "(H)ERMA(CHORAS)," has acquired his superior's staff. In contrast to the previous episode, Hermagoras is portrayed with a youthful clean-shaven face. The titulus is well preserved and can be read in its entirety as "AMBO SIMVL MARCVS ROMA(M) + EVNT ET ALV(M)NVS." In this case, the titulus merely describes the scene: Both Mark and his disciple go at once to Rome.

This episode appears in the Pala d'Oro but is absent from the mosaics of San Marco in Venice (fig. 138). There is no significant relationship between the composition of the enamel and that of the crypt painting. The moment represented in the enamel is not the journey proper but the reception of Hermagoras and Mark by Saint Peter. The different emphasis is apparent from the inscription which reads: "DEFERT BEATVS MARCVS HERMA(C)HORA(M) AD P(ETRVM)" (Saint Mark brings Hermagoras to Peter). This serves as a substitute for the Consecration of Hermagoras by Peter, which is not included in the enamel cycle.

H7. Peter consecrates Hermagoras as bishop of Aquileia (pl. II; fig. 62)
See section H6 for *Passio* text.

This panel, due to its size, location, and elaborate borders, is one of the most prominent in the cycle. Peter, inscribed "S. PETRVS," strides forward from the left to bless the bowed head of Hermagoras and to bestow upon him the *baculum*, or crozier. Hermagoras ("S. HERMACHORAS") is fully vested, with the exception of a miter: he wears an alb with a stole, a richly patterned dalmatic, an elaborately embroidered vestment cope, and a Y-shaped pallium, the symbol of his metropolitan dignity. Mark ("S[ANCTVS] MARCVS") stands to the right as witness to the consecration. A two-story pavilion anchors the left side of the composition.

In the mosaic cycle of the Cappella San Pietro in San Marco (fig. 141), this episode is placed in the lower register of the west half of the vault on axis with the Consecration of Mark in order to emphasize the episcopal line of succession from Mark to Hermagoras. The composition is iconographically very close to the Aquileia scene. Peter approaches Hermagoras from the left, raising his right hand to bless him and holding out the *baculum* with his left. Hermagoras, fully vested in episcopal attire, here including the miter, stoops to receive Peter's blessing with outstretched arms. Mark, holding a book rather than a scroll, stands to the right as witness. Two details relating to the figure of Hermagoras are particularly important: he is portrayed as the youthful, unbearded type seen in the Aquileia image and he wears the Y-shaped pallium.[57] The pallium distinguishes Hermagoras as a metropolitan. By the twelfth century, it was standard practice for a newly elected metropolitan to seek papal confirmation immediately after his investiture with temporal regalia by the emperor or local monarch. The same legalistic concern motivated a more elaborate rendition of the consecration procedure in the enamels of the Shrine of Saint Heribert, executed for the Abbey of Deutz near Cologne during the last decades of the twelfth century.[58] The consecration cycle includes no fewer than six scenes: the bestowal of temporal regalia of the archbishopric by the emperor, the bestowal of the pallium by the pope, the journey home over the Alps, the reception by the people of Cologne, the confirmation of Heribert's consecration by the suffragans of his province, and finally the consecration proper by one of the suffragans.

The second distinctive attribute of the Consecration of Hermagoras, the bestowal of the *baculum*, finds its source in the Roman *ordines* dating back as far as the second half of the tenth century.[59] In the Roman *Ordo ad vocandum et examinandum seu consecrandum electum episcopum (XX-XVB)*, the crozier, or *baculum*, is the last item of regalia bestowed upon the new bishop (in the West) during his consecration.[60] Like the pallium it is a symbol of the bishop's office and the powers that he can exercise.

A century after this ordo was compiled, the prerogative of bestowing the *baculum* was customarily usurped by the German emperor and other monarchs and became part of the secular ceremony of investiture. In the Concordat of Worms, the compromise made between Henry V and Callixtus II in September 1122, the emperor agreed among other things to renounce investiture with ring and crozier and to permit free canonical elections; the pope, for his part, conceded the monarch's right to grant temporal regalia "per sceptrum" and to voice his consent at the election.[61]

This new state of affairs is reflected in pictorial representations of episcopal consecration following the Concordat. In miniatures from two mid-twelfth-century Salzburg manuscripts, the bishop receives his crozier during the consecration ceremony. In the illustrated *Vitae Sanctorum* of Hugh of Saint Victor (Berlin Staatsbibliothek, Ms. Theol. lat. IV, 150), Saint Nicholas is shown already in possession of his crozier, receiving the miter—both details which reflect the contemporary Western liturgy.[62] Closer to Aquileia is the miniature of Saint Peter consecrating Eucharius in the presence of the deacons Valerius and Maternus in the Liutold Passional (Vienna National-Bibliothek Codex 444, fol. 2v): Peter simultaneously blesses and bestows the crozier on the new bishop.[63] The textual source of this image also bears a striking resemblance to the Hermagoras legend. According to the Trier legend of Pope Silvester, which dates back as far as the fifth century, Peter bestowed his *ferula*, or staff, on Eucharius and his followers to signify that the bishops of Trier were to rule as primates of the Church in Gaul and Germany, thus recalling the description of Hermagoras's consecration as "proton Episcopus provinciae Italiae."[64]

The importance of this detail cannot be overestimated: it is given particular prominence both in the narrative of the *Passio* and in the liturgy for the festival of Saint Hermagoras, as it is known from late-twelfth-century texts. The phrase "Accipe baculum pontificatus et perge Aquilegiam ad predicandum dominum Ihesum Christum" is used as a response several times, recalling the words of the consecration service, "Accipe baculum, sacri regiminis signum, ut inbecilles consolides, titubantes confirmes, pravos corrigas, rectos dirigas in viam salutis eterne . . . cooperante domino nostro."[65] If the *baculum* was the symbol of the bishop's office and a prerequisite to the exercise of his authority, it was also a symbol of the apostolic succession. Thus, the apostolic *baculum* bestowed upon Mark by Peter was believed to have been granted to Hermagoras as his episcopal crozier at his consecration. This is confirmed pictorially in scenes H1 and H7, and a single *baculum* of Mark and Hermagoras was preserved as a relic in Aquileia's treasury.[66]

H8. Hermagoras arrives at Aquileia (fig. 63)
See text for H10.

Hermagoras is received at the gate of the city by a group of clergy. Standing at left and dressed now in the simple cassock of the Journey scene, he raises his right hand to bless them, holding a tau-shaped staff in his left. In the immediate foreground of the group, one cleric holds out an olive branch, a second swings a thurible to cense the new bishop, and a third holds a processional cross. The city is depicted in much the same way as it is in the Conversion of Athaulf at the beginning of the cycle—a collection of walls, towers, and pavilions—but the prominent ciborium has particular significance as symbol of the new Christian cathedral sanctuary over which Hermagoras presides in the subsequent two episodes.

This scene is not specifically mentioned by any text of the legend. It is instead a topos of the episcopal saint's life, which confirms the official acceptance of the new bishop into his church. In the enamels of the Shrine of Saint Heribert, there is a similar representation of the archbishop's arrival at Cologne following his acceptance of the pallium in Rome.[67] Like Hermagoras, Heribert blesses the clergy and citizens who greet him at the gate of the city in a triumphal procession led by a crucifer. Beyond these generic hagiographic features, the Hermagoras scene seems also to allude to

a Christological scene—the Entry into Jerusalem—in the detail of the man holding out an olive branch. Thus, the new bishop, like Christ, is received triumphantly into the city in which he is later to be put to death for professing his faith.

H9. Hermagoras preaching or instructing the clergy (fig. 64)

This scene, which is badly damaged, cannot be identified with any particular event in the early mission of Hermagoras. Kugler's suggestion that it portrays Hermagoras preaching is possible, since both the *Passio* and breviary texts state that the faith grew rapidly under the new bishop's tutelage.[68] But it may also represent Hermagoras instructing candidates for the ministry, for the next scene portrays an ordination.

Hermagoras is clearly identified by his nimbus as well as by his episcopal vestments, including a purple chasuble and white pallium. He stands within a sanctuary enclosure beneath a ciborium and holds out one hand to bless a crowd dressed in secular costume.[69] Four or five deacons or priests stand behind him. The inscription, though difficult to read, could support both identifications: "H(ERMA)G(ORA)S VERBIS SACRI(S?) . . . IMOR..T . . . "

H10. Fragmentary scene: Hermagoras ordaining priests (figs. 65, 66)

Et regressus ad urbem Aquileiam ecclesiae suae moderationem composuit, presbyteros et levitas ordinavit, quos ad civitatem Tergestinam et per alias civitates direxit (312, ll. 14–15).

[And after returning to the city of Aquileia, he formed the government of his church and he ordained priests whom he sent to the city of Trieste and through other cities.]

Only the lower section of this panel survives, but there is enough to reconstruct most of the original composition. Hermagoras, again identifiable by his vestments and pallium, stands before the altar of the sanctuary, which comprises a two-stepped platform with sanctuary doors and a brick enclosure at far right as in the previous scene. Facing Hermagoras are two figures: the first, clad in a long green dalmatic, a red chasuble, and a white stole, stands very close to and appears to lean toward Hermagoras with right arm extended toward the shaft of the *baculum*; the second figure, wearing a simple alb and red stole, stands close behind the first with his right arm raised.

On the basis of costumes and attitudes of the figures, this scene can be identified as the consecration of a priest or bishop by Hermagoras. Apart from the provision of a more specific setting, this image corresponds very closely to the simple three-figure compositions already discussed in connection with the Consecration of Hermagoras (H7, fig. 62). The first act of Hermagoras upon his arrival at Aquileia, recorded in the *Passio*, is the ordination of priests and deacons to serve in Aquileia, Trieste, and other centers in the region. It is possible that the image in the crypt was merely intended to symbolize all the ordinations at the beginning of Aquileia's mission to Friuli and the Veneto. However, it may refer more specifically to the ordination of Cyrus of Pavia, who appears with Fortunatus at Hermagoras's side over the central aisle of the crypt.[70]

Neither the ordination of Cyrus as priest nor his consecration as bishop of Pavia is mentioned in the *Passio* and the liturgical texts for the festival of Hermagoras, but his consecration is recorded in a separate Pavian legend dating from the eighth or early ninth century. This text, which was probably invented to support Pavia's autonomy from Milan, traces the lineage of the first bishop and his deacon Iuventus ultimately back to Peter through Mark and Hermagoras: "a Christo in Petrum, a Petro in Marcum, a Marco in Hermagoram et ab Hermagora in Syrum atque Iuventum."[71] The legend goes on to describe the missionary activity of Cyrus in Verona, Brescia, Lodi, and even Milan itself, thus reversing the established relationship between Pavia and the metropolitan See of Milan. The reasons for including this particular episode are discussed above in connection with Hermagoras

Orant (I3). Suffice it to recall here that the consecration of Cyrus supports Aquileia's patriarchal jurisdiction in the province of Italy (i.e., the northern Lombard kingdom of Italy), even encompassing territories that properly belonged within the jurisdiction of the rival metropolitan See of Milan.

H11. Fragmentary scene (fig. 67)

Of the subsequent panel, located on the soffit of the south entrance stair, adjacent the thirteenth-century pillar, only the upper right-hand corner survives. A nimbed head facing left appears immediately beneath an arch that springs from the roof of a pavilion to frame the composition in the fashion of the later scene showing Fortunatus baptizing the blind woman, Alexandria (H22).

Between the ordination of priests and the interrogation of Hermagoras by the Roman prefect, Sevastus, there are six possible episodes for illustration: Hermagoras receiving the multitudes (ll. 16–22), Hermagoras performing miracles (ibid.), the arrival of the Roman prefect (ll. 23–29), the pagans protesting against Hermagoras before the prefect (ll. 29–38), Hermagoras praying with his people prior to his arrest, and Hermagoras arrested by the soldiers of Sevastas (ll. 40–42). The two scenes which involve the prefect but exclude the saint may be ruled out. Among the remaining alternatives no clear choice emerges. It is also possible that another mission scene, relating to Trieste or centers evangelized by Saint Cyrus, was depicted here.

Another episode may have been represented in a panel on the west half of the soffit. Only a small section of the red border and titulus band survive.

H12. Hermagoras interrogated by Sevastus (figs. 68, 69)

His verbis exasperatus praeses, ut leo infremuit, et plurima militum turba convocata, suo eum praetorio exhiberi praecepit. . . . (Hermagoras) comprehensus et ferro vinctus Sevasto praesidi praesentatur (312, ll. 38–43).

[The prefect, exasperated by these words (i.e., the testimony of the pagan priests against Hermagoras), shook like a lion and after a great crowd of soldiers had been assembled, commanded him (Hermagoras) to be brought to his palace. . . . Having been seized and shackled with iron (Hermagoras) is presented to the prefect Sevastus.] (Then follows a long dialogue in which Hermagoras defends the Christian faith and refuses to pay any homage to the pagan gods [313, ll. 1–36]).

The interrogation of Hermagoras by Sevastus is the first of three poorly preserved panels over the west aisle of the crypt. As if prematurely aged, Hermagoras is now portrayed with gray hair and beard. He stands at far left to face his two interlocutors. Sevastus, the prefect, enthroned before an architectural prop symbolizing his palace, gesticulates with his right hand. In front of him stands one of the accusers, dressed in a tunic and a long cape; he holds a scroll presumably describing the charges against Hermagoras. A fourth figure, nimbed and dressed in a cassock like Hermagoras, stands at his side. This figure cannot be explained by the texts, and Kugler has suggested that it was merely copied from a model in which two saints are brought before a ruler to be judged.[72] It is also possible that the figure of Fortunatus—who is not mentioned until later in the texts—was added intentionally to emphasize the resemblance of the two Aquileian patrons to other hagiographic pairs such as Peter and Paul.[73]

H13. Hermagoras flagellated by Sevastus (figs. 70, 71)

Haec audiens praeses, extensum nervis crudis jussit caedi . . . dum non acquiesceret . . .

jubet eum equuleo appendi; et hoc tormento singulis ejus membris emortuis, solum os vivebat divinae laudi et saeviebat in contumeliam deorum et judicis. Deinde pectus ejus jubet ungulis radi et laminas ferreas candentes ejus pectori imprimi et lampades ardentes ejus lateribus applicari. Inter haec sanctus martyr hymnum constanter Deo canebat (313, l. 35–314, l. 4).

[Hearing these things, the prefect ordered the man stretched out to be struck with rawhide whips. . . . When (Hermagoras) had not acquiesced . . . (Sevastus) commanded him to be hung on a rack; and since his individual limbs had perished by this torture, his mouth alone was alive for divine praise and raged in contempt of the (pagan) gods and the judge. Then he ordered (Hermagoras's) chest to be scraped with claws and white-hot iron plates to be pressed into his chest, and burning lamps to be applied to his sides. During these (tortures) the holy martyr constantly sang hymns to God.]

This series of nefarious tortures, inflicted upon Hermagoras for refusing to worship the pagan gods, is summarized in two scenes. The scene over the central aisle shows a representative torture, the flagellation with rawhide whips. Hermagoras lies prostrate on the ground with his nimbed head just visible at the feet of the prefect. Sevastus, enthroned at right, stretches out his arm to command his henchmen to whip the saint. One dressed in a green tunic stands adjacent the prefect with his arms swung behind his head in preparation to strike a blow. Another tormentor, of whom only the head and part of his whip survive, leans over the saint further to the left.

The torture of a prostrate saint before an enthroned prefect is a hagiographic topos that can be connected with apostolic cycles in Early Christian Rome.[74]

H14. Hermagoras tortured with claws and lamps ("Crucifixion") (figs. 72, 73)
See text for H13.

Et cum h(a)ec fierent sanctus dei martyr pendens in ligno. jmnum (sic) d(omi)no canebat . . . (San Daniele del Friuli, Biblioteca Guarneriana Ms. 4, Vale, *I Santi Ermagora e Fortunato*, 18).

[And when these things had been done, the holy martyr of God, hanging on the wood, sang a hymn to the Lord. . . .]

Generally described as the Crucifixion of Hermagoras, this scene actually portrays further tortures: namely, the application of white-hot irons and claws to his flesh. Hermagoras hangs on a tau-shaped cross, while two henchman apply their instruments to his side. The prefect, whose upper body no longer survives, is enthroned at left.

Although it is not properly speaking a crucifixion, this pictorial rendition of the tortures has been modeled on a composition of Christ's Crucifixion with Hermagoras's torturers replacing the centurions on either side of Christ. Such a compositional assimilation enhances the martyr's conscious "imitatio Christi." At Aquileia, the short passage cited from the breviary may have served as the textual inspiration; it alone describes the saint as "hanging on the wood," implying a comparison with Christ.

H15. Destroyed scene
There was probably a scene in the northwest corner of the vault balancing H11 on the opposite side. Only a fragment of its border contiguous with the Conversion of Pontianus survives. It may have represented one of four episodes: the multitude praising the Christian God (314, l. 4–7); the priests accusing Hermagoras of seducing the people with magic (ll. 8–10); the removal of Her-

magoras to prison (ll. 11–14); or Hermagoras praying in prison, emitting a bright light and a sweet odor (ll. 14–19).

H16. Hermagoras converts his jailer, Pontianus (fig. 74)

> accepit (Hermagoras) post orationem majoris fiduciae firmitatem, lumen scilicet quod divinitus refulsit in carcere et odorem suavissimum carceris foetorem excludentem. Quo viso, custos (Pontianus) carceris illuminatus est hoc lumine, et depulsis infidelitatis suae tenebris, aperta carceris janua, provolvitur pedibus sancti martyris, orans ut sicut fide jam videbat, ita ipso adjuvante videret et baptismo. . . . Hermagoras . . . indixit ei triduano jejunio baptismum praevenire . . . (314, ll. 17–29).

> [(A)fter praying, Hermagoras received the firmness of greater faith; namely, the light which shone in the prison in a divine way and the very sweet odor which shut out the stench of the prison. On account of this sight, the jailer (Pontianus) was illuminated in this light, and after the shadows of his unfaithfulness had been expelled, since the door of the prison was open, he threw himself at the feet of the holy martyr, praying that, as he already saw by faith, he would see by (Hermagoras's) help and by baptism. . . . Hermagoras . . . ordered him to prepare for baptism with a three-day fast. . . .]

Hermagoras, inscribed "s. HERMACHORA(S)," appears at the window of his cell, a classicizing structure with a tetrastyle pedimented portico. He leans out of the window with hands extended to receive two figures, the first wearing a long patrician tunic and chlamys pinned over his left shoulder, the second, dressed in a simple, short tunic. The second figure is the jailer, Pontianus, who has come to be converted by the bishop. The patrician is not specifically named in any text of the legend but may simply be included to represent the multitude attracted from all walks of life to the saint's prison.

A prototype for this episode—both pictorial and textual—can again be found in an apostolic cycle. Paul and Barnabas converted their jailer, and in the early medieval murals of San Paolo fuori le mura, they were depicted preaching from the window of a porticoed structure, similar to the prison in the Aquileia panel.[75] This architectural detail betrays a certain antiquarianism that is also apparent in the ornamental repertoire, and it seems to be designed to reinforce the authenticity of Aquileia's claim to an apostolic foundation.[76]

H17. Fortunatus baptizes Pontianus (fig. 75)

> Medie noctis tempore precepit sanctus Hermachoras venire presbiterum cum diacone suo. qui et baptizavit eum (Pontianum) in nomine patris et filii et spiritus sancti (San Daniele Breviary, Vale, *I Santi Ermagora e Fortunato*, 19).

> [In the middle of the night, Saint Hermagoras instructed a priest to come with his deacon. And he baptized him (Pontianus) in the name of the Father and the Son and the Holy Spirit.]

The Namur *Passio* implies that Hermagoras himself baptized Pontianus, but the image in the crypt conforms to the breviary text which states that the rite was performed by a priest and deacon whom Hermagoras summoned to the prison. A double arcade indicates an interior setting. In the right-hand bay, Pontianus stands naked in a quatrefoil-shaped font as a priest, unbearded and nimbed, pronounces a benediction over his head and grasps his right arm by the wrist. The same holding gesture is used by Saint Mark in the Conversion of Athaulf but here it seems to have particular relevance to the theme of resurrection in the baptismal liturgy.[77] Pontianus stands waist-

deep in a marble font of the same type used in the Baptism of Athaulf. Two deacons, the first of whom holds a gospel book, stand in the left bay as witnesses.

This composition follows the pattern established in previous baptisms in the crypt cycle; however, it includes one extraneous iconographic detail that cannot be explained by the hagiographic texts. The priest is nimbed, thus suggesting that he be identified as Fortunatus, the disciple and comartyr of Hermagoras, but the protodeacon is not mentioned in the textual narrative until much later. As in the composition Hermagoras before Sevastus (H12), then, it can only be surmised that the nimbed priest was either unintentionally taken over from a model depicting a saint baptizing or was added in order to give the comartyr a greater prominence in the pictorial cycle of the crypt where he was buried.

H18. Healing and conversion of Gregory's son (fig. 76)

> Igitur inter innumeram populi multitudinem quidam, Gregorius dictus, videns sanctum episcopum tormenta derisisse nec defecisse, credens etiam haec mira virtute potuisse, filium suum daemone triennio vexatum ei curandum obtulit. . . . Hac viri professione potius quam bonae conscientiae securitate adductus ad misericordiam, orationem pro puero fudit et daemone eum absolvit, et deinde eum cum patre baptismo ablutum et peccatis absolutum, triduanuam vitae suae dilationem gratulatus est isti fructuosam (315, ll. 8–18).

> [Therefore, among the countless multitude of people, a certain man, called Gregory, seeing the holy bishop derided and abandoned in torment, also believing that he could perform these wondrous deeds through his virtue, brought him his son, who had been troubled by a demon for three years, to be cured. . . . Drawn to mercy, on account of the man's profession (of faith) rather than the confidence of his good conscience, (Hermagoras) poured out prayer for the child and set him free from the demon, and then when (the child) had been cleansed with his father through baptism and absolved from sins, he thanked (the bishop) for the fruitful extension of his life on the third day.]

Hermagoras appears at right in the window of his prison, the same structure shown in the Conversion of Pontianus. He grasps the son by his right wrist and raises his own right arm to cast out the demon. A ray of light extends from the arc of heaven to his head, signifying the descent of the Holy Spirit as the demon is cast out. Gregory, dressed in a tunic with an embroidered hem and a long cloak, stands at left before a small pavilion and raises his arms in a gesture of prayer.

H19. Hermagoras baptizes Gregory and his family (fig. 77)

> Media nocte beatus Hermachoras baptizavit Gregorium cum tota domo suo (San Daniele Breviary, Vale, *I Santi Ermagora e Fortunato*, 20) .

> [In the middle of the night, the blessed Hermagoras baptized Gregory with all of his household.]

The crypt painting is again closer to the breviary text, for it shows the baptism of Gregory's entire household, whereas the Namur *Passio* mentions only Gregory and his son.[78] The scene is set in the open air beside a domed building with trees sprouting from its roof. Its resemblance to early medieval representations of the Holy Sepulcher may be intended to reinforce the Pauline theology of baptism as a participation in the death and resurrection of Christ (Romans 6:3–6);[79] such an allusion would certainly be prompted by the performance of the baptism "on the third day after the healing of Gregory's son" (see text for H18). No less than five family members stand naked, waist-

deep in a large, green marble font. Repeating the formula used for the Baptism of Pontianus and the two previous conversion scenes, Hermagoras grasps Gregory's right wrist with his own left hand and blesses him with his right. Hermagoras and Gregory are inscribed, respectively, "s. her-machoras" and "gregorius." Gregory's wife, like Athaulf, crosses her arms over her breast. A ray of light, signifying the presence of the Holy Spirit, descends upon them from the arc of heaven.

H20, H21. Hermagoras ordains Fortunatus and heals Alexandria (fig. 78)

> Post haec congregato omni clericorum ordine, quos ipse in sacris mysteriis habebat consecretales, hoc modo ab omnibus sollicitatur et non sine lacrimis, quas ejus exequiis quas condignas inferias praemittebant: . . . Oportet pastoris ordinationem consulte disponere. . . . Quod illis suggerentibus, ad quod explendum plus illis erat voluntarius, quemdam Fortunatum discipulum suum, ab ipso a puero eruditum, sibi ordinavit substitui et sua hereditate potiri. . . . Hoc ita ordinato, mulier quaedam, Alexandria nuncupata, timens Deum, per Pontianum carcerarium ad beatum Hermagoram in carcere positum inducitur. . . . beatus martyr oculis ejus signo crucis signatis illuminavit et, expleto triduano jejunio ab illo sibi indicto, per supradictum Fortunatum baptizavit (315, l. 18–316, l. 1).

> [After this, the entire order of clergy, whom (Hermagoras) himself had held as ministers in the holy mysteries, assembled. In this way he was solicited by all of them, and not without tears, as they anticipated his funeral and the worthy offerings for the deceased: ". . . It is necessary to arrange with due consideration the ordination of a pastor. . . ." What they were suggesting, he was more eager to fulfill than they, and he ordained a certain Fortunatus, his disciple (whom he had) instructed as a child, as his substitute and to possess his inheritance. . . . After this matter had been settled in this way, a certain woman, named Alexandria, fearing God, was led by the jailer Pontianus to the blessed Hermagoras in prison. . . . The blessed martyr illuminated her eyes by signing them with the sign of the cross, and after she had fulfilled the three-day fast stipulated for her by him, he had her baptized by the aforementioned Fortunatus.]

These two episodes, which follow a long account of the clergy's request that Hermagoras appoint a successor, are united in one panel. At left, in an abbreviated composition of the consecration, Hermagoras, inscribed "s. herm(agoras)," raises his right hand in benediction, while Fortunatus, inscribed "s. fortunat(v)s," stands with arms crossed over his chest. Alexandria stands behind Fortunatus, thus taking the position of the deacon or witness in the typical consecration images examined above in connection with the Consecration of Hermagoras (H7). She represents yet another discrepancy between text and image. As far as the sources are concerned, Alexandria does not come into the picture until the ordination is complete. Her presence here seems to be motivated by purely pictorial needs; she provides continuity between two otherwise disconnected scenes which have been combined in the same panel.

The Healing of Alexandria in the right half of the panel has been marred by the fifteenth-century iron screen. Thus, her head and arms and part of Hermagoras's right hand have been lost. Hermagoras stands again in the window of his cell and stretches out one arm to touch the blind woman's eyes. The composition resembles the Conversion of Gregory's Son or the Conversion of Pontianus (in reverse), but it probably derives ultimately from Christological miracles of healing the blind by touching the eyes.[80]

H22. Fortunatus baptizes Alexandria (fig. 79)
(See text for H21.)

After her eyesight had been restored, Alexandria was baptized by Fortunatus. The scene takes place beneath an arch linking two pavilions of the type used in the Crucifixion and Deposition (F3, F4). Alexandria (inscribed "AL(E)XAN(D)RIA") stands naked in a veined, pink marble font at right. Fortunatus is vested in an alb and wears a red stole over one shoulder according to diaconal fashion. Following the baptismal formula seen in H3, H17, and H19, Fortunatus blesses her with his right hand and grasps her right wrist with his left hand.

H23. Execution of Hermagoras and Fortunatus (fig. 80)

> Misit quippe noctu spiculatorem in carcerem et decollavit beatum Hermagoram cum Fortunato designato herede episcopatus ejus, sed modo melius facto consorte profectionis ejus ad Christum (316, ll. 27–30).

> [In fact, (Sevastus) sent an executioner to the prison during the night and he beheaded the blessed Hermagoras together with Fortunatus, who had been designated heir in the episcopate, but what is better, now became a partner in his departure to Christ.]

The events leading up to the martyrdom are as follows. Learning from the pagan priests of the baptism of Alexandria by Fortunatus, Sevastus had the new leader incarcerated with his teacher (ll. 4–10). From there they continued their mission, attracting great multitudes away from the pagan rites (ll. 13–16). Angered that Sevastus had not killed the Christian leaders, the pagan priests threatened the prefect himself with destruction (ll. 16–24). Because Sevastus feared reprisals from the people, he had Hermagoras and Fortunatus executed in their cell in the middle of the night.

Following a formula widespread in both Byzantine and Western hagiographic illustration, the executioner raises his sword behind his head in preparation for the blow to Fortunatus ("S. FORTUNATVS"), who stands blindfolded immediately in front of him.[81] Hermagoras ("S. HERMAGORAS") falls forward, as streams of blood rush from his neck and severed head. Signaling their apotheosis, a ray of light descends upon him from the arc of heaven. The forward movement of the figures, particularly Hermagoras whose right hand overlaps the frame, leads the eye to the subsequent scene of the Entombment.

H24. Entombment of Hermagoras and Fortunatus (fig. 81)

> Quorum corpora cum cruore effuso Pontianus custos carceris collegit, et in remuneratione beneficii ab eis accepti Gregorius, filii daemoniaci ereptionem recordatus, et Alexandria, caecitatis suae illuminatione commonita, venerunt nocte occulte, et linteaminibus mundis involuta et aromatibus condita sepelierunt ea foras murum Aquileiae, in agello memoratae Alexandriae matronae (315, ll. 31–35).

> [Pontianus, the guard of the prison, collected the bodies with the blood that had gushed forth, and in recompense for the benefits received from them, Gregory, who remembered the deliverance of his demoniac son, and Alexandria, who was reminded about the illumination of her blindness, came secretly during the night, and after wrapping the bodies in clean linen and covering them with spices, they buried them outside the walls of Aquileia in a little field of the aforementioned noblewoman, Alexandria.]

Pontianus ("PONCIANVS") and Gregory ("GREGORIV[S]") hold the ends of a *sudarium* containing the two bodies which they gently lower into a veined, pink and white marble sarcophagus. Behind them stand Alexandria ("ALEXA[N]DRIA") and an unnamed priest. Alexandria holds the heads of the

martyrs in veiled hands and directs her mournful gaze to the tomb. The priest holds an open gospel book in one hand and censes the body with a thurible. The unusually well-preserved titulus is oriented so as to be read from the opposite direction from which the scene is viewed. It reads: "xp(ist)ic(o)lae plangvnt vbi patris m(e)mbr(a) rec(on)dvnt" (The followers of Christ grieve where they bury the relics of the father).[82]

Although the Aquileian composition belongs to a standard type diffused in Byzantine and Western hagiographic cycles by the end of the eleventh century, there is a distinct emphasis on grief both in the inscription (plangvntvr) and in the facial expressions of the participants, especially Alexandria and Gregory. The overtones of *Threnos*, or lamentation, at the burial scene seem to reflect the recent shift from triumphant to sorrowful images of the Passion of Christ (compare F3–F5 below).

The liturgical character of the scene—manifested in the figure of the priest with the thurible and service book—is paralleled in Byzantine menologia[83] and in Western cycles such as the Heribert Shrine in Cologne.[84] Here, as at Aquileia, the body of the saint rests on a shroud and is being lowered into the sarcophagus by two laymen dressed in tunics, while the priest censes the body from behind. The detail of the shroud must ultimately be based on representations of the Entombment or *Threnos*, which by the end of the eleventh century commonly showed Christ resting on a shroud rather than wrapped in a mummylike cloth.[85]

The liturgical aspect of this composition cannot be explained by the texts of the *Passio*: they speak only of the burial of the saints in the field belonging to Alexandria outside the walls of the city. What is portrayed is a formal ceremony reflecting actual funerary rites and depositions of relics. From the fourth century on, the testimony for the use of incense in the funerals and depositions of the relics of saints is legion in both Western and Byzantine sources.[86] These literary sources are corroborated by liturgical texts for the deposition of relics. In the earliest dedication rites that have come down to us, from the ninth-century, the relics are brought in procession to the church on a *sindonem* (corresponding to the cloth in our images), "cum honore et laudes decantando cum crucibus et turibulis et luminibus multis,"[87] and deposited either in the altar or in the "tomb" of the confessio together with particles of the eucharistic bread and incense. None of these texts is illustrated, but a later liturgical text, the eleventh-century Sacramentary of Ivrea Cathedral, includes no less than ten illustrations accompanying each phase of the mortuary rite.[88] The image of the final burial exhibits all the elements included in the Aquileia scene: the priest holding the service book, the incense, the sarcophagus, and the body wrapped in a shroud.

The terminology used for the act of depositing the relics is of some significance, for it corresponds to that of the titulus in this scene. In both cases a form of recondo is the principal verb: "recondit ipse pontifex manu sua ipsas reliquias in locum altaris" in the liturgical text; "plangunt ubi patris membra recondunt" in the crypt inscription. That the inscription makes use of a liturgical term rather than the more common terms for burial—"sepelio", which is employed in the texts of the legend, or "depono" or "pono", which are used in the texts of burial rites—suggests that the scene is intended to be interpreted in terms of the liturgical deposition of the relics.[89] In light of the context in which the image appears—the vault of a crypt where the relics of the saints are buried ("recondunt")—the Entombment and its accompanying inscription function together as an affirmation of the possession of the relics of the titular saints. Since the relics were likely interred in the niche at the west end of the crypt, the inversion of the inscription, which forces the viewer to read it facing west, may have been intended to enhance the connection between the initial burial outside the walls of the city and the final collocation of the relics in the crypt itself, following their translation back to Aquileia from Grado under Patriarch Poppo.

H25, H26. Translation of the relics back to Aquileia? (fig. 82)

A large enough fragment survives from the lower third of the southern lunette of the west wall to indicate that it was not part of the feast cycle but probably a hagiographic scene.[90] At the extreme left of the largest surviving fragment, a red vertical line over a white vestment, falling close to the ground line appear to represent the red stole and alb of a cleric, such as those Hermagoras wears underneath his dalmatic in the scene of his Consecration as Bishop. Further to the right are the lower bodies of two men in secular costume—tunics with capes. The way in which the figures are crowded together suggests that they were part of a throng like that found in translation scenes such as the Translation of Clement to Rome represented in the lower church of San Clemente in Rome or the Translation of Saint Magnus in the crypt of Anagni.[91]

If a translation was indeed depicted here, it must have recorded the return of the relics from Grado under Patriarch Poppo following his siege of the rival patriarchate in 1023.[92] According to Paul the Deacon's *Historia Langobardorum*, the relics had been taken to Grado when the Aquileian clergy fled there in the wake of the Lombard siege of Aquileia in 568. Poppo, who was instrumental in reviving the power of the Aquileian See, rebuilt and reconsecrated the cathedral with much fanfare in 1033. As I have argued in chapter 2, he also renovated the Carolingian crypt to receive the recently repatriated relics of Hermagoras and Fortunatus.

Nothing of the northern lunette survives, but the *collocatio* proper or dedication of the church would have been a likely pendant.[93] Since the relics must originally have been placed in an altar in the central niche, these flanking lunettes would have appropriately drawn attention to the process by which the relics had arrived in the crypt.

IV. Feast Cycle

F1 and F6. Destroyed hemicycle lunettes

The feast cycle appears complete in its current state, but the decoration of the two westernmost lunettes of the hemicycle no longer survives. These paintings may have been destroyed during the earthquake at the beginning of the fourteenth century, which prompted the reconstruction of the nave arcades and crossing. Certainly they were not visible to Giandomenico Bertoli when he visited and recorded the decoration of the crypt in 1724, and there is no earlier record to guide us.[94]

Only a small fragment of the southern one survives. At the extreme left of the panel appears a pleated swath of blue-gray drapery set against the usual ocher ground line and a dark blue background. Both lunettes are somewhat narrower than the others, and although the wide splayed jambs may represent modifications of the late fifteenth century, the round-arched windows appear to antedate the decoration.[95] Thus, there is little space for a narrative scene, and it is quite possible that only single figures were depicted to fill in the spaces around the windows.

F2. Dormition of the Virgin (fig. 83)

Moving clockwise from the northwest corner of the crypt, the first of the extant scenes is the Dormition of the Virgin.[96] Mary lies on her deathbed parallel to the picture plane with her head to the left, propped up on a *kline*. Mourners are grouped in front of two pavilions flanking the bed. Christ stands behind the bed on the central axis beneath the dome of heaven; he glances at his mother as he holds her mummylike soul aloft to be received into the veiled arms of two angels. Among the apostles on the left are two Eastern hierarchs or bishops, both wearing a Y-shaped pallium; one is youthful and tonsured, the other old with long gray hair and beard. The toga-clad apostles express their emotions through a variety of gestures: one with outstretched arms, another with his head propped on one arm, and still others wiping tears from their faces with draped

hands.[97] One apostle, the aging, gray-bearded John, is singled out by the addition of a nimbus and occupies a privileged position between Christ and the Virgin. Saint Paul, distinguished by his bald forehead, stoops down to touch the feet of the Virgin. Peter, now barely visible, leans toward the Virgin at the head of the bed, swinging a thurible.[98]

Almost invariably included in Middle Byzantine feast cycles, the Dormition rarely appears in Western monumental cycles. While the narrative is believed to originate in Eastern apocrypha composed in the aftermath of the Council of Ephesus (431), the key sources for the later medieval accounts all date from the sixth or seventh centuries: the *Transitus Mariae* by the Pseudo-Melito (erroneously ascribed to Melito, Bishop of Sardes, d.180), and two further versions of the same text by the Pseudo-Joseph and the Pseudo-John; this last author was most influential on the accounts of the Dormition given by later patristic writers.[99] These sources all tell how, at the hour of the Virgin's death, the twelve disciples and Saint Paul were miraculously assembled at her side from the far corners of the earth and witnessed Christ raising up the soul of his mother to be transported to the heavenly Paradise by angels.

The pictorial tradition in the Orthodox world can be traced back to the early tenth century. A fresco in the church of Ateni, Georgia, an ivory plaque in Munich, and a wall painting in the crypt of Hosios Lukas already display the principal elements of the centralized feast image which inspired the Aquileia composition.[100] Absent from these examples are the two bishops, the figure of John at the Virgin's side, and the apostle with the outstretched arms. The bishops' presence is explained ultimately by a passage from the *De divinis nominibus* of Dionysius the Pseudo-Areopagite (fl. 490–531).[101] The author recounts here that he himself and two bishops—James, bishop of Jerusalem, and Hierotheus, the disciple of Paul and bishop of Athens—contemplated with Peter "the body which is the principle of life and the residence of the divinity." Maximus of Turin (d.662) and later patristic writers identified this passage with the Dormition.[102] John of Damascus (d.749) and Andrew of Crete (d.740) confirmed the presence of James and Dionysius at the Dormition but substituted Timothy, bishop of Ephesus, for Hierotheus; thus, in the absence of inscriptions, it is not possible to specify which of these bishops are portrayed at Aquileia.[103] The two clerics appear as early as the mid eleventh century at Saint Sophia in Ochrid and become standard in the feast images of the twelfth century.[104]

John's position at Mary's side is suggested by the text of the Pseudo-John.[105] This account begins with the scene of Christ's Crucifixion and reiterates John's special role as guardian of his mother ("Behold, thy mother": John 19:27). After the angel has announced to the Virgin her impending death, John is miraculously transported to the Virgin's house, the first of the apostles to come to her. The tender relationship between John and Jesus demonstrated in images of the Last Supper is thus paralleled by the closeness of John and the Virgin in the Dormition. An early-eleventh-century miniature in Ms. l of the Iviron Monastery on Mount Athos provides one of the earliest pictorial renditions of this theme as it appears at Aquileia.[106]

All the features of the Aquileia Dormition can be accounted for in Byzantine renditions of the subject from the eleventh century on. At the end of the twelfth century, however, a new compositional type was developed in which Christ stands within a mandorla accompanied by angels. This expanded version of the Dormition appears as early as 1191 in the church of St. George at Kurbinovo (Macedonia) and is present in Byzantine representations of the scene throughout the thirteenth and fourteenth centuries.[107] Its absence here strengthens the case for dating the crypt program before 1200.

F3. Crucifixion (figs. 84, 85)
(Mat. 27:26–44; Mk. 15:15–41; Lk. 23:26–49; Jn. 19:16–30)

The contiguous lunette to the right of the Dormition, depicting the Crucifixion, is pierced at

the extreme left side by a door with an open, arched tympanum leading to a blind corner between the hemicycle wall and the rectangular exterior wall of the crypt. That this opening antedates the upper layer of decoration is demonstrated by the careful accommodation of border and composition to the irregular shape of the left corner. A large patch of the painting immediately adjacent to the door is completely destroyed and the lower sixth of the lunette is badly damaged, leaving the eleventh-century layer of decoration exposed to view in the lower right corner. The pigment of the green background field survives faintly, while the inset blue field has all but disappeared.

The scene is set within a shallow foreground precinct delimited by a low wall, a hill in the left background, and a gabled pavilion at right. The crucified Christ dominates the central axis. Marked by a cruciform nimbus and clad only in a loin cloth, Christ is already dead, his eyes closed, his head resting on his right shoulder and his body slumped in a gentle s-curve. Blood springs from the wounds in his hands, feet, and side. The top of the cross is inscribed with the Greek monogram "IC XC" (Iesous Christos). On either side appear the sun and moon and angels gesticulating with open arms.

The Virgin Mary ("[SAN]C[TV]S [sic] MARIA") stands to the left of the cross in the company of four weeping women ("MVL[I]ERES"). With her left hand she holds a cloth up to her chin, while one of the attendant women, standing between her and the cross, sympathetically takes hold of her right hand. The other three women crowd behind the Virgin, one of them covering her eyes with her left hand. The Virgin and her entourage are balanced on the opposite side by John the Evangelist and the centurion, Saint Longinus. His head bowed in grief, John holds his right hand to his face and clenches a swath of drapery in his left. The centurion, attired in a tunic with delicately embroidered cuffs and hem, turns his head toward Christ and raises his right arm to acclaim his faith.

A textual basis for the representation of the dead Christ is found in the *Hodegos* of Anastasios Sinaites, written around 641. Pictorial counterparts, which may have originated as illustrations to the text, can be found as early as the seventh or eighth century,[108] but the image apparently became standard only in the post-iconoclastic period. The emphasis on Christ's death through the closed eyes, emaciated torso, and slumped head and arms is first found in Byzantine ivories and enamels of the tenth century and is an integral part of monumental feast compositions from the late tenth or early eleventh century.[109] Concomitant with the emphasis on Christ's human suffering, the sorrow expressed by both John and the Virgin is amplified, particularly in monumental representations such as the mosaics in the Catholicon of Hosios Lukas and Nea Moni on the island of Chios.[110] In both instances, the Virgin bows her head in grief, her eyes narrowed and tearful, and she holds one arm to her breast while beseeching Christ with the other; John, even more stooped than Mary, cradles his head in one arm. Gesticulating angels above the cross empathize with their sorrow.

Rose Valland has rightly emphasized the eloquence with which the Aquileia artist expresses the pathos of the event, particularly in the figures of the Virgin and her attendants.[111] But her assumption that this is an innovation of the humanizing proto-Renaissance current in Italian art around 1200 is unacceptable. The entire composition finds a precise precedent in the mid-eleventh-century mosaics of Nea Moni on the island of Chios.[112] Here, as at Aquileia, the dead Christ is slumped on the cross, and accompanied by angels, the Virgin, John the Evangelist, the mourning women, and the centurion. Two of the mourners are absent from the Greek work, but the same eloquent gestures of despair are already present: John props his head on one hand, the centurion gesticulates toward Christ with an open hand, one mourner raises draped arms to her face, and another woman holds one hand to her face. As Henry Maguire has demonstrated, these gestures have a venerable pedigree stretching back to classical antiquity, preserved in classicizing Byzantine literature and visual art, and from there transmitted back to the Latin West.[113]

A more immediate parallel for the Aquileia Crucifixion may be found in Venice. The mosaic of the Crucifixion on the western crossing arch of San Marco shares with Aquileia the expanded entourage (four women) of the Virgin and the iconographic types of Christ, John, and the centurion.[114] Nonetheless, it need not be considered the direct model for the crypt composition as Demus has suggested, for the Venetian image represents a more complex composition that became the norm in monumental art of the thirteenth and fourteenth centuries.[115] The early medieval narrative details—the soldiers gambling for the cloak, the piercing of Christ's side, the offering of the sponge soaked in vinegar—have been restored. The cast of attendants has been expanded: three figures accompany the centurion, and the host of angels numbers eight. Furthermore, the emotional tenor of the scene is much more exaggerated: whereas at Aquileia the mourners are stationary and contemplative, those in the San Marco Crucifixion—particularly the Virgin's entourage and the centurion—are agitated both in their movements and their facial expressions.

An exceptional feature of the Aquileian composition is the mourner who turns her back on the Crucifixion to attend to the Virgin, holding her outstretched hand and sharing in her personal grief. As Valland has observed, this emphasis on the Virgin and her personal grief is common in mural painting of the Balkans and Italian panel painting from the later thirteenth and fourteenth centuries, but in these images, John the Evangelist, fulfilling Christ's wishes from the cross, takes charge of the Virgin, and she no longer stands upright but swoons under the burden of grief.[116] An earlier Italian or Constantinopolitan source for the Aquileia motif is suggested by the presence of this episode in two south Italian works: the mosaic in the transept of Monreale Cathedral, executed by Byzantine artists in the 1180s or 1190s, and a miniature from the Exultet Roll of Fondi, executed in 1115 by South Italian artists closely following Byzantine models.[117]

F4. Deposition from the Cross (pls. III, IV; fig. 86)
(Mat. 27:58–59; Mk. 15:45–46; Lk. 23:50–53; Jn. 19:38–40)
Conspicuously interrupted by two episodes from Mark's mission to Aquileia in the central lunette, the feast cycle continues to the right with the Deposition. As in the case of the Crucifixion, this panel is pierced at one side by a doorway leading to the corner chamber between the hemicycle and perimeter walls. Here, the accommodation is less sympathetic: a rectangular opening cuts off the figure of John the Evangelist just below the knee cap. Nonetheless, there is no doubt that the opening antedates the decoration, since the intonaco is continuous from lunette to door jambs.

The cross, shifted slightly to the left of center to allow for the doorway, again defines the principal vertical axis of the composition, and a pair of angels occupies the apex of the lunette. Christ's limp body is twisted away from the base of the cross in an elegant curve to the left. Joseph of Arimathaea, at center, stands with one foot on a stool and the other on the *suppedaneum* to lift Christ's lower body from the cross. The Virgin stands behind Christ with her face pressed against his, her right arm supporting his torso from beneath, and her left arm holding his left. Nicodemus, inscribed "NICHODEMVS," works energetically with pincers to pry the nails from Christ's bleeding feet. Nails from Christ's hands lie in a basket between Nicodemus and the cross. Beside the Virgin stand four mourning women, fused into a single, columnar group. The foreground figure covers her eyes with one hand; two women hold draped arms to their faces; the fourth glances sorrowfully at the empty cross shaft. On the opposite side stands John the Evangelist with arms enveloped in drapery raised to his chin.

The Aquileian iconography conforms to conventions established in Byzantine art as early as the ninth century when the Deposition appears in the Paris manuscript of the Homilies of Gregory Nazianzus.[118] In contrast to the earliest Western illustrations of the theme, Aquileia and the Byzantine images include two participants not mentioned in the biblical text: the Virgin Mary and John

the Evangelist. In the Paris manuscript, both figures stand to the right of the cross, but the standard feast image diffused throughout the East and West from the tenth to thirteenth centuries is modeled on the Crucifixion, with the Virgin and John standing at opposite ends of the composition.[119]

The Virgin's tender embrace of Christ at the Deposition, though absent from the biblical narrative, is described in a late-ninth-century sermon by George of Nicomedia and a late-tenth-century Lament of the Virgin composed by Symeon Metaphrastes.[120] Pictorial equivalents to these texts exist as early as the tenth century, including a fragmentary wall painting in the apse of the New Church at Tokali Kilise and an ivory plaque in the Hanover Museum.[121] These two works clearly stand at the beginning of the evolution of the Pietà/Deposition composition. In both cases, the Virgin still stands to one side as in the standard Crucifixion images, but she holds her head close to Christ's and takes his upper torso in her arms. A miniature in a late-eleventh-century gospel book belonging to the Morgan Library in New York comes a step closer to the Aquileia composition: here, the Virgin takes more of the burden of the corpse, supporting one arm from beneath, and she embraces him from behind rather than the side;[122] this is also the stance taken by the Virgin in the Nerezi Deposition (fig. 102).

Aquileia's more immediate model is to be found in Venice. Otto Demus has persuasively argued that the Aquileian painting copies a mosaic on the southeast pier of the central dome in the basilica of San Marco.[123] Of the original mosaic, which was uncovered in 1954 in the course of consolidation work, only two fragments survive, one depicting the angelic host and part of the empty horizontal bar of the cross from the upper portion of the composition, the second, portraying the four mourning women (figs. 130, 132).[124] While the host of seven angels was impossible for the lunette format and therefore not included in the Aquileia image, the tightly knit group of mourners has been duplicated in every respect, right down to individual gestures and facial expressions. The inclusion of four women is an important detail since only two women are normally present in twelfth-century compositions.[125]

Unfortunately the crucial focal group of Christ and the Virgin no longer survives in the Venetian mosaic. It is here that the Aquileia Deposition surpasses Middle Byzantine conventions in its emphasis on the Virgin's active role (pls. III, IV). Standing behind Christ, she no longer merely grasps one arm but actually holds Christ's upper body in her arms, her face poignantly pressed against his.[126] Thus, we see an important step toward the creation of the pietà, which was later to be excerpted from its original narrative context.[127] As I have suggested in chapter 6, the appropriation and intensification of the Byzantine Deposition image was fostered in the West by increasing attention given to the Virgin's *Compassio* or shared suffering with Christ in meditation literature and in the liturgical *Planctus*.

F5. *Threnos* (fig. 87)
(Mat. 27:59–60; Mk. 16:46–47; Lk. 23:53–56; Jn. 19:38–42)

The *Threnos* has suffered serious damage particularly in the lower quarter, and extensive paint loss has left the preparatory drawings exposed to view throughout. Thus, it is possible to see minor changes made in the landscape and a vertical line apparently drawn to aid the artist in the placement of the heads of Christ and the Virgin.

The unquestioned focus of the scene is again the juxtaposed faces of Christ and his mother. The Virgin (" . . . MARIA") embraces Christ's upper body, holding his head up to hers with one arm wrapped in his shroud and the other grasping his right arm. To the right, Joseph of Arimathaea ("IOSEPH") kneels down to hold Christ's feet. Behind him, Nicodemus ("[NI]CHODEMVS") weeps with his head propped in his hands, while John the Evangelist stoops and grasps Christ's left arm to kiss the hand. The tomb, carved into a hummock, lies open at left. From behind it emerge the four

mourners, arranged in a single row—the first shown in profile, the second with arms flung in the air in despair, the third turning away from the scene, the fourth, holding her mantle up to her face. The apex of the lunette is again occupied by the arc of heaven and a pair of angels, one gesturing to the mourners below, the other in profile, gazing upward, with arms outstretched.

Kurt Weitzmann has demonstrated that the *Threnos* image, focusing on the lament of Mary and the disciples, was gradually isolated from the Entombment narrative in manuscripts and ivories during the tenth and eleventh centuries.[128] The fully evolved compositional type on which Aquileia's *Threnos* is based, appears in an eleventh-century Vatican gospel book, Cod. grec. 1156, and on a contemporary ivory relief in the Rosgarten Museum at Konstanz.[129] These miniatures display all of the humanizing details associated with late Comnenian compositions: John kissing Christ's left hand, Joseph of Arimathaea prostrated at his feet, the mourning entourage above the tomb, and most significant of all, the tender embrace of the Virgin.

The fully developed *Threnos* composition first appears in monumental art in the second half of the twelfth century. Particularly close to Aquileia in detail and emotional tenor is the fresco in the Macedonian monastery of Saint Panteleimon at Nerezi (fig. 103).[130] Aquileia's *Threnos* is unparalleled in Western art prior to the late Dugento. When the burial sequence was portrayed, the episode of the Entombment proper was favored, as for example, at Sant'Angelo in Formis (late eleventh century), San Giovanni a Porta Latina in Rome (1191–98), or Monreale Cathedral (1180s).[131] Only in the later thirteenth and fourteenth centuries does the *Threnos* appear with any frequency in panel painting and wall painting of the West.

V. Socle

S1. Tiger and panther flanking Tree of Life (figs. 88, 89)

Beginning at the north of the eastern hemicycle wall, the first panel depicts a striped feline creature—likely a tiger—at left facing a spotted panther on the opposite side of a three-branched tree.[132] This panel is badly damaged. The upper border has been destroyed except for a small section at the far right. Only the tiger's head and part of its back, tail, and hind leg survive. Of the panther, one can make out the upper part of the head, its posterior back, hind legs, and tail.

Paired lions, panthers, and other beasts flanking a central tree are common in the repertoire of late Antique and Byzantine textiles for clothing and hangings.[133] By the later Middle Ages, however, such motifs were employed in both secular and ecclesiastical contexts. Similar motifs are found in the mosaics decorating the Norman palace of Palermo and in the presbytery floor and nave ceiling of the Cappella Palatina.[134] Closer in function to the dado panels are the stone transem reliefs from the templon of Torcello Cathedral and the gallery balustrades of San Marco in Venice.[135]

S2. Superbia and the Vices? (figs. 90–92)

The panel beneath the Dormition is badly damaged in the right half but still preserves the main lines of the composition. Slightly to the left of center squats or sits an anatomically complex figure. Facing to the right, the figure's profile head sports what appears to be either a simple crown or a low-peaked helmet with a transverse band arching over its peak.[136] The upper body is turned at a forty-five degree angle to the viewer, while the buttocks and dangling bare foot and right leg indicate that the figure's lower body faces the opposite direction. Unless these limbs belong to another overlapping figure, our crowned figure is shown in an anatomically difficult position, turning abruptly about face, with right arm thrust forward in a commanding gesture. Wearing a chiton girded high above the waist and a chlamys or cloak over the left shoulder, the figure is likely a woman.

The regal woman is approached from both sides by rather loutish-looking youths with long, flaming hair. Each is barefoot and clad only in a loin cloth. Following the woman's extended arm to the right, one finds the evident object of her attention, a youth bound with ropes. Immediately behind him emerge the front legs, mane, and belly of a crouching lion. The youth is certainly not riding the lion but rather seems to be thrown down to it by an unseen actor in the lost right-hand portion of the fresco, perhaps responding to the command of the dominatrix. To the left, two (possibly three) similarly clad youths stride toward the ruler, one of whom holds his arm around the other's back.

Kugler has associated the figure adjacent the lion with representations of Dionysius and has further argued that the bare feet of the figures support an identification of this subject with the mythological realm, albeit transposed into a medieval idiom.[137] However, the figure she identifies as Dionysius is curiously bound with ropes and does not actually ride the lion. Moreover, Kugler's interpretation fails to account for the central female figure.

The key to a new interpretation lies in this crowned, bare-footed woman. A similarly clad figure personifies Superbia in a drawing from the eleventh-century Moissac manuscript of Halitgarius's Treatise on the Eight Vices (Paris Bib. Nat. Lat. 2077, fol. 163; fig. 153).[138] What is more, in this drawing, she commands a similar array of companion Vices depicted as tumbling, half-naked louts with flaming hair.[139] The figure bound with ropes at Aquileia may be compared with the toppling figure of Superbia in the lower left corner of the drawing, lassoed by one of her colleagues.

As I indicate in chapter 7, the battle of Vices is certainly in keeping with themes of the socle zone elsewhere, including the chapel in the Abbey of Summaga, where paired Virtues and Vices appear alongside biblical exempla of spiritual combat.

S3. Saint George slaying the dragon (figs. 93, 94)

Of the panel beneath the Crucifixion only a narrow band along the upper border survives. Barely discernible in the upper left corner is the clean-shaven head of a man with tousled hair who glances off to the right; lower down nested folds of drapery cover his lower body. Projecting from behind the drapery, just below and to the right of the head, is a small beast's head apparently extending from an arm or a shaft. This might be identified as the end of a mace, for it closely resembles twelfth- or thirteenth-examples of this weapon manufactured in Iran.[140] However, it is also a common ornamental feature of Western folding thrones, or *faldistoria*.[141] Since the beast-headed maces are not as common in the West and it is difficult to see how a mace would connect with the figure's arm, it is more likely that in this case the beast head is part of a throne.

Further to the right along the lower edge of the surviving patch of fresco, there is another clean-shaven male head looking up at the enthroned figure. Because he appears at a lower level than the left-hand figure, he may be paying homage to a ruler. Continuing along the upper border, one can discern two more male figures: first, the head and shoulder of a long-haired youth facing right, and second, a knight clad in a mail hauberk and coif, who raises a dagger behind his back to face the long snout of a serpentine beast.[142]

With so much of the original composition destroyed a definitive interpretation is impossible. Enough survives, however, to suggest that the classic story of Saint George slaying the Dragon is intended for the main scene at right. This apocryphal Eastern legend is first recorded in Western Europe during the twelfth century in the wake of the Crusades.[143] Sometimes represented on foot, George is more frequently shown in Western images of the late twelfth century, as at Aquileia, mounted on horseback facing the serpentine dragon head-on or trampling it underfoot.[144] The scene at left could be identified as Saint George addressing the king, offering to dispatch the dragon, or one of the knight's many later encounters with the emperor Dacian, under whom he was martyred.[145]

S4. David playing the lyre (figs. 95, 96)

Almost the entire left-hand side of the composition in the middle bay of the hemicycle socle is destroyed, but the original focus of the panel can be made out slightly to the right of the central axis. There one can discern in the faint outlines an enthroned youth clad in a tunic and playing a lyre; a marble pilaster or colonnette to his left forms part of the throne. He is surrounded by birds and animals. At his feet sits a small dog; above his head a long curving serpent confronts a mouse. In the upper right stands a camel; in the lower right, a small, horned animal, possibly a goat. Along the upper left border are an owl perching on the branch of a tree, another bird in a tree, and a long-eared rabbit. Finally, in the bottom left corner lies a slumbering lion.

Kugler has identified this pastoral scene as Orpheus playing his lyre, observing similarities with venerable compositions from late antique floor mosaics.[146] However, Orpheus is never represented on a throne as the Aquileia figure is, and all the attributes associated with Orpheus—his youthful appearance, the playing of the lyre, the animals surrounding him in the open landscape—are equally appropriate to his Old Testament counterpart, King David. Indeed David was consciously assimilated to Orpheus in both Judaism and early Christianity.[147] Cassiodorus provides testimony for the identification of David with Orpheus in Christian theology by the beginning of the sixth century.[148] In medieval art, David appears in his Orphic guise by the Middle Byzantine period; in a series of psalters of the "aristocratic group" beginning with the Paris Psalter of the mid-tenth century, there are classicizing compositions of David playing the lyre in an open landscape accompanied by personifications and animals.[149]

Such miniatures may have provided the general model for the composition as a whole, but individual details from the Western tradition were interpolated: for example, the throne with columns supporting its seat belongs to a type employed in the eleventh-century Wulstanus Breviary in Cambridge (Corpus Christi Ms. 391), and the dog lying at David's feet recurs in a twelfth-century illustration of Peter Lombard's *Commentary on the Psalms* in Oxford (Bodleian Library, Auct. D. 2.8, fol. 1r).[150] Finally, details such as the serpent with the mouse suggest a familiarity with earlier medieval Orpheus images.[151]

S5. Crusader pursuing Saracen (pl. VI, figs. 97, 98)

The fifth panel of the fictive curtain is the most straightforward and best preserved. It portrays a Western knight on horseback pursuing a mounted archer, who turns to fire upon his adversary. The archer may be identified as a Saracen, since these archers were particularly noted for their abilities to attack their opponents while retreating.[152] Moreover, the portrayal of the archer with long unkempt hair and beard, a long tunic and salet helmet, corresponds to the type used for Saracens in Byzantine illustrated manuscripts like the Skylitzes Chronicle, recently redated to the twelfth century.[153]

The profile equestrian knight, who bears a lance-standard and kite-shaped shield, and is clad entirely in mail, corresponds to the emblematic image of noblemen and rulers in Western Europe, propagated on seals from the end of the eleventh century.[154] Quite precise dating information can be gleaned from the details of arms and armor. The mail hauberk, rendered by a series of overlapping cusps, unprotected by surcoat or metal plates, is typical of Western representations from the end of the eleventh century to circa 1200.[155] The flat-topped kite shield with a boss appears in Western art between circa 1150 and circa 1210; from 1200 on it is replaced with increasing frequency by the short equestrian shield, decorated with heraldic designs.[156] The helmet is an early form of "salet" which seems first to have appeared at the end of the twelfth century.[157] The *infulae*, or streamers, extending from the helmet can be found on aristocratic seals issued during the second

half of the twelfth century.[158] Finally, the pointed shoes with down-turned toes find comparisons in representations from the 1130s well into the thirteenth century.[159]

Although there are no specific details to connect this image with a particular conflict, it is reasonable to assume within the context of the late twelfth century that the Western knight pursuing a Saracen would generally be understood as a Crusader.

S6. Pilgrims presenting reliquary to a seated ruler (figs. 99, 100)

The panel beneath the *Threnos* is the most enigmatic of the surviving scenes. The action is focused at right where a bearded man dressed in a tunic and pointed shoes presents a squat cylindrical object to a seated official. The official likewise wears a tunic but is distinquished by his fur-lined chlamys and the *faldistorium* throne with *suppedaneum*—attributes traditionally associated with emperors, princes, and government officials. Behind the official stands a tall, long-necked bird holding a fish in its bill. The bird is usually identified as an ibis, which is known as a scavenger of dead fish, but bestiary illustrations depict this bird with squatter proportions.[160] The crane is a more likely candidate.[161]

The presenter is followed by three rugged men with unkempt, long hair and beards. Each wears an animal skin over the tunic, holds a long pointed staff in the right arm, and raises the left hand in an exclamatory gesture. Above the presenter are the remains of a short painted inscription, usually transcribed as "MARK(V)s." The name "SIMEON" was incised in the plaster above the ruler at a later date, effacing the original inscription for that figure.[162]

Various interpretations have been offered, but none explains all of the elements in any satisfactory fashion. Swoboda identified the presenter as Saint Mark on the basis of the inscription, which he read as "MARKVS"; he suggested that the evangelist was presenting his gospel—in the form of a "cista" of books—to an African ruler named Simeon at the city of Pentapolis.[163] Toesca rightly questioned the reading of the inscription and pointed out that the incised name, Simeon, was a later addition.[164] He, in turn, identified the object as a goblet and the bird, an ibis, as the personification of Egypt; on this basis he interpreted the scene as Joseph's servant returning the goblet that had been planted in Benjamin's sack. Nevertheless, there are a number of arguments against this interpretation. Toesca does not resolve the problem of the painted inscription or explain why the servant should be singled out in this way; the presumed goblet is not recognizable as such; and finally, he offers no justification for the insertion of this particular Old Testament scene within the context of the curtain.

Bettini does try to connect the scene thematically with the other panels.[165] He proposes to view the curtain as a secular romance, involving a Christian knight named "Markus." In the panel in question, the hero, labeled by the painted inscription, is apparently being brought before the ruler of a barbarian tribe. This interpretation is weak because it fails to explain the attributes of the so-called barbarian tribesmen and the object being presented to the seated ruler.

Johanna Kugler, in her dissertation, cautiously proposed to identify the panel as a tribute scene on the basis of a comparison with a clearly identified representation of tribute in Petrus de Ebulo's *Carmen de Rebus Siculis*.[166] This proposal is also suspect, for the Aquileian rustics, unlike their counterparts in the Norman manuscript, show no clear signs of submission, and the object presented to the ruler cannot easily be identified as the customary offering of money or treasure.

Finally, Giovanni Luca proposed that the panel portrays the defeated Prince Zacharias of Serbia paying tribute to King Simeon of Bulgaria in 924.[167] To arrive at this curious narrative—involving two characters who have no apparent connection with Aquileia or the Latin West—Luca ignored the discrepancy in date and technique of the two inscriptions, reinterpreted the painted inscription as (ZAC)HAR(I)VS, and tried to find a tribute scene involving the two named protagonists.

An essential key to solving the identity of this unusual scene is the object presented to the ruler (fig. 100). The object is roughly cylindrical with a slight taper toward the bottom and an ovoid top. On its side, it is decorated with what appears to be a medallion frieze; the top must be closed, since there is a meandering line extending halfway across the diameter, followed by a cross. Similar round or ovoid-shaped containers were used for both pyxides and reliquaries from the fifth to sixth centuries, but the form continued to be popular in the eleventh and twelfth centuries, executed in silver, wood, or ivory.[168] The depicted object is not unlike an eleventh- or twelfth-century reliquary in the treasury of the Sancta Sanctorum: both containers are ovoid in plan with a flat top and cylindrical base slightly tapering toward the bottom.[169] The medallion frieze on the Aquileian object could be seen as shorthand for the series of *imagines clipeatae* of saints on the silver reliquary, and the meandering line as a locking device or handle. Furthermore, the attitudes expressed by the participants toward the object seem to support its identification as a reliquary. All appear to revere the object: the presenter holds it high in the air, while the three men clad in animal skins raise their heads to follow it with their eyes and extend their left hands in a supplicatory gesture.

A second iconographic element requiring clarification is the costume of the three rustics. Animal skins, it is true, can be found in representations of shepherds in Byzantine Nativity scenes, and the hair shirt worn by ascetics like John the Baptist is approximated to the same form.[170] The Aquileian figures, though, are distinguished from ascetics and shepherds by two features: they wear a tunic underneath the skin and they hold long banded staffs. The same two attributes appear in a number of English Romanesque miniatures depicting the Journey to Emmaus. In the Bury Gospels, Christ and the apostles wear animal skins over their conventional apostolic togas and carry long, banded staffs of the kind portrayed in the Aquileia scene.[171] In the Saint Albans Psalter, Christ alone has these attributes, but he wears in addition a cap and a satchel both inscribed with a cross.[172] Unexplained by the gospel narrative, these attributes have long been identified with pilgrim's dress described in the contemporary texts of the Peregrinus passion plays.[173]

On the basis of the identification of these two elements of the composition, it appears that the subject of this panel is the presentation of a reliquary pyx to a ruler by a band of pilgrims. The indication of specific names in this panel (fig. 100) suggests a historical event connected with Aquileia itself, but this remains to be determined. It should be noted that the present state of the crucial inscription leaves open a wide range of possibilities for identification. Only the middle letters AR and the terminal s are clear; the letter preceding AR could be an M, N, V, or W, and there is enough space for one or two additional characters. The letter following AR has a clear, perpendicular stroke which might belong to a B, D, E, F, H, I, K, L, P, or R. The simplest alternatives for the name include MARKVS, MARIVS, and EDWARDVS.

S7. Group of knights on horseback (fig. 101)

The last panel on the hemicycle wall is badly damaged, and a large, ugly audio box with its electric wire cuts through the center of the fresco. Here are depicted seven or eight knights on horseback, galloping off to the right.[174] The best-preserved section at left indicates the setting with a single tree and shows a pair of equestrian knights, clad in mail and armed with lances. Near the center of the panel, one knight moves out of formation to lower ground, perhaps to challenge an unseen adversary. Finally, at the far right are preserved the rear end of a horse and above, three heads of knights, which disappear behind the right border of the panel.

Although different conventions are used to portray the pattern of the mail,[175] these knights are attired much like the knight of S5 in long mail hauberks with coifs and are armed with lances. The helmets are of two different types—simple round-topped helmets and brimmed chapel-de-fer helmets—paralleled in Western representations from the late eleventh to the thirteenth centuries.[176]

S8, S9. Fragmentary panels, west side

 The two panels flanking the west absidiole have all but been destroyed and are now largely concealed from view by the reliquary cases installed in the late 1960s. Of the northern panel beneath the scene identified above as the Translation of Relics, only a small portion of the lower red boundary survives. On the south side, most of the seven swags of the lower hem of the curtain are visible, and up from the hem, the tail of a feline animal and the trunks of two trees.

Giandomenico Bertoli's Description of the Crypt, 30 April 1724

GIANDOMENICO BERTOLI, the great eighteenth-century antiquarian of Aquileia and the founder of its museum, provides only a brief description of the crypt and two engravings of scenes that are still well preserved in his published work, *Le antichità di Aquileia profane e sacre* of 1739. However, he gives a much more detailed description of the "barbare pitture" in a previously unpublished letter in the archives of the Archiepiscopal Seminary of Udine.[1] Writing to his good friend, Cardinal Giusto Fontanini, on 30 April 1724, he speaks first of the lunette panels on the hemicycle wall and then of the better preserved scenes on the ceiling. Nine drawings of these scenes originally accompanied the letter, but they are unfortunately lost. He makes no reference to scenes in the central aisle or from the intercolumniations because they were then hidden from view by the "cassone di ferro" which was constructed at the end of the fifteenth century. The document is transcribed here in full, followed by a brief commentary on its implications for the iconographic program.

Letter to Cardinal Giusto Fontanini

Ill(ustrissi)mo et R(everendissi)mo Sig(nore) Sig(nore) Prov(veditore?) Colmo

Questa volta io mi onorerò di raccontar a V(ostra) S(antità) Ill(ustrissi)ma e R(everendissi)ma le barbare pitture antiche, che infino ad ora sussistono sui muri della Capella, che è sotto il coro della cattedrale di Aquileia, dove si conservano le sante Reliquie, eccettuate alcune di esse, che troppo sono disguisate e consumate dal tempo per poterle ben distinguere o ravvisare; avendone anche fatto copia di alcune delle meglio conservate che sono le qui annesse. Questa Capella dalla parte del muro, che la circonda, è sostenuta da otto colonne appoggiate a detto muro, et in mezzo da altre sei piantate intorno al cassone di ferro dove stanno le Reliquie e sopra i capitelli di ogni colonna vi è dipinto un santo. Sotto e infra gli archi delle colonne appoggiate al muro vi è dipinta la Passione di Christo: cioè, sotto un'arco quando lo flagellano; sotto un altro quando lo pongono in croce; altrove quando sta in croce; quando velo levano, quando velo seppeliscono & nelle quai pittore non vi è cosa di più osservabile, che la rozzezza loro.

I. Nella volta di questa capella, nel primo ingresso giù della scala alzando gli occhi, vi si vedono dentro uno spazio quadrato tre figure: una delle quali è San Pietro, leggendovisi sopra il di lui capo s. PETRVS, che consegna colla sinistra il pastorale, fatto come quello antichissimo che si conserva nel cassone delle Reliquie, a Sant'Ermagora, presso il cui capo stà scritto così s. HERMAG

<div align="center">

O

R

AS

</div>

ed è vestito appunto come quello che è dipinto nel coro, e come Popone. San Pietro gli pone la mano sul capo per benedirlo o consagrarlo, colle due *dita minori chiuse*: aggiungo questa particolarità delle *due dita chiuse*, perche, come vedrà qui sotto, osservo che altrove solenno benedire col *solo anulare chiuso*: rito da me più non inteso, o capriccio insolente del pittore. Alle spalle poi di Sant'

<div align="center">

120

</div>

Ermagora vi si vede San Marco, leggendovisi presso il di lui capo s. MARCVS, che colla sinistra stringe un volume, che sarà l'Evangelio suo.

II. Nel quadro sequente, di cui ne ho fatto la qui annessa copia segnata II. vi si vede San Marco colla sinistra appoggiata a(d) un bastone, e colla destra in atto come di benedire col solo *dito anulare chiuso*. Nel mezzo vi è una figura vestita da Principe, che colla sinistra stringe il braccio sinistro di Sant'Ermagora, il cui nome gli vi si vede alle di lui spalle; e vi si vedono anche altre tre figure più in dietro come nella copia. Il Principe non saprei chi potesse essere ne che azione rappresentono queste figure.

III. Vi è in altro quadro Sa(n) Marco, che pare che predichi a tre uomini.

IV. Vi si vede poi San Pietro sedente, che consegna il pastorale a Sant'Ermagora stante.

V. Vi seguita poi quello, che ho copiato nella carta segnata V., in cui si vedono i santi Ponciano, Gregorio et Alessandria, come si conosce dai nomi, che gli stanno sopra il capo, i quali seppeliscono due corpi senza capo; e due santi avanti Alessandria, che più bassi stanno forse inginochiati; ed uno che incensa col turribulo.

VI. Nel quadro seguente vi è un carnefice, che taglia la testa a San Fortunato, dopo aver tagliata quella di S. Ermagora, il cui capo si vede separato del busto; ed è bendato gli occhi, come anco quello di San Fortunato, sopra cui lascia il manigoldo cadere il colpo; e vi si leggono a scritti i lor(o) nomi presso alle teste di ambedue.

VII. Nel settimo vi è San Fortunato, leggendovisi vicino alla di lui testa s. FORTVNATVS, che benedice o battezza una donna, presso alla quale stà scritto ALEXANDRIA, la quale è mezza imersa in cosa, che rassomiglia pozzo, e la benedice col solo *anulare chiuso*, e cogli altri stesi, stringendoli colla sinistra, il destro braccio; rito pratticato forse sempre in questa funzione, come si vede anco nella copia segnata IX.

VIII. Nel ottavo vi è Sant'Ermagora, che benedice, o crea Diacono San Fortunato.

IX. Nel nono parimente si vede Sant'Ermagora, che come dissopra battezza *col solo anulare chiuso* San Gregorio stringendoli colla sinistra il braccio destro; e altre figure parimente nel pozzo, come nell'anessa copia segnata IX. con altre figure senza nome nel pozzo.

A queste pitture barbare aggiungo una iscrizione barbarissima,[2] che ebbi negli ultimi giorni della mia dimora in Aquileia; cioè prima, che nel timor del seratta de passi e della peste mi convenisse di seguitare fuga di tutte le monache, e di tutti li Canonici, alla riserva del solo C(olonell)o Frangipani, che ha il suo domic..(sic) domicilio in stato Austriaco. Fuga che interruppe miei disegni di far delle cave nei campi di Aquileia dopo che io avea già ottenuto una licenza da S(ua) E(ccellenza) il Sig(nor) Capitanio di Gorizia di poter cavare. Mi fu, dico, portata questa barbara pietra da riporre nella mia conserva di laggiù: nella quale benche io vi abbia posta tutta la diligenza et accuratezza nel copiarla, non mi è riuscito non solo di poterla leggere, ma ne meno di sapere da qual parte debba incominciarsi a leggerla • Ne credo, che le risposte degli oracoli, o gli enigmi della sfinge mi potreggero riuscire così imbrogliati e dificili come questo frammento, che copierò qui sotto acuratamente. (Here, Bertoli transcribes the text of a Hebrew inscription, upside down.)

Aggiungo la copia di una piccola medaglia d'argento, avenuta in Aq(uilei)a, che mi riesce nulla meno dificile della sovraposta iscrizione. E mi rassegno in tanto con ogni maggior divozione A V(ostro) S(ignore) Ill(ustrissi)mo e R(everendissi)mo. Divotis(si)mo Umil(issi)mo S(ervitore?), Giand(omeni)co Bertoli.
Mereto (di Tomba, Friuli), 30 aprile 1724

Commentary

Despite his lack of enthusiasm for medieval wall painting, Bertoli does provide us with a valuable record of the state of the wall paintings in the crypt some two hundred years prior to the earliest

modern study of the crypt by Niemann and Swoboda. We learn that parts of the decoration were already destroyed or illegible by the beginning of the eighteenth century: ". . . alcune di esse, . . . troppo sono disguisate e consumate dal tempo per poterle bene distinguere o ravvisare." We also hear that the iron fence, removed in the 1950s, was then in place, screening off the central aisle where the relics were kept. Most interesting for our purposes is the account of the scenes that could still be seen in the lunette panels and on the ceiling. As I shall demonstrate, this description is not entirely trustworthy and poses more questions than it answers concerning the lost parts of the decoration.

Bertoli describes a cycle of the Passion of Christ located "sotto e infra gli archi delle colonne appoggiate al muro." Here he probably refers exclusively to the lunettes of the hemicycle wall, since there are no engaged columns on the west wall.[3] Five scenes are mentioned in rapid succession: the Flagellation, the Elevation of the Cross ("quando lo pongono in croce"), the Crucifixion ("quando sta in croce"), the Deposition ("quando velo levano"), and the Entombment ("quando velo seppeliscono"). Only three can positively be identified with surviving lunettes on the hemicycle wall: the Crucifixion, Deposition, and Entombment (figs. 84–87). The hagiographic scenes of the central lunette are omitted, presumably because Bertoli was primarily interested in the Passion cycle which he could easily identify. The Dormition (fig. 83) may likewise have been omitted because it was an anomaly, but it is also the most poorly preserved of all the surviving lunettes and would therefore have been difficult to see without adequate lighting. The remaining two scenes mentioned by Bertoli do not correspond to any of the extant lunettes. Assuming that Bertoli was reading the scenes from left to right, following the order of the three clearly identified Passion scenes, it is possible that a composition of the Flagellation once decorated the lunette to the left of the Dormition and that Bertoli filled in the gap between the Flagellation and Crucifixion with an episode known to him from a sixteenth-century Venetian painting. If Bertoli actually did see an image of the Raising of Christ on the Cross, it might have been a later work covering the Dormition; but there is no trace of later painting anywhere in the crypt and no written documentation of such an undertaking.[4] It might also be argued that an Elevation of Christ on the Cross was painted as part of the original feast cycle in one of the Western lunettes or in the last lunette of the hemicycle wall adjacent the Threnos, but this would place the episode out of sequence both in the intended programme and in Bertoli's description. Furthermore, it seems unlikely that either the Flagellation or the Raising of Christ on the Cross could have formed part of the medieval feast cycle at Aquileia. Neither episode belongs to the standard Byzantine repertoire upon which the designer of the Aquileia program relied in the selection and iconography of individual scenes that have survived. Moreover, both episodes are absent from monumental programs, both Byzantine and Western, prior to the fourteenth century.[5]

In sum, it seems unlikely that either the Flagellation or the Elevation of the Cross could have been part of the original decoration. Whether or not some of the lunettes were painted over with new scenes corresponding to Bertoli's description is a moot point. On the basis of architectural evidence, it is likely that the terminal lunettes of the hemicycle wall were pierced with windows prior to the execution of the current decoration, thus leaving only a small free wall surface on either side suitable for single standing figures rather than narrative scenes.[6]

Nine scenes from the saint's life are described in greater detail. The order of Bertoli's account is dictated not by the narrative of the *vita* but by his own perception of scenes as he moves counterclockwise from the southwest entrance, around the then-enclosed treasury of the central aisle. The antiquarian's ignorance of the facts of the Marcian legend—somewhat surprising in light of the attention given to it by Venice in the debates leading up to the suppression of the patriarchate in

1767—is manifested both by the sequence in which he presents the scenes and by his inability to identify them properly even when he could make out specific details.

He begins with the first legible scene over the south aisle, the Consecration of Hermagoras by Peter (pl. II; fig. 62). Although he does not identify the scene as such, he records accurately the action—Peter consigning the crozier to Hermagoras—and the inscriptions identifying the three figures. He seems primarily interested in the different gestures of blessing here and elsewhere in the decoration, but he also makes the pertinent observation that the crozier resembles the one believed to belong to Hermagoras conserved in the treasury.[7]

In the second scene mentioned, the Election of Hermagoras (fig. 60), Bertoli is able to identify only the figure of Mark, even though the inscription of Hermagoras survives. He describes the third scene, Mark confronted by the citizens of Aquileia (fig. 59), as Mark preaching—an understandable identification in the absence of specific iconographic details for this episode. The Commission of Mark, scene IV (fig. 57), is mistakenly described as another consecration of Hermagoras. Again, Bertoli may be forgiven this lapse, since the inscriptions are not easily legible, but a knowledge of the *vita* would surely have allowed him to sort out the problem of duplication. In his description of the Entombment of Hermagoras and Fortunatus, scene V (fig. 81), his inability to make out details of iconography under poor lighting conditions is manifested by his curious reading of the two disembodied heads as two shorter figures of saints, "perhaps kneeling." He again shows an ignorance of the *vita*, calling Pontianus, Gregory, and Alexandria saints. Scene VI, the Martyrdom of Hermagoras and Fortunatus (fig. 80), is properly identified with its inscriptions. The next scenes (VII–IX) are likewise accurately described with the aid of the inscriptions respectively as the baptism of a woman named Alexandria (fig. 79), Fortunatus made deacon by Hermagoras (fig. 78), and the Baptism of Gregory (fig. 77). At this point, Bertoli leaves off his description of the crypt to transcribe an unrelated "iscrizione barbarissima" in Hebrew, which he is unable to read.

Thus, the letter adds little to our knowledge of the iconographic program of the crypt. Concentrating on the scenes that are still in a good state of preservation, it merely confirms that the current gaps were the result of damage suffered prior to the eighteenth century. With improved lighting available and the advantage of seeing the crypt after cleaning and the removal of the iron screen, we are indeed in a better position to observe the decoration than Bertoli.

NOTES

Introduction

1. On *praesentia* see P. Brown, *The Cult of the Saints: Its Rise and Function in Latin Christianity* (Chicago, 1982), 86–105.

2. Peter the Venerable, "Sermo in honore sancti illius cuius reliquiae sunt in presenti," ed. G. Constable, "Petri Venerabilis Sermones Tres," *Revue bénédictine* 64 (1954): 265–72. Cited and translated by C. Bynum, *Fragmentation and Redemption. Essays on Gender and the Human Body in Medieval Religion* (New York, 1991), 239–97, esp. 263–65.

3. For a useful overview, see B. Abou-el-Haj, *The Medieval Cult of Saints: Formations and Transformations* (Cambridge, 1994), 7–32; and J. Fontaine, "Hagiographie et politique, de Sulpice Sévère à Venance Fortunat," *Revue d'Histoire de l'Eglise de France* 62 (1976): 113–40.

4. P. Sheingorn, *The Book of Sainte Foy* (Philadelphia, 1995), esp. 4–21.

5. For James, see Abou-el-Haj, *The Medieval Cult of Saints*, 19–22. For Martial of Limoges, see D. F. Callaghan, "The Sermons of Adémar of Chabannes and the Cult of St. Martial of Limoges," *Revue Bénédictine* 86 (1976): 251–95. On Cyrus of Pavia, see A. M. Orselli, "La città altomedioevale e il suo santo patrono," *RSCI* 32 (1978): 47ff.

6. For the role church officials played in the cult of the saints, see T. Head, *Hagiography and the Cult of Saints: The Diocese of Orléans, 800–1200* (Cambridge, 1990), esp. 15–19; Brown, *The Cult of the Saints*, 8–10, 31–49.

7. See Dale, "Inventing a Sacred Past," 53–104 and chap. 1 below.

8. G. de Renaldis (*Della Pittura Friulana* [Udine, 1798], 6) already speaks of the "gusto greco-barbaro." The first modern publication of the crypt describes Byzantine "influence" more favorably as an outgrowth of the Benedictine revival of the arts at Montecassino in the late 11th century: H. Swoboda in *Der Dom*, 93–94.

9. Toesca, "Gli affreschi," esp. 47–48.

10. Valland, *Aquilée*.

11. Morgagni Schiffrer, "Gli affreschi della cripta"; eadem, "Gli affreschi medioevali," 323–48; Kugler, "Die Kryptafresken"; eadem, "Byzantinisches und Westliches," 7–31.

12. The same conclusions are championed in subsequent literature. See Demus, *Romanesque Mural Painting*, 306–8; Gioseffi and Belluno, *Aquileia*, esp. 45f.; G. Suitner, *Le Venezie*, Italia Romanica, 12 (Milan, 1991), 152, 171.

13. J. Baschet, *Lieu sacré, lieu d'images. Les fresques de Bominaco (Abruzzes, 1263)—Thèmes, Parcours, Fonctions* (Paris/Rome, 1991), esp. 5–10; M. Kupfer, *Romanesque Painting in Central France: The Politics of Narrative* (New Haven, 1993), esp. 1–25; H. Toubert, *Un art dirigé: réforme grégorienne et iconographie* (Paris, 1990).

14. This is also of course the basic tenet of the medieval exegesis of texts. See H. de Lubac, *Exégèse médiévale*, 1 (Paris, 1959), 43ff.

Chapter One. History and Hagiography

1. *AASS*, Julii, vol. III, ed. J. Carnandet, 238ff. The earliest surviving texts of the legend are contained in 11th- or 12th-century liturgical manuscripts, the passional in the Bibliothèque de la Ville, Namur (Codex 53), and in the Aquileian breviaries of the Biblioteca del Museo Archeologico at Cividale del Friuli (Codex 91) and the Biblioteca Guarneriana in San Daniele del Friuli (Codex 4). Published respectively in *AnalBoll* 2 (1883): 311ff.; and Egger, "Der heilige Hermagoras" (1947), 16ff. (esp. 40–55) and (1948), 208ff.; G. Vale, *I Santi Ermacora e Fortunato nella liturgia* (Udine, 1910); and G. C. Menis, "La 'Passio' dei santi Ermacora e Fortunato nel codice n. 4 della Biblioteca Guarneriana," *Studi di letteratura popolare friulana* 1 (1969): 15–49. An abbreviated account of the legend was in existence by the time of the Synod of Mantua in 827 (*MGH, Legum*, Sectio

III: *Concilia*, Tom. II: *Concilia aevi karolini*, I, pars. I, 583–89). For a slightly later version, see Rajko Bratož, *Krščanstvo u Ogleju in na Vzhodnem območju oglejske Cerkve od Začetkov do Nastora verske svobode* (= Christianity in Aquileia and the eastern influential area of the Aquileian Church from its beginnings to the introduction of religious freedom), Serbo-Croatian with English summary (Ljubljana, 1986), 357ff.

2. Cf. Dale, "Inventing a Sacred Past," 47–87.

3. On Mark's career and the development of later legends, see A. Niero, "Marco, Evangelista, santo," *Bibliotheca Sanctorum*, VIII, cc. 711–38; S. Tramontin, "Origini e sviluppi della leggenda marciana," in *Le origini della Chiesa di Venezia*, ed. F. Tonon (Venice, 1987), 167–86; A. Niero, "Il culto di S. Marco (da Alessandria a Venezia)," *AntAltAdr* 38 (1992): 15–40.

As Tramontin ("Origini e sviluppi," 167–69) points out, the Aquileian tradition was first questioned by Pio Paschini in 1904, and subsequent scholarship has followed Paschini's lead. A notable exception is Giorgio Fedalto: see, e.g., "Dalla predicazione apostolica in Dalmazia ed Illirico alla tradizione Marciana Aquileiese: considerazioni e problemi," *AntAltAdr* 26 (1985), 1:237–59.

4. According to the catalogue, Hermagoras was succeeded by Hilarius (d.284?); then followed Saint Chrysogonus (d.302/3) whose remains are venerated in Rome, and Chrysogonus II, the immediate predecessor of Theodore. See Picard, *Souvenir*, 402ff., 411ff.; and E. Klebel, "Zur Geschichte der Patriarchen von Aquileja," *Beiträge zur älteren europäischen Kulturgeschichte* (Klagenfurt, 1952), 1:396–422. Egger ("Der heilige Hermagoras" [1947], 29ff.) proposed the now generally discredited theory that Hermagoras was invented by scribal error in the copying of earlier texts during the compilation of the fifth-century work. Armigeri and its variant, Armageri, he argues, are merely corruptions of the name of the Pannonian martyr Hermogenes (Ermodori, Hermogerati) commemorated with another Fortunatus on 23 August. This theory is improbable for three reasons: (1) the archaic forms of Hermagoras and Hermogenes are different enough to make it unlikely that one is merely a corruption of the other; (2) the commemorations for Hermagoras and Hermogenes appear at distant points in the calendar; (3) Hermagoras never entirely superseded Hermogenes: both saints enjoyed independent cults at Aquileia throughout the Middle Ages. His theory is accepted by Demus, *The Church*, 30ff. and Kugler, "Kryptafresken," 115ff.

5. Theodore's activities as bishop of Aquileia are documented in the proceedings of the Council of Arles in 314 and in mosaic inscriptions in the floors of the double cathedral. See the series of studies, *Aquileia nel quarto secolo*, in *AntAltAdr* 22 (1982) and C. Cecchelli, "Gli edifici e i mosaici paleocristiani nella zona della Basilica," in *La Basilica*, 107ff.

6. Egger, "Der Heilige Hermagoras" (1947), 19ff.

7. The earliest reference to the cult of Hermagoras and Fortunatus is found in the fifth century "Martyrologium Hieronymianum": *Martyrologium Hieronymianum*, in *AASS*, Novembris, II, pars prior, 90. See S. Tavano, "Storicità dei martiri aquileiese alla luce di recenti scoperte archeologiche," *Voce Diocesana di Gorizia* 26–27 (1962); P. Paschini, "Le fasi di una leggenda Aquileiese," *RSCI* 8 (1954): 162ff. and Egger, "Der heilige Hermagoras" (1947), 27ff. The diffusion of the cult of Hermagoras within the ecclesiastical province of Venetia and Istria is corroborated as early as the late fifth or sixth century by the construction of a church dedicated to the Aquileian patrons at Flur Samagher ("the place of Saint Hermagoras") near Pola. See G. Cuscito, "I reliquiari paleocristiani di Pola," *MemSocIstrArch StorPatr* 20–21 (1972–73): 91–126; Egger, "Der heilige Hermagoras" (1948), 225f.; A. Gnirs, "La basilica ed il

reliquiario d'avorio di Samagher presso Pola," *MemSocIstrArchStorPatr* 24 (1908): 5–48.

8. On this genre of apostolic foundation myth, see Egger, "Der heilige Hermagoras" (1948), 230–32; Demus, *The Church*, 3–7, 30ff; Picard, *Souvenir*, 560–64, 689f.

9. T. Kane, *The Jurisdiction of the Patriarchs of the Major Sees in Antiquity and in the Middle Ages*, Canon Law Studies, 276, (Washington, D. C., 1949), esp. 3–31; H. Fuhrmann, "Studien zur Geschichte mittelalterlicher Patriarchate, I. Teil," *ZSav* 70 (1953): 112–76, esp. 112–42; V. Peri, "Aquileia nella trasformazione storica del titolo patriarcale," *AntAltAdr* 38 (1992): 41–63.

10. W. Lenel, *Venezianisch-Istrische Studien*, Schriften der Wissenschaftlichen Gesellschaft in Strassburg (Strasbourg, 1911), 100ff.; H. Fuhrmann, "Studien zur Geschichte mittelalterlicher Patriarchate, II. Teil," *ZSav* 71 (1954): 1–84, esp. 49–50; Peri, "Aquileia," 54–56.

11. H. Schmidinger, *Patriarch und Landesherr. Die weltliche Herrschaft der Patriarchen von Aquileia bis zum Ende der Staufer* (Graz and Cologne, 1954); S. Tavano, *Aquileia cristiana* (Udine, 1973) (= *AntAltAdr* 3 [1972]), esp. 11–16; G. Biasutti, "Aquileia e la Chiesa di Alessandria," *AntAltAdr* 12 (1977), 1:215–29.

12. *La tradizione marciana Aquileiese* (Udine, 1959), 39, n. 16.

13. Cf. Demus, *The Church*, 10; Tramontin, "Origini e sviluppi," 173.

14. Egger, "Der heilige Hermagoras" (1948), 226. Though Sergio Tavano and Giuseppe Cuscito reject Egger's thesis that Hermagoras was invented by scribal error, they concur with his view that the legend was created in conjunction with the Aquileian Schism. See S. Tavano, "Il culto di San Marco a Grado," *Scritti Storici in Memoria di Paolo Lino Zovatto* (Milan, 1972), 202–3; G. Cuscito, *Il primo cristianesimo nella "Venetia et Histria"—indagine ed ipotesi* (Udine, 1986), 2ff. and idem, "I reliquiari," 106. Most other Italian scholars distinguish between the dating of the Marcian tradition to the sixth century and the *Passio* text, connecting Mark and Hermagoras, to the eighth century. See most recently Tramontin, "Origini e sviluppi," 167ff. with previous bibliography. Among the more important exponents of this theory, see Paschini, "Le fasi," 161–84.

15. See G. Cuscito, "Aquileia e Bisanzio nella controversia dei Tre Capitoli," *AntAltAdr* 12 (1977): 231–262.

16. According to Egger ("Der Heilige Hermagoras" [1948], 226) Pelagius voices opposition to the presumed Aquileian claim to apostolicity in his letter of 558/60 to the Venetian patrician John, when he refers to the "confictes approbationes" of bishop Paulinus. Cf. Epistola 24, "Pelagius Iohanni Patricio Caburtario," in *Pelagii I Papae: Epistulae quae supersunt*, ed. P. Gassó, Scripta et Documenta, 8 (Montserrat, 1956), line 5.

17. Epistola 24, in *Pelagii I Papae*, ed. Gassó, 73–74: "Peto utrum aliquando in ipsis generalibus quas veneramur synodis vel interfuerit quispiam Ven-

etiarum, ut ipsi putant, atque Histryae pat(r)iarc(h)a, vel legatos aliquando direxerit. Quod si hoc, nec confictis quidem approbationibus, nulla rerum poterit ratione monstrari, discant aliquando non modo se generalem ecclesiam non esse, sed nec generalis quidem partem dici posse, nisi, cum fundamento apostolicarum adunata sedium, a praecis(s)ionis suae ariditate liberata, in Christi membris coepit numerari. . . ."

18. The absence of Aquileian pretensions to apostolicity at this time is further corroborated by a friend and guest of Patriarch Paulinus, Venantius Fortunatus. In his *De vita sancti Martini*, he speaks of the veneration of the Cantiani martyrs and a certain Fortunatus there but neglects to mention either Mark or Hermagoras. Venantius Fortunatus, *De vita sancti Martini*, 4 in *Honorii Clementiani et Fortunati Operum*, lines 658–64 (*PL* 88:424–25). The saint named Fortunatus is probably the companion of Saint Felix, to whom a church was dedicated outside the walls of the city.

19. For a convenient summary, see Demus, *The Church*, 30–44.

20. See W. Dorigo, "L'architettura della basilica patriarcale di Aquileia," *AntAltAdr* 23 (1992): 191–213; S. Tavano, "San Paolino e la Sede Patriarcale," *AntAltAdr* 32 (1988): 268ff.; Brusin and Lorenzoni, *L'arte del Patriarcato*, 19ff.

21. Cf. Lenel, *Venezianisch-Istrische Studien*, 100ff.; and C. G. Mor, "Riflessi politici nelle 'Titulationes' della Basilica di Aquileia," in *Geschichte und ihre Quellen: Festschrift für Friedrich Hausmann zum 70. Geburtstag*, ed. R. Hartel (Graz, 1987), 93–97. The first reference to the title from this period appears in the *Historia Langobardorum* composed in the 780s by the Friulian chronicler Paul the Deacon, who attributes the innovation to Paulinus I (*Historia Langobardorum* [= *De Gestis Langobardorum*], Bk. II.10, ed. in *MGH*, *Scriptores Rerum Germanicarum*, XLVIII, 92). On the other hand, an outsider, Notker Balbulus, comments on the novelty of the patriarchal title in his *Gesta Karoli Magni Imperatoris*, composed in the mid-9th century (ed. H. Haefele in *MGH*, *Scriptores Rerum Germanicarum*, n.s. XII, 85, lines 14–15).

22. *MGH*, *Scriptores*, II, 260–70.

23. Ibid., 261, lines 12–14: "Marcum vero, qui praecipuus inter eius discipulos habetur, Aquileigiam destinavit, quibus cum Hermagoram, suum comitem, Marcus praefecisset, ad beatum Petrum reversus, ab eo nihilominus, Alexandriam missus est."

24. Thereafter, Carolingian diplomas confirm unequivocally the patriarchal title and its supporting apostolic foundation. In 792 one diploma refers to Paulinus II as "vir venerabilis Paulinus sanctae Aquileiensis ecclesie patriarcha, que est in honore sanctae dei genitricis semperque virginis Mariae vel sancti Petri principis Apostolorum sive sancti Marci constructa," while another calls Paulinus "patriarcha Aquilegiensis ecclesie que est in honore sancti Petri principis apostolorum vel sancti Hermachore martiris Christi constructa." See *MGH*, *Diplomata Karolinorum*, I, nos. 174 and 175.

25. *MGH*, *Concilia aevi karolini*, I, pars 1, 589.

26. H. Kretschmeyer, *Geschichte von Venedig*, 3 vols. (Gotha, 1905–20), 1:51–66; R. Cessi, *La Storia della Repubblica di Venezia*, 2 vols. (Milan, 1944), 1:22–40.

27. Cf. A. Pertusi, "L'impero bizantino nell'alto Adriatico," in *Le origini di Venezia* (Florence, 1964), 59–93, rpt. in *Saggi Veneto-Bizantini*, Civiltà veneziana, Saggi 37 (Venice, 1990), 33–65, esp. 48–51.

28. The anti-Aquileian argument of the translation was first recognized by A. Gfrörer, "Storia di Venezia dalla sua fondazione fino all'anno 1084," *Archivio veneto* 13 (1877): 291–349, esp. 331. Cf. Kretschmeyer, *Geschichte von Venedig*, 1:65; Cessi, *Storia della Repubblica di Venezia*, 1:37; Demus, *The Church*, 34f.; P. Geary, *Furta Sacra: Thefts of Relics in the Central Middle Ages*, 2nd ed. (Princeton, 1990), 88–94. For the translation's significance as a statement of autonomy from Byzantium, see G. Pavanello, "San Marco nella leggenda e nella storia," *RivVen* 7 (1928): 293–324, esp. 294; Demus, *The Church*, 20–21; Geary, *Furta Sacra*, 91–92.

29. *MGH*, *Legum, Sectio IV: Constitutiones et Acta Publica Imperatorum et Regum*. no. 38, 82–84. Pope John XIX's bull confirms Aquileia's metropolitan title and condemns the false appropriation of the patriarchal title by Grado: "confirmamus vobis vestrisque successoribus Patriarchatum sanctae Aquilejensis Ecclesiae fore Caput, et Metropolim Super omnes Italiae Ecclesias, quoniam ante omnes constitutam, et in fide Christi fundatam fuisse cognoscimus. . . . Nec non confirmamus vobis vestrisque successoribus Insulam, quae Gradus vocatur cum omnibus suis pertinentiis, quae barbarico impetu ab eadem Aquilejensi Ecclesia subtracta fuerant, et falso Patriarchali nomine utebatur. . . ." Ughelli, *Italia Sacra*, 5:cols. 49–50. P. F. Kehr, *Regesta Pontificum Romanorum, Italia Pontificia*, 7: *Venetia et Histria*, pars I (Berlin, 1923), nos. 29, 53.

30. On the vicissitudes of the relics, see V. Joppi, "Le sacre reliquie della chiesa patriarcale d'Aquileia," *ArchStorTrieste* 3 (1884–86): 195–223. For the invasion, see Andrea Dandolo, *Chronica per extensum descripta*, IX.37, ed. by E. Pastorello in L. A. Muratori, *Rerum Italicarum Scriptores*, 2nd ed. (Bologna, 1939), vol. 12, pt. I, fasc. 3, 209–10. Revealing his Venetian bias, Dandolo refuses to allow that any relics were recuperated by Poppo. The Aquileians, for their part, explicitly record the relics of Hermagoras and Fortunatus in the dedication inscription in the apse, originally painted in 1033, and later in an altar dedication in the crypt in 1058. More explicitly, in 1077, two diplomas of Emperor Henry IV record donations to the church of Aquileia "in which the relics of Saint Hermagoras rest, as is manifested by miracles." See Ughelli, *Italia Sacra*, 5:57; cited in Joppi, "Sacre reliquie," 201–2.

31. Vale, *I santi Ermacora e Fortunato*, 10–11.

32. The Acts for September to October 1028 mention the votive offering of Abbot Ossiach of 12 denare per year on the festival of Saint Hermagoras "super altare eius." Cited by G. Vale, "La liturgia della basilica," in *La Basilica*, 51–52.

33. Ughelli, *Italia Sacra*, vol. 5, col. 51A: "idem roman(us) summus pont(ifex) de gratia apostolica concessit indulg(entiam) c(entorum) ann(orum) et c(entorum) dier(um) singulis annis ominib(us) vere poenitent(ibus) et confess(is) dictam Aquilejensem Ecclesiam visitantibus causa devotionis, et in festo dictorum Martyrum Hermach(orae) et Fort(unati) et per octavas eorum. . . ." Kehr (*Italia Pontificia*, vol. 7, pt. 1, 47, nos. 2 and 3) classifies the indulgence recorded in two inscriptions, from the 14th and 15th centuries, as spurious apparently because it is not recorded in the apse inscription.

34. *Necrologium Aquileiense*, ed C. Scalon, in Fonti per la Storia della Chiesa in Friuli, 1 (Udine, 1982): "(25) XVII. c.VII Kal. Marci Evangeliste Passion. Letania Maior. Dedicatio Altaris SS. Martyrum Hermachore et Fortunati."

35. Ughelli, *Italia Sacra*, 5:cols. 1113–15.

36. P. Jaffé, ed., *Regesta Pontificum Romanorum*, 2 vols. (Leipzig, 1885), 1:545, no. 4295.

37. P. Paschini, "I patriarchi di Aquileia nel secolo XII," *MemStorFor* 10 (1914): 113–81. For a fuller discussion of Ulrich's career, see below, chap. 5.

38. On the suppression of the patriarchate of Aquileia see G. Fedalto, "La fine del patriarcato di Aquileia," *AntAltAdr* 38 (1992): 115–36.

Chapter Two. The Architectural Setting of the Relics

1. The inscriptions found in the crypt are described in an unpublished letter of Giandomenico Bertoli to Cardinal Giusto Fontanini, Udine, Biblioteca del Seminario Arcivescovile, Mss. Fontanini, Vol. XIX, 8 June 1721. On the general use of antique spoils in the basilica, see M. Buora, "I patriarchi di Aquileia e la sopravvivenza della cultura materiale dell'antichità," *AntAltAdr* 38 (1992): 265–79.

2. On the Theodoran complex see L. Bertacchi, "Il complesso basilicale: impianti romani ed edifici teodoriani," in *Da Aquileia a Venezia* (Milan, 1980), 185–221; M. Mirabella Roberti, "Considerazioni sulle aule teodoriane di Aquileia," in *Studi Aquileiesi in onore di G. Brusin* (Padova, 1953), 209–44; F. Franco, "Un'interpretazione architettonica del complesso teodoriano di Aquileia," *Atti del I congresso internazionale di studi longobardi*, Spoleto, 1952, 331ff.; F. Forlati, "L'architettura della basilica," in *La Basilica*, 273–98 with previous bibliography. For the early history of excavations in Aquileia, see Cecchelli, "Gli edifici e i mosaici paleocristiani," 109–18.

3. Also known as the basilica "cromaziana" (after the Patriarch Chromatius, 388–407/8) or "postattilana" (after the invasion of Attila in 452). For the preliminary excavation report, see L. Bertacchi, "La Basilica postattilana di Aquileia," *AqN* 42 (1971): 15–55. Bertacchi has presented compelling arguments for the attribution of the post-Theodoran construction phase to Nicetas or his immediate successor in the period immediately after the sack of the city by Attila in 452.

4. There is no evidence that it was rebuilt by the partisans of the "Three Chapters" who returned to Aquileia after the Schism of 610: indeed, the Lombard patriarchs of Aquileia resided first in Cormons and then in Cividale until the beginning of the 9th century.

5. *Versus de destructione Aquilegiae numquam restaurandae*, MGH, *Poetae Latini*, I, 143.

6. MGH, *Diplomata Karolinorum*, I, 285–87, no. 214.

7. Ibid.: "petiit celsitudini nostrae, ut in elemosina nostra ad eandem sanctam sedem aliquam portionem hereditatis, quam Rotgaudus Langobardus et germanus illius Felix intra civitatem vel foras prope moenia civitatis ipsius habuerunt . . . (et) traderemus vel confirmaremus, quatenus opportunius atque decentius atria vel reliquas constructiones, quae ad honorem illius loci pertinerent, secundum quod ipse (Maxentius) mente provida tractaverat, adimplere valeret."

Forlati argues in *La Basilica*, 286, n. 3 that "atria" applies to the entire church building.

8. Ibid., 286ff.; H. Thümmler, "Die Baukunst des XI. Jahrhunderts in Italien," *RJbK* 3 (1939): 176f.; Brusin and Lorenzoni, *L'arte del Patriarcato*, 19ff. and Tavano, "San Paolino e la Sede Patriarcale," 268ff.

9. Bertacchi, "La Basilica postattilana," 15–55.

10. *Der Dom*, 6; Forlati, "L'architettura," 287–88; Thümmler, "Die Baukunst," 176; Brusin and Lorenzoni, *L'arte del Patriarcato*, 19ff.; Gioseffi and Belluno, *Aquileia*, 39f.; S. Tavano, "La cripta d'Aquileia e i suoi affreschi," *Arte in Friuli, Arte a Trieste* 2 (1976): 157–70 and most recently, idem, "San Paolino," 268ff.

11. Toesca, "Gli affreschi," 32–34; Bertacchi, "La Basilica postattilana," cols. 33–34, n. 28; C. Heitz, "Composantes occidentales de l'architecture romane d'Aquilée," *AntAltAdr* 19 (1981): 313–14; and Dorigo, "L'architettura," 191–213, esp. 201–5.

12. Tavano, "La cripta d'Aquileia," 157–70. Tavano is evidently thinking of such Carolingian apses as those of St. John at Müstair or St. Benedict at Malles, where the "horseshoe" shape is much more exaggerated (cf. Brusin and Lorenzoni, *L'arte del Patriarcato*, fig. 4). The perimeter of the Aquileia hemicycle is actually quite irregular because it is fitted into a preexisting structure.

13. It appears in the 10th-century in the crypt of S. Andreas in Trier Cathedral (F. Oswald et al., *Vorromanische Kirchenbauten* [Ausbach, 1966], 340f.); and San Pietro Maggiore in Ravenna (M. Mazzotti, "Cripte Ravennati," *Felix Ravenna* 74 [1957]: 44–47). From the 11th century, three examples may be cited: San Secondo in Asti near Milan (M. Magni, "Cryptes du haut moyen-âge en Italie," *CahArch* 28 [1979]: 41–85, esp. 75–77); San Pietro in Agliate, near Milan (M. Burke, "Hall Crypts of First Romanesque," Ph.D. diss., University of California, Berkeley, 1976, 78ff.); and St. Mauritius in Amsoldingen, Switzerland

(ibid., 173ff.; L. Hertwig, *Entwicklungsgeschichte der Krypta in der Schweiz. Studien zur Baugeschichte des frühen und hohen Mittelalters* [Kiel, 1958], 23–25; and S. Rutishauser, "Genèse et développement de la crypte à salle en Europe du Sud," *Les cahiers de Saint-Michel de Cuxa* 24 [1993]: 43–44).

14. The crypts of Asti (Piedmont), Agliate (Lombardy), Amsoldingen (Switzerland), Sta. Maria at Cavour and Notre-Dame-du-Port at Étampes are particularly close in plan. See Hertig, *Entwicklungsgeschichte*, esp. 145–77; Burke, "Hall Crypts," 30ff.; Magni, "Cryptes," 56ff., 124ff., and 328ff.; and Rutishauser, "Genèse et développement," 37–45.

15. Four examples are: Augsburg Cathedral (Oswald, *Vorromanische Kirchenbauten*, 995); S. Andreas at Neuenberg (Fulda) (ibid., 231); S. Giovanni Domnarum at Pavia (Magni, "Cryptes," 73f., figs. 14g, 40, and 41); and S. Maria di Farneta near Cortona (ibid., 52–53, figs. 9, 10).

16. *Der Dom*, 6. Forlati ("L'architettura," 285) repeats and amplifies this information: "Le finestre erano certo non molto grandi e a tutto sesto: di una di esse sembra anzi si siano trovate le tracce in un tratto già in curva, sotto gli affreschi di età popponiana che decorano il catino." However, because he neither cites his source nor provides any documentation of his own, his statement must have been derived solely from the information provided by Swoboda. Photographs of the apse provided in Forlati's publication offer no evidence of the presumed Carolingian window. Brusin and Lorenzoni (*L'arte del Patriarcato*, 20) accept Swoboda's account but express reservations similar to my own concerning the reliability of Forlati's statement. For the Carolingian dating of the floor mosaic, see ibid., 23; S. Tavano, "Scultura altomedioevale in Aquileia fra Oriente e Occidente," *AntAltAdr* 19 (1981): 345–46.

17. As Bertacchi points out in "La Basilica postattilana," n. 28, the window to which Swoboda and his adherents refer is visible on the exterior of the north wall.

18. X. Barral i Altet, "La mosaïque de pavement médiévale dans l'abside de la Basilique Patriarcale d'Aquilée," *CahArch* 26 (1977): 105–16. Dorigo ("L'architettura") has independently arrived at the same conclusion on the basis of Barral's arguments.

19. In these examples, we find the same squat proportions, schematized acanthus "petals," low-relief volutes, and arcaded neck. See A. Tagliaferri, *Le Diocesi di Aquileia e Grado*, Corpus della Scultura Altomedievale, 10 (Spoleto, 1981), 82–83, nos. 23–28; Tavano, "Scultura altomedievale," 346–47; Thümmler, "Die Baukunst," 177ff.; H. Buchwald, "Eleventh-century Corinthian Palette Capitals in the Region of Aquileia," *Art Bulletin* 48 (1966): 148; and Brusin and Lorenzoni, *L'arte del Patriarcato*, 22ff. Toesca ("Gli affreschi," 32–34) is one of the few detractors from the Carolingian attribution; he has proposed an 11th-century date on the basis of comparisons with the capitals in the 11th-century crypt of San Baronto in Tuscany, but these capitals may be considered spolia. Other close comparisons for the Aquileia capital type

may be found in the Trichora of Sant'Eufemia in Grado (Tagliaferri, ibid., 362, fig. 549) and the Museo Cristiano of Brescia (G. Panazza and A. Tagliaferri, *La Diocesi di Brescia*, Corpus della Scultura Altomedievale 3 (Spoleto, 1966): no. 117, fig. 115; no. 180, fig. 190.

20. For the spolia used in the throne and the exterior buttresses, see Brusin and Lorenzoni, *L'arte del Patriarcato*, 26–28, figs. 64–67 and Tagliaferri, *Aquileia e Grado*, nos. 29–35, 39–42. On the campanile, see L. Bertacchi, "La torre campanaria di Aquileia," *AqN* 44 (1973): 1–36.

21. Brusin and Lorenzoni, *L'arte del Patriarcato*, 23.

22. *Der Dom*, 87 and n. 1.

23. The presumed "I" following the first "N" of the upper line of script is very tentative in the transcription and is therefore questioned here. It should also be observed that there is no appreciable space between the initial "O" and "P" of the first line, thus suggesting that they are part of the same word.

24. In this case, the shadowy upstroke between the "N" and the "E" which Swoboda interpreted as an "I" would have to be identified as part of a second "N" formed with the upstroke that underlies the oblique of the first "N." This doubling of the consonant may have been an intentional optional spelling of "POP(P)ONE" or simply the residue of an inscription that was repainted shortly after its initial execution. Such shadowy double letters appear frequently in the 12th-century inscriptions of the crypt.

25. For the dedicatory inscription (which was repainted in the 13th century) see G. Cuscito, "Le epigrafi dei patriarchi nella Basilica di Aquileia," *AntAltAdr* 38 (1992): 155–73, esp. 162–64 and M. C. Cavalieri, "L'affresco absidale della basilica patriarcale di Aquileia," *Bollettino d'Arte* 61 (1976): 1–11, esp. 1, n. 3, 2, n. 50, and 3, n. 63.

26. Ughelli, *Italia Sacra*, 5:col. 53.

27. For the Abbey of Pomposa, see T. Mistrorigo, *L'Abbazia di Pomposa* (Bologna, n.d.), 5; S. Stocchi, *L'Emilia-Romagna*, Italia Romanica, 6 (Milan, 1984), 352ff., fig. 136.

28. As such, it would have resembled the crypts of Saint George at Reichenau-Oberzell (C. Heitz, *L'architecture religieuse carolingienne* [Paris, 1980], 124–25, 128–29), Roßtal (H. Buschow, *Studien über die Entwicklung der Krypta im deutschen Sprachgebiet* [Würzburg, 1934], 26–28) and Konstanz Cathedral (ibid., 44–46).

29. S. Tavano, *Aquileia e Grado* (Trieste, 1986), 178–79; G. Vale, "La storia della basilica dopo il secolo IX," in *La Basilica*, 61ff. The inscription on the tomb of Marquardus, placed in the middle of the transept, gives him credit for the renovations: "Vir primitus iste ruinis / fundamentam gravibus presentem struxit egenam / Ecclesiam sacratus opum moderamine nullo" (ibid., 63).

30. These sections of wall were removed in 1973. See Gioseffi and Belluno, *Aquileia*, 45.

31. Tavano, *Aquileia e Grado*, 181–83; idem, "Il rivestimento marmoreo al esterno della cripta nella Ba-

silica di Aquileia," *MemStorFor* 42 (1956–57): 139ff.; Vale, "La storia della basilica," 70ff.; *Der Dom*, 112–13.

32. This sarcophagus now stands empty in the south transept; it was moved there during the restoration of the crypt in 1946–47. See *La Basilica*, 71, fig. 5.

33. The first record of the iron fence, which once enclosed the space between the six free-standing columns, is found in an inventory of 12 November 1524, which describes the treasury as "inter claustra ferrea in sanctuario sub confessionali" (cited in *Der Dom*, 120, n. 4). It caused great damage to the saints of the spandrels and the hagiographic scenes in the intervening vaults. It was removed during restoration work in 1946–47. See E. Belluno, *Il restauro come opera di gusto* (Udine, 1973).

34. Vale ("La storia della basilica," 70) erroneously calls Carlo the bishop of Chioggia and claims that the date of consecration is unknown. But the correct information is provided in *Der Dom*, 137 and n. 4 (where Bertoli's unpublished manuscript of volume 2 of the *Antichità di Aquileia*, 128, is cited as the source). This altar was replaced in 1743 by the Rococo one visible in prerestoration photographs (see fig. 13).

35. Gioseffi and Belluno, *Aquileia*, 44–45.

36. For episcopal burials in general, see Picard, *Souvenir*. For episcopal and abbatial tombs in crypts, see J. von Schlosser, *Schriftquellen zur Geschichte der Karolingischen Kunst* (Vienna, 1892), nos. 1779, 2058, 2493 and O. Lehmann-Brockhaus, *Schriftquellen zur Kunstgeschichte des 11. und 12. Jahrhunderts für Deutschland, Lothringen und Italien*, 2 vols. (Berlin, 1938), nos. 135, 187, 238, 562, 590, 603, 1032, 1355. For lay burials in crypts, see J. Mitchell, "The Crypt Reappraised," in R. Hodges, *San Vincenzo al Volturno 1: The 1980–86 Excavations, Part I* (Rome and London, 1993), esp. 110–14; and Lehman-Brockhaus, ibid., nos. 691, 809, 892.

37. See S. de Blaauw, "Die Krypta in stadtrömischen Kirchen: Abbild eines Pilgerziels," in *Akten des 12. Internationalen Kongresses für christliche Archäologie* (Bonn, 1992). The author kindly allowed me to read his typescript.

38. This is the case in a series of First Romanesque hall crypts, including San Pietro at Tuscania (C. A. Isermeyer, "Die mittelalterlichen Malereien der Kirche S. Pietro in Tuscania," *RJbK* 2 [1938]: 291ff.); San Pietro at Agliate (Burke, "Hall Crypts," 78); San Vincenzo in Prato, Milan (ibid., 108); the Abbey of Sta. Maria at Cavour (ibid., 129); St. Mauritius at Amsoldingen (ibid., 178); Notre-Dame du Fort at Étampes (ibid., 331), and the parish church of Thynes (ibid., 360). Likewise, in semiannular crypts, the relics are consistently located at the west end of a long central corridor, so that the relics are vertically aligned with the high altar.

On the contrary, Johanna Kugler ("Kryptafresken," 9 and 106) has taken it for granted that the Renaissance disposition of relics in the central aisle of the crypt reflected the medieval one.

39. See M. Andrieu, *Les "Ordines Romani" du haut Moyen Age*, 5 vols. (Louvain, 1931–61), 4:327–28; J. Gagé, "*Membra Christi* et la déposition des reliques sous l'autel," *Revue archéologique* 29 (1929): 137–53; and J. Braun, *Der christliche Altar in seiner geschichtlichen Entwicklung*, 2 vols. (Munich, 1924), 1: 557ff. and 656–61.

40. Translation by C. Davis-Weyer, *Early Medieval Art, 300–1150*, (Toronto, 1986), 21. Cf. Gagé, "*Membra Christi*," 149 and A. Frolow, *Les reliquaires de la Vraie Croix* (Paris, 1965), 121.

41. "Vidi subtus altare, animas interfectorum propter verbum Dei et propter testimoniam quod habebant. . . ."

42. N. Herrmann-Masquard, *Les reliques des saints: formation coutumière d'un droit* (Paris, 1975), 146ff.; Andrieu, *Ordines romani*, 4:327–33; and Braun, *Der christliche Altar*, 1: 527–32.

43. On Ambrose, see Andrieu, *Ordines Romani*, 4:332ff.; E. Dassmann, "Ambrosius und die Märtyrer," *Jahrbuch für Antike und Christentum* 18 (1975): 49–68; Brown, *Cult of the Saints*, 36–37.

44. *Epistolae*, XXII; *PL* 16:1066B.

45. Picard, *Souvenir*, 45.

46. See Geary, *Furta Sacra*, 18–20, 35–43; Herrmann-Masquard, *Les Reliques des saints*, 162ff.; Andrieu, *Ordines Romani*, 4:327ff.; and Braun, *Der christliche Altar*, 1: 531.

47. At Aachen (801) and Mainz (813). See Geary, *Furta Sacra*, 37.

48. G. Mansi, ed., *Sacrorum Conciliorum* (Paris and Leipzig, 1901–27), 14:356; Geary, *Furta Sacra*, 34–35; Braun, *Der christliche Altar*, 1: 623ff. The *Ordines Romani* from this period also include this form of consecration for the first time. In a 9th-century rite, Ordo XLI ("Denuntiatio cum reliquiae sanctorum martyrum ponendae sunt"), the relics are brought from the church where the vigil is held and interred in the loculus of the altar immediately preceding the mass at the conclusion of the consecration rite. See Andrieu, *Ordines Romani*, 4:339ff., esp. 346–47, nos. 28–29).

49. M. Andrieu, C. Vogel, and R. Elze, *Le pontifical Romano-Germanique du dixième siècle*, Studi e Testi, 226 (Vatican, 1963), 171; M. Andrieu, *Le pontifical romain au Moyen-âge, 1: Le pontificale romain du XIIe siècle*, Studi e Testi, 86 (Vatican, 1938), 188.

50. Gorizia, Biblioteca del Seminario Arcivescovile, Codex B: *Ordo officii secundum morem et consuetudinem aquileiensis ecclesiae per circulum totius anni*, 174v–179r. The key passage on fol. 178v reads: "In s(e)c(un)da vesp(er)a. . . . Post or(ati)o(ne)m de s(an)c(t)o Hermachora dica(n)t ant(iphona), Concurrebant ad sanctu(m) Hermach(oram). Et fiat processio ad sanctu(m) hermachoram et dica(n)t or(at)iones). . . . "

51. See chap. 1, note 33.

52. The diploma in question records certain donations to the church of Aquileia "in which the remains of Saint Hermagoras rest, as is clear from miracles." See Ughelli, *Italia sacra*, 5:57 and Joppi, "Sacre reliquie," 202 who cites this source.

53. Cf. R. Wallrath, "Zur Bedeutung der mit-telalterlichen Krypta (Chorumgang und Mar-ienkapelle)," in *Beiträge zur Kunst des Mittelalters*, Vorträge des Ersten Deutschen Kunsthistoriker-tagung auf Schloss Brühl (Berlin, 1951), 54–69, esp. 63ff.

54. Rutishauser, "Genèse et développement," 44–45.

55. On the "missa privata," see J. A. Jungmann, *Missa Sollemnia: Eine Genetische Erklärung der Rö-mischen Messe*, 2 vols. (Freiburg, 1958), 1: 283–306 and M. Righetti, *Manuele di storia liturgica*, 4 vols. (Milan, 1956), 3:125–27.

56. Cf. Braun, *Der christliche Altar*, 1: 375–78.

57. See chap. 1, note 32.

58. *Necrologium Aquileiense*: "(25) XVII. C.VII Kal. Marci Evangeliste Passion. Letania Maior. Dedicatio Altaris SS. Martyrum Hermachore et Fortunati."

59. See Picard, *Souvenir*, 358–69.

60. See Geary, *Furta Sacra*, 35–43 and Herrmann-Masquard, *Les reliques des saints*, 162ff. On the changes in papal policy that made relics of Ro-man saints more available to the Franks, see J. Mc-Culloh, "From Antiquity to the Middle Ages: Continuity and Change in Papal Relic Policy from the Sixth to Eighth Century," in *Pietas: Festschrift für Bernhard Köttig = JbAntChr, Ergänzungsband* 8 (1980): 311–24 and M. Mauck, "The Mosaic of the Triumphal Arch of Sta. Prassede: A Liturgical Inter-pretation," *Speculum* 62 (1987): 826–27.

61. On this church and its relationship to the pres-ent crypt, see W. Dorigo, "Lo stato della discussione storico-archeologica dopo i nuovi lavori nella cripta di San Marco," in A. Niero et al., *Basilica Patriarcale in Venezia. San Marco: La cripta, il restauro* (Milan, 1993), 25–40; E. Vio, "Dalle volte ulteriori notizie sulla fabbrica marciana," in Niero, *Basilica Patriarcale*, 43–55; idem, "Cripta e prima cappella ducale?" in E. Vio et al., *Basilica Patriarcale in Venezia. La Cripta, la storia, la consecrazione* (Milan, 1992), 23–70; O. Rich-ardson, "The Byzantine Element in the Architecture and Architectural Sculpture of Venice, 1063–1140,"

Ph.D. diss., Princeton University, 1988, 23ff.; and Demus, *The Church*, 66f.

62. The patriarch's epitaph of 1044 emphasizes his accomplishments as the builder of the city and its cathedral. Ughelli, *Italia Sacra*, 5:54: "Post cineres quod habet muros Aquileja, quod ingens/Stat tem-plum, Turris celsa quod astra petit . . . Debuntur cunc-ta haec illi, qui clauditur arca hac: Poppo . . . fuit."

63. Documenting his ordination of fifty priests, Poppo refers to his recent consecration of the basilica "in honorem S. Dei Genitricis et perpetuae Virginis Mariae, SS. Martyrum Hermagorae et Fortunati" (Ughelli, *Italia Sacra*, 5:55). Furthermore, the recog-nition of this complete form of the dedication outside Aquileia itself is confirmed in Emperor Henry III's diploma of January 1040 granting privileges to "Pop-ponis Patriarchae Aquilegensis Ecclesiae . . . in hon-orem scilicet SS. Hermachorae et Fortunati constructae . . . " and in the bull of John XIX re-cording the decision of the Synod at Rome in 1027 (ibid., 49–50 and *MGH, Diplomata regum et impera-torum germaniae* V, 25–26, no. 19).

64. Buchwald, "Eleventh-century Corinthian Pal-mette Capitals," 156.

65. On the Popponian decoration of the apse, see Dale, "Inventing a Sacred Past," 59–61; Cavalieri, "L'affresco absidale," 1–11; Brusin and Lorenzoni, *L'arte del Patriarcato*, 41ff.; Morgagni Schiffrer, "Gli affreschi medioevali," 323ff.; A. Morassi, "La pittura e la scultura nella basilica," in *La Basilica*, 306ff.

66. Among these six saints, Euphemia is the su-pernumerary. Her inclusion in the conch may have been intended to usurp from Grado the patron of its cathedral church.

67. On the relationship between San Marco and the Apostoleion of Constantinople, see Buchwald, "Eleventh-century Corinthian Palmette Capitals," 157; Demus, *Mosaics of San Marco*, 1: 232ff.; and idem, *The Church*, 88ff.

68. On the invention or rediscovery of the relics of Saint Mark, see Dale, "Inventing a Sacred Past," 85–88; and Demus, *Mosaics of San Marco*, 2:27ff.

Chapter Three. Byzantine and Romanesque

1. The strongest characterization of this "master" and his Byzantine formation is found in Lorenzoni and Brusin, *L'arte del Patriarcato*, 59–67. For the most recent adoption of this artistic personality, see G. Ber-gamini, "La pittura medievale in Friuli-Venezia-Giulia," in *La Pittura in Italia: L'Altomedioevo*, ed. C. Bertelli (Milan, 1994), 131–45, esp. 140–41.

2. For these systems of decoration, see O. Demus, *Byzantine Mosaic Decoration* (London, 1947) and idem, *Romanesque Mural Painting*.

3. Morgagni Schiffrer, "Gli affreschi," 139. The best-preserved example, which appears on the red border between lunette and socle in the central bay of the hemicycle, apparently commemorates a death in 1217: "REQU(I)EM ETERNA(M) + (M)CCXVII."

4. Pietro Toesca anticipated this attribution in his

groundbreaking study of 1925, "Gli affreschi." His general dating was accepted or refined slightly by the following authors: Morassi, "La pittura e la scultura," 301–28, esp. 319–26; Valland, *Aquilée*; Morgagni Schiffrer, "Gli affreschi della cripta" and "Gli af-freschi medioevali"; Kugler, "Kryptafresken" and "Byzantinisches und Westliches"; Gioseffi and Bel-luno, *Aquileia*; Tavano, "La cripta d'Aquileia," 157–80; G. Luca, "Il sostrato culturale della cripta di Aq-uileia," *AntAltAdr* 38 (1992): 231–54.

5. See Demus, *Romanesque Mural Painting*, 61–64; Kugler, "Kryptafresken," 33ff. D. Winfield, "Middle and Later Byzantine Wall Painting Methods: A Com-parative Study," *DOP* 22 (1968): 62–139. One of our best medieval sources of information on the tech-nique of painting, Theophilus's *De diversis artibus* (ed.

and trans. C. R. Dodwell, London, 1965, 7ff.) describes a procedure for modeling draperies and flesh which is very close to the system actually followed by the artists of the Aquileia crypt. A Byzantine counterpart is provided by the late-17th-century *Hermeneia* or "Painter's Manual" of Dionysius of Fourna, a work which reflects to a large extent the practices of Byzantine painters from the Middle Ages. See P. Hetherington, trans., *The "Painter's Manual" of Dionysius of Fourna*, rev. ed. (London, 1981).

6. The pigment of this zone has all but disappeared in the lunette panels, but it is better preserved in the spandrels.

7. Occasional variations occur for compositional reasons. In the Deposition (fig. 86), for example, Christ's body is elongated to conform to a continuous curve in the composition, culminating in the juxtaposed heads of the Virgin and her son; at the same time, John's mass is considerably enhanced in order to provide a counterweight for the fused figure group at the opposite side, comprising the four mourning women. In the panels of the saint's life, which decorate the soffits between free-standing columns, the restricted space afforded by the architecture has dictated squatter, more compact proportions as in the scene of the Arrival of Hermagoras at Aquileia (fig. 63).

8. This convention seems to stem from patterns of chrysography employed in panel painting, mosaics, and illuminated manuscripts. It appears in the early 12th century in the mosaics of the apse of the destroyed church of Saint Michael at Kiev and at the beginning of the 11th-century illuminated manuscript, the Menologion of Basil II. For the Kiev mosaics see V. Lazarev, *Old Russian Murals and Mosaics from the XI to the XVI Century* (London, 1966), 68ff. and fig. 51; for the Menologion, see idem, *Storia della pittura bizantina* (Turin, 1967), 140–41 and figs. 121, 122, and 125.

9. Cf. C. R. Dodwell, *The Pictorial Arts of the West, 800–1200* (New Haven, 1993), figs. 10–12.

10. See particularly Swoboda in *Der Dom*, 86ff.; Kugler, "Kryptafresken," 245ff.; eadem, "Byzantinisches und Westliches," 24ff.; Demus, *Romanesque Mural Painting*, 306–8; idem, *Mosaics of San Marco*, 1:293; Brusin and Lorenzoni, *L'arte del Patriarcato*, 90; and Morassi, "La pittura e la scultura," 320. Morgagni Schiffrer ("Gli affreschi della cripta," 117), on the other hand, rightly warns against sharply separating the style of the curtain from that of the other parts of the program.

11. This is also suggested by Morgagni Schiffrer, "Gli affreschi della cripta," 116.

12. Girolamo de Renaldis (*Della Pittura Friulana* [Udine, 1798], 6), in language reminiscent of Vasari, already speaks of the "gusto greco-barbaro, mal disegnate, e peggio colorite da que' pittori, che vennero allora da Costantinopoli a Venezia ed in Toscana, come anche in Aquileja per ragione dei loro traffici." The next publication of the crypt by Heinrich Swoboda, *Der Dom* (93–94), takes up the re-

cent "Benedictine" theory propounded by Emile Bertaux in *L'art dans l'Italie méridionale* (Paris, 1904) that Byzantine influence in South Italian art was channeled through the Abbey of Montecassino to other Benedictine foundations. Toesca ("Gli affreschi") was the first writer to recognize Aquileia's affinities with Byzantine art of the late 12th century. For subsequent literature, see introduction.

13. The most thorough assessment of Aquileia's relationship to Byzantine art is provided by Johanna Kugler, "Byzantinisches und Westliches." For the notion of successive "waves" of Byzantine influence on Romanesque painting, see W. Koehler, "Byzantine Art and the West," *DOP* 1 (1941): 63–87 and O. Demus, *Byzantine Art and the West* (New York, 1970), esp. 179–240. For the late Comnenian style in general, see V. Djurić, "La peinture murale byzantine: XIIe et XIIIe siècle," in *Actes du XVe congrès international des études byzantines*, Athens, 1976, 1:255–83; E. Kitzinger, "The Byzantine Contribution to Western Art in the Twelfth and Thirteenth Century," *DOP* 20 (1966): 25ff.; and D. Mouriki, "Monumental Painting in Greece, Eleventh to Twelfth Centuries," *DOP* 34–35 (1980–81): 77–124.

14. On Nerezi, see I. Sinkević, "Alexios Angelos Komnenos, A Patron Without History?" *Gesta* 35 (1996): 34–42; V. Djurić, *Byzantinische Fresken in Jugoslawien* (Munich, 1976), 15–17, n. 8, 236–37; and R. Hamann-Maclean, *Grundlegung zu einer Geschichte der mittelalterlichen Monumentalmalerei in Serbien und Makedonien*, 3 vols. (Giessen, 1976), 2:261–75 with previous bibliography.

15. On Bačkovo, see E. Bakalova, *The Ossuary-Church of the Bachkovo Monastery* (Sophia, 1977), English summary, 231–43. Byzantine mural painting in four Russian churches with reasonably secure dates provides an approximate chronological scheme within which to situate the Aquileian murals: St. George at Staraya Ladoga (c. 1167–70), the Annunciation Church near Arkazhy (c. 1189), the Demetrius Cathedral at Vladimir (1195), and the Cathedral of Spas Nereditsa (1199) near Novgorod. Aquileia's more dynamic figure style and pronounced linear modeling, exhibited in figures such as Saint Peter, lie somewhere between Ladoga and Arkazhy. For illustrations, see Kugler, "Byzantinisches und Westliches," 18–22 and Lazarev, *Old Russian Murals and Mosaics*, pls. 94–108 (Nereditsa), pls. 60–68 (Wladimir), pls. 85–91 (Staraya Ladoga), pls. 92–93, figs. 49–50 on p. 248 (Arkazhy). For the successive waves of Byzantine influence in the Sicilian mosaics, see Demus, *Norman Sicily*, 369–442 and Kitzinger, "The Byzantine Contribution." Aquileia's relationship to Byzantine art is considered more comprehensively in Kugler, "Byzantinisches und Westliches" and Dale, "The Crypt of the Basilica Patriarcale at Aquileia: Its Place in the Art and History of the Upper Adriatic," Ph.D. diss., Johns Hopkins University, Baltimore, 1990, 215–23.

16. The most complete surveys of wall painting in Friuli are: G. Bergamini and L. Perissinotto, *Affreschi del Friuli* (Udine, 1973); and Brusin and Lorenzoni,

L'arte del Patriarcato. See also the recent overview in Bergamini, "La pittura medievale in Friuli-Venezia-Giulia," 131–45.

17. P. L. Zovatto in *Monumenti romani e cristiani di Iulia Concordia,* ed. D. Antonini (Pordenone, 1960), 164ff.; Brusin and Lorenzoni, *L'arte del Patriarcato,* 55–58; A. M. Damigella, *Pittura veneta dell'XI–XII secolo* (Rome, 1969); L. Coletti, "L'arte nel Territorio di Concordia dal Medio Evo al Rinascimento," in B. Scarpa Bonazza et al., *Iuli Concordia dall'età romana all'età moderna,* 2nd ed. (Treviso, 1978), 211ff.; and E. Ortis Alessandrini, *Arte sacra a Summaga* = Gruppo di Ricerca sull'abbazia di Summaga, *Quattro quaderni di studio editi fra il 1982 e il 1984,* fasc. III (Summaga, 1982).

18. On the baptistery of Concordia, see Demus, *Romanesque Mural Painting,* 310, fig. 9; Brusin and Lorenzoni, *L'arte del Patriarcato,* 57–58 and P. Zovatto, "Il Battistero di Concordia," *Arte Veneta* 1 (1947): 171ff.

19. On the development of this shield type, see H. Nickel, *Der mittelalterliche Reiterschild des Abendlandes,* Inaugural diss., Free University of Berlin, 1958, 7–207. (I am indebted to Roger Gardner for this reference.) For examples on dated seals see E. Kittel, *Siegl* (Braunschweig, 1970), figs. 162–63.

20. The rare composition of the Madonna and Child with the four evangelist symbols in the central apse of Summaga is taken over from the apse of Aquileia or the central vault of the crypt where the same iconographic scheme is repeated. See Appendix I, I2.

21. For a similar juxtaposition of these distinct artistic phases within a single monument, we need only compare the mosaics of the Ascension workshop of the 1180s to the early-13th-century Life of the Virgin in San Marco. See Demus, *Mosaics of San Marco,* 1:288ff., pls. 234–377; 142ff., pls. 150–57. In this text Demus dates the second group of mosaics to the mid or late 12th century, but he revised his opinion to the turn of the thirteenth century in "San Marco Revisited," *DOP* 41 (1987): 155–56, following the arguments of L. Eleen, "A Thirteenth-Century Workshop of Miniature Painters in the Veneto," *Arte veneta* 29 (1985): 9–21.

22. M. Belli (*L'abbazia di Summaga* [Motta di Livenza, 1925], 10–11) cites a document of 1188 in which the bishop of Concordia makes a series of donations to Summaga and another in which the patriarch of Aquileia grants the abbey jurisdiction over certain villages in the vicinity of Summaga and rights of clerical investiture.

23. E. Cozzi, "L'arcangelo S. Michele: in affresco poco noto dell'abbazia di Sesto al Reghena," *Arte Veneta* 29 (1975): 75–77; T. Geometta, *L'abbazia benedettina di S. Maria in Sylvis* (Portogruaro, 1964), 131–32; and I. Furlan, *L'abbazia di Sesto al Reghena* (Milan, 1968), 80–81. Otto Demus—apparently without firsthand knowledge of Sesto—ruled out any direct connection between the Sesto painter and Aquileia in his article on the baptistery of San Marco:

"Ein Wandgemälde in San Marco, Venedig," *Harvard Ukranian Studies* 6 (1983): 124–44.

24. K. Knotig, *Der Sonnenburg im Pustertal* (Bolzano, 1985), 78–82, 95. I am grateful to Mr. Karl Knotig, the proprietor of the hotel on the site, for allowing me to photograph the crypt, and to Dr. Nino Zchomelidse for facilitating the visit.

25. F. Forlati, "Ritrovamenti in S. Marco—un affresco del Duecento," *Arte Veneta* 17 (1963): 223–24; S. Bettini, "Appunti di storia della pittura veneta nel Medioevo," *Arte Veneta* 20 (1966): 26f.; Brusin and Lorenzoni, *L'arte del Patriarcato,* 70–71; Demus, "Ein Wandgemälde in San Marco," 125–44.

26. Cf. Brusin and Lorenzoni, *L'arte del Patriarcato,* 71.

27. The existence of a patriarchal workshop is suggested by documents during the reign of Wolfger (1204–18). A certain painter in the entourage of Bishop Conrad of Rodenico named Ugo ("Hugonis Pictoris") appears as witness to a patriarchal document at Aquileia in 1210. See N. Rasmo, *Affreschi medioevali atesini* (Milan, 1971), 66. "Pistoribus" (pictoribus?) are included amongst the artisans assembled at Aquileia by this patriarch in a document of 1211. See V. Joppi, "La basilica di Aquileia," *Archeografo triestino,* n.s. 20 (1896): 5 and 32. Kugler ("Kryptafresken," 9) suggests that these painters might be connected with the crypt, but they could also have worked in the patriarchal palace, where Marin Sanuto saw in 1483 "tre magnifiche capelle tute dipente, una sopra l'altra." See *Itinerario di Marin Sanuto per la Terraferma Veneziana nell'anno MCCCCLXXXIII* (Padua, 1847), 145.

28. S. Bettini, "Introduzione," in *Venezia e Bisanzio,* exh. cat., Palazzo Ducale (Venice, 1974) 72ff.; Demus, *Mosaics of San Marco,* 1:288f.; C. Rizzardi, *Mosaici altoadriatici* (Ravenna, 1985), 54ff.

29. For the documentation of the original program, see S. Pasi, "Osservazioni sui frammenti del mosaico absidale della Basilica Ursiana," *Felix Ravenna* 11–12 (1976): 213–37; eadem, "Il mosaico absidale dell'Ursiana: spunti per un inquadramento del problema iconografico," *Felix Ravenna* 13–14 (1977): 219–39; and Rizzardi, *Mosaici altoadriatici,* 136ff.

30. Brusin and Lorenzoni, *L'arte del Patriarcato,* 68.

31. I. Furlan, "Aspetti di cultura greca a Venezia nell'XI secolo," *Arte Veneta* 29 (1975): 34f.; Demus, *Mosaics of San Marco,* 1:31ff.; Rizzardi, *Mosaici altoadriatici,* 47f.

32. T. Dale, "Easter, Saint Mark and the Doge: The Deposition Mosaic in the Choir of San Marco in Venice," *Thesaurismata* (= Bollettino dell'Istituto Ellenico di Studi Bizantini e Post-Bizantini di Venezia) 25 (1995): 21–33; R. Polacco, *San Marco, la Basilica d'Oro* (Milan, 1991), 13–17; Demus, *Mosaics of San Marco,* 1:209–12; G. Galassi, "I nuovi mosaici scoperti in San Marco a Venezia," *Arte veneta* 9 (1955): 243–48.

33. The proponents of a late-12th-century dating include M. Campitelli, "Nota sul mosaico con i dodici apostoli di San Giusto a Trieste," *Arte Veneta* 12

(1958): 19–30; Kugler, "Byzantinisches und West-liches," 18, n. 39; and Lazarev, *Storia*, 241, 270–71. The following authors have attributed these mosaics to the late 11th or early 12th century: M. Mirabella Roberti, *San Giusto* (Trieste, 1970), 29–30; D. Gioseffi, "I mosaici parietali di S. Giusto a Trieste," *AntAltAdr* 8 (1975): 287–300; Rizzardi, *Mosaici alto-adriatici*, 155–161; and I. Andreescu-Treadgold, "Les mosaïques de la lagune véitienne aux environs de 1100," in *Actes du XVe congrès internationale d'études byzantines* (Athens, 1976), 2:15–30.

34. On motif books, model books, and pictorial guides, see E. Kitzinger, "The Role of the Miniature Painting in Mural Decoration," in *The Place of Book Illustration in Byzantine Art* (Princeton, 1975), 108ff.; idem, *The Mosaics of Monreale* (Palermo, 1960), 84f.; Demus, *Romanesque Mural Painting*, 58–60; and R. W. Scheller, *A Survey of Medieval Model Books* (Harlem, 1963). Kitzinger offers motif books as an explanation for a comparable replication of individual figures, compositions, and stylistic conventions in the Old Testament cycles of the Cappella Palatina in Palermo and Monreale Cathedral. The Wölfenbuttel Model Book, ascribed to a Venetian artist by Hugo Buchthal, may be cited as a rare survival of this practice. See H. Buchthal, *The "Musterbuch" of Wölfenbuttel and Its Position in the Art of the Thirteenth Century* (Vienna, 1979), figs. 3, 6, 12, and 14.

35. E.g., Villard de Honnecourt includes in his model book subjects from a wide range of periods and media but translates them all into his own personal style. See H. R. Hahnloser, *Villard de Honnecourt: Kritische Gesamtausgabe des Bauhütterbuches, ms. fr. 19093 der Pariser Nationalbibliothek*, 2nd ed. (Graz, 1972), esp. 209–11.

36. This is particularly true for the question of Byzantium's role in Western art of the 12th and 13th centuries. The most comprehensive overview remains Demus, *Byzantine Art and the West*.

37. A. Cutler, "La 'questione bizantina' nella pittura italiana: una visione alternativa della 'maniera greca'" in *La pittura in Italia: L'Altomedioevo*, ed. C. Bertelli (Milan, 1994), 335–54.

38. Cutler, ibid., esp. 335–41. In a similar vein, see H. Belting, *Likeness and Presence: A History of Images before the Era of Art*, trans. E. Jephcott (Chicago, 1994), 304–10 and 330–48.

39. For Leo of Ostia on the importation of Byzantine artists, see H. Hoffmann, ed., *Chronicon Monasterii Casinensis* in *MGH*, Scriptores, 34, III, 28ff.; and H. Bloch, *Montecassino in the Middle Ages*, 3 vols. (Cambridge, 1986), 1:122ff.

40. On San Marco and the Apostoleion of Constantinople, see Buchwald, "Eleventh-century Corinthian Palmette Capitals," 157; Demus, *Mosaics of San Marco*, 1.l:232ff.; and idem, *The Church*, 88ff.

41. The following overview of the subject of modes draws upon the excellent synthesis provided by Jan Bialostocki, "Das Modusproblem in den bildenden Künsten. Zur Vorgeschichte und zum Nachleben des 'Modusbriefes' von Nicholas Poussin," in *Stil und Ikonographie. Studien zur Kunstwissenschaft*

(Dresden, 1966), 9–35. I am indebted to David Freedberg for this reference.

42. The ancient classifications of tonal modulation lived on in medieval musical theory, which distinguished as many eight modes. These modes in turn were grouped into two broader categories defined as the elevated (*elevatus*) and the low (*humilis*) modes. See, for example, the 11th-century *Dialogus de Musica arte domini Ottonis*, wrongly attributed to Odo of Cluny, ed. *PL* 133: cols. 759–96, esp. 767–74.

43. For the various medieval connotations of "modus" see F. Blatt et al., eds., *Novum Glossarium Mediae Latinitatis ab anno DCCC usque ad annum MCC* (Copenhagen, 1959–63), vol. M, cols. 691–697.

44. Cf. H. Caplan, trans., *Rhetorica ad Herennium*, IV.8–11, Loeb Classical Library (Cambridge, Mass., 1954), 252–69.

45. E. Farral, *Les arts poétiques du XIIe et du XIIIe siècle. Recherches et documents sur la technique littéraire du Moyen Age* (Paris, 1962), 86–88, 312–13; K. M. Fredborg, *The Latin Commentaries by Thierry of Chartres*, Pontifical Institute for Mediaeval Studies, Studies and Texts, 84 (Toronto, 1988), 323–29. By contrast, Augustine, though acknowledging the need to vary one's style, recommended the lowly style as the mode most appropriate for the explication of scripture. See E. Auerbach, *Literary Language and Its Public in Late Latin Antiquity and in the Middle Ages*, trans. R. Manheim (Princeton, 1965; rpt. 1993), chap. 1.

46. Farral, *Arts poétiques*, 87.

47. M. Schapiro, "Style," rpt. in *Theory and Philosophy of Art: Style, Artist and Society*, Selected Papers, 4 (New York, 1994), 51–102, esp. 94–96. Similarly, Ernst Kitzinger and Kurt Weitzmann have suggested that different styles were used in Early Byzantine art to distinguish two or more different planes of existence within a single religious image, and Henry Maguire has taken up the idea more recently for the discussion of imperial and hagiographic portraiture in Middle Byzantine art. In these cases, modes are defined either by execution of detail or by distinctions in pose (e.g., frontal vs. contrapposto), modeling, perspective, and composition. E. Kitzinger, *Byzantine Art in the Making* (Cambridge, Mass., 1977), 117–18; K. Weitzmann, "The Classical in Byzantine Art as a Mode of Individual Expression," in *Studies in Classical and Byzantine Manuscript Illumination*, ed. H. L. Kessler (Chicago, 1971), 151–75, esp. 163–66; H. Maguire, "Style and Ideology in Byzantine Imperial Art," *Gesta* 28 (1989): 217–31; and idem, "Disembodiment and Corporality in Byzantine Images of the Saints," in *Iconography at the Crossroads*, ed. B. Cassidy (Princeton, 1993), 75–90.

48. Kitzinger, *Byzantine Art in the Making*, 74–75.

49. One could also argue that there are further modal distinctions within the hierarchy of saints. Martyrs and apostles as classes of saints tend to be more dynamic and active in their poses than bishops, who are cast in more frontal, ascetic poses. Henry Maguire, in "Disembodiment and Corporality," has

been able to document modal distinctions of this kind in Byzantine texts and images.

50. Demus, *Byzantine Mosaic Decoration*, 13–14.

51. On the authority of the written word in authenticating saints' lives, see B. Stock, *The Implications of Literacy: Written Language and Models of Interpretation in the Eleventh and Twelfth Centuries* (Princeton, 1983), 64–73.

52. For Baudri de Bourgueil and the allegorical function of *ekphrasis* of textiles and other works of art in the 12th-century, see C. Ratkowitsch, *Descriptio Picturae. Die literarische Funktion von Kunstwerken in der lateinischen Grossdichtung des 12. Jahrhunderts*, Wiener Studien, Beiheft 15 (Vienna, 1991), esp. 121–23, 353–55. For precedents in ancient art, see J. M. Blanchard, "The Eye of the Beholder: On the Semiotic Status of Paranarratives," *Semiotica* 22, no. 3/4 (1978): 235–68, esp. 236 and 238 (for tapestries).

Chapter Four. The Intercessory Program

1. Christ is enthroned between the interceding archangels Michael and Gabriel in the early 11th-century apse fresco of Bahatin Samanligi Kilise at Belisirama in Cappadocia. See M. Restle, *Byzantine Wall Painting in Asia Minor*, 3 vols. (Recklinghausen, 1967), 3:pls. 518–19. Archangels also appear in conjunction with the "official" *Deesis* comprising the enthroned Christ, his Mother, and John the Baptist in a number of Cappadocian apses: Tagar (c. 1080), the Kirkdam alti Kilise (1282–1304), and the Dirckli Kilise (1020–25) at Belisirama. See ibid., 3:pls. 355, 359, 511, 530.

2. G. Bovini, "I mosaici dell'Oratorio di S. Venanzio a Roma," *CorsiRav* 18 (1971): 141–54.

3. E. Kantorowicz, "Ivories and Litanies," *JWCI* 5 (1942): 56–81. On the "Angel Deesis" in stone reliefs, see R. Lange, *Byzantinische Reliefikone* (Recklinghausen, 1964), 105, no. 36. As Cutler has recently reaffirmed, Byzantine pictorial compositions and texts describing the *Deesis* could include any combination of saints or angels addressing their prayers of intercession to Christ—not just to the Virgin and the Baptist: A. Cutler, "Under the Sign of the Deesis," *DOP* 41 (1987): 145–153.

4. See Appendix I, I2.

5. On the origins and diffusion of this icon type, see Belting, *Likeness and Presence*, 73–77.

6. On the intercessory role of the Virgin at the Assumption and Coronation, see W. Tronzo, "Apse Decoration, the Liturgy and the Perception of Art in Medieval Rome: S. Maria in Trastevere and S. Maria Maggiore," in *Italian Church Decoration of the Middle Ages and Early Renaissance* (Bologna, 1989), 167–93.

7. The classic Byzantine paradigms are Daphni and Hosios Lucas. See Demus, *Byzantine Mosaic Decoration*, 17–22, pls. 7, 10A, 42, 43A. For the adaptation of that scheme to Western apses in Sicily, see ibid., 64–67, pls. 48 and 49. Hans Belting has pointed to a comparable arrangement as early as the 9th century on the central vault in the crypt of Epiphanius at San Vincenzo al Volturno. See his *Studien zur Beneventischen Malerei* (Wiesbaden, 1968), 216ff.

8. Distinct roles are assigned to Mark and Hermagoras in the decoration. The titulus of the Commission of Saint Mark designates the evangelist as the "patronus" of Aquileia. In north Italy, this title was applied from the 9th century on to saints credited with the initial conversion of a community to Chris-

tianity. See Picard, *Souvenir*, 705f and Orselli, "La città altomedievale," 47ff. Hermagoras, more intimately connected with the city by the presence of his relics, is defined as the chief intercessor.

9. See above, chap. 2, 18–19.

10. The 6th-century apse mosaic of Sant'Apollinare in Classe provides a telling analogy. The first bishop of the See of Ravenna, vested in full archiepiscopal attire, stands orant over the high altar and crypt to which he was translated in the 6th century. O. von Simson, *Sacred Fortress: Byzantine Art and Statecraft in Ravenna*, 2nd ed. (Princeton, 1987), 40–62; F. W. Deichmann, *Ravenna. Geschichte und Monumente* (Wiesbaden, 1969), 261–79; and C. Belting-Ihm, *Die Programme der christlichen Apsismalerei vom vierten Jahrhundert bis zur Mitte des achten Jahrhunderts* (Wiesbaden, 1960), 70ff.

11. See F. Lanzoni, *Le diocesi d'Italia dalle origini al principio del secolo VII* (Faenza, 1927), 984; R. Majocchi, "Le tradizioni sull'apostolicità di S. Siro," *Bollettino della società pavese di storia patria* 1 (1901): 58–68; and Orselli, "La città altomedioevale."

12. Lanzoni, *Le diocesi*, 983–84.

13. On the topography of Aquileia, see G. Brusin, "Chiese paleocristiane di Aquileia," *AqN* 22 (1951): 45–60, and G. Vale, "Contributo per la topografia di Aquileia medievale," *AqN* 2 (1931): 1–34; idem, "Per la topografia di Aquileia medievale," *AqN* 6 (1935): 3–12.

14. 1177, ind. X. Luglio. col. 117 in *I Libri Commemoriali della Republica di Venezia*, Registri, tomo V. Monumenti Storici, Serie Prima, Documenti, vol. X (Venice, 1901), 189.

15. This theme is emphasized in the *Passio* of Hermagoras and Fortunatus and is probably illustrated in the right aisle of the crypt. (See below, chap. 5.) The choice of Cyrus may have been intended to challenge the neighboring See of Milan. As early as the 7th century, Milan's metropolitan authority was eroded when Como was transferred to the Aquileian patriarchate. The exemption of Pavia from Milanese jurisdiction in the 9th century represents a further gain for Aquileia at Milan's expense. The ultimate infringement of Aquileia on the Milanese hegemony was the coronation of Henry VI as king of Italy by the patriarch Godfrey in 1186. The ceremony took place in Sant'Ambrogio in Milan without the sanction of Urban III who had recently vacated that archbishopric to become pope. In retaliation,

Urban III suspended Godfrey and the other partici-
pants from divine offices. For the early history, see
Picard, *Souvenir*, 5:627–28. For the coronation of
Henry VI, see Paschini, "I patriarchi di aquileia nel
secolo XII," 249f.

16. This metaphor seems to originate with Saint
Paul in Galatians 2:9, wherein James, Peter, and John
are called "columns." Constantine seems to have
popularized the concept of apostles as physical and
spiritual columns in the early Church. It was ex-
tended later to all orders of saints. See J. Onians,
*Bearers of Meaning. The Classical Orders in Antiquity,
the Middle Ages, and the Renaissance* (Princeton, 1988),
70–71, 85, 88; and B. Reudenbach, "Säule und Apos-
tel. Überlegungen zum Verältnis von Architektur und
architekturexegetischer Literatur im Mittelalter,"
Frühmittelalterliche Studien 14 (1980): 310–51, esp.
321ff. For a 12th-century example, see Abbot Suger's
description of the new chevet at Saint-Denis in E.
Panofsky, trans., *Abbot Suger on the Abbey Church of
St.-Denis and Its Art Treasures*, 2nd ed. (Princeton,
1979), 105.

17. E.g., the apse of Santa Pudenziana (circa 390).
See R. Krautheimer, *Rome: Profile of a City, 312–1308*
(Princeton, 1980/1983), 40–42. On the promotion of
Peter and Paul's joint patronage of Rome, see also
H. L. Kessler, "The Meeting of Peter and Paul in
Rome: An Emblematic Narrative of Spiritual Broth-
erhood," *DOP* 41 (1987): 265–75.

18. See Appendix I, I4–I15.

19. The same selection appears in the central apse
of Torcello, with the exception of one: Thaddeus re-
places Matthias. As at Aquileia, Thomas and Philip
are paired. See Rizzardi, *Mosaici altoadriatici*, 89–96,
figs. 59–60 and I. Andreescu-Treadgold, "Torcello
III: La chronologie relative des mosaïques pariétales,"
DOP 30 (1976): 247–76.

20. All these saints are commemorated in the
12th-century Aquileian breviaries, Codex 91 of the
Museo Civico Archeologico, Cividale, and Codex 3
(formerly) of the Archivio Capitolare, Udine. A
church dedicated to Sergius and Bacchus stood on
the site of San Pietro in Castello as early as the 5th
century; it was replaced by the cathedral of San Pi-
etro in 841 (U. Franzoi and D. di Stefano, *Le Chiese
di Venezia* [Venice, 1976], 525–27). Cosmas and
Damian were venerated in a monastery belonging to
Aquileia, nearby off the Adriatic coast (see Brusin,
"Chiese paleocristiane," 45–46), as well as in Venice
on the Giudecca (Franzoi and di Stefano, 281–89).
Theodore was the original patron of Venice, prior to
the acquisition of Saint Mark's relics in 828 (see
Demus, *The Church*, 19ff.).

21. S. Tavano, "Testimonianze epigrafiche del
culto dei martiri Proto e Crisogono a San Canciano,"
Studi Goriziani 28 (1960): 151–64 and idem, *Storicità
dei martiri aquileiesi*, 6–8.

22. Swoboda (*Der Dom*, 48) identified the figures
as Anastasia and Diomedes, but in neither case can
these readings be confirmed by inscriptions. See Ap-
pendix I, I22, I23.

23. See, for example, the explication of Martin's

prominent position in the procession of saints at
Sant'Apollinare Nuovo in Ravenna, in Simson, *Sacred
Fortress*, 83.

24. Tavano, *Aquileia cristiana*, 122–30. The build-
ing survived into the 18th century, as documented by
G. Bertoli, *Le Antichità d'Aquileja Profane e Sacre per
la maggiorparte finora inedite* (Venice, 1739), 409–12.
Picard (*Souvenir*, 256f.) argues that the church was
dedicated like a Roman titulus to its patron, named
Hilary, only later to be identified as the second
bishop of Aquileia.

25. See Demus, *Mosaics of San Marco*, 1:32–33.

26. Cividale, Museo Civico Archeologico, Brevia-
rium Aquileiense, Codex 91, fol. 45r; Udine, Biblio-
teca del Seminario Arcivescovile, Capitulario et Col-
lectario, Codex 43, fol. 12v.

27. It is tempting to see the origins of a cult of
Martial in Aquileia in the *Martyrologium Hieronymum*
which lists Martial on the same day as the Aquileian
martyrs, Hermogenes and Fortunatus: "x kl. sep. In
Aquileia nat(atle) s(an)c(t)orum furtunati her-
moge(n)is. marcialis, hermogerati Rom(am)
civit(atem) s(an)c(t)orum laurenti . . ." (Wissenburg
Ms., *MH*, August 23, in *AASS*, Novembris, Tomus II,
pars I). However, the earliest reference to the venera-
tion of Martial in Aquileia, apart from the crypt
painting, is found in a 13th- or 14th-century (it lists
Elizabeth of Hungary [d.1231] and Francis) "Cata-
logus Vitarum Sanctorum ex codice aquileiensis"
whose contents are recorded in the 18th century by
Giusto Fontanini (*Opuscula variae eruditionis de rebus
foroiuliensibus a Iusto Fontaninio collecta, quaedam sua
manu*, Venice, Marciana, lat. XIV.51 [= 4271], 193v).

28. Franzoi and di Stefano (*Chiese di Venezia*, 127)
suppose a 9th-century foundation for the church
without providing documentary or archaeological
proof.

29. Callaghan, "Sermons of Adémar of
Chabannes," 251–95.

30. A complete litany is preserved in the 12th-
century Aquileian breviary now in the Museo Civico
Archeologico at Cividale (Codex 91, fol. 45r).

31. Demus, *Norman Sicily*, pls. 58B and 76B. For
a detailed discussion of this portrait format see E.
Kitzinger, *The Mosaics of St. Mary's of the Admiral in
Palermo*, DOS, 27 (Washington, D.C., 1990), 197–
206 and pl. XXII; and Appendix I, I37.

32. The Aquileian donor may also have held a
model.

33. Even Roger II who consciously had himself
portrayed as a Byzantine emperor in the Martorana is
shown without the nimbus. See Kitzinger, *St. Mary's*,
pl. XXIII. Two rare exceptions to this rule are: (1)
the unidentified "ruler" in a sacramentary produced
in the Court School of Charles the Bald (Paris, Bibl.
Nat. lat. 1141, fol. 2v; P. Schramm and F. Mütherich,
Denkmale der deutschen Könige und Kaiser [Munich,
1962], no. 39) and (2) the lost wall painting from
Farfa Abbey depicting Otto II (ibid., no. 94). The
first case is unclear, since we do not know who is
represented or even whether the intention is to por-
tray a specific ruler. The second representation may

be explained by Byzantine influence: Otto II was married to the Byzantine princess Theophano and in other works had himself portrayed with his wife in Byzantine vesture (ibid., nos. 91 and 92).

34. R. Folz, *Le souvenir et la légende de Charlemagne dans l'empire germanique médiévale*, Publications de l'Université de Dijon, 7 (Paris, 1950), 186–202.

35. See Folz, *Souvenir*, 192, n. 178; 203–13.

36. Ibid., 209.

37. See above, chaps. 1 and 2.

38. On medieval portraits of Charlemagne, in general see P. E. Schramm, *Die deutschen Kaiser und Könige in Bildern ihrer Zeit, 751–1190* (Munich, 1983); and D. Kötzsche, "Darstellungen Karls des Grossen in der lokalen Verehrung des Mittelalters," in *Karl der Grosse. Lebenswerk und Nachleben*, eds. W. Braunfels and P. E. Schramm, 4 vols. (Düsseldorf, 1967), 4:157–214.

39. F. Steenbock, *Der kirchliche Prachteinband im frühen Mittelalter* (Berlin, 1965), 173–74; Schramm, *Die deutschen Kaiser*, 250, no. 185.

40. See Schramm and Mütherich, *Denkmale*, 188–89, no. 195; and P. Lasko, *Ars Sacra 800–1200* (Harmondsworth, 1972), 253–54.

41. A. Iacobini, "Il mosaico del Triclinio Lateranense," in *Fragmenta Picta. Affreschi e mosaici staccati del Medioevo romano*, ed. M. Andaloro (Rome, 1989), 189–96; H. Belting, "I mosaici dell'Aula Leonina come testimonianza della prima *renovatio* dell'arte medievale di Roma," in *Roma e l'età carolingia* (Rome, 1976), 167–82; C. Davis-Weyer, "Eine patristische Apologie des Imperium Romanum und die Mosaiken der Aula Leonina," in *Minuscula discipulorum. Kunsthistorische Studien Hans Kauffmann zu 70. Geburtstag 1966* (Berlin, 1968), 71–83; P. E. Schramm, *Die zeitgenössischen Bildnisse Karls des Grossen* (Hildesheim, 1973), 3–16.

42. Folz, *Souvenir*, 197ff.

43. For Barbarossa's relationship with Aquileia, see pages 40, 41, 52.

44. The stucco figure of Charlemagne at Müstair appears to have fulfilled a similar role. Once thought to be a contemporary portrait of the emperor as founder of the abbey, it is now generally believed to have been commissioned by a strong ally of Barbarossa, Bishop Egino of Chur, in the late 12th century to strengthen (retroactively) the abbey's imperial ties. See Kötzsche, "Darstellungen," 207–9.

Chapter Five. The Hagiographic Cycle and Ecclesiastical Politics

1. Most of the tituli have vanished or are indecipherable. All the surviving evidence is recorded in Appendix I.

2. See chapter 1, n. 1 for editions of these texts. Appropriate excerpts are cited in Appendix I.

3. URBS AQ(U)ILEIA BONUS TIBI MITTITUR ECCE PATRONUS.

4. The full text is cited and translated in Appendix I.

5. "Episcopos autem ordinare ante pallium acceptum nec archiepiscopo, nec primati, nec patriarchae licet . . . " (*Decretum magistri Gratiani*, pars I. 100, ed. E. Friedberg [Leipzig, 1879], cols. 351–52). For commentary, see R. Benson, *The Bishop Elect: A Study in Medieval Ecclesiastical Office* (Princeton, 1968), 167ff.

6. *Liber extra, Decretales Gregorii IX*. Lib. l, Tit. 6, Cap. 4; trans. in Benson, *Bishop Elect*, 169–70.

7. *Liber extra, Decretales Gregorii IX*. 1.8.3; Benson, *Bishop Elect*, 171.

8. "Italia" here denotes the former Lombard territories in North Italy, including Friuli, the Veneto, and Istria.

9. See Appendix I, H8.

10. See Appendix I, H10 for complete reconstruction.

11. XP(IST)IC(O)LAE PLANGUNT UBI PATRIS M(E)MBR(A) REC(ON)DUNT.

12. See Appendix I, H24 for an extended discussion of this terminology.

13. A comparable sequence can be found in the early-13th-century frescoes in the central apse of the crypt of Anagni Cathedral. There, a more extensive translation sequence provides the backdrop of the reliquary altar of the patron saint and bishop, Saint Magnus. Demus, *Romanesque Mural Painting*, pl. 68; and M. Q. Smith, "Anagni: An Example of Mediaeval Typological Decoration," *PBSR* 23 (1965): 1–47.

14. Abou-el-Haj, *The Mediaeval Cult of Saints*, 33–60; H. L. Kessler, "Pictorial Narrative and Church Mission in Sixth-Century Gaul," in *Pictorial Narrative in Antiquity and the Middle Ages = Studies in the History of Art* 16 (1985): 75–91; C. Hahn, *Passio Kiliani, Ps. Theotimus, Passio Margaretae, Orationes*, Codices Selecti, 83 (Graz, 1988), 9ff.; eadem, "Picturing the Text: Narrative in the Life of the Saints," *Art History* 13 (1990): 1–33, esp. 3f.; M. Carrasco, "Spirituality and Historicity in Pictorial Hagiography: Two Miracles by St. Albinus of Angers," *Art History* 12 (1989): 1–21, esp. 1–2. For the use of conventional structures and scriptural topoi in hagiographic texts, see M. van Uytfanghe, "La controverse biblique et patristique autour du miracle, et ses répercussions sur l'hagiographie dans l'Antiquité tardive et le haut Moyen Age latin," in *Hagiographie, Culture et Sociétés, IVe–XIIe siècles* (Paris, 1981), 205–31, esp. 211ff.; J. Earl, "Typology and Iconographic Style in Early Medieval Hagiography," *Studies in the Literary Imagination* 8 (1975): 15–46; B. de Gaiffier, "Hagiographie et historiographie: Quelques aspects du problème," in *Recueil d'Hagiographie*, Subsidia Hagiographica, 61 (Brussels, 1977), 136–66, esp. 153ff.; idem, "Miracles bibliques et vie de saints," in *Études critiques d'hagiographie et d'iconologie*, Subsidia Hagiographica, 43 (Brussels, 1967), 50–61; J. Leclercq, "L'écriture sainte dans l'hagiographie monastique du haut moyen âge,"

in *La Bibbia nell'alto Medioevo* = Settimane di studi medievali, 10 (Spoleto, 1963), 103–28; and H. Delehaye, *Les Passions des Martyrs et les genres littéraires* (Brussels, 1921), 153f., 239ff.

15. Compare S. Nichols, *Romanesque Signs* (New Haven, 1983), 1–14, esp. 9: "*historia* did not seek to describe events as they were, but to transform them into texts paralleling those of Scripture and theology in order to complete the dialectic of Revelation."

16. The continuity between the Christ's terrestrial mission and his intervention through the saints in the historical present was emphasized particularly in the performance of miracles. Compare Kessler, "Pictorial Narrative and Church Mission," who argues that the conventional miracles of Saint Martin represented in the cathedral of Tours provided the "principal vehicle for extending continuity from the authority of apostolic mission to later saints." This notion is confirmed by the *Vita Sancti Martini* of Paulinus of Périgueux: "Christ, whose missions are in all the world, planted many miracles in our land by giving in far-off Gaul Martin's outward signs" (ibid., 84). See also Lerclerq, "Écriture sainte," 112f. On the theme of "imitatio Christi" in medieval spirituality, see G. Constable, "The Ideal of the Imitation of Christ," in *Three Studies in Medieval Religious and Social Thought* (Cambridge, 1995), 145–248.

17. *MGH. Scriptores Rerum Merovingicarum*, Tom. I, pars 2, 662–63; cited in C. Hahn, "Narrative and Liturgy in the Earliest Illustrated Lives of the Saints," Ph.D. diss., Johns Hopkins University, Baltimore, 31. Similarly, in the 11th century Reginald of Canterbury justified having altered the *vita* of Malchius composed by Jerome in order to demonstrate the harmony that exists amongst all the members of the body of Christ. See de Gaiffier, "Miracles bibliques et vies de saints," 58.

18. See Abou-el-Haj, *The Mediaeval Cult of Saints*, 67–102; eadem, "Consecration and Investiture in the Life of Saint Amand, Valenciennes. Bibl. Mun. Ms. 502," *Art Bulletin* 61 (1979): 342–58.

19. M. Seidler, "Schrein des heiligen Heribert," in *Ornamenta Ecclesiae* (Cologne, 1985), 2:314–23; and H. Schnitzler, *Der Schrein des heiligen Heribert* (Mönchengladbach, 1962).

20. For the Barberini drawings of the destroyed early medieval fresco of that subject in San Paolo fuori le mura, see S. Waetzoldt, *Die Kopien des 17. Jahrhunderts nach Mosaiken und Wandmalereien in Rom* (Vienna, 1964), no. 659.

21. For Peter and Paul at Monreale, see Demus, *Norman Sicily*, 296, 299, pl. 83. The same convention of paired saints on trial is found in elsewhere at Monreale in the cycle of Castus and Cassius (ibid., 300, pl. 109B) and in the crypt of Saint-Savin-sur-Gartempe (idem, *Romanesque Mural Painting*, pl. 141). A similar formula is used for Byzantine *vita* illustrations: e.g., the trials of Saint Basil of Caesarea or Cyprian before Decius. See G. Galavaris, *The Illustrations of the Liturgical Homilies of Gregory Nazianzenus* (Princeton, 1969), figs. 153, 157, 216.

22. Demus, *Norman Sicily*, 277–78, pl. 85A.

23. Kugler, "Kryptafresken," 118–53, esp. 136–38.

24. A striking parallel for this deliberate assimilation of monumental imagery to miniatures is found in the atrium of San Marco in Venice. Here the Genesis cycle reproduces quite faithfully the iconography, style, and density of illustration found in its model, the Cotton Genesis. See Demus, *Mosaics of San Marco*, 2:72–177.

25. See Dale, "Inventing a Sacred Past," 53–54.

26. On the interpretive aspect of medieval memory (invention and composition) in general, see M. Carruthers, *The Book of Memory: A Study of Memory in Medieval Culture* (Cambridge, 1990), 189–220 and 259: "Adaptation, the essential conduct of *memoria ad res* lies at the very basis of medieval literary activity."

27. Dale, "Inventing a Sacred Past," 63–67; H. R. Hahnloser and R. Polacco, eds., *La Pala d'Oro* (Venice, 1994), 89–93, 115–29; M. Frazer, "The Pala d'Oro and the Cult of St. Mark in Venice," *JÖB* 32 (1982): 273–79; O. Demus, "Zur Pala d'Oro," *JÖBG* 16 (1967): 263ff.

28. The titulus does not specify who is baptized ("Hic Baptizat Beatus Marcus"), but it is generally assumed that Anianus is the catechumen. Against this interpretation, it should be observed that Anianus appears without a nimbus in the scene of his healing and his curly hair distinguishes him from the catechumen in the Baptism scene. On the other hand, the facial type resembles that of Hermagoras in the scene of his presentation before Peter. This episode in Hermagoras's career is not mentioned in the text of the legend, but it was a necessary precondition for his consecration as bishop. Its inclusion here would emphasize further the role of Mark in the foundation of the Church of Aquileia.

29. Frazer, "The Pala d'Oro," 279.

30. Demus, *Mosaics of San Marco*, 1:82–83; idem, *Die Mosaiken von San Marco in Venedig* (Baden, 1935), 37–38; S. Bettini, *Mosaici antichi di San Marco a Venezia* (Bergamo, 1944), 23–24; G. Gombosi, "Il più antico cicolo di mosaici di San Marco," *Dedalo* 13 (1933): 323ff.

31. Dale, "Inventing a Sacred Past," 75–78.

32. The earliest extant liturgical texts from Venice for the feast of Saint Mark are found in two antiphonaries from the 13th and 14th centuries. See G. Cattin, *Musica e liturgia a San Marco. Testi e melodie per la liturgia delle ore dal XII al XVII secolo*, 4 vols. (Venice, 1990–92), 2:86–88 and 3:3*–18*.

33. On the Venetian appropriation of the Marcian tradition, see A. Carile, "Le origini di Venezia nella tradizione storiografica," in *Storia della cultura veneta* (Vicenza, 1976), 135–66; Demus, *The Church*, 30–43; and R. Cessi, "Nova Aquileia," *Atti del Reale Istituto Veneto di scienze, lettere ed arti* 88 (1928–29): 542–94.

34. The figure of Helias was heavily restored in the 15th century, at which time the figure of Nicholas of Tolentino was added. The iconography of the figure of Helias and the accompanying inscription appear to be faithful to the original. See Demus, *Mosaics of San Marco*, 1:55.

35. QVIA IVSTIS PETITIONIBVS TVIS VENERANDE FRATER, CONTRADICERE NEQVIMVS, PER NOSTRI PRIVILEGII SERIEM CONFIRMAMVS GRADENSE CASTRVM METROPOLIM TOTIVS VENETIAE HISTRIAE ATQVE DALMATIAE. See Demus, *The Church*, 39–40 and idem, *Mosaics of San Marco*, 1:56.

36. Helias: METROPOLIM ROGITO, PATER, ESSE GRADVM VENETORVM; Pelagius: SIT VENETIS ISTRIS POPVLIS ET DALMATICORVM. Demus, *Mosaics of San Marco*, 1:55–56.

37. See Cattin, *Musica e Liturgia*, 2:44–45, 240–41; and 3:147*–60*.

38. For the complete text of the *Translatio Marci*, see N. McCleary, "Note storiche ed archeologiche sul testo della *Translatio Marci*," *MemStorFor* 29 (1933): 223–64. McCleary transcribes an 11th-century text, but Baudoin de Gaiffier claims to have discovered a 10th-century version in Codex 197 of the Bibliothèque d'Orléans. See his review of H. C. Peyer in *AnalBoll* 76 (1958): 444–46, esp. 445.

39. McCleary, "Note," 250–55.

40. Immediately following the saint's intervention to save the Venetians from shipwreck, the advent of the relics of Mark is revealed *a domino* to the inhabitants of Dalmatia and Istria as the ship passes their coasts. See McCleary, "Note," 259, lines 1–18. On the *praedestinatio* see Dale, "Inventing a Sacred Past," 88–89, 93–101.

41. PONTIFICES CLERVS P(O)P(V)L(V)S DVX M(E)NTE SERENVS LAVDIBVS ATQVE CHORIS EXCIPIVNT DVLCE CANORIS. Cf. Demus, *Mosaics of San Marco*, 1:68 and H. Hubach, "Pontifices, Clerus/Populus, Dux. Osservazioni sul più antico esempio di autorappresentazione politica della società veneziana," in *San Marco: aspetti storici ed agiografici, Atti del convegno internazionale di studi*, April, 1994, ed. A. Niero (Venice 1996), 370–97.

42. Demus observes that the present group of three patricians dates from the end of the 19th century and replaces two Renaissance-style figures recorded in engravings executed in the 1880s. See Demus, *Mosaics of San Marco*, 1:68 and fig. 69.

43. G. Monticolo, *Cronache Veneziane antichissime* (Rome, 1890), 1:38.30 and 39.6. This assertion is repeated in later sources. Marin Sanuto, writing of the Marcian mission in 1483, affirms that Mark, at Aquileia, "scrisse li evanzelij, . . . et fo fato prothopresul di San Piero ivi . . ." (Sanuto, *Itinerario*, 143). Giovanni Candido, in his *Commentarii de i Fatti d'Aquileia* (Venice, 1544), 25 and 71, distinguishes between Mark's position as "primo patriarca di Aquileia" and that of Hermagoras as "primo patriarca d'Italia," thus conflating the Venetian and Aquileian strands of the legend; later in the same work he refers to Mark as "nostro primo patriarca."

44. See the diploma issued by Charlemagne to Patriarch Paulinus on 4 August 792 (*MGH, Diplomata Karolinorum*, I [1906], no. 174, 233–34).

45. On Frederick Barbarossa's interventions in episcopal elections, see Benson, *Bishop Elect*, 284–91.

46. *MGH, Concilii*, II, 589. Cf. Lenel, *Venezianisch-Istrische Studien*, 29 and Cessi, "Nova Aquileia," 588–94.

47. McCleary, "Note," 241–43.

48. Ioannes Diaconus, *Chronicum Venetum*, ed. in Monticolo, *Cronache Veneziane antichissime*, 1:62: "in quo etiam loco post paucum tempus Helyas, egregius patriarcha, qui tertius post Paulum regendam suscepit ecclesiam, ex consensu beatissimi pape Pelagii, facta synodo viginti episcoporum, eandem Gradensem urbem totius Venecie metropolym esse instituit."

49. Ibid., 62–63.

50. Monticolo, *Cronache veneziane antichissime*, 1:5, 48.

51. Lenel, *Venezianisch-Istrische Studien*, 30ff., 46ff., 72ff.

52. Dandolo, *Chronica*, vol. 12, pt. I, 82: "Igitur, quia petisti a nobis . . . conscientientibus suffraganeis tibi episcopis, quatenus gradense castrum tocius(sic) Venecie(sic) fieri immo et Istrie metropolim, ad regendam scilicet ecclesiam . . . suprascriptum castrum Gradense tocius Venecie fieri cum omnibus vestre ecclesie pertinentibus et Istrie metropolim perpetuo confirmamus."

53. Demus, *The Church*, 37ff.

54. See J. Ferluga, *L'amministrazione bizantina in Dalmatia* (Venice, 1978), 235ff.; idem, "La Dalmazia fra Bisanzio, Venezia e l'Ungheria ai tempi di Manuele Comneno," in *Byzantium on the Balkans*, ed. J. Ferluga (Amsterdam, 1976), 193–213; and J. Duša, *The Mediaeval Dalmatian Episcopal Cities: Development and Transformation* (New York, 1991), esp. 45–50 and 55ff.

55. *Codex Diplomaticus Regni Croatiae, Dalmatiae et Slavoniae*, ed. T. Smičiklas (Zagreb, 1904), 2:79–81, nos. 79 and 80.

56. Ibid.

57. L. Steindorff, *Die dalmatischen Städte im 12. Jahrhundert: Studien zu ihrer politischen Stellung und gesellschaftlichen Entwicklung* (Cologne, 1984), 74ff.; Duša, *Mediaeval Dalmatian Episcopal Cities*, 59–61.

58. *Codex Diplomaticus Regni Croatiae*, 3:61, no. 55: "metropolitica dignitas propter vestrum honorem specialiter fuit illis ab apostolica sede concessa, ut videlicet ecclesia vestra non solo nomine, sed pleno iure patriarchalem dignitatem haberet, cum ei subiecta fieret metropolis Jadertina. . . ." The excerpt appears within the context of a letter reprimanding the Venetians for capturing Christian Zara on their way to the Fourth Crusade.

59. Ughelli, *Italia Sacra*, 5:62–63; Kehr, *Italia Pontificia*, 7.2:35, no. 79. The Istrian bishoprics—Pola, Trieste, Parenzo—are included at the outset of the privilege.

60. The renewal of Gradese tutelage over the Istrian bishoprics is alluded to indirectly in the bull issued by Anastasius IV to Henricus of Grado on 13 June 1157. Here, the pope states that he is renewing the privileges granted by his predecessors, Pelagius, Alexander, Urban II, Hadrian, and Leo IX, the last of whom had restored the Istrian bishops to Grado's jurisdiction in 1053. See *Codex Diplomaticus Regni Croatiae*, 2: 82, no. 81.

61. Demus, *Mosaics of San Marco*, 1: 82–83; idem, *Die Mosaiken von San Marco* (Baden, 1935), 37–38; Bettini, *Mosaici antichi di San Marco*, 23–24; Gombosi, "Il più antico cicolo," 323ff.

62. The striding pose of Hermagoras in the baptizing scene (fig. 141, lower right) and specific linear patterns of the drapery—the gently fluttering hems, the teardrop-shaped "damp fold" pressed over the knee and shoulder—find close analogies in the annunciate angel, Gabriel, in the mid-12th-century frescoes of Pskov. Similarly, the more subdued pattern of elongated, inverted V-folds over the legs of stationary figures, such as Peter in the Consecration of Hermagoras (fig. 141, lower left), resembles that of Saint Peter in the Russian fresco of Christ with the Samaritan Woman. For the Pskov frescoes, see Lazarev, *Old Russian Murals and Mosaics*, 99–107, pls. 78 and 83.

63. The inscription, which is incised in marble strips at the summit of the marble revetment on the south wall of the Cappella San Clemente, is transcribed by Demus, *Mosaics of San Marco*, 1:82, as follows: "+ ANN(O) D(OMINI).C.L VIIII CV(M) DVX VITALIS MICHAEL GOT. . . .(C)EPIT TABVLAS PETRVS A DD . . . EPIT". Polacco (*Basilica d'Oro*, 217) proposes that "tabula" could refer to "pannello musivo" and on this basis, dates the mosaic decoration of the choir chapel shortly *after* 1159. Against such an interpretation, Demus (*Mosaics of San Marco*, 1: 329, n. 135), points out that the inscription is executed in marble rather than mosaic and that the term "tabula" is indeed used to denote marble revetment in another inscription at San Marco itself.

64. Demus, *Mosaics of San Marco*, 1:69.

65. S. Sinding-Larsen, *Christ in the Council Hall: Studies in the Religious Iconography of the Venetian Republic = Acta ad archaeologiam et artium historiam pertinentia* 5 (Rome, 1974), 159–66; A. Pertusi, "Quedam regalia insignia: Ricerche sulle insegne del potere ducale a Venezia durante il medioevo," *Studi veneziani* 7 (1965): 71ff.; R. Cessi, "L'investitura ducale," *Atti dell'Istituto Veneto di Scienze, Lettere ed Arti, Classe di Scienze morali e Lettere* 126 (1967–68): 284–86.

66. On Ulrich II, see Paschini, "I patriarchi," 113–81, esp. 113–32.

67. A document of 24 March 1169 confirming the possessions of Gurk in the market of Aquileia gives Ulrich the title "Dei gratia s(an)cte Aquilegensis ecclesiae patriarcha et apostolice sedis legatus"; cited in Paschini, "I patriarchi," 132.

68. The political ramifications of the Pax Venetiae for the crypt program have already been recognized in a general way by Gioseffi and Belluno, *Aquileia*, 55–56 and Tavano, *Aquileia e Grado*, 200. Chiara

Morgagni Schiffrer ("Gli affreschi medioevali," 347–48) argues for Ulrich's patronage primarily on the basis of the economic gains from the Pax Venetiae and accessibility to Venetian craftsmen.

69. Ughelli, *Italia Sacra*, 5: 66–68.

70. Ibid., 65–66; Migne, *PL*, CC, 1283–84.

71. Ughelli, *Italia Sacra*, 5:65B–D: "Licet omnium Apostolorum par esset dilectio, et omnes ligandi, et solvendi eandem acceperint potestatem, juxta verbum tamen Beati Leonis velut quedam servata est juxta eos distinctio dignitatis, et uni datum est, ut caeteris praesideret. Inque eundem utique modum in ecclesia Dei officiorum facta est, dignitatumque diversitas, et ad majora ministeria exhibenda majores sunt statutae personae, quae et praerogativa dignitatis eminerent, et aliarum curam habeant ampliorem. Unam vero de dignioribus, et nobilioribus Ecclesiis Occidentis ab antiquis temporibus Aquilejensem constat Ecclesiam extitisse, quae et excellentia dignitatis emicuit, et Sacrosanctae Romanae Ecclesiae fideliter et devote noscitur adhaerere. Unde et Apostolica Sedes eidem Ecclesiae semper jura, et dignitates suas conservavit attentius, et Praelatos ipsius propensius honoravit, et justas postulationes eorum benignius admittere consuevit. Eapropter Venerabilis in Christo frater Aquilejensis Patriarcha, tibi et per te Sanctae Aquilejensi Ecclesiae, . . . ad exemplar praedecessoris nostri bonae memoriae adriani Papae potestatem super sexdecim Episcopatus . . . Metropolitico jure concedimus."

72. F. Dvornik, *The Idea of Apostolicity in Byzantium and the Legend of the Apostle Andrew*, DOS, 4 (Cambridge, Mass., 1958), 70ff.

73. G. C. Menis, *Storia del Friuli* (Udine, 1969), 15–50.

74. Anastasius IV's restoration of the Istrian bishoprics to Grado is confirmed in the bull issued from the Lateran on 13 June 1157 (*Codex Diplomaticus Regni Croatiae*, 2: 82, no. 81).

75. At a special meeting with Alexander III in the Lateran, Patriarch Enrico Dandolo made the following declaration: "renuntio omni juri acquisto et acquirendo et omnis actionibus tam in rem, quam in personam acquistis et acquirendis quos et quas habeo in nomine meo et Gradensis ecclesiae vel habere possum ego vel successores mei in futurum adversus Uldericum aquilejensem patriarcham et ejus ecclesiam super episcopatibus Istriae et super thesauris quos Poppo Aquileijensis patriarcha de Gradu asportavit . . ." (G. Cappelletti, *Le Chiese d'Italia dalla loro origine sino ai nostri giorni* [Venice, 1851], 8: 253; Ughelli, *Italia Sacra*, 5: col. 1129).

76. Morgagni Schiffrer, "Gli affreschi medioevali," 347–48.

Chapter Six. Christ's Passion and the Compassio of the Virgin

1. It is unlikely that the two lunettes at either end of the hemicycle wall contained additional feast scenes. Only a small fragment of a single figure survives on the south wall. As these lunettes are substantially narrower than the others and had large

windows by the 11th century, the original decoration probably comprised single figures. See Appendix I, F1 and F6.

2. The configuration of the Byzantine feast cycle, while focusing on the primary liturgical events from

the life of Christ and the Virgin (the Dormition), was quite flexible in the number and selection of scenes during the Middle Byzantine period. See E. Kitzinger: "Reflections on the Feast Cycle in Byzantine Art," *CahArch* 36 (1988): 51–73.

3. Demus, *Byzantine Mosaic Decoration*, 13–14.

4. Ibid., 13.

5. H. Belting, *The Image and Its Public: Form and Function in Early Paintings of the Passion*, trans. M. Bartusis and R. Meyer (New Rochelle, 1990), 131–85; A. Derbes, *Picturing the Passion in Late Medieval Italy: Narrative Painting, Franciscan Ideologies, and the Levant* (Cambridge, 1996).

6. So prominent is the Virgin in all four scenes that some authors have referred to the four lunettes as a cycle of the Virgin. See Swoboda, *Der Dom*, 89 and Morassi, "La pittura e la scultura," 322.

7. Badly damaged by humidity, this lunette was already hard to read when Bertoli recorded the decoration in 1724, but its main outlines are still intact: this first known eye-witness account of the decoration does not mention the scene in his description of the lunettes. See Appendix 1, F2.

8. Kugler "(Kryptafresken," 68) aptly describes this development as a transformation of the image from "Ereignis" to "Andachtsbild." Erwin Panofsky traced the evolution from the narrative Deposition image to the iconic "Imago Pietatis" in "*Imago Pietatis*: Ein Beitrag zur Typengeschichte des *Schmerzenmanns* und der *Maria Mediatrix*," in *Festschrift für Max J. Friedländer zum 60. Geburtstag* (Leipzig, 1927), 261ff.

9. K. Weitzmann, "The Origin of the Threnos," in *De Artibus Opuscula XL, Essays in Honor of Erwin Panofsky*, ed. M. Meiss, 2 vols. (New York, 1961), 1:476–90; H. Maguire, "The Depiction of Sorrow in Byzantine Art," *DOP* 31 (1977): 123ff.; idem, *Art and Eloquence in Byzantium* (Princeton, 1981; rpt. 1994), 96–108.

10. In *SS. Mariam assistentem cruci, PG* 100:1457–89, esp. 1488B; cited and translated by Maguire, "Depiction of Sorrow," 162.

11. *PG* 114:216B–C; trans. Maguire, "Depiction of Sorrow," 162–63.

12. Belting, *Image and Its Public*, 91–129; on the liturgical developments, see particularly 97–103.

13. The most complete discussions of this theme are H. Barré, "Le 'Planctus Mariae' attribué à Saint Bernard," *Revue d'ascétique et de mystique* 28 (1952): 243–66; and A. Luis, "Evolutio Historica doctrinae Compassione," *Marianum; Ephemerides mariologiae* 5 (1943): 261–85. For the seminal role of the prophecy of Simeon, see Luis, 262ff. and Barré, 243.

14. For Augustine, see *Epistolae* 143, 33, ed. *PL* 33:644. For Ambrose, see *De instit. virg.*, VII, 49–50, ed. *PL* 16:318–19 and *Epistolae* 63, 110, ed. *PL* 16:1218C.

15. "Quia spiritualiter et caro eius passa est gladio passionis Christi, plus quam martyr fuit. Unde constat quia plus omnino dilexit: propterea et plus doluit" (*De Assumptione Beatae Virginis Mariae*, ed. *PL* 30:142). Cf. T. Meier, *Die Gestalt Marias im geistlichen Schauspiel des deutschen Mittelalters* (Berlin, 1959), 149.

16. A. Wilmart, *Auteurs spirituels et textes dévots du Moyen Age latin. Etudes d'histoire littéraire* (Paris, 1932), 506. Cf. Barré, "Planctus Mariae," 244 and idem, *Prières anciennes de l'Occident à la Mère du Sauveur des origines à saint Anselme* (Paris, 1963), 297. A different edition of the text appears as "Oratio 20" in *PL* 158:903–4.

17. "Cur, o anima mea, te praesentem non transfixit doloris gladius acutissimi, cum ferre non posses vulnerari lancea latus tui salvatoris? . . . Cur non es inebriata lacrimarum amaritudine, cum ille potaretur amaritudine fellis? Cur non es compassa castissimae Virgini, dignissime matri eius, benignissimae dominae tuae? Domina mea misericordissima, quos fontes dicam erupisse de pudicissimis oculis, cum attenderes unicum filium tuum innocentem coram te ligari, flagellari, mactari? Quos fluctos credam perfudisse piisimum vultum, cum susciperes eundem filium et Deum et Dominum tuum in cruce sine culpa extendi et carnem de carne tua ab impiis crudeliter dissecari? Quibus singultibus aestimabo purissimum pectus vexatum esse, cum tu audires: "Mulier, ecce filius tuus" et discipulus: "Ecce mater tua"; cum acciperes in filium discipulum pro magistro, servum pro domino? (Wilmart, *Auteurs spirituels*, 506; trans. B. Ward in *The Prayers and Meditations of St. Anselm* (Harmondsworth, 1973), 95–96.

18. Cf. Barré, "Planctus Mariae," 245–46 and J. Leclercq, "Dévotion et théologie mariales dans le monachisme bénédictin," in *Maria: Etudes sur la sainte Vièrge*, 2: ed. D'Hubert du Manoir (Paris, 1952), 549–78. Leclercq (557) finds that Anselm was "à l'origine d'un courant de piété destiné à devenir presque prédominant vers la fin du moyen-âge."

19. S. Sticca, *The "Planctus Mariae" in the Dramatic Tradition of the Middle Ages* (Athens, Ga. and London, 1988), 102–17.

20. *Explicatio in Cantica Canticorum*, XXVI, ed. in *PL* 196:483–84: "Super haec martyrio decorata fuit. Ipsius enim animam pertransivit gladius, non materialis sed doloris. Quo martyrio gravius passa fuit quam ferro. . . . In martyribus magnitudo amoris dolorem lenivit passionis, sed beata Virgo quanto plus amavit, tanto plus doluit." Cf. Sticca, *Planctus Mariae*, 107.

21. *De laudibus Beata Mariae Virginis, PL* 189:1727: "Maria Christo se spiritu immolat et pro mundi salute obsecrat, Filius impetrat, Pater condonat. . . . Movebat enim eum Matris affectio, et omnino tunc erat una Christi et Mariae voluntas, unumque holocaustum ambo pariter offerebant Deo: haec in sanguine cordis, hic in sanguine carnis." (cited by Sticca, *Planctus Mariae*, 24).

22. *PL* 183:437–38; Sticca, *Planctus Mariae*, 108: "Vere tuam, o beata mater, animam gladius pertransivit. . . . Et quidem posteaquam emisit spiritum tuus ille Jesus . . . ipsius plane non attigit animam crudelis lancea, quae ipsius (nec mortuo parcens, cui nocere non posset) aperuit latus, sed tuam utique animam pertransivit. Ipsius nimirum anima jam tibi non erat;

sed tua plane inde nequibat avelli. Tuam ergo pertransivit animam vis doloris, ut plus quam martyrem non immerito praedicemus, in qua nimirum corporeae sensum passionis excesserit compassionis effectus."

23. Barré, "Planctus Mariae," 251–66; Sticca, *Planctus Mariae*, 132–36. For the possible impact of these texts on art, see Belting, *Image and Its Public*, 157–58; A. Derbes, "Byzantine Art and the Dugento: Iconographic Sources of the Passion Scenes in Italian Painted Crosses," Ph.D. diss., University of Virginia, Charlottesville, 1980, 220ff.

24. *Liber de Passione Domini*, ed. *PL* 182:1133–42. For a partial translation, see P. Ratkowska, "The Iconography of the Deposition without Saint John," *JWCI* 27 (1964): 314–17.

25. *PL* 182:1138D–39A: "Stabat et Maria, brachia levans in altum, ut caput et manus dependentia Christi super pectus traheret ipsa simul. Quem dum attingere valuit in osculis, et amplexibus ruens de eo suo dilecto, licet exstincto, satiari non poterat. Hoc dum de cruce in terra corpus depositum fuit, super ipsum ruens prae incontinentia doloris et immensitate amoris quasi mortua stabat."

26. *PL* 182:1140AB: "Nolite eum tradere sepulturae tam cito, date illum miserae matri suae, ut habeam illum mecum, vel saltem defunctum, aut si illum ponitis in sepulcro, me miseram deponite cum illo; mallem, quia et post id supererit mihi. Illi ponebant Christum in tumbam, et illa trahebat ad seipsam. Illa volebat eum ad se retinere, et illi volebant eum tradere sepulturae, et sic fiebat haec pia lis, et miseranda contentio inter eos. . . . Videbant intrare matrem omni destitutam solatio, et super illam dabant potius planctum, quam super exstinctum filium suum, Dominum nostrum. Major illis erat dolor de matris dolore, quam fuerat de sui Domini morte. Flebant igitur cuncti miserando dolore gementes, et sic vitae Dominum mortis sepulturae dederunt."

27. *Dialogus de Passione Domini*, ed. *PL* 159:287A: "Et ego caput ejus in sinum meum recipiens amarissime flere coepi, dicens: Heu! dulcissime fili, qualem consolationem habeo quae mortuum filium coram me video. Tunc accurrens Joannes evangelista cecidit super pectus Jesu, plorans et dicens: Heu, heu, de isto pectore heri potabam dulcia verba, hodie tristia et lamentabilia. Tunc Petrus advenit; et . . . amarissime flere coepit; tunc Maria Magdalena plus omnibus flere coepit super Dominum suum."

28. See S. Corbin, *La déposition liturgique du Christ au Vendredi Saint. Sa place dans l'histoire des rites et du théatre religieux* (Paris, 1960), 210ff.; K. Young, *The Drama of the Medieval Church*, 2 vols., rpt. (Oxford, 1967), 1:492–539; S. Sticca, *The Latin Passion Play: Its Origins and Development* (Albany, 1970).

29. Sticca, *Planctus Mariae*, 131: "A ccui me lassi, oi me dolente ch'eo te portai nillu meu ventre. Quando te beio (mo)ro presente / Nillu teu regnu agi me mmente. . . . "

30. Sticca, *Planctus Mariae*, 153–221.

31. Young (*Drama*, 1:503, n. 6), following Girolamo de Rubeis, cites a 14th-century Friulian mis-

sal prescribing the singing of the Planctus "ad crucifixum," immediately after the recitation of the Passion: "Postea fit planctus ad crucifixum, prout patet in cantuariis; et hoc si placet."

32. Sticca, *Planctus Mariae*, 104–5. For the complete text see C. Blume and H. M. Bannister, eds., *Analecta hymnica medii aevi* (Leipzig, 1915; rpt. London, 1961), 54:318–20, no. 202.

33. Blume and Bannister, *Analecta hymnica*, vv. 19–29: "Sic stat mater desolata,/ Iam non mater, sed orbata/ Dulci suo filio. Plangit, plorat, praestolatur,/ Quoadusque deponatur/ Corpus de patibulo. O lacrimosus intuitus! Sedet semimortua parens/ et extincti funeris / in gremio tenet exuvias. Omnia pererrat stigmata/ locaque cruenta clavorum/ necnon et plagas singulas./ . . . O gravis dolor et gemitus! Nati quondam speciosa / membra, modo livida,/ Tractat mater inter manus teneras. Amplexatur, osculatur/ ora facta pallida/ Propter poenas/ atque plagas asperas. Manus extorquens exclamavit/ Fletuque corpus irrigavit / Stillas ut rivos lacrimans."

34. On the Virgin's role as mediatrix at the Assumption, see T. Koehler, "Marie (Sainte-Vierge)," in A. Rayer et al., eds., *Dictionnaire de Spiritualité* (Paris, 1980), 10:409–82, esp. 449–51; F. de Maffei, "Le arti a San Vincenzo al Volturno: il cicolo della cripta di Epifanio," *Miscellanea Cassinese* 51 (1985): 269–352; and W. Tronzo, "Apse Decoration, the Liturgy and the Perception of Art in Medieval Rome: S. Maria in Trastevere and S. Maria Maggiore," in *Italian Church Decoration in the Middle Ages and Early Renaissance* (Bologna, 1989), 167–93.

35. For the antithesis of Mary holding the Christ child and the Dead Christ in Byzantine art and literature, see Maguire, *Art and Eloquence*, 59–68. A rare parallel for the Aquileian juxtaposition of Dormition and *Threnos* is found on an 11th-century Byzantine ivory in the Victoria and Albert Museum in London. See D. Buckton, ed., *Byzantium. Treasures of Byzantine Art and Culture from British Collections* (London, 1994), 146, no. 157.

36. For the funerary program of Hosios Lukas, see C. Connor, *Art and Miracles in Medieval Byzantium: The Crypt of Hosios Lukas and Its Frescoes* (Princeton, 1991), 53–57. Here a more extensive Passion cycle, commencing with the Entry into Jerusalem, is combined with the Dormition in the lunette program, while a hierarchy of the saints in medallion busts decorates the vault.

37. G. Constable, "The Ideal of the Imitation of Christ," in *Three Studies of Medieval Religious and Social Thought* (Cambridge, 1995), 194–248, esp. 202–17.

38. Belting, *Likeness and Presence*, 115–21.

39. E. Palazzo, "Les pratiques liturgiques et dévotionnelles et le décor monumental dans les églises du Moyen Age," in *L'emplacement et la fonction des images dans la peinture murale du Moyen Age = Cahiers du Centre International d'Art Mural* 2 (1993): 45–56.

40. Ibid., 55; André de Fleury, *Vie de Gauzlin, abbé de Fleury*, ed. and trans. R.-H. Bautier and G. Labory (Paris, 1969), 145.

41. Palazzo, "Pratiques liturgiques," 55; J. Au-

tenrieth, "Purchards Gesta Witigowonis im Codex Augiensis CCV," *Studien zur mittelalterlichen Kunst 800–1250, Festschrift für Florentine Mütherich* (Munich, 1985), 101–6.

42. For the notion of "liturgical memory" see Palazzo, "Pratiques liturgiques," 48ff., 50–52. A broader connection between medieval pictures and memory (including the exercise of meditation or "silent reading") is made by Carruthers, *The Book of Memory*, 221–57, esp. 221–22.

Chapter Seven. The Fictive Curtain as Allegorical Veil

1. Further arguments for the precise identifications proposed here are furnished in Appendix I.

2. See A. Katzenellenbogen, *Allegories of the Virtues and Vices in Medieval Art*, 2nd ed. (Toronto, 1989), 11–13 and fig. 9; and M. T. Sauvel, "Les vices et les vertus d'après les dessins d'un manuscrit de Moissac," *Mémoires de la Société des Antiquaires de France*, ser. 9, 3 (1954): 155–64, esp. 158–59 and fig. 1.

3. See Al-Jahiz (776–869), *Manaqib*, 11–12, cited by J. D. Latham and W. F. Paterson, *Saracen Archery* (London, 1970), xxiii; and Radulfus Cadomensis, *Gesta Tancredi in expeditione hierosolymitana*, 715: "illi (the archers) facile terga vertunt, sperantes, ut est moris, fugiendo gyrare, gyrando sagittare"; cited in R. C. Smail, *Crusading Warfare* (Cambridge, 1956), 81, n. 1. I thank E. McGeer for these references.

4. Bernard of Clairvaux, *Apologia ad Guglielmum, Sancti Tierri Abbatam* in *PL* 182:914–16, trans. in E. G. Holt, *A Documentary History of Art* (New York, 1957), 1:19–22, esp. 21. See M. Schapiro, "On the Aesthetic Attitude in Romanesque Art," *Originality in Art and Thought: Issued in Honour of Ananada K. Coomaraswamy* (London, 1947), 130–50; rpt. in *Romanesque Art* (New York, 1977), 1–27; and C. Rudolph, *The "Things of Greater Importance": Bernard of Clairvaux's Apologia and the Medieval Attitude toward Art* (Philadelphia, 1990).

5. Demus, *Romanesque Mural Painting*, 21.

6. Demus, *Romanesque Mural Painting*, 14.

7. Schapiro, *Romanesque Art*, 1–27.

8. Schapiro, *Romanesque Art*, 6–7.

9. The seminal study is L. Randall, *Images on the Margins of Gothic Manuscripts* (Berkeley and Los Angeles, 1966), esp. 12–20. She observes on page 12 that "the impression of haphazard spontaneity in marginal illustrations is exaggerated by their juxtaposition with representational elements of long-standing formalistic tradition. . . . the distribution was not always as unsystematic as it appears. It would indeed have been atypical of the medieval mind to have discarded wholly all structure of programmatic design." A broader canvas has been sketched most recently by Michael Camille in *Image on the Edge. The Margins of Medieval Art* (Cambridge, Mass., 1992), esp. 56–75. In contrast to earlier iconographic studies which tended to isolate the meaning of individual motifs, Camille emphasizes how marginalia function in their larger contexts on manuscript pages, objects, and within architectural space. He omits wall painting from his discussion, perhaps because it does not conform to his concept of marginal imagery being associated with "liminal" areas of the church—exterior portals and facades.

10. On the meaning of *mappaemundi* and the monstrous races, see A.-D. von den Brincken, "'Ut describeretur universus orbis': Zur Universal Kartographie des Mittelalters," in *Methoden in Wissenschaften und Kunst des Mittelalters*, ed. A. Zimmermann = Miscellanea Mediaevalia, 7 (Berlin, 1970), 249–78; J. B. Friedman, *The Monstrous Races in Medieval Art and Thought* (Cambridge, Mass., 1981), esp. 30ff., 37ff., 59ff., 87ff.; D. Woodward, "Reality, Symbolism, Time, and Space in Medieval World Maps," *Annals of the Association of American Geographers* 74 (1985): 510–21; M. Kupfer, "The Lost *Mappamundi* at Chalivoy-Milon," *Speculum* 66 (1991): 540–71, esp. 555ff. Still fundamental for the monstrous races is the study by Rudolph Wittkower, "Marvels of the East: A Study in the History of Monsters," *JWCI* 5 (1942): 159–97, esp. 176–82.

11. For the floor mosaic in the presbytery of Otranto Cathedral (1163–65), which includes the Fall of Adam and Eve, beast combat, and heroes from the romances, see C. Frugoni, "Per una lettura del mosaico pavimentale della cattedrale di Otranto," *Bullettino dell'Istituto Storico Italiano per il Medio Evo* 80 (1968): 213–56. The author aptly characterizes the program as a freely arranged sermon on redemption drawing on both sacred and profane examples.

A rare and perceptive analysis of painted socle decoration is found in M.E.N. Zchomelidse, "Die mittelalterlichen Fresken in Santa Maria dell'Immacolata Concezione in Ceri bei Rom," Ph.D. diss., University of Bern, 1992, 147–65. In the late-11th-century socle decoration of San Clemente in Rome and the church of the Immaculate Conception at Ceri, the author finds in each panel a relationship between the demonic or terrestrial themes of the socle and the sacred narratives on the same axis above. In San Clemente, for example (151), the votive portraits of the donors and their children, including the "puerulus Clemens," appear in the socle zone as pendants to the family miraculously recovering their child at the shrine of St. Clement in the upper zone. At Ceri, a battle of demons appears beneath a triumphant martyrdom of St. Andrew (158–161).

For a symbolic interpretation of the socle zone of San Baudelio de Berlanga in Castile, which includes wild beasts and hunting scenes, see Joan Sureda, *La pintura románica in España* (Madrid, 1985), 319–27.

12. Cf. Kupfer, "The Lost *Mappamundi*," 565–71.

13. Swoboda (*Der Dom*, 89–91) argued that the series depicted local history. He believed that a lost titulus on the north side of the hemicycle wall, inscribed ". . . (AQVILE)IENSIS," referred to the socle, but his transcription is tenuous, and in any case it is unlikely that it referred to the curtain. His identifica-

tion of the panel S6 as Saint Mark taking the Gospel is likewise unconvincing. Solely on the basis of the panels depicting knights in combat, P. Salviato associated the entire series with the Crusades: "Gli affreschi della cripta della Basilica di Aquileia," *AqN* 26 (1955): 51–62. S. Bettini (*La pittura veneta dalle origini al Duecento* [Padua, 1963–64], 179) likewise invented a Crusader Romance for a local hero named "Markus" or "Marius" whose name appears to be inscribed in the pilgrim panel. The same panel with its inscription prompted Johanna Kugler ("Kryptafresken," 248 and "Byzantinisches und Westliches," 26f.) to identify the subject of the curtain as local history, assembled and written by minstrels documented at the court of Patriarch Wolfger (1204–18). Gerevich connected the entire sequence with the chronicles of the Hungarian invasions of Aquileia in the tenth century. See L. Gerevich, "The Horsemen of Aquileia," *Acta Archeologica Accademiae Scientiarum Hungaricae* 17 (1965): 395ff. Finally, Luca ("Sostrato culturale della cripta," 231–54, esp. 252–53) fancifully associates panels S5 and S6 with a 10th-century war between King Zacharias of Serbia and King Simeon of Bulgaria.

14. For Prudentius's text, see H. J. Thompson, ed., *Prudentius*, Loeb Classical Library, 2 vols. (London, 1961). For a commentary on the theme and style of the work, see M. Smith, *Prudentius's Psychomachia: A Re-examination* (Princeton, 1976), esp. 168–233. The principal art-historical studies are Katzenellenbogen, *Allegories of the Virtues and Vices*; R. Stettiner, *Die illustrierten Prudentius-Handschriften*, 2 vols. (Berlin, 1895/1905); H. Woodruff, "The Illustrated Manuscripts of Prudentius," *Art Studies* 7 (1929): 33ff; and J. O'Reilly, *Studies in the Iconography of the Virtues and Vices in the Middle Ages* (New York and London, 1988).

15. On *Psychomachia* in sculptural decoration, see R. Bernheimer, *Romanische Tierplastik und die Ursprünge ihrer Motive* (Munich, 1931) and F. Klingender, *Animals in Art and Thought to the End of the Middle Ages* (Cambridge, Mass., 1971), 329ff.

16. Cf. J.-T. Welter, *L'exemplum dan la littérature religieuse et didactique du Moyen Age* (Paris, 1927), esp. 34–61.

17. The following is a preliminary list of examples in North Italy and contiguous territories (excluding Aquileia and Summaga):

Briga Novarese (Novara), San Tommaso: G. Bianchi, "Affreschi medievali inediti a Briga Novarese," *Novarien* 4 (1970): 145–48.

Carugo (Como), San Martino: O. Zastrow, *Affreschi romanici nella provincia di Como* (Lecco, 1984), 214, pls. 87–88.

Cassano di Albese (Como), San Pietro: Zastrow, *Affreschi romanici*, figs. 1–2.

Castel Appiano/Hocchepan (Trentino-Alto Adige): A. Morassi, *Storia della pittura romanica nella Venezia Tridentina* (Rome, 1935), 82, fig. 42.

Castelbadia/Sonnenburg (Trentino-Alto Adige), castle chapel, crypt: Knotig, *Sonnenburg im Pustertal*, 78–82.

Chiusa Pesio (Piemonte), Cappella di Sant' Andrea: N. Gabrielli, "Pitture medievali piemontesi," in *Civiltà del Piemonte*, eds. G. P. Clivio and R. Massano (Turin, 1975), 1:97, n.2, fig. 11.

Como, San Giorgio in Borgovico: Zastrow, *Affreschi romanici*, 217–21, pls. 107–28, esp. 120.

Como, San Pietro in Atrio: Zastrow, *Affreschi romanici*, 202–4, figs. 46–49.

Lurago Marinone (Como), San Giorgio: Zastrow, *Affreschi romanici*, 235, figs. 170–72.

Milan, San Lorenzo, Cappella Cittadini, apse: G. dell'Aqua, *La basilica di San Lorenzo a Milano* (Milan, 1985), 171–204.

Oleggio (Novara), San Michele: R. Capra, *La basilica di San Michele in Oleggio* (Novara, 1968).

Parenzo (Istria), Basilica Eufrasiana, left apse: unpublished.

Piobesi (Piemonte), San Giovanni: N. Gabrielli, *Le pitture romaniche. Repertorio delle cose d'arte del Piemonte* (Turin, 1944).

Pombia (Varese), San Vincenzo in Castro, chapel in west gallery: D. d'Oldenico, "Gli affreschi ottoniani di Pombia," *Bollettino storico per la provincia di Novara* 60, no. 2 (1969): 3–18.

Prugiasco/Negregento (Ticino, Switzerland), Sant'Ambrogio Vecchio: V. Gilardoni, *Il Romanico*, Arte e Monumenti della Lombardia Prealpina, 3 (Bellinzona, 1970), 486–98, figs. 307, 315, 316.

Quinto, San Martino di Deggio (Ticino): Gilardoni, *Il Romanico*, 503–6, figs. 320–21.

Riva San Vitale (Ticino), baptistery: I. Marcionetti, *Il battistero di Riva San Vitale* (Lugano, 1978), 72, pls. 27, 29, 30, 35, 40.

Roccaforte Mondovi (Piemonte), San Maurizio, right apse: Gabrielli, *Le pitture romaniche*, 1:57–58, figs. 153, 161–63.

Susa Cathedral (Piemonte): Gabrielli, *Le pitture romaniche*, 1:68–69, figs. 183–86.

Trieste (Friuli), San Giusto, south central apse: Brusin and Lorenzoni, *L'arte del Patriarcato*, 89ff., figs. 219–20.

18. See Brusin and Lorenzoni, *L'arte del Patriarcato*, 55–58; A. Damigella, *Pittura veneta*; and Coletti, "L'arte nel Territorio di Concordia," 211ff. For the stylistic relationship between the chapel at Summaga and the crypt, see chap. 3 above.

19. To the left of the doorway cut into the chapel sometime in the 13th century, a lost pair, Charity and Avarice, is identified by the vertical inscription AVARICIA. Immediately beneath the doorway appears a recumbent figure inscribed ". . . RIA" which may be reconstructed as VANA-GLORIA, the counterpart of Humility. The third pair shows a female personification of Hope (preserved up to the waist) vanquishing the prostrate figure inscribed as DESPERACIO. Finally the fourth pair shows the lower body of a knight, armed with shield, lance, and chain mail, identified as TEMPERANICA triumphing over his counterpart, Intemperance.

20. Katzenellenbogen, *Allegories of the Virtues and Vices*, 15 and fig. 13.

21. On the paired images of Virtues trampling Vices in Romanesque sculpture, see P. Deschamps, "Le combat des vertus et des vices sur les portails romans de la Saintonge et du Poitou," *Congrès archéologique* 79 (1912): 309–24; R. J. Adams, "The Virtues and Vices at Aulnay Re-examined," in *The Twelfth Century*, eds. B. Levy and S. Sticca (Binghamton, N.Y., 1975), 53–73; and L. Seidel, *Songs of Glory: The Romanesque Façades of Aquitaine* (Chicago, 1981), 48–55. More generally see Katzenellenbogen, *Allegories of the Virtues and Vices*, 14–21, figs. 13–22.

22. On the ordeal of trial by combat, see F. M. Besson, "A armes égales: Une représentation de la violence en France et en Espagne au XIIe siècle," *Gesta* 26 (1987): 113–26, esp. 118–19 and "Ordalies," in A. Vacant, E. Mangenot, and E. Amann, *Dictionnaire de la théologie catholique*, 15 vols. (Paris, 1949), 11.1:1139–52.

23. This broader conception of *psychomachia* is persuasively argued by Linda Seidel in her analysis of Romanesque facade programs in Aquitaine: *Songs of Glory*, 35–80.

24. On the Christian moralization of Physiologus, see D. Hassig, *Medieval Bestiaries: Text, Image, Ideology* (New York, 1995), 5–16; F. N. M. Diekstra, "The *Physiologus*, the Bestiaries, and Medieval Animal Lore," *Neophilologus* 69 (1985): 142–55; M. J. Curley, "'Physiologus,' Physiologhia, and the Rise of Christian Nature Symbolism," *Viator* 11 (1980): 1–10; and F. McCulloch, *Medieval Latin and French Bestiaries*, 2nd ed. (Chapel Hill, 1962), 15ff. On the use of bestiary images as mnemonic devices for moral instruction, see B. Rowland, "The Art of Memory and the Bestiary," in *Beasts and Birds of the Middle Ages: The Bestiary and Its Legacy*, eds. W. B. Clark and M. T. McMunn (Philadelphia, 1989), 12–25; and W. Clark, "The Illustrated Aviary and the Lay-Brotherhood," *Gesta* 21 (1982): 63–74.

25. W. von Blankenburg, *Heilige und dämonische Tiere*, 2nd ed. (Cologne, 1975), 221, 304ff. See also Bernheimer, *Romanische Tierplastik*, 85–90.

26. See T. H. White, *The Book of Beasts* (New York, 1984), 8, 159–61, 165–67.

27. Ibid., 5. The panther is described (17) as "an animal with small spots daubed all over it, so that it can be distinguished by the circled dots upon the tawny and also by its black and white variegation." See also G. Druce, "The Mediaeval Bestiaries and Their Influence on Ecclesiastical Decorative Art, Part 2" *JBAA* 26 (1920): 45f.; Hassig, *Medieval Bestiaries*, 156–66; N. Henkel, *Studien zum Physiologus im Mittelalter = Hermaea, Germanistische Forschungen*, n.s., 38 (Tübingen, 1976), 167–68; and B. Rowland, *Animals with Human Faces: A Guide to Animal Symbolism* (Knoxville, 1973), 131–33.

28. Rabanus Maurus, *PL* 111:219; Garnerus, *PL* 193:113; cited in Rowland, *Animals with Human Faces*, 149–52. The Cambridge Bestiary that is White's source provides no moralization, but the tiger is associated with human worldliness in the Picardy Bestiary (Paris, Bibl. Arsenal, Ms. 3516). "Take care you are not like the tiger. And Amos the

prophet proclaims that the world is an image of the forest in which the tigers congregate, and adjures us to keep watch attentively over our cub, that is, over our soul"; cited in G. Druce, "The Mediaeval Bestiaries and Their Influence, Part 1," *JBAA* 25 (1919): 52.

29. St. George and the Dragon also appear on the *velum* of the Cappella Cittadini of San Lorenzo in Milan. See Dell'Aqua, *La basilica di San Lorenzo*, 171–204. For other examples of the theme in Romanesque wall painting, see P. Deschamps, "La légende de Saint Georges et les combats des Croisés dans les peintures murales du Moyen-Age," *Monuments et Mémoires* 44 (1950): 109–23.

30. See the excellent summary in J. Le Goff, "Ecclesiastical Culture and Folklore in the Middle Ages: Saint Marcellus of Paris and the Dragon," in *Time, Work and Culture in the Middle Ages*, trans. A. Goldhammer (Chicago, 1977), 159–88, esp. 165–69. For the moralizations of the dragon, see Rowland, *Animals with Human Faces*, 68–69 and White, *Book of Beasts*, 165–67.

31. Le Goff, "Ecclesiastical Culture," 175f. For George's crusading associations, see Deschamps, "La légende de St. Georges," 113–15.

32. The references to armed crusaders as "peregrini" are legion; the term "crusader" never actually appears in 12th-century sources. See C. Erdmann, *The Origin of the Idea of Crusade*, ed. and trans. M. Baldwin and W. Goffart (Princeton, 1977), 331ff. and G. Constable, "Mediaeval Charters as a Source for the History of the Crusades," in *Crusade and Settlement* (Cardiff, 1983), 74–75.

33. On the penitential aspects of crusade, see Erdmann, *Origin*, 344ff.; H. E. J. Cowdrey, "The Genesis of the Crusades," in T. P. Murphy, ed., *The Holy War = 5th Conference on Mediaeval and Renaissance Studies*, Ohio State University, 1974 (Columbus, 1976).; 22ff. and G. Constable, "The Second Crusade as Seen by Contemporaries," *Traditio* 9 (1953): 213–79. See also the discussion of Christian knighthood and the spiritual rewards of the Crusades in connection with Romanesque facade programs in Aquitaine by Seidel, *Songs of Glory*, 48–66, 71–74.

34. *Epistolae*, ed. *PL* 182:565–7, trans. in L. Riley Smith and J. Riley Smith, *The Crusades: Idea and Reality, 1095–1274*, Documents in Mediaeval History, 4 (London, 1981), 95f.

35. Guibert de Nogent, *Historia que dicitur Gesta Dei per Francos*, I , ed. *Recueil des historiens des Croisades: Historiens occidentaux*, 5 vols. (Paris, 1844–95), 4:124; trans. in Cowdrey, "The Genesis of the Crusades," 23.

36. Bernard of Clairvaux, *De laude novae militiae ad milites templi*, I, ed. J. Leclercq, in *Sancti Bernardi Opera* (Rome, 1957), 3:214 and *PL* 182:921–31, esp. 921B–23B; trans. in Riley Smith, *The Crusades: Idea and Reality*, 102.

37. *De laude novae militiae ad milites templi*, I, ed. Leclercq, 3:214.

38. Trans. in H. M. Smyser, *The Pseudo-Turpin* (Cambridge, Mass., 1937), 24 and 63. This metaphor

originates in St. Paul's Epistle to the Ephesians VI:10f.

39. Prudentius himself uses David as exemplar for individual virtues, and this association is made explicit on the ivory cover of the Melisenda Psalter (1131–44). Cf. Katzenellenbogen, *Allegories of the Virtues and Vices*, 9, fig. 7.

40. See Kugler, "Kryptafresken," 254–56; Morgagni Schiffrer, "Gli affreschi," 109–10. For a survey of the mosaic pavements in Italy from the late 11th to 12th centuries, see A. Venturi, *Storia dell'Arte italiana*, 3: *L'Arte Romanica* (Milan, 1904), 418–40. A survey of medieval European floor mosaics, focusing on Germany, is provided by H. Kier, *Die mittelalterliche Schmuckfussboden* (Düsseldorf, 1970).

41. Kier (*Schmuckfussboden*, 72) lists four extant examples for which Annus is the central figure: San Michele at Pavia, Aosta Cathedral, the choir of San Savino in Piacenza, and the Benedictine abbey of Nienburg.

42. W. Tronzo, "Moral Hieroglyphs: Chess and Dice at San Savino in Piacenza," *Gesta* 16 (1977): 15–26.

43. A fourth Romanesque mosaic pavement, that of Saint Rémi in Reims, depicted David playing the harp in the center field, but it is known only from written sources. See H. Stern, ed., *Recueil général des mosaïques de la Gaule*, vol. 1, pt. 1 (= *Gallia*, Supplement 10) (Paris, 1957): 91–95; and X. Barral i Altet, "Poésie et iconographie: un pavement du XIIe siècle décrit par Baudri de Bourgueil," *DOP* 41 (1987): 41ff., esp. 53 and fig. 8. David also appeared in the floor mosaic of Trani Cathedral, but the figure and its context no longer survive. See E. Bertaux, *L'art médiévale dans l'Italie méridionale* (Paris, 1903), 2:492. For the surviving fragments, see B. Ronchi, *Invito a Trani* (Rome, 1980), 83 and pls. 165–168.

44. E. aus'm Weerth, *Der Mosaikboden in St. Gereon zu Köln . . . Mosaikböden Italiens* (Bonn, 1873), 1ff.

45. Stern, *Recueil*, 96–99.

46. Kier, *Schmuckfussboden*, 40, 44, 45, 48; R. Lejeune and J. Stiennon, *La légende de Roland dans l'art du Moyen Age*, 2 vols. (Brussels, 1966), 1:77–84. For the most complete description, see Weerth, *Der Mosaikboden*, 15–16.

47. See H. Steger, *David Rex et Propheta* (Nürnberg, 1961), 120–21; L. Spitzer, "Classical and Christian Ideas of World Harmony," *Traditio* 2 (1944): 409–64; and Charles de Tolnay, "The Music of the Universe," *JWAG* 6 (1943): 83–104.

48. See C. R. Dodwell, O. Pächt, and F. Wormald, *The Saint Albans Psalter* (London, 1960), 206.

49. J. J. G. Alexander, "Ideological Representation of Military Combat in Anglo-Norman Art," in *Anglo-Norman Studies* 15 (1992): 1–24, esp. 1–4, 19.

50. H. Helsinger, "Images on the Beatus Page of some Mediaeval Psalters," *Art Bulletin* 53 (1971): 161–76.

51. Dodwell, Pächt, and Wormald, *Saint Albans Psalter*, 163–64; Alexander, "Ideological Representation," 4.

52. Cassiodorus, writing to Boethius in 507, also refers to the psalms as a path to salvation: "Let us now talk of the Psalter descended from the skies, which a man whose fame is heard throughout the world composed; the Psalms are so modulated that they may save the soul" (trans. in E. Pickering, *Literature and Art in the Middle Ages* [Coral Gables, 1966], 287 from *MGH, Auctores Antiquissimi*, XII: 70ff.).

53. Dodwell, Pächt, and Wormald, *Saint Albans Psalter*, 149–64; Alexander, "Ideological Representation," 4. For Bernard's sermons, see excerpts above.

54. This reading of the curtain as a contemporary gloss of the salvation history that appears above it is again paralleled at Summaga. In the 12th-century program of the *sacellum*, the exempla of *Psychomachia* on the socle are juxtaposed with Old Testament and New Testament images. While the Fall of mankind is conveyed in the Temptation of Adam and Eve, redemption is promised by the Crucifixion and its sacramental prefigurations—the Offering of Abel and the Sacrifice of Isaac.

55. Honorius Augustodunensis, *Elucidarium sive Dialogus de summa totius christianae Theologiae* II, 27: De prophetis et Scriptura sacra (*PL* 172:1154A): "Sacra Scriptura non est nisi filiis Dei scripta, quibus mater Ecclesia per clavem David aperit omnia clausa."

56. For the ancient Roman fictive curtains, see A. Barbet, *La peinture romaine: les styles décoratifs pompéiens* (Paris, 1985), 27–29, fig. 15 (House of the Faun, Pompeii) and fig. on page 28 (Brescia). On the examples in medieval Rome see John Osborne, "Textiles and Their Painted Imitations in Early Mediaeval Rome," *PBSR* 60 (1992): 309–51. Notable examples in north and central Italy include the tower chapel at Torba and the crypt of Farfa Abbey. See C. Bertelli, *Gli affreschi nella torre di Torba*, Quaderni del FAI (Milan, 1988), 33–34 and C. McClendon, *The Imperial Abbey of Farfa* (New Haven, 1987), pls. 12–14, 30–31.

57. Osborne, "Textiles," esp. 324–45. For Sta. Maria Antiqua in Rome see W. Grüneisen, *Ste. Marie Antique* (Rome, 1911), pls. XXIA, XXIV, XXIVA, L.

58. Osborne, "Textiles," esp. 324–45.

59. For the repertory of decorated textiles, see the useful summary in Dodwell, *Pictorial Arts of the West*, 9–10; and the more detailed earlier studies of A. de Waal, "Figürliche Darstellungen auf Teppichen und Vorhängen in römischen Kirchen bis zur Mitte des IX Jahrhunderts nach dem Liber Pontificalis," *Römische Quartalschrift* 2 (1888): 313–21; and S. Beissel, "Gestickte und gewebte Vorhänge der römischen Kirchen in der zweiten Hälfte des VII. Jahrhunderts und in der ersten Hälfte des IX. Jahrhunderts," *Zeitschrift für christliche Kunst* 7 (1894): 357ff. See also B. Kurth, *Die deutschen Bildteppiche des Mittelalters* (Vienna, 1925), 1:17f.

60. Dodwell, *Pictorial Arts*, 15–29.

61. See Kurth, *Die Deutschen Bildteppiche*, 1:53–67 and Dodwell, *Pictorial Arts*, 19–21.

62. See Lehmann-Brockhaus, *Schriftquellen*, 555ff. The most interesting texts are conveniently summarized in Dodwell, *Pictorial Arts*, 15ff.

63. *Chronicon episc. Mindensium*, ed. Lehmann-Brockhaus, *Schriftquellen*, 610, no. 2605; Dodwell, *Pictorial arts*, 16.

64. Reinero, *De ineptiis cuiusdam idiotae libellus*, ed. Lehmann-Brockhaus, *Schriftquellen*, 610–11, no. 2606.

65. *Catalogus abbatum SS. Udalrici et Afrae*, 98, ed. Lehmann-Brockhaus, *Schriftquellen*, 579–607, nos. 2575–2602. See also U. Kuder, "Das Fastentuch des Abtes Udalscalc mit Ulrichs- und Afraszenen," in B. Hamacher and C. Karnehm, eds., *Pinxit/sculpsit/fecit. Kunsthistorischen Studien. Festschrift für Bruno Bushart* (Munich, 1994), 9–23. I owe this last reference to Hans-Peter Autenrieth of Munich.

66. My discussion of patristic texts concerning allegorical veils is heavily indebted to the work of Johann Konrad Eberlein. See "The Curtain in Raphael's Sistine Madonna," *Art Bulletin* 65 (1983): 60–77 and *Apparitio regis—revelatio veritatis. Studien zur Darstellungen des Vorhangs in der bildenden Kunst von der Spätantike bis zum Ende des Mittelalters* (Wiesbaden, 1982). Earlier studies that touch upon the issue include H. L. Kessler, *The Illustrated Bibles from Tours* (Princeton, 1977), 75–83, figs. 107–8 (frontispieces to the Apocalypse); A. A. Schmid, "Die Apokalypse Bild," in J. Duft et al., *Die Bibel von Moutier-Grandval* (Bern, 1971), 178–84; and K. Hoffmann, "Sugers 'Anagogisches Fenster' in St. Denis," *Wallraf-Richartz Jahrbuch* 30 (1968): 57–88.

More recently, Herbert Kessler has focused on the theme of the veil in Old Testament–New Testament exegesis in a series of studies on Carolingian and Byzantine manuscript illumination: "'Facies bibliothecae revelata': Carolingian Art as Spiritual Seeing," in *Testo e immagine nell'alto Medioevo = Settimane di Studio del Centro Italiano di Studi sull'alto Medioevo* 41 (1994): 533–94; "Through the Temple Veil: The Holy Image in Judaism and Christianity," *Kairos (= Zeitschrift für Judaistik und Religionswissenschaft)* 32/33 (1990–91): 53–77; and "Medieval Art as Argument," in *Iconography at the Crossroads*, ed. B. Cassidy (Princeton, 1993), 59–70.

67. Bruno Episcopus Sigiensis, *Expositio in Exodum*, XXVI (*PL* 164:326B): "Hoc ergo velum, quod sic praedicat, sic admonet, sic docet, sic suadet, Evangelii praedicatio est. Unde et ante, quatuor columnas pendere dicitur, per quas quatuor evangelistas intelligimus. . . . Ante hos autem hoc velum pendet, quoniam ab ipsis pingitur, ab ipsis variatur, ab ipsis praedicatur, ab ipsis sustinetur et portatur." Embroidered hangings for the Tabernacle are mentioned in Exodus 26:4 and 26:36.

68. Honorius Augustodunensis, *Gemma Animae*, Pt. III, Bk. 3, Ch. XLVI: De velo quod suspenditur Quadragesima (*PL* 172:656–57). "Et quia mysterium Scripturae in hoc tempore a nobis velatur, ideo velum ante oculos nostros in his diebus extenditur. Sacerdos et pauci post velum ingrediuntur, quia paucis doctoribus tantum mysteria scripturae aperiuntur. In Pascha velum aufertur . . . quia in resurrectione omnia nuda et aperta erunt, ubi beati Regem gloriae in decore suo videbunt. . . . Resurgens quippe velamen ab-

stulit, dum eis sensum ut intelligerent Scripturas aperuit, et credentibus coelum patefecit."

69. *Rationale Divinorum Officiorum*, trans. J. M. Neale and B. Webb, *The Symbolism of Churches and Church Ornaments* (London, 1906), 1: ch. 3:34–36, 56–61.

70. Durandus, trans. Webb, 58–59 (modified by author). The Latin text reads as follows: "Tertium inde tunc habuit origine(m), quia in primitiva ecclesia peribolus, id est, paries, qui circuit choru(m) non elevabatur, nisi usque ad appodiationem, quod adhuc in quibusdam ecclesiis observatur, quod ideo fiebat, ut populus videns clerum psallentem, inde bonum sumeret exemplum. Verumtamen hoc tempore quasi comuniter suspenditur sive interponitur velum aut murus inter cleru(m) et populu(m), ne mutuo se conspicere possint, quasi ipso facto dicatur: Averte oculos tuos, ne videant vanitate(m), etc." (Guglielmus Durandus, *Rationale divinorum officiorum*, ed. Ioannes Belethus [Lyons, 1612], Bk. I, Cap. III.35, fol. 17r).

71. See Krautheimer, *Rome*, 162, 170, figs. 117, 125. On the liturgical function of the schola cantorum, see T. Mathews, "An Early Roman Chancel Arrangement and Its Liturgical Uses," *Rivista di archeologia cristiana* 38 (1962): 71–95.

72. See Green, *Hortus Deliciarum*, 2, fols. 45v–45r.

73. For pictorial/typological relationships between images of the Temple and Christian sanctuary, see D. H. Verkerk, "Exodus and Easter Vigil in the Ashburnham Pentateuch," *Art Bulletin* 77 (1995): 94–105, esp. 99–103; and H. Rosenau, "Some Aspects of the Pictorial Influence of the Jewish Temple," *Palestine Exploration Fund Quarterly* (1936): 157ff. For representations of the Temple in general, see C. Krinsky, "Images of the Temple of Jerusalem before 1500," *JWCI* 33 (1970): 1–19, where the role of pictorial convention is stressed.

74. This line of inquiry was suggested to me by Herbert Kessler's study of the Pauline pictorial metaphor in Byzantine art. See his "Mediaeval Art as Argument," esp., 60ff.

75. "Umbram enim habens lex bonorum futurorum non ipsam imaginem rerum per singulos annos hisdem ipsis hostiis quas offerunt indesinenter numquam potest accedentes perfectos facere" (*Biblia Sacra iuxta vulgatam versionem*, ed. R. Weber [Stuttgart, 1983]).

76. *Expositio in Epistolam Pauli ad Hebraeos*, ed. *PL* 100:1075: "Hoc est, non ipsam veritatem. Usquequo enim veluti in pictura aspiciat quis lineamenta umbrarum, significans quid pingere velit, umbra quaedam est, et non imago si enim flores ipsos quis colorum intinxerit et imposuerit super lineamenta, tunc imago efficitur. Tale quiddam erat etiam lex, umbra veritatis."

77. *Epistola ad Hebraeos, Glossa ordinaria*, ed. *PL* 114:660: "Non ipsam imaginem. Id est veritatem, ut in pictura usquequo ponat quis colores, quaedem est substratio. Vel substratio est umbra quaedam, et non imago; cum vero flores ipsos quis colores intinxerit, tunc imago efficitur."

78. William of Tyre, *Chronicon*, in R. B. C. Hugens, H. E. Mayer, and G. Rosch, eds. *Corpus Christianorum, continuatio medievalis* (Turnholt, 1986), vol. 63, 99 (lines 57–64): "Nam et in picturis rudes et ad artis archana nondum admissi luteos primum solent colores substenere et prima lineamenta designare quibus manus prudentior fucis nobilioribus decorem consuevit addere consummatum: prima enim cum summo labore iecimus fundamenta, quibus sapientior architectus, observata veritatis regula quam nullo deseruimus, egregio tractatu artificiosa magis poterit superedificare triclinia."

Chapter Eight. Ornament as Decoration, Frame, and Bearer of Meaning

1. For a recent critique of traditional approaches to ornament, see O. Grabar, *The Mediation of Ornament* (The A. W. Mellon Lectures in the Fine Arts, 1989) (Princeton, 1992), esp. 37–46. An exemplary study of the meaning of ornament in Roman art is D. Castriota, *The Ara Pacis and the Imagery of Abundance in Late Greek and Early Roman Imperial Art* (Princeton, 1995). Castriota uses the tendril ornament on the lower level of the altar as an interpretive lens for the program as a whole, in which the appropriation of models from the Greek past conveys themes of renovatio and prosperity, and a new sense of "Romanitas" under Augustus. My thinking has also been inspired in part by the papers presented during the conference "Le rôle de l'ornement dans la peinture murale du Moyen Age," 1–3 June 1995, Saint-Lizier, France. The Acts will be published in *Cahiers de civilisation médiévale*.

2. A similarly eccentric application of ornament can be seen in a number of the Cappadocian cave churches (e.g., Qaranleq Kilisse, Elmale Kilisse, and Tchareqle Kilisse), and in these churches as in the crypt, the unusual architectural setting must have played a decisive role, often creating irregular spaces that could only be filled with ornament. For the Cappadocian churches, see Restle, *Byzantine Wall Painting* vol. 2, esp. figs. 161, 174, 175, 193, 226.

3. Demus, *Romanesque Mural Painting*, pls. 69 and 71; pls. 222 and 223.

4. E.g., the abbey of Saint-Savin-sur-Gartempe; Demus, *Romanesque Mural Painting*, fig. 129.

5. Honorius Augustodunensis refers to wall painting in general as fulfilling this function of "ornamenta" for the church ("ut domus tali decore ornetur") in his *De gemma animae*, I, in *PL*, 132:586; cited in Baschet, *Lieu sacré, lieu d'images*, 192.

6. These essential functions of ornament—to please the eye, to bring the viewer into dialogue with the object—have been recently emphasized by Oleg Grabar in his discussion of ornament in medieval Islam. See Grabar, *Mediation of Ornament*, 39, 43, and 234.

7. Grabar has observed a similar bracketing of figural imagery in the cloister of Moissac, where vegetal designs on certain capitals provide a visual break every so often amongst the historiated capitals depicting scriptural and hagiographic themes. *Mediation of Ornament*, 208–9.

8. Djurić, *Byzantinische Fresken in Jugoslawien*, pl. IV.

9. This is the interpretation of Prof. Saverio Lomartire who kindly brought this example to my attention. For illustrations see Bertelli, *Affreschi nella torre di Torba*. In a stimulating paper given at the Saint-Lizier conference (see note 1 above), John Mitchell has suggested that socle decoration could be used not only to distinguish between public and private spaces of the monastery of San Vincenzo al Volturno, but also as a means of guiding the viewer's movements from one space to another.

10. For a comprehensive catalogue of ornament in the crypt, see Kugler, "Kryptafresken," 161ff. I do not intend to duplicate her excellent work here, but only to introduce a few new comparisons and to emphasize important trends in the selection of models that parallel those observed for iconography and style.

11. Demus, *Mosaics of San Marco*, 1:pl. 19 (central acanthus motif without the surrounding oval) and Mirabella Roberti, *San Giusto*, plates on pages 208, 210, 211.

12. Demus, *Mosaics of San Marco*, 1:color pl. 5. Among the numerous parallels from Byzantine art are the representations of trees in the Old Testament cycle of Monreale Cathedral (idem, *Norman Sicily*, pls. 94A, 95AB, 96–99A, 119). They had already been absorbed into the vocabulary of Byzantinizing Romanesque art in South Italy by the late eleventh century, when the church of Sant'Angelo in Formis was decorated. See O. Morisani, *Gli affreschi di Sant'Angelo in Formis* (Cava dei Tirreni, 1962), pls. 61, 62.

13. Demus, *Mosaics of San Marco*, 1:color pl. 5.

14. Demus, *Mosaics of San Marco*, 1:color pl. 2.

15. Demus, *Mosaics of San Marco*, 1:pl. 27: windows beneath Daniel and Solomon.

16. Demus, *Mosaics of San Marco*, 1:pl. 27. Byzantine examples include the 11th-century mosaics in the narthex of the Catholicon at Hosios Lukas (Demus, *Byzantine Mosaic Decoration*, pls. 18B, 19, and 27AB) and the late Comnenian decoration of the Chapel of the Virgin and the refectory in the monastery of Patmos (A. Orlandos, *L'architecture et les fresques byzantines du monastère de St. Jean à Patmos* [Athens, 1970], pls. 8, 9, 73).

17. Demus, *Mosaics of San Marco*, 1:pl. 145.

18. Kugler, "Kryptafresken," 169–70. The stylized version of the motif frequently appears in Romanesque apse decoration: for example, Sant'Angelo in Formis near Capua (Demus, *Romanesque Mural Painting*, fig. 18) and Foro Claudio (ibid., fig. 41). It also is used as a canopy for single figures as in the 11th-century decoration of the Baptistery of Concordia (Brusin and Lorenzoni, *L'arte del Patriarcato*, fig. 136).

19. Kugler, "Kryptafresken," 161–62, 167–180.

20. Kugler ("Kryptafresken," 168, n. 3) mentions the examples from Rome. For the Pola relief, see G. Cavalieri Manasse, *La decorazione architettonica romana di Aquileia, Trieste, Pola*, 1: *L'età repubblicana, augustea e giulio claudia* (Padua, 1978), 158, fig. 129. A rosette of the form found in the crypt frieze—with drooping petals and a bulbous center—is found on a sculptural frieze from Aquileia itself (ibid., fig. 45c). For a broad study of the motif in ancient and Romanesque art, see M. Wegner, "Blattmasken," *Festschrift zum 70. Geburtstag für A. Goldschmidt* (Berlin, 1935), 43ff. For later Byzantine variations on the theme, see D. Mouriki, "The Mask Motif in the Wall Paintings of Mistra," *Deltion* 1 (1980–81): 307ff.

21. See *Iulia Concordia dall'età romana all'età moderna*, cover illustration and fig. 103.

22. For early medieval Roman examples, see G. Matthiae, *I mosaici medioevali delle chiese di Roma*, 2 vols. (Rome, 1967), 2:pls. 27, 28, 84. For the revival of the motif in late-12th- and early-13th-century apses in Rome, e.g., San Paolo fuori le mura, see ibid., pl. 270. For the Arian Baptistery at Ravenna, see E. Deichmann, *Frühchristliche Bauten und Mosaiken von Ravenna* (Baden-Baden, 1958), pl. 251.

23. For Nicaea, see H. Maguire, *Earth and Ocean* (University Park, Penn., 1987), 39–40, fig. 51. For the Roman catacombs, see H. Lother, *Die Pfau in der altchristlichen Kunst* (Leipzig, 1929), 59ff. For examples on sarcophagi, see G. Bovini, *Sarcophagi paleocristiani di Ravenna* (Vatican, 1954), figs. 52 and 62.

24. M. A. Frantz, "Byzantine Illuminated Ornament," *Art Bulletin* 16 (1934): 43ff.

25. See L. Haderman-Misguich, *Kurbinovo. Les fresques de St. Georges et la peinture du XIIe siècle* (Brussels, 1975), pls. 31–32; and Lazarev, *Old Russian Murals and Mosaics*, fig. 85. Contrary to Kugler's opinion, the way in which the foliage springs from the architectural frame is not a uniquely Venetian interpretation of the Byzantine ornament: the same phenomenon occurs in the prophet spandrels of Staraya Ladoga. Here too, there are no columns to support the springing of the arch, though capitals are provided.

26. See K. Skawran, *The Development of Middle Byzantine Fresco Painting in Greece* (Pretoria, 1982), figs. 315, 216–17.

27. See above, chap. 1; chap. 5, 46–48.

28. Cabrol-Leclercq, *DACL* 13:947–61, esp. 948–50.

29. For the association of vegetal imagery with ecclesiastical renewal, see H. Toubert, "Le renouveau paléochrétien à Rome au début du XIIe Siècle," *CahArch* 20 (1970): 99–154.

Conclusion

1. K. F. Morrison, *History as a Visual Art in the Twelfth-Century Renaissance* (Princeton, 1990), 175–76, n. 57; Goscelin, *Vita S. Edithae*, ed. A. Wilmart, *AnalBoll* 56 (1938): 5–101, 265–307, esp. 87.

2. L. Duggan, "Was Art really the 'book of the illiterate'?" *Word and Image* 5 (1989): 227–51, esp., 229.

3. There is a vast recent literature on this topic. For a complete citation of the two letters and the context in which they were originally written, see C. M. Chazelle, "Pictures, Books, and the Illiterate: Pope Gregory I's Letters to Serenus of Marseilles," *Word and Image* 6 (1990): 138–53, and Kessler, "Pictorial Narrative and Church Mission," 75–91. For the interpretation of Gregory's influential text in the later Middle Ages, see Duggan, "Book of the illiterate."

4. Kessler, "Pictorial Narrative and Church Mission," 75.

5. Duggan, "Book of the illiterate," 230.

6. Kupfer, *Romanesque Wall Painting*, 1–16.

7. Morrison, *History as a Visual Art*, 230–39, esp. 232.

8. Morrison, *History as Visual Art*, 181.

9. B. Smalley, *The Gospel in the Schools, 1100–1280* (London, 1985), 71–83; Kupfer, *Romanesque Wall Painting*, 10.

10. Smalley, *Gospel in the Schools*, 71.

11. Ibid., 72: "Ideoque tradunt splendorem illum non fuisse in corpore dominico, sed in aere circumfuso, cui opinioni consonant picture in parietibus ecclesiarum, ubi depingitur transfiguratio."

12. Cited in ibid., 73. *PL* 141:101–2: "Mox ibi ei ostendit picturas multa antiquitate vix parentes et ait: Unde sint istae picturae? Ille videns Martialem ministrantem Domino ad mandatum, et caeteras picturas, sicut legitur in eius Vita, rubore confusus non sine omnium qui aderant derisu confessus est mendacium suum."

13. Martino da Canal, *Les Estoires de Venise*, I:xii, ed. A. Limentani, in *Civiltà veneziana, Fonti e Testi*, 12 (Florence, 1972), 20–22: "Et se aucun vodra savoir la verité tot ensi con je le vos ai conté, veigne veoir la bele yglise de monsignor saint Marc en Venise et regarde tres devant la bele yglise, que est escrit tote ceste estoire tot enci con je la vos ai contee. . . ."

14. See Appendix II.

15. The most recent discussion of the suppression of the Aquileian patriarchate is Fedalto, "La fine del patriarcato," 115–36. On the return of the relics of Hermagoras to Aquileia, see S. Tavano, "La cripta deve riaquistare l'antica e originaria funzione," *Voce isontina*, 22 luglio 1969, 2.

Appendix I

1. The east walls of both chambers, covered over to align with the 14th-century piers probably at the time of the 15th-century remodeling of the west end of the crypt, were restored in 1973 during a general

cleaning campaign conducted by the Istituto Centrale
di Restauro of Rome. See Gioseffi and Belluno, *Aqui-
leia*, 45 and E. Belluno, *Il Restauro come opera di gusto*,
87–91.

2. Similar dado decoration can be seen in Middle
Byzantine naos programs, e.g., St. Sophia at Ochrid
and St. Panteleimon at Nerezi (ill. in Hamann-
Maclean, *Grundlegung*, 1:pls. 5 and 37.)

3. This is the only Virtue/Vice pair in which the
endings will work out: Concor*dia* and Discor*dia*. See
O'Reilly, 45, 46, 168, for tables of Virtues and Vices.

4. For the Melisenda Psalter cover, see Katzen-
ellenbogen, *Allegories of the Virtues and Vices*, fig. 7.
For the illustration of the *Psychomachia* in the Middle
Ages, see also O'Reilly, *Iconography of the Virtues and
Vices*, 39ff. and P. Deschamps, "Le combat des Vertus
et des Vices," 309–24. For a further discussion of the
theme with respect to the allegory of the fictive cur-
tain in the crypt, see chap. 7 above.

5. For the meaning of high-backed and lyre-
backed thrones in Byzantine art as a symbol of har-
mony and the Majesty of Christ incarnate, see A.
Cutler, *Transformations: Studies in the Dynamics of Byz-
antine Iconography* (University Park, Penn., and Lon-
don, 1975), 5–52. For the history of the enthroned
Pantocrator on Byzantine coins, see G. Alteri, "Im-
magini della storia sulle monete bizantine," in *Splen-
dori di Bisanzio* (Bologna, 1990), 71–83, esp. 76–77
and Cutler, *Transformations*, 5–10. For the enthroned
Pantocrator in monumental decoration see Demus,
Mosaics of San Marco, 1:31–32.

6. Kantorowicz, "Ivories and Litanies," *JWCI* 5
(1942): 56–81. On the "Angel Deesis" in stone re-
liefs, see R. Lange, *Byzantinische Reliefikone* (Reck-
lingshausen, 1964), 105, no. 36. As Cutler has
recently reaffirmed, Byzantine pictorial compositions
and texts describing the "Deesis" could include any
combination of saints or angels addressing their
prayers of intercession to Christ—not just the Virgin
and *Prodromos*; thus, the Aquileia panel and the By-
zantine ivories may all be described as "Deesis" com-
positions or more specifically, "Angel Deesis"; see A.
Cutler, "Under the Sign of the Deesis," *DOP* 41
(1987): 145–53. See also an earlier statement of this
idea in C. Osieczkowska, "La mosaïque de la porte
royale de Sainte Sophie et la litanie de tous les
saints," *Byzantion* 9 (1934): 41–83, esp. 46f.

7. For Megara, see Kitzinger, *St. Mary's*, fig. 177.
For Cappadocian examples see Restle, *Byzantine Wall
Painting* 2:pl. 490; 3:pls. 162–66, 193–94, 223, 232,
and 280. For Nea Moni on Chios see D. Mouriki,
The Mosaics of Nea Moni on Chios, 2 vols. (Athens,
1985), 2:color pls. 2–5.

8. This is the same order in which the symbols
are arranged in the *Maiestas Domini* of Sant'Angelo in
Formis near Capua. See Demus, *Romanesque Mural
Painting*, pl. 18.

9. For the Aquileia apse, see Cavalieri, "L'affresco
absidale." For Summaga, see Brusin and Lorenzoni in
L'arte del Patriarcato, 85–86. The theme is also dis-
cussed by Kugler in "Kryptafresken," 97ff.

10. Belting-Ihm, *Apsismalerei*, 55f.

11. A. H. S. Megaw and E. J. W. Hawkins, *The
Church of the Panagia Kanakaria at Lythrankomi in Cy-
prus* (Washington, 1977), 76–79 and 85ff.; A. M.
Sacopoulo, *La Théotokos à la mandorle de Lythrankomi*
(Paris, 1975), 102ff.

12. Cutler, *Transformations*, 10–16, 38–52.

13. A. Grabar, "The Virgin in a Mandorla of
Light," in *Late Classical and Mediaeval Studies in
Honor of A. M. Friend, Jr.*, ed. K. Weitzmann (Prince-
ton, 1955), 305–11.

14. Brescia, Biblioteca Comunale, Cod. A VI.26,
fol. 14r. See G. Galavaris, *The Illustrations of the Pref-
aces in Byzantine Gospels* (Vienna, 1979), 111ff. and R.
Nelson, *The Iconography of Preface and Miniature in the
Byzantine Gospel Book* (New York, 1980), 60–61.

15. Nelson, *Iconography*, 60–61.

16. The inscription for Fortunatus has vanished,
but his identification seems indisputable in light of
the presence of his relics in the crypt, his designation
as the principal successor of Hermagoras, and his po-
sition in the fresco on the *dexter* side.

17. Kugler, "Kryptafresken," 93.

18. See Kitzinger, *St. Mary's*, fig. 41.

19. Kitzinger, *St. Mary's*, fig. 40, cat. 19; Mira-
bella Roberti, *San Giusto*, 215. An earlier version of
the same type is found in the late-11th-century
narthex mosaics of San Marco in Venice: see Demus,
Mosaics of San Marco, 1:pl. 7.

20. Demus, *Mosaics of San Marco*, 1:color pl. 13,
pl. 15.

21. Cf. Kitzinger, *St. Mary's*, fig. 42; Demus, *Mo-
saics of San Marco*, 1:pls. 6, 8.

22. For the Hosios Lukas fresco, see K. Skawran,
*The Development of Middle Byzantine Fresco Painting in
Greece* (Pretoria, 1982), fig. 74. For the Nea Moni
mosaics see Mouriki, *Mosaics of Nea Moni*, 2:color pls.
58 and 60. For Nerezi, see Hamann-Maclean, *Grun-
dlegung*, 1:pl. 35.

23. Compare Lazarev, *Storia*, fig. 127 and
Maguire, "Disembodiment and Corporality," fig. 1.

24. 24.*Der Dom*, 48.

25. E.g., the Synaxarion in the Public Library of
Saint Petersburg: Lazarev, *Storia*, fig. 218.

26. Demus, *Mosaics of San Marco*, 2:pls. 136, 137.

27. *Der Dom*, 88.

28. On Anastasia's associations with Aquileia, see
Egger, "Heilige Hermagoras" (1948), 208ff. On the
inventory, see V. Joppi, "Inventario del tesoro della
chiesa di Aquileia fatto tra il 1358 e il 1378," *Archiv-
StorTrieste* 3 (1884–86): 1–15, esp. 5.

29. Demus, *Mosaics of S. Marco*, 1:pl. 130.

30. See J. Braun, *Die liturgische Gewandung im Oc-
cident und Orient* (Freiburg im Breisgau, 1907), 247ff.,
and for contrast with the Byzantine East, 302f.

31. The 5th-century *Martyrologium Hieronymum*
lists Fortunatus and Hermogenes at the head of four
martyrs commemorated on August 23 at Aquileia: "x
KL. SEP. In Aquileia nat(atle) s(an)c(t)orum furtunati
hermogeis. marcialis, hermogerati Rom(am)
civit(atem) s(an)c(t)orum laurenti . . . " (Wissenburg
Ms., *MH*, August 23, in *AASS*, Novembris, tomus II,
pars I).

32. Demus, *Mosaics of San Marco*, 1:pls. 101–2.

33. *Der Dom*, 48 and fig. 20.

34. A comparable pattern of rondels with griffins is found on a 10th- or 11th-century silk textile from the tomb of St. Viventia in the Schnütgen Museum, Cologne, and on a 12th-century silk from Spain, now in the Treasury of St. Gereon in Cologne. See *Ornamenta Ecclesiae*, 2:341, E105 for the former and ibid, 2:236–37, E31 for the latter.

35. Demus, *Mosaics of San Marco*, 1:pl. 18; Dale, "Inventing a Sacred Past," 63.

36. Cividale, Museo Civico Archeologico, Codex 91 (Breviary), fol. 45r as "Wodolrice" in the Litany; fol. 267v as "Wodolrici conf(essore)"; Udine, Biblioteca del Seminario Arcivescovile, Codex 43 (Capitulary and Collectary), fol. 12v as "Vodalrico."

37. The only published account of this work (Gioseffi and Belluno, *Aquileia*, 45) fails to mention the spandrel painting.

38. Kötzsche, "Darstellungen Karls des Grossen," 169–71 and Abb. 18.

39. Cf. I. Spatharakis, *The Portrait in Byzantine Illuminated Manuscripts* (Leiden, 1976), figs. 6, 7, 102.

40. Lazarev, *Storia*, 73–74, fig. 42; R. Cormack, *Writing in Gold* (London, 1985), 50–94; idem, "The Mosaic Decoration of S. Demetrios, Thessaloniki," *Annual of the British School at Athens* 64 (1969): 17–52, rpt. in *The Byzantine Eye: Studies in Art and Patronage* (London, 1989), part II, 44–122, pls. 29, 30, 32, 34, and 36.

41. See H. Belting, "Ein Privatkapelle im frühmittelalterlichen Rom," *DOP* 41 (1987): 55–69.

42. P. Bloch, "Zum Dedikationsbild im Lob des Kreuzes des Hrabanus Maurus," *Das Erste Jahrtausend* (Düsseldorf, 1962), 1:fig. 33. Spatharakis, *The Portrait*, 7–14, fig. 1.

43. S. der Nersessian, "Two Images of the Virgin in the Dumbarton Oaks Collection," *DOP* 14 (1960): 71–86; esp. 80f.

44. Demus, *Norman Sicily*, pls. 58B and 76B. For a detailed discussion of this portrait format see Kitzinger, *St. Mary's*, 197–206.

45. Like all the surviving inscriptions in the crypt, it is a Leonine hexameter and is not based directly on the prose texts of the legend.

46. F. Volbach in Hahnloser and Polacco, *La Pala d'Oro*, 35, no. 73, misidentifies the scene as "Peter conferring episcopal dignity upon Saint Mark."

47. The autograph Gospel of Mark is listed among the relics of Aquileia's treasury in an inventory taken between 1358 and 1378: "primo Liber Beati Marci evangeliste quem proprio manu scripsit, in quo sunt carte scripte quadraginta: tabule vero ipsius argentis et de super deauratis contexte sunt in totum." See Joppi, "Inventario del tesoro," 57–75. Venice acquired a relic of the Gospel of Saint Mark only in 1420. See Demus, *The Church*, 16, n. 54.

48. For my arguments in favor of this dating see chap. 5, n. 62. Demus (*Mosaics of S. Marco*, 1:60–61 and 82–83) dates the mosaics to the first half of the 12th century.

49. See Demus, *Norman Sicily*, 298, fig. 79.

50. Demus, *Mosaics of S. Marco*, 1:277–78, fig. 85.

51. Demus, *Norman Sicily*, 277–78, pl. 85A.

52. Demus (*Mosaics of San Marco*, 1:61) notes that the figure of Athaulf was completely refabricated by 19th-century restorers, since this part of the mosaic had already been lost by the time Kreutz's engravings were made at the beginning of the 19th century. Moreover, a description of 1761 refers to the scene in the following words: "quando (Marco) lo battezza con tutta la sua famiglia." Thus the original composition may well have resembled the Aquileia image.

53. For the mosaics, see Demus, *Mosaics of S. Marco*, 1:224, figs. 360, 371, color pl. 80. For the enamel, see Hahnloser and Polacco, *La Pala d'Oro*, 34 no. 69. It should be noted that the identification as the Baptism of Anianus is only conjectural, since the inscription is vague: "HIC BA(P)TIZAT BEATUS MARCUS."

54. Demus, *Norman Sicily*, 298, fig. 79.

55. Cf. Lazarev, *Storia*, 189, figs. 214, 216; and T. Velmans, *Le Tetrévangile de la Laurentienne* (Paris, 1971), figs. 190, 223, 283.

56. The meaning of this phrase is somewhat clarified in the S. Daniele breviary text (15): "a beato petro accipiens baculum pontificatus et velamen sacramenti suscipiens factus est prothon episcopus provincie italie."

57. On the pallium, see Braun, *Die liturgische Gewandung*, 620ff. (bestowal, 634–39) and Benson, *Bishop Elect*, 169f.

58. Seidler, "Schrein des heiliges Heribert," 314–23; Schnitzler, *Schrein des heiligen Heribert*.

59. Andrieu, *Ordines Romani*, vol. 4, Ordo XXXVB, 77ff.

60. Ibid., 109 no. 37: "Cum datur baculus, dicit (the presiding bishop): Accipe baculum, sacri regiminis signum, ut inbecilles cosolides, titubantes confirmes, pravos corrigas, rectos dirigas in via salutis eterne, habeasque postestatem eligendi dignos et corrigendi indignos, cooperante domino nostro."

61. Benson, *Bishop Elect*, 228ff.

62. G. Swarzenski, *Die Salzburger Buchmalerei* (Leipzig, 1908–13), 154f.

63. Ibid., 97f.

64. S. Beissel, "Der Bischofstab," *Stimmen aus Maria-Laach, Katholische Blätter* 75 (1908): 170–80, particularly 171ff.

65. For the Aquileian responses, see Vale, *I Santi Ermacora e Fortunato*, 24. For the liturgical consecration formula, see Andrieu, *Ordines Romani*, vol. 4, 109, no. 37.

66. See Joppi, "Inventario del Tesoro," 57–71.

67. Seidler, "Schrein des heiliges Heribert," 314–23.

68. Kugler, "Kryptafresken," 149.

69. The composition generally conforms to liturgical scenes in Byzantine and Western mural painting. Cf. Demus, *Romanesque Mural Painting*, pl. 48; idem, *Mosaics of San Marco*, 1:pl. 150; and Hamann-Maclean, *Grundlegung*, 1:fig. 25; 2:6.

70. Kugler ("Kryptafresken," 146) suggested but then rejected this identification on the grounds that the candidate in the Aquileian scene is not wearing

the pallium. However, the present state of painting does not permit us to confirm this detail.

71. Orselli, "La città altomedioevale," 67–69.

72. Kugler, "Kryptafresken," 146–47.

73. For Peter and Paul at Monreale, see Demus, *Norman Sicily*, pl. 83. For other paired saints in trial scenes, see idem, *Romanesque Mural Painting*, pl. 141; idem, *Norman Sicily*, pl. 109B; Galavaris, *Homilies of Gregory Nazianzenus*, figs. 153, 157, 216.

74. E.g., San Paolo fuori le mura: Waetzoldt, *Kopien*, nos. 642 and 644.

75. Waetzoldt, *Kopien*, no. 659.

76. See chap. 8.

77. Kugler ("Kryptafresken," 138f.) connects this gesture with Early Christian baptismal liturgies, where the grasping of the neophyte's arm was intended to recall the grasping of Adam at the Anastasis as a symbol of reawakening and new life. On the association of the Anastasis with baptismal liturgies, see A. Kartsonis, *Anastasis: The Making of an Image* (Princeton, 1986), 173–77 and fig. 65.

78. The 15th-century *Passio* text in the Ljubljana codex (pt. 18) further expands on the story, recounting that Hermagoras went secretly with Gregory "ad domum Gregorii et baptizavit eum cum coniuge sua, et duobus filiis suis, omnique familia domus sue. . . ." See Bratož, *Christianity in Aquileia*, 344.

79. For a series of representations of the Holy Sepulchre as a small domed structure in 5th- to 9th-century ivories and manuscript illuminations, see Schiller, *Ikonographie*, 3:figs. 4, 11, 13, 14, 277. For actual funerary monuments of its type and models of the Holy Sepulchre, see S. Puissi, "Il Santo Sepolcro di Aquileia," *AntAltAdr* 12 (1977): 511–59.

80. Schiller, *Iconography*, 2:170–73, figs. 513–16.

81. Comparable compositions include: the execution of John and Paul, SS. Giovanni e Paolo, Spoleto (Demus, *Romanesque Mural Painting*, pl. 64); the martyrdom of Cyprian, Paris Bibl. Nat. Cod. Coislin 239, fol. 54r (Galavaris, *Homilies of Gregory Nazianzenus*, fig. 218); martyrdom of five martyrs of Sebastea, Mt. Sinai, calendar icon (K. Weitzmann, "Illustrations to the Lives of the Five Martyrs of Sebaste," *DOP* 33 [1979], fig. 9).

82. Kugler ("Kryptafresken," 153, n. 1) first deciphered this inscription. "PATRIS MEMBRA" seems to refer to the relics of the saints as "members of the father" (or members of the body of Christ).

83. E.g., Vat. grec. 1613, 121: Deposition of the relics of Saint Luke. See K. G. Holum and G. Vikan, "The Trier Ivory, *Adventus* Ceremonial, and the Relics of S. Stephen," *DOP* 33 (1979): 120, fig. 7.

84. Seidler, "Schrein des heiliges Heribert," 314–23.

85. See below, F5.

86. See E. Atchley, *A History of the Use of Incense in Divine Worship*, Alcuin Club Collections, 13 (London, 1909), 97ff. On the triumphal nature of funerary processions and translations of relics of the saints, see Holum and Vikan, "The Trier Ivory," 115–133.

87. Andrieu, *Ordines Romani*, vol. 4, 398 (Ordo XLII, no. 2); vol. 4, 346–47 (Ordo XLI, nos. 28 and 29).

88. L. Magnani, *Le miniature del Sacramentario d'Ivrea e di altri codici Warmondiani* (Vatican, 1934), 37–39. For a recent overview of these miniatures from the standpoint of social history, see P. Geary, *Phantoms of Remembrance: Memory and Oblivion at the end of the First Millennium* (Princeton, 1996), 51–73.

89. The term "recondo" is used in precisely the same context of liturgical deposition by John the Deacon in the *Chronicum Venetum*, ed. Monticolo, 105, line 17; cited by F. Arnaldi, ed., *Lexicon Latinitatis Italicae Medii Aevi*, pars III, fasc. 1 = *Bulletin du Cange* 27 (1957): 72. For the terminology used in the burial rites, see D. Sicard, *La liturgie de la mort dans l'église latine des origines à la réforme carolingienne* (Münster Westfalen, 1978), 223 and 230.

90. Swoboda (*Der Dom*, 88) tentatively identified this scene as the Adoration of the Magi. The connection with the Translation of the relics of Hermagoras and Fortunatus was first suggested by Kugler, "Kryptafresken", 19–20. The Feast of Translation of Hermagoras and Fortunatus on August 27 is recorded in Gorizia, Biblioteca del Seminario Arcivescovile, Codex B, 218v ("Festum Translat(i)o(n)is s(an)c(t)o(rum) Hermachore et Fortunati") and the *Necrologium Aquileiense*: "XI.A.VI.KAL. Translacio SS. Hermachore et Fortunati, Legenda." The only extant editions of translation texts are found in Gradese-Venetian sources which concentrate on the initial translation of the relics from Aquileia to Grado and ignore the later return of the relics to Aquileia in the 11th century. See *AASS*, Iulii III:255–57.

91. F. Guidobaldi, *San Clemente: Gli edifici romani, la basilica paleocristiana e le fasi altomedievali*, San Clemente Miscellany 4.1 (Rome, 1992), fig. 234; Demus, *Romanesque Mural Painting*, pl. 68.

92. For a concise account of the peregrinations of the relics of Hermagoras and Fortunatus, see Joppi, "Sacre reliquie."

93. Parallels for translation cycles completed by collocatio or dedication images are: the late-11th-century fresco cycle of Saint Clement in the lower church of San Clemente in Rome, where the translation and dedication of the church are conflated within the same panel (Guidobaldi, *San Clemente*, fig. 234); the 13th-century mosaics of Saint Mark's translation to Venice on the facade of San Marco, where the initial 9th-century procession of the relics into Venice is followed by the later collocatio in 1094 when the present church was dedicated (Dale, "Inventing a Sacred Past," figs. 49 and 50); the early-13th-century translation of Saint Magnus in the crypt of Anagni, near Rome, where an extensive translation cycle culminates in the collocatio of relics in the Cathedral of Anagni (Demus, *Romanesque Mural Painting*, pl. 68).

94. Giandomenico Bertoli, unpublished letter to Giusto Fontanini, 30 April 1724, Biblioteca del Seminario Arcivescovile, Udine. For a transcription of this letter and a discussion of its usefulness as a source, see Appendix II.

95. An examination of the windows from the exterior suggests that they are original, since they conform in design to the central eastern window. But the interior jambs have likely been slightly enlarged. Cf. Kugler, "Kryptafresken," 11.

96. Badly damaged by humidity, this lunette was already hard to read when Bertoli recorded the decoration in 1724, but its main outlines are still intact: this first known eye-witness account of the decoration does not mention the scene in his description of the lunettes. See Appendix II.

97. On these conventional gestures of despair in Byzantine and late antique art, see Maguire, "Depiction of Sorrow."

98. The thurible, aligned with the vertical axis of the Virgin's head and shoulders, appears just above the upper pair of parallel lines on the exposed 11th-century layer of intonaco.

99. Pseudo-Melito, Transitus Mariae (B), ed. in C. Tischendorf, Apocalypses Apocryphae (Leipzig, 1866), 124–36; Pseudo-John, Liber de Dormitione Mariae. ed. in ibid., 95–112; Pseudo-Joseph, Transitus Mariae (A), ed. in ibid., 113–23. For a full commentary on these and other relevant texts concerning the Dormition, see A. Martin Jugie, La mort et l'assomption de la Sainte Vierge, Studi e Testi, 114 (Vatican City, 1944). See also the brief summary of the textual tradition by Schiller, Ikonographie, 4.2:84–88.

100. Schiller, Ikonographie, 4.2, 92ff.; J. Mysliveć, "Tod Mariens," in Lexikon der christliche Ikonographie (Freiburg im Breisgau, 1972), 2, cols. 333–38; L. Wratislaw-Metrović and N. Okunev, "La dormition de la Sainte Vierge dans la peinture médiévale orthodoxe," Byzantinoslavica 3 (1931): 134–80. For the ivory, see A. Goldschmidt and K. Weitzmann, Die Byzantinische Elfenbeinskulpturen des X.–XIII. Jahrhunderts, Bd. 2: Reliefs, 2nd ed. (Berlin, 1979), no. 110. For the Dormition in the crypt of Hosios Lukas, see Connor, Art and Miracles, 40, fig. 77.

101. De divinis nominibus, III.2, ed. in PG 3:681; French trans. and commentary by Jugie, L'assomption, 99–101.

102. Jugie, L'assomption, 100.

103. Andrew of Crete, ed. PG, 97:1061; John of Damascus, ed. PG, 96:749. Cf. M. Sacopoulo, Asinou en 1106 et sa contribution à l'iconographie (Brussels, 1966), 42 and P. Verdier, Le couronnement de la Vierge (Montreal, 1980), 30.

104. E.g., Church of the Panaghia, Asinou, Cyprus, 1106 (Sacopoulo, Asinou, pl. 10 and 37–47); the Martorana, Palermo, c. 1160 (Demus, Norman Sicily, 81, pl. 56). For Ochrid, see Hamann-Maclean, Grundlegung, 1:pls. 26 and 3; 2:27–30.

105. Pseudo-John, Liber de Dormitione Mariae, ed. in Tischendorf, Apocalypses Apocryphae, 95 ff.; English trans. by M. R. James, The Apocryphal New Testament (Oxford, 1955), 201ff.

106. S. Pelikanides et al., The Treasures of Mount Athos (Athens, 1975), 2:pl. 6.

107. For Kurbinovo, see Hadermann-Misguich, Kurbinovo, pl. 90. For the later expanded composition of the Dormition, see Sacopoulo, Asinou, 43f.

108. Kartsonis, Anastasis, 40–67.

109. Tenth-century examples of the composition in ivory are found in the Victoria and Albert Museum, c. 988 (Schiller, Iconography, 2:fig. 338) and the Hanover Museum (ibid., fig. 340). Monumental representations are found in the crypt of Hosios Lukas, dating from the late 10th to early 11th century (Skawran, Middle Byzantine Fresco Painting, fig. 66), and in the mosaics of the Catholicon of Hosios Lukas from the mid-11th century (O. Demus and E. Diez, Byzantine Mosaics in Hosios Lukas and Daphni (Cambridge, Mass., 1931), 68–69, color pl. XIII), and at Daphni, dating from around 1100 (ibid., 67–68, pl. 99).

110. Mouriki, Mosaics of Nea Moni, 1:57–60, 130–32; 2:pls. 162–171.

111. Valland, Aquilée, 17f.

112. Mouriki, Mosaics of Nea Moni, 130–32.

113. Maguire, "Depiction of Sorrow," 123–71.

114. For the mosaic, see Demus, Mosaics of S. Marco, 1:202–4, pl. 332.

115. The expanded entourage of the Virgin is not a reliable indication of late dating for the composition, although increasingly large groups of mourners are more popular in the Palaeologan period of Byzantine art and Italian panel painting of the Dugento and Trecento. No less than seven female mourners appear in Guglielmo's Sarzana Cathedral Crucifix of 1138 (E. Sandberg Vavala, La croce dipinta italiana e l'iconographia della Passione [Verona, 1929], no. 223, fig. 244), and five appear on the left side of the Crucifixion in Sant'Angelo in Formis, painted at the end of the 11th century (Morisani, Gli affreschi di Sant'Angelo in Formis, pl. 44). Four appear as early as the 9th century on a Carolingian ivory book cover in the Staatsbibliothek of Munich (Schiller, Iconography, 2:fig. 356).

116. Valland, Aquilée, 27ff. An early example of the swooning Virgin supported by John the Evangelist is found in the nave of the lower church at Assisi, ascribed to the first half of the 13th century. See J. Poeschke, Die Kirche von San Francesco in Assisi und ihre Wandmalereien (Munich, 1985), 17, pl. 34.

117. Valland, Aquilée, 22. For the Monreale mosaic, see Demus, Norman Sicily, 287–88, pl. 71. For the Fondi Exultet (Paris, Bibl. Nat., Nouv. acq. lat. 710), see Exultet: rotoli liturgici del medioevo meridionale, exh. cat. Montecassino Abbey (Rome, 1994), 281.

118. Schiller, Iconography, 2:fig. 548, 178; Y. Nagatsuka, Descente de Croix (Tokyo, 1979), 7f.

119. Typical examples are found in a 10th-century gospel book in the Laurentian Library (Conv. soppr. 160) and a 12th-century gospel book in the Staatsbibliothek der Stiftung Preussischer Kulturbesitz in Berlin (Ms. gr. qu 66): Schiller, Iconography, 2:178; figs. 550, 552.

120. See Maguire, "Depiction of Sorrow," 162–63, and idem, Art and Eloquence, 96–101.

121. On the Tokali Deposition, see A. Wharton Epstein, Tokali Kilise: Tenth-century Metropolitan Art in Byzantine Cappadocia, DOS 22 (Washington, D.C.,

1988), 74, figs. 83, 85. For the ivory, see Gold-schmidt and Weitzmann, *Byzantinische Elfenbeinskulpturen*, 2:no. 40, 37 and Schiller, *Iconography*, 2:178–79.

122. See Maguire, "Depiction of Sorrow," 163, fig. 77.

123. Demus, *Mosaics of San Marco*, 1:209–12. For the reconstruction and function of this mosaic, see Dale, "Easter, Saint Mark, and the Doge," 21–33 and fig. 8.

124. F. Forlati, "I Lavori a San Marco," *Arte Veneta* 9 (1955): 241; Demus, *Mosaics of San Marco*, 1:209–12; and Rizzardi, *Mosaici altoadriatici*, 37–42.

125. See the discussion of the Crucifixion, F3. This element of the Deposition, like the incorporation of John and Mary at opposite ends of the composition, may well have been imported from the Crucifixion. Contrary to Valland (*Aquilée*, 30), Kugler ("Kryptafresken," 71) rightly points out that this is not a Palaeologan invention.

126. Two Western manuscripts depict the Virgin in the same disposition as the Aquileia Deposition: a sacramentary from Weingarten Abbey now in the Hessisches Landesbibliothek of Fulda (Ms. Aa 39, fol. 8v) which dates from the 1120s or 1130s, and a mid-12th-century gospel book of the Archivio della Badia at Nonantola. H. Kölner, *Die illuminierten Handschriften der Hessischen Landesbibliothek Fulda* (Stuttgart, 1976), 1:no. 38; P. Toesca, *Storia della pittura italiana: Il Medioevo*, 2:105ff.

127. Kugler ("Kryptafresken," 68) aptly describes this development as a transformation of the image from "Ereignis" to "Andachtsbild." The evolution from the narrative Deposition image to the iconic "Imago Pietatis" is traced by Panofsky, "*Imago Pietatis*," 261ff.

128. Weitzmann, "Origin of the Threnos."

129. Maguire, "Depiction of Sorrow," 144 and 146, fig. 3; Schiller, *Iconography*, 2:187, fig. 595; Weitzmann, "Origin of the Threnos," 483.

130. For Nerezi, see Hamann-Maclean, *Grundlegung*, 1:pls. 37 and 39; 2:267–68; and Maguire, *Art and Eloquence*, 102. Two other Macedonian examples show similar compositions: St. George at Kurbinovo (Hadermann-Misguisch, *Kurbinovo*, 155–58, pls. 74 and 75; Maguire, ibid., 104–5) and the Anargyroi at Kastoria (Skawran, *Development of Middle Byzantine Fresco Painting*, 171–72, fig. 263).

131. For Sant'Angelo in Formis, see Demus, *Romanesque Mural Painting*, pl. 36. For San Giovanni a la Porta Latina, see G. Matthiae, *Pittura Romana del Medioevo*, 2nd ed. by M. Andaloro (Rome, 1987), 1:fig. 88. For Monreale, see Demus, *Norman Sicily*, 288, pl. 71B. Even the Italian painted crosses, which made great advances in the iconography of the Deposition, preserved a fairly conservative type of the Entombment (in a sarcophagus beneath a ciborium), to which a few aspects of the expanded Lamentation scene such as the Virgin's tender embrace were added. See Derbes, "Byzantine Art and the Dugento," 274ff. and Sandberg Vavala, *La croce dipinta*, 297–308.

132. For images of the spotted panther in bestiaries see Hassig, *Medieval Bestiaries*, figs. 166–71.

133. For examples on Byzantine silks, see *Ornamenta Ecclesiae*, 2:E94 and E104, 326 and 340. For an example of a Coptic tunic medallion, see W. F. Volbach and E. Kuehnel, *Late Antique, Coptic, and Islamic Textiles of Egypt* (London, 1926), pl. 53.

134. For the Palermo mosaics, see Demus, *Norman Sicily*, pls. 115B and 119; for the presbytery mosaic and ceiling panel, see J. Deer, *The Dynastic Porphyry Tombs of the Norman Period in Sicily*, DOS, 5 (Cambridge, Mass., 1959), figs. 154, 155.

135. A. Grabar, *Sculptures byzantines du Moyen Age*, 2 vols. (Paris, 1976), 2:nos. 73, 75.

136. Kugler ("Kryptafresken," 246) identifies this as a helmet.

137. Kugler, "Kryptafresken," 250.

138. Katzenellenbogen, *Allegories of the Virtues and Vices*, 11–13 and fig. 9; Sauvel, "Les vices et les vertus," 155–64.

139. Flaming hair is also an attribute of vice in a series of 11th-century miniatures of the *Psychomachia* by Prudentius. See *Ornamenta Ecclesiae*, 1:69–73, A17 and A18. Kurt Weitzmann likewise calls attention to the "raised hair" of Abel in a 13th-century mosaic in the atrium of San Marco in Venice as symbolic of an "evil person." See his contribution to Demus, *Mosaics of San Marco*, 2:116 and pl. 139.

140. D. Nicolle, *Arms and Armour of the Crusading Era* (White Plains, N.Y., 1988), nos. 319, 344b, 3810, 474, 569d.

141. See, for example, the miniature of David playing the lyre in the 12th-century German psalter in St. John's College, Cambridge, Ms. B. 18 fol. 1r. (Steger, *David Rex et Propheta*, no. 38). For an extant example in gilt bronze, see the "Throne of Dagobert" in the treasury of Saint-Denis (Panofsky, *Abbot Suger*, 73, 200–201 and fig. 22). For a rare example in ivory and wood, see the *faldistorium* of Abbess Gertrud of Nonnberg (1232–52) in Salzburg (A. Goldschmidt, *Die Elfenbeinskulpturen aus der romanischen Zeit, XI.–XIII Jahrhundert*, 7 vols. [Berlin, 1923], 3:33–35, no. 123 and Tafeln XL–XLII).

142. Kugler ("Kryptafresken," 247) was able to discern the faint outline of the second combatant to the right of the dagger-wielding knight.

143. For the textual history, see K. Dorsch, *Georgszyklen des Mittelalters*, Europäische Hochschulschriften, ser. 28, vol. 28 (Frankfurt, 1983), 18–24.

144. The closest parallel for Aquileia is found on another fictive curtain from the late 12th century in the Cappella dei Cittadini at San Lorenzo in Milan: Dell'Aqua, *La basilica di San Lorenzo*, 171–204. For other French examples from the 12th century, see Deschamps, "La légende de Saint Georges," 110–13.

145. For cycles from the 12th and 13th centuries showing George before an enthroned ruler, see Dorsch, *Georgszyklen*, 276, no. 5; 285, no. 18; 287–90, no. 22 and pl. 1; 290–93, no. 23.

146. Kugler, "Kryptafresken," 247–48.

147. On the assimilation of David to Orpheus in Judaism and early Christianity, see A. Dupont-

Sommer, *Le mythe d'Orphée aux animaux et les pro-longements dans le Judaïsme, le Christianisme et l'Islam* (Rome, 1975), 3–12; P. Finney, "Orpheus-David: A Connection in Iconography between Greco-Roman Judaism and Early Christianity?" *Journal of Jewish Art* 5 (1978): 6–15 and G. Hanfmann, "The Continuity of Classical Art: Culture, Myth, and Faith," in *Age of Spirituality: A Symposium* (New York, 1980), 87–89. On the David-Orpheus panel at Dura, see K. Weitzmann and H. Kessler, *The Frescoes of the Dura Synagogue and Christian Art*, DOS, 28 (Washington, D.C., 1990), 91–94, 168ff.

148. See, for example, his letter to Boethius, cited by Pickering, *Literature and Art in the Middle Ages*, 285f.

149. A. Cutler, *The Aristocratic Psalters in Byzantium* (Paris, 1984), figs. 153, 191, 245, 290, 294, and 308.

150. For the Wulstanus Breviary see C. M. Kauffmann, *Romanesque Manuscripts, 1066–1190* (London, 1975), 54 and fig. 8. For the Peter Lombard manuscript in Oxford, see O. Pächt and J. J. G. Alexander, *Illuminated Manuscripts in the Bodleian Library* (Oxford, 1973), 3:pl. XXIII.

151. E.g., the mosaic of Orpheus from the area of the Damascus Gate in Jerusalem (Dupont-Sommer, *Le mythe d'Orphée*, fig. 7) and the 6th-century mosaic of David from the synagogue of Gaza (see H. Stern, "Un nouvel Orphée-David dans une mosaïque du VIe siècle," *CompRendAcInscr* n.v. (1970): 63–79, figs. 5 and 6).

152. Radulfus Cadomensis, *Gesta Tancredi in expeditione hierosolymitana*, 715 (for text see above, chap. 7, n. 3).

153. I. Ševčenko, "The Madrid Manuscript of the Chronicle of Skylitzes in the Light of its New Dating," in *Byzanz und der Westen, Studien zur Kunst des Europäischen Mittelalters* (Vienna, 1984), 117–30. For the miniatures and later, thirteenth-century dating, see A. Grabar and M. Manoussacas, *L'illustration du Manuscrit de Skylitzes de la Bibliothèque Nationale de Madrid* (Venice, 1979).

154. See Kittel, *Siegl*, 250ff.

155. E.g., the seal of William II of England (1087–1100): Nicolle, *Arms and Armour*, no. 881.

156. For an outline of the evolution of the form of shield used by equestrians, see Nickel, *Mittelalterliche Reiterschild*. For examples of the Aquileian shield type see Nicolle, *Arms and Armour*, no. 1299A: Roland and Faragut, facade relief of San Zeno, Verona (c. 1138); *Enamels of Limoges, 1100–1350*, exh. cat., Metropolitan Museum of Art (New York, 1996), 98–99: enamel tomb of Geoffrey of Anjou (c. 1151); Nicolle, *Arms and Armour*, no. 730: La Charité Psalter (end of 12th cent.); and Kittel, *Siegel*, figs. 162–63.

157. See, for example, the column figure forming the base of the high altar of Modena Cathedral (Nicolle, *Arms and Armour*, no. 1306B). This helmet type is distinguished by the forward-tilted crown and the extension at the back to protect the neck.

158. See E. von Berchem, *Siegel* (Berlin, 1923), figs. 75–77.

159. Nicolle, *Arms and Armour*, no. 303: stone relief of St. George, west facade of Ferrara Cathedral (c. 1135); no. 897: Seal of Aubrey de Vere, British Library, London (mid-12th cent.); and no. 90lc: wall painting of combat scene, All Saints Church, Claverly, England (late 12th–early 13th cent.).

160. See, for example, White, *Book of Beasts*, 119.

161. Ibid., 110.

162. Kugler ("Kryptafresken," 248, n. 2) tentatively suggests that the name of the Venetian episcopal Castellanus (1291–92), Simeon Maurus, may have been inscribed at a time when the original meaning of the scene was no longer understood.

163. Swoboda, *Der Dom*, 91.

164. Toesca, "Gli affreschi," 32ff.

165. Bettini, *La pittura veneta*, 1:179.

166. Kugler, "Kryptafresken," 251.

167. Luca, "Il sostrato culturale," 252–53.

168. See J. Braun, *Die Reliquiare des christlichen Kultes und Ihre Entwicklung* (Freiburg im Breisgau, 1940), 160ff., and *Ornamenta Ecclesiae*, 1:97–98, E17–18.

169. See *Splendori di Bisanzio* (Milan, 1990), 188–89, cat. 74.

170. See for example, Schiller, *Iconography*, 2:figs. 157–58.

171. Dodwell, Pächt, and Wormald, *Saint Albans Psalter*, pls. 122a and 122f. In her article "Byzantinisches und Westliches" (26), Kugler came to the same conclusion concerning the costume of the figures and relabeled the panel "Pilgerszene."

172. Dodwell, Pächt, and Wormald, *Saint Albans Psalter*, pl. 38.

173. On the influence of the Peregrinus plays in depictions of the Emmaus episodes, see ibid., 73ff. and O. Pächt, *The Rise of Pictorial Narrative in Twelfth-Century England* (Oxford, 1962), 33–59. As early as the 11th century, Christ is given the pilgrim's attributes in the Emmaus scene: the cap, satchel, and banded staff. But the animal skin seems to be an English innovation of the early 12th century. The rare appearance of this costume in Mediterranean Europe on the bronze doors of Monreale Cathedral suggests that the English iconography was transmitted by Norman Sicily. See Schiller, *Ikonographie*, 3:figs. 291, 306, 312, 313, 315, 316.

174. The composition calls to mind the illustration of the Departure of Charlemagne and his army on a crusade in the Codex Callixtinus. See Lejeune and Stiennon, *Légende de Roland*, 2:pl. 33.

175. It is quite common to find different conventions for portraying the same mail hauberk even within a single image. See, for example, the various representations of mail in the Bayeux Tapestry, discussed by F. Stenton et al., *The Bayeux Tapestry* (London, 1957), 60ff.

176. Nicolle, *Arms and Armour*, no. 1313 (entry on Aquileia). For the chapel-de-fer type, see ibid., nos. 709H–I: "Atlantic Bible," S. France, Florence, Laurentiana Ms. Edilei 125–26 (late 11th century). For both types, see ibid., no. 753: Saint-Denis, lost stained-glass windows of the First Crusade (ca. 1150).

Appendix II

1. Giandomenico Bertoli, Letter to Cardinal Giusto Fontanini, 30 April 1724; bound in FONTANINI. LETTERE MSS. TOMO XVII, Biblioteca del Seminario Arcivescovile. I am most grateful to the director of the library, Rev. Prof. Luigi de Biasio, for making the manuscript available to me.

2. Here he describes a Hebrew inscription unrelated to the crypt.

3. The pilasters attached to the piers flanking the apse appear to date from the 15th-century renovations of the crypt. See chap. 2 above.

4. Girolamo de Renaldis (*Della Pittura Friulana* [Udine, 1798], 6–7) mentions that part of the decoration had been damaged by "inopportune imbiancature," but he does not record any new figural painting.

5. Sant'Urbano alla Caffarella in Rome (Waetzoldt, *Kopien*, no. 1096) is the exception that proves the rule. The Flagellation, however, does belong to the repertoire of the Italian painted crosses, from the 12th century on; it also appears sporadically in other media, for example, the bronze doors of Benevento and of San Zeno in Verona (Schiller, *Iconography*, 2:7 and Sandberg Vavala, *La croce dipinta*, 246f.). In every case, though, it is found within the context of a densely illustrated Passion cycle—not a selective feast cycle like that of Aquileia.

Similarly, the Elevation of Christ on the Cross is included in the regular repertoire of the painted crosses from the 13th century but is otherwise extremely rare prior to the 14th century. For the emergence of these new themes in Passion narratives of the Dugento, see Derbes, *Picturing the Passion*, 138–57; and Schiller, *Iconography*, 2:86–88.

6. It must be recalled that these terminal bays are much narrower than the central lunette where there was space enough to depict two separate narrative images on either side of the central window.

7. See L. Crusvar, "Il tesoro dei Patriarchi," *AntAltAdr* 38 (1992): 289–337, esp. 308–15, figs. 6–7; Swoboda, *Der Dom*, 128, fig. 56.

BIBLIOGRAPHY

Manuscripts

Cividale, Museo Civico Archeologico, Codex 91, Breviary of the Aquileian Church. 12th century.

Gorizia, Biblioteca del Seminario Arcivescovile, Codex B, *Ordo officii secundum morem et consuetudinem aquileiensis ecclesiae per curriculum totius anni.* Aquileia, 13th century.

Udine, Biblioteca del Seminario Arcivescovile, Codex 3 (formerly of the Archivio Capitolare, Udine). 12th century.

Udine, Biblioteca del Seminario Arcivescovile, Codex 43, Capitolary and Collectary from Moggio Abbey. 12th century.

Udine, Biblioteca del Seminario Arcivescovile, *Mss. Fontanini,* Vol. XIX. 1720s.

Venice, Biblioteca Nazionale Marciana, Cod. lat. III.172 (= 2276), *Caerimoniale rituum sacrorum ecclesiae S. Marci Venetiarum.* Venice, 16th century.

Venice, Biblioteca Nazionale Marciana, Cod. lat. XIV.49 (= 4270), *Opuscula a Iusto Fontanino collecta.* Venice, 18th century.

Venice, Biblioteca Nazionale Marciana, Cod. lat. XIV.51 (= 4271), *Opuscula variae eruditionis de rebus foroiuliensibus a Iusto Fontanino collecta, quaedam sua manu.* Venice, 18th century.

Published Editions and Collections of Primary Sources

Acta Sanctorum, Iulii III. Ed. J. Carnandet. Rome, 1867.

Andrieu, M. *Les "Ordines Romani" du haut Moyen Age,* 5 vols. Spicilegium sacrum lovaniense, nos. 11, 23, 24, 28, 29. Louvain, 1931–61.

———. *Le pontifical romain au Moyen Age.* 4 vols. Studi e Testi, nos. 86–88 and 99. Vatican, 1938–41.

Andrieu, M., C. Vogel, and R. Elze. *Le pontifical Romano-Germanique du dixième siècle.* Studi e Testi, 226. Vatican, 1963.

Barré, H. "Le 'Planctus Mariae' attribué à Saint Bernard." *Revue d'ascétique et de mystique* 28 (1952): 243–66.

———. *Prières anciennes de l'Occident à la Mère du Sauveur des origiorigines à saint Anselme.* Paris, 1963.

Bernard of Clairvaux. *De laude novae militiae ad milites templi.* Vol. 1. Ed. J. Leclercq. In *Sancti Bernardi Opera.* Rome, 1957.

Blume, C., and H. M. Bannister, eds. *Analecta hymnica medii aevi,* 54. Leipzig, 1915. Rpt. London, 1961.

Bratož, R. *Krščanstvo u Ogleju in na Vzhodnem območju oglejske Cerkve od Začetkov do Nastora verske svobode* (Christianity in Aquileia and the eastern influential area of the Aquileian Church from its beginnings to the introduction of religious freedom; Serbo-Croatian with English résumé). Ljubljana, 1986.

Cattin, G. *Musica e liturgia a San Marco. Testi e melodie per la liturgia delle ore dal XII al XVII secolo.* 4 vols. Venice, 1990–92.

Codex Diplomaticus Regni Croatiae, Dalmatiae et Slavoniae. Ed. T. Smičiklas. Zagreb, 1904.

Dandolo, Andrea. *Chronica per extensum descripta.* Ed. E. Pastorello. In L. A. Muratori, *Rerum Italicarum Scriptores,* 12. 2nd ed. Bologna, 1939.

Davis-Weyer, C. *Early Medieval Art, 300–1150.* Toronto, 1986.

Durandus, Guglielmus. *Rationale Divinorum Officiorum.* Trans. J. M. Neale and B. Webb. *The Symbolism of Churches and Church Ornaments.* London, 1906.

———. *Rationale Divinorum officiorum.* Ed. Ioannes Belethus. Lyons, 1612.

Holt, E. G. *A Documentary History of Art.* 1. New York, 1957.

Jaffé, Philippe, ed. *Regesta Pontificum Romanorum.* 2 vols. Leipzig, 1885.

James, M. R., trans. *The Apocryphal New Testament.* Oxford, 1955.

Kehr, P. F. *Regesta Pontificum Romanorum. Italia Pontificia.* Berlin, 1923.

Lehmann-Brockhaus, O. *Schriftquellen zur Kunstgeschichte des 11. und 12. Jahrhunderts für Deutschland, Lothringen und Italien.* 2 vols. Berlin, 1938.

Mansi, Giandomenico, ed. *Sacrorum Conciliorum.* Venice, 1774. Rpt. Paris, 1901–27.

McCleary, N. "Note storiche ed archeologiche sul testo della *Translatio Marci.*" *MemStorFor* 29 (1933): 223–64.

Menis, G. C. "La 'Passio' dei santi Ermacora e Fortunato nel codice n. 4 della Biblioteca Guarneriana." *Studi di letteratura popolare friulana* 1 (1969): 15–49.

Monticolo, G. *Cronache Veneziane antichissime.* Rome, 1890.

Necrologium Aquileiense. Ed. C. Scalon. In *Fonti per la Storia della Chiesa in Friuli,* 1. Udine, 1982.

Notker Balbulus. *Gesta Karoli Magni Imperatoris.* Ed. H. Haefele. In *MGH, Scriptores Rerum Germanicarum,* n.s., 12.

Paulus Diaconus. *Historia Lombardorum.* Eds. G. Waitz and L. Bethmann. *MGH, Scriptores Rerum Langobardicarum et Italicarum saec. VI–IX,* 48.

Patrologiae cursus completus, Series Graeca. Ed. J.-P. Migne. Paris, 1857–66.

Patrologiae cursus completus, Series Latina. Ed. J.-P. Migne. Paris, 1844–80.

Pelagius I, Pope. *Epistolae.* Ed. P. Gassó. *Pelagii I Papae: Epistulae quae supersunt.* Scripta et Documenta, 8. Montserrat, 1956.

Riley Smith, L., and J. Riley Smith. *The Crusades: Idea and Reality, 1095–1274.* Documents in Mediaeval History, 4. London, 1981.

Schlosser, J. von. *Schriftquellen zur Geschichte der Karolingischen Kunst.* Vienna, 1892.

Theophilus. *De diversis artibus.* Trans. C. R. Dodwell as *On the Various Arts.* London, 1965.

Tischendorf, C. *Apocalypses Apocryphae.* Leipzig, 1866.

Ughelli, F. *Italia Sacra.* 10 vols. Venice, 1720. Rpt. Liechtenstein, 1970.

Vale, G. *I Santi Ermacora e Fortunato nella liturgia.* Udine, 1910.

Wilmart, A. *Auteurs spirituels et textes dévots du Moyen Age latin. Etudes d'histoire littéraire.* Paris, 1932.

Secondary Literature

Abou-el-Haj, B. "Consecration and Investiture in the Life of Saint Amand, Valenciennes, Bibl. Mun. Ms. 502." *Art Bulletin* 61 (1979): 342–58.

———. *The Medieval Cult of Saints: Formations and Transformations.* Cambridge, 1994.

Alexander, J. J. G. "Ideological Representation of Military Combat in Anglo-Norman Art." In *Anglo-Norman Studies* 15 (1992): 1–24.

Andreescu-Treadgold, I. "Les mosaïques de la lagune vénitienne aux environs de 1100." *Actes du XVe congrès international d'études byzantines,* 2: 15–30. Athens, 1976.

———. "Torcello III: La chronologie relative des mosaïques pariétales." *DOP* 30 (1976): 245–341.

Antonini, Daniele, ed. *Monumenti romani e cristiani di Iulia Concordia.* Pordenone, 1960.

Atchley, E. *A History of the Use of Incense in Divine Worship.* Alcuin Club Collections, 13. London, 1909.

Auerbach, E. *Literary Language and Its Public in Late Latin Antiquity and in the Middle Ages.* Trans. R. Manheim. Princeton, 1965. Rpt. 1993.

Bakalova, E. *The Ossuary Church of the Bachkovo Monastery.* In Bulgarian with English résumé. Sophia, 1977.

Barral i Altet, X. "La mosaïque de pavement médiévale dans l'abside de la Basilique Patriarcale d'Aquilée." *CahArch* 26 (1977): 105–16.

Barré, H. "Le 'Planctus Mariae' attribué à Saint Bernard." *Revue d'ascétique et de mystique* 28 (1952): 243–66.

———. *Prières anciennes de l'Occident à la Mère du Sauveur des origines à saint Anselme.* Paris, 1963.

Baschet, J. *Lieu sacré, lieu d'images. Les fresques de Bominaco (Abruzzes, 1263)—Thèmes, Parcours, Fonctions.* Paris and Rome, 1991.

Beissel, S. "Der Bishofstab." *Stimmen aus Maria-Laach. Katholische Blätter* 75 (1908): 170–80.

Belli, M. *L'abbazia di Summaga.* Motta di Livenza, 1925.

Belluno, E. *Il restauro come opera di gusto. La difesa dei beni culturali nel Friuli-Venezia-Giulia.* Udine, 1973.

Belting, H. "I mosaici dell'Aula Leonina come testimonianza della prima *renovatio* dell'arte medievale di Roma." In *Roma e l'età carolingia,* 167–82. Rome, 1976.

———. "Ein Privatkapelle im frühmittelalterlichen Rom." *DOP* 41 (1987): 55–69.

———. *The Image and Its Public: Form and Function in Early Paintings of the Passion.* Trans. M. Bartusis and R. Meyer. New Rochelle, N.Y., 1990.

———. *Likeness and Presence: A History of the Image before the Era of Art.* Trans. E. Jephcott. Chicago, 1994.

Belting-Ihm, C. *Die Programme der christlichen Apsismalerei vom vierten Jahrhundert bis zur Mitte des achten Jahrhunderts.* Wiesbaden, 1960.

Benson, R. *The Bishop Elect: A Study in Medieval Ecclesiastical Office.* Princeton, 1968.

Bergamini, G. "La pittura medievale in Friuli-Venezia-Giulia." In *La Pittura in Italia: L'Altomedioevo,* ed. C. Bertelli, 113–45. Milan, 1994.

Bergamini, G., and L. Perissinotto, *Affreschi del Friuli.* Udine, 1973.

Bernheimer, R. *Romanische Tierplastik und die Ursprünge ihrer Motive.* Munich, 1931.

Bertacchi, L. "La Basilica postattilana di Aquileia." *AqN* 42 (1971): 15–55.

———. "La torre campanaria di Aquileia." *AqN* 44 (1973): 1–36.

Bertelli, C. *Gli affreschi nella torre di Torba.* Quaderni del FAI. Milan, 1988.

Bertelli, C., ed. *La pittura in Italia: L'Altomedioervo.* Milan, 1994.

Bertoli, G. *Le antichità d'Aquileja Profane e Sacre per la maggiorparte finora inedite.* Venice, 1739.

Bettini, S. *Mosaici antichi di San Marco a Venezia.* Bergamo, 1944.

———. *La pittura veneta dalle origini al Duecento.* 2 vols. Padua, 1963–64.

———. "Appunti di storia della pittura veneta nel Medioevo." *Arte Veneta* 20 (1966): 20–42.

Bialostočki, J. "Das Modusproblem in den bildenden Künsten. Zur Vorgeschichte und zum Nachleben des 'Modusbriefes' von Nicholas Poussin." In *Stil und Ikonographie. Studien zur Kunstwissenschaft,* 9–35. Dresden, 1966.

Biasutti, G. *La tradizione marciana Aquileiese.* Udine, 1959.

———. "Aquileia e la Chiesa di Alessandria." *AntAltAdr* 12 (1977), 1:215–29.

Blanchard, J. M. "The Eye of the Beholder: On the Semiotic Status of Paranarratives." *Semiotica* 22, no. 3/4 (1978): 235–68.

Blankenburg, W. von. *Heilige und dämonische Tiere.*

Die Symbolsprache der deutschen Ornamentik im Frühenmittelalter. 2nd ed. Cologne, 1975.

Blaauw, S. de. "Die Krypta in stadtrömischen Kirchen: Abbild eines Pilgerziels." In *Akten des 12. Internationalen Kongresses für christliche Archäologie.* Bonn, 1992.

Braun, J. *Die liturgische Gewandung im Occident und Orient nach Ursprung und Entwicklung, Verwendung und Symbolik.* Freiburg im Breisgau, 1907.

———. *Der christiliche Altar in seiner geschichtlichen Entwicklung.* 2 vols. Munich, 1924.

———. *Die Reliquiare des christlichen Kultes und ihre Entwicklung.* Freiburg im Breisgau, 1940.

Brincken, A.-D., von den. "'Ut describeretur universus orbis': Zur Universal Kartographie des Mittelalters." In *Methoden in Wissenschaften und Kunst des Mittelalters*, ed. A. Zimmermann, 249–78. = Miscellanea Mediaevalia, 7. Berlin, 1970.

Brown, P. *The Cult of the Saints: Its Rise and Function in Latin Christianity.* Chicago, 1982.

Brusin, D. dalla Barba, and G. Lorenzoni. *L'arte del Patriarcato di Aquileia dal secolo IX al secolo XIII.* Padua, 1968.

Brusin, G. "Chiese paleocristiane di Aquileia." *AqN* 22 (1951): 45–60.

———. "La basilica apostolorum di Aquileia. Problema storico-archeologico." In *Mullus: Festschrift Theodor Klauser = JbAntChr, Ergänzungsband*, 1 (1964): 28–33.

Buchthal, H. *The "Musterbuch" of Wolfenbuttel and Its Positon in the Art of the Thirteenth Century.* Vienna, 1979.

Buchwald, H. "Eleventh-century Corinthian Palette Capitals in the Region of Aquileia." *Art Bulletin* 48 (1966): 147–158.

Buckton, D., ed. *The Treasury of San Marco.* Milan, 1984.

Buora, M. "I patriarchi di Aquileia e la sopravvivenza della cultura materiale dell'antichità." *AntAltAdr* 38 (1992): 265–79.

Burke, M. "Hall Crypts of First Romanesque." Ph.D. diss., University of California, Berkley, 1976.

Buschow, H. *Studien über die Entwicklung der Krypta im deutschen Sprachgebiet.* Würzburg, 1934.

Bynum, C. *Fragmentation and Redemption. Essays on Gender and the Human Body in Medieval Religion.* New York, 1991.

Callaghan, D. F. "The Sermons of Adémar of Chabannes and the Cult of St. Martial of Limoges." *Revue Bénédictine* 86 (1976): 251–95.

Camille, M. *Image on the Edge. The Margins of Medieval Art.* Cambridge, Mass., 1992.

Campitelli, M. "Nota sul mosaico con i dodici apostoli di San Giusto a Trieste." *Arte Veneta* 12 (1958): 19–30.

Candido, G. *Commentarii de i Fatti d'Aquileia.* Venice, 1543. Rpt. in Historiae Urbium et Regionum Italiae Rariores, 29. Bologna, n.d. (18??).

Carile, A. "Le origini di Venezia nella tradizione storiografica." In *Storia della cultura veneta*, 135–66. Vicenza, 1976.

Carrasco, M. "Spirituality and Historicity in Pictorial Hagiography: Two Miracles by St. Albinus of Angers." *Art History* 12 (1989): 1–21.

Carruthers, M. *The Book of Memory: A Study of Memory in Medieval Culture.* Cambridge, 1990.

Cavalieri, M. C. "L'affresco absidale della basilica patriarcale di Aquileia." *Bollettino d'Arte* 61 (1976): 1–11.

Cavalieri Manasse, G. *La decorazione architettonica romana di Aquileia, Trieste, Pola.* Vol. 1, *L'età repubblicana augustea e giulio claudia.* Padua, 1978.

Cecchelli, C. "Gli edifici e i mosaici paleocristiani nella zona della basilica." In *La Basilica*, 109–18.

Cessi, R. "Nova Aquileia." *Atti del Reale Istituto Veneto di scienze, lettere ed arti* 88 (1928–29): 542–94.

———. *La Storia della Repubblica di Venezia.* 2 vols. Milan, 1944.

———. "L'investitura ducale." *Atti dell'Istituto Veneto di Scienze, Lettere ed Arti, Classe di Scienze morali e Lettere* 126 (1967–68): 284–86.

Coletti, L. "L'arte nel Territorio di Concordia dal Medio Evo al Rinascimento." In B. Scarpa Bonazza et al., *Iulia Concordia dall'età romana all'età moderna*, 211–000. 2nd ed. Treviso, 1978.

Connor, C. *Art and Miracles in Medieval Byzantium: The Crypt of Hosios Lukas and Its Frescoes.* Princeton, 1991.

Constable, G. "The Second Crusade as Seen by Contemporaries." *Traditio* 9 (1953): 213–79.

———. "Mediaeval Charters as a Source for the History of the Crusades." In *Crusade and Settlement*, ed. P. W. Edbury, 75–00. Cardiff, 1983.

———. "The Ideal of the Imitation of Christ." In *Three Studies of Medieval Religious and Social Thought.* Cambridge, 1995.

Corbin, S. *La déposition liturgique du Christ au Vendredi Saint. Sa place dans l'histoire des rites et du théâtre religieux.* Paris, 1960.

Cormack, R. *Writing in Gold.* London, 1985.

———. *The Byzantine Eye: Studies in Art and Patronage.* London, 1989.

Coronini, F. *I Sepolchri dei patriarchi di Aquileia.* Trans. G. Loschi. Vienna, 1867.

Cowdrey, E. J. "The Genesis of the Crusades." In *The Holy War*, ed. T. P. Murphy, 22–32. 5th Conference on Mediaeval and Renaissance Studies, Ohio State University, 1974. Columbus, 1976.

———. "Martyrdom and the First Crusade." In *Crusade and Settlement*, ed. P. W. Edbury, 46–56. Cardiff, 1983.

Cozzi, E. "L'archangelo S. Michele: un affresco poco noto dell'abbazia di Sesto al Reghena." *Arte Veneta* 29 (1975): 75–77.

———. *Pittura murale di soggetto profano in Friuli dal XII al XV secolo.* Udine, 1976.

Crema, L., and S. Degani, *L'architettura religiosa del Medioevo occidentale: l'altomedioevo.* Milan, 1956.

Cuscito, G. "I reliquiari paleocristiani di Pola." *MemSocIstrArchStorPatr* 20–21 (1972–73): 91–126.

———. "Questioni agiografiche di Aquileia e dell'Istria. Contributo alla conoscenza del Cristianesimo pre-Constantiniano." *Atti del IX Congresso internazionale di archeologia cristiana.* Rome, 1975.

———. "Aquileia e Bisanzio nella controversia dei Tre Capitoli." *AntAltAdr* 12 (1977), 1: 231–62.

——. *Il primo cristianesimo nella "Venetia et Histria"—indagine ed ipotesi.* Udine, 1986.

——. "Le epigrafi dei patriarchi nella Basilica di Aquileia." *AntAltAdr* 38 (1992): 155–73.

Cutler, A. *Transformations: Studies in the Dynamics of Byzantine Iconography.* University Park, Penn., 1975.

——. *The Aristocratic Psalters in Byzantium.* Paris, 1984.

——. "Under the Sign of the Deesis: On the Question of Representativeness in Mediaeval Art and Literature." *DOP* 41 (1987): 145–53.

——. "La 'questione bizantina' nella pittura italiana: una visione alternativa della 'maniera greca'." In *La pittura in Italia: L'Altomedioevo,* ed. C. Bertelli, 335–54. Milan, 1994.

Da Aquileia a Venezia. Milan, 1980.

Dale, T. "The Crypt of the Basilica Patriarcale at Aquileia: Its Place in the Art and History of the Upper Adriatic." Ph.D. diss., Johns Hopkins University, Baltimore, 1990.

——. "Easter, Saint Mark and the Doge: The Deposition Mosaic in the Choir of San Marco in Venice." *Thesaurismata* (= Bollettino del' 'Istituto Ellenico di Studi Bizantini e Post-Bizantini di Venezia) 25 (1995): 21–33.

——. "*Inventing* a Sacred Past: Pictorial Narratives of St. Mark the Evangelist, ca. 1000–1300." *DOP* 48 (1994): 53–104.

Damigella, A. M. *Pittura veneta dell'XI–XII secolo.* Rome, 1969.

Davis-Weyer, C. "Eine patristische Apologie des Imperium Romanum und die Mosaiken der Aula Leonina." In *Minuscula discipulorum. Kunsthistorische Studien Hans Kauffmann zu 70. Geburtstag 1966,* 71–83. Berlin, 1968.

Deichmann, F. W. *Ravenna. Geschichte und Monumente.* Wiesbaden, 1969.

Delehaye, H. *Les passions des martyrs et les genres littéraires.* Brussels, 1921.

——. *Les origines du culte des martyrs.* Subsidia Hagiographica, 20. 2nd ed. Brussels, 1933.

Dell'Aqua, G. *La basilica di San Lorenzo a Milano.* Milan, 1985.

Della Torre, R. *L'Abbazia di Sesto in Sylvis dalle origini alla fine del'200.* Udine, 1979.

Demus, O. *Die Mosaiken von San Marco in Venedig.* Baden, 1935.

——. *Byzantine Mosaic Decoration.* London, 1947.

——. *The Mosaics of Norman Sicily.* London, 1949.

——. "Salzburg, Venedig und Aquileia." In *Festschrift für K. M. Swoboda zum 28. Januar 59,* 75–82. Vienna, 1959.

——. *The Church of San Marco in Venice. History—Architecture—Sculpture.* DOS, 6. Cambridge, Mass., 1960.

——. *Byzantine Art and the West.* New York, 1970.

——. *Romanesque Mural Painting.* Trans. Mary Whittall. London, 1970.

——. "Ein Wandgemälde in San Marco, Venedig." In *Okeanos. Essays presented to Ihor Ševčenko on his Sixtieth Birthday by his Colleagues and Students = Harvard Ukranian Studies* 6 (1983): 124–44.

——. *The Mosaics of San Marco in Venice.* 2 vols. Chicago, 1984.

Demus, O., and E. Diez. *Byzantine Mosaics in Hosios Lukas and Daphni.* Cambridge, Mass., 1931.

Derbes, A. "Byzantine Art and the Dugento: Iconographic Sources of the Passion Scenes in Italian Painted Crosses." Ph.D. diss. University of Virginia, Charlottesville, 1980.

——. *Picturing the Passion in Late Medieval Italy: Narrative Painting, Franciscan Ideologies, and the Levant.* Cambridge, 1996.

Der Nersessian, S. "Two Images of the Virgin in the Dumbarton Oaks Collection." *DOP* 14 (1960): 71–86.

Deschamps, P. "Le combat des Vertus et des Vices sur les portails romans de la Saintonge et du Poitou." *Congrès archéologique* 79 (1912): 309–24.

——. "La légende de Saint Georges et les combats des Croisés dans les peintures murales du Moyen-Age." *Monuments et Mémoires* 44 (1950): 109–23.

Deshman, R. "Servants of the Mother of God in Byzantine and Mediaeval Art." *Word and Image* 5 (1989): 33–70.

Djurić, V. *Byzantinische Fresken in Jugoslawien.* Munich, 1976.

——. "La peinture murale byzantine: XIIe et XIIe siècle." In *Actes du XVe congrès international des études byzantines,* 1: 255–83. Athens, 1976.

Dodwell, C. R. *The Pictorial Arts of the West, 800–1200.* New Haven, 1993.

Dodwell, C. R., O. Pächt, and F. Wormald. *The Saint Albans Psalter.* London, 1960.

Dorigo, W. "L'architettura della basilica patriarcale di Aquileia." *AntAltAdr* 23 (1992): 191–213.

——. "Lo stato della discussione storico-archeologica dopo i nuovi lavori nella cripta di San Marco." In A. Niero et al., *Basilica Patriarcale in Venezia. San Marco: La cripta, il restauro,* 25–40. Milan, 1993.

Dorsch, K. *Georgszyklen des Mittelalters.* Europäische Hochschulschriften, ser. 28, vol. 28. Frankfurt, 1983.

Druce, G. "The Mediaeval Bestiaries and Their Influence on Ecclesiastical Decorative Art, Part 1." *JBAA* 25 (1919): 41–82.

——. "The Mediaeval Bestiaries and Their Influence on Ecclesiastical Decorative Art, Part 2." *JBAA* 26 (1920): 35–79.

Duggan, L. "Was Art really the 'book of the illiterate'?" *Word and Image* 5 (1989): 227–51.

Dupont-Sommer, A. *Le mythe d'Orphée aux animaux et ses prolongements dans le Judaïsme, le Christianisme et l'Islam.* Rome, 1975.

Duša, J. *The Mediaeval Dalmatian Episcopal Cities: Development and Transformation.* New York, 1991.

Dvornik, F. *The Idea of Apostolicity in Byzantium and the Legend of the Apostle Andrew.* DOS, 4. Cambridge, Mass., 1958.

Eberlein, J. K. *Apparitio regis—revelatio veritatis. Studien zur Darstellungen des Vorhangs in der bildenden Kunst von der Spätantike bis zum Ende des Mittelalters.* Wiesbaden, 1982.

——. "The Curtain in Raphael's Sistine Madonna." *Art Bulletin* 65 (1983): 60–77.

Egger, R. "Der Heilige Hermagoras: Eine kritische Untersuchung." *Zeitschrift für geschichtliche Landeskunde vom Kärnten* (= *Carinthia* I) 134 (1947): 16ff. and 137 (1948): 208ff.

Eleen, L. "A Thirteenth-Century Workshop of Miniature Painters in the Veneto." *Arte Veneta* 29 (1985): 9–21.

Epstein, A. Wharton. *Tokali Kilise: Tenth-Century Metropolitan Art in Byzantine Cappadocia*. DOS, 22. Washington, D.C., 1988.

Erdmann, C. *The Origin of the Idea of Crusade*. Trans. M. Bladwin and W. Goffart. Princeton, 1977.

Exultet: rotoli liturgici del medioevo meridionale. Exhibition catalogue, Montecassino Abbey. Rome, 1994.

Farral, E. *Les arts poétiques du XIIe et du XIIIe siècle. Recherches et documents sur la technique littéraire du Moyen Age*. Paris, 1962.

Fedalto, G. "Dalla predicazione apostolica in Dalmazia ed Illirico alla tradizione marciana aquileiese: considerazioni e problemi." *AntAltAdr* 26 (1985), 1: 237–59.

———. "La fine del patriarcato di Aquileia." *AntAltAdr* 38 (1992): 115–36.

Ferluga, J. "La Dalmazia fra Bisanzio, Venezia e l'Ungheria ai tempi di Manuele Comneno." In *Byzantium on the Balkans*, ed. J. Ferluga, 193–213. Amsterdam, 1976.

———. *L'amministrazione bizantina in Dalmatia*. Venice, 1978.

Ferrante, G. *Piani e Memorie dell'Antica Basilica di Aquileja con i Capolavori d'arte che in essa si trovano nonchè del campanile, chiesa e battistero dei pagani e la pianta della città ristabilita da Popone*. Trieste, 1853.

Folz, R. *Le souvenir et la légende de Charlemagne dans l'empire germanique médiévale*. Publications de l'Université de Dijon, 7. Paris, 1950.

Forlati, F. "L'architettura della basilica," in *La Basilica*, 273–98.

———. "I lavori a San Marco." *Arte Veneta* 9 (1955): 241–242.

———. "Ritrovamenti in S. Marco—un affresco del Duecento." *Arte Veneta* 17 (1963): 223–24.

Frantz, M. A. "Byzantine Illuminated Ornament." *Art Bulletin* 16 (1934): 43–76.

Franzoi, U., and D. Di Stefano. *Le Chiese di Venezia*. Venice, 1976.

Frazer, M. "The Pala d'Oro and the Cult of St. Mark in Venice." *JÖB* 32 (1982): 273–79.

Friedman, J. B. *The Monstrous Races in Medieval Art and Thought*. Cambridge, Mass., 1981.

Frugoni, C. "Per una lettura del mosaico pavimentale della cattedrale di Otranto." *Bullettino dell'Istituto Storico Italiano per il Medio Evo* 80 (1968): 213–56.

Fuhrmann, H. "Studien zur Geschichte mittelalterlicher Patriarchate." In 2 parts. *ZSav* 70 (1953): 112–76 and 71 (1954): 1–84.

Furlan, I. *L'Abbazia di Sesto al Reghena*. Milan, 1968.

———. "Pie Donne." In *Venezia e Bisanzio*. Exhibition catalogue, no. 33. Venice, 1974.

Gabrielli, N. *Repertorio delle cose d'arte del Piemonte*. vol. 1, *Le pitture romaniche*. Turin, 1944.

Gagé, J. "*Membra Christi* et la déposition des reliques sous l'autel." *Revue archéologique* 29 (1929): 137–53.

Gaiffier, B. de. "Miracles bibliques et vie des saints." In *Études critiques d'hagiographie et d'iconologie*, 50–61. Subsidia Hagiographica, 43. Brussels, 1967.

———. "Hagiographie et historiographie: Quelques aspects du problème." In *Recueil d'Hagiographie*, 136–66. Subsidia Hagiographica, 61. Brussels, 1977.

Galavaris, G. *The Illustrations of the Liturgical Homilies of Gregory Nazianzenus*. Princeton, 1969.

———. *The Illustrations of the Prefaces in Byzantine Gospels*. Vienna, 1979.

Geary, P. *Furta Sacra: Thefts of Relics in the Central Middle Ages*. 2nd ed. Princeton, 1990.

Geometta, T. *L'Abbazia benedettina di S. Maria in Sylvis*. 2nd ed. Portogruaro, 1964.

Gerevich, L. "The Horseman of Aquileia." *Acta Archaeologica Accademiae Scientiarum Hungaricae* 17 (1965): 395–409.

Gioseffi, D. "I mosaici parietali di S. Giusto a Trieste." *AntAltAdr* 8 (1975): 287–300.

———. "Le pitture della cripta di Aquileia tra Oriente ed Occidente." *AntAltAdr* 12 (1977): 561–69.

Gioseffi, D., and E. Belluno. *Aquileia. Gli Affreschi della Cripta*. Udine, 1976.

Gnirs, A. "La basilica ed il reliquiario d'avorio di Samagher presso Pola." *MemSocIstrArchStorPatr* 24 (1908): 5–48.

Goldschmidt, A., and K. Weitzmann. *Die Byzantinische Elfenbeinskulpturen des X.–XIII. Jahrhunderts*. Bd. 2, *Reliefs*. 2nd ed. Berlin, 1979.

Gombosi, G. "Il più antico ciclo di mosaici di San Marco." *Dedalo*. 13 (1933): 323ff.

Grabar, A. "The Virgin in a Mandorla of Light." In *Late Classical and Mediaeval Studies in Honor of A. M. Friend, Jr.*, ed. K. Weitzmann, 305–11. Princeton, 1955.

———. *Sculptures byzantines du Moyen Age*. 2 vols. Paris, 1976.

Grabar, O. *The Mediation of Ornament*. The A. W. Mellon Lectures in the Fine Arts, 1989. Princeton, 1992.

Green, R., et al. *The Hortus Deliciarum of Herrad of Hohenbourg*. 2 vols. Leiden, 1979.

Guidobaldi, F. *San Clemente: Gli edifici romani, la basilica paleocristiana e le fasi altomedievali*. San Clemente Miscellany, 4.1. Rome, 1992.

Hadermann-Misguich, L. *Kurbinovo. Les fresques de St. Georges et la peinture du XIIe siècle*. Brussels, 1975.

Hahn, C. "Narrative and Liturgy in the Earliest Illustrated Lives of the Saints, Hanover, Niedersächsisches Landesbibliothek, Ms. 189." Ph.D. diss., Johns Hopkins University, Baltimore, 1982.

———. *Passio Kiliani, Ps. Theotimus, Passio Margaretae, Orationes*. Codices Selecti, 83. Graz, 1988.

———. "Picturing the Text: Narrative in the Life of the Saints." *Art History* 13 (1990): 1–33.

Hahnloser, H. R., and R. Polacco, eds. *La Pala d'Oro*. Venice, 1994.

Hamann-Maclean, R. *Grundlegung zu einer Geschichte der mittelalterlichen Monumentalmalerei in Serbien und Makedonien*. 3 vols. Giessen, 1976.

Hassig, D. *Medieval Bestiaries: Text, Image, Ideology*. New York, 1995.

Heitz, C. *L'architecture religieuse carolingienne*. Paris, 1980.

———. "Composantes occidentales de l'architecture romane d'Aquilée." *AntAltAdr* 19 (1981): 309–23.

Herrmann-Masquard, N. *Les reliques des saints: formation coutumière d'un droit*. Paris, 1975.

Hertig, L. *Entwicklungsgeschichte der Krypta in der Schweiz. Studien zur Baugeschichte des frühen und hohen Mittelalters*. Kiel, 1958.

Hoffmann, K. "Sugers 'Anagogisches Fenster' in St. Denis." *Wallfraf-Richartz Jahrbuch* 30 (1968): 57–88.

Holum, K., and G. Vikan. "The Trier Ivory, *Adventus* Ceremonial, and the Relics of S. Stephen," *DOP* 33 (1979): 115–33.

Hubach, H. "Pontifices, Clerus/Populus, Dux. Osservazioni sul più antico esempio di autorappresentazione politica della società veneziana." In *San Marco: aspetti storici ed agiografici. Atti del convegno internazionale di studi*, Venice, 26–29 April 1994, ed. A. Niero, 370–97. Venice, 1996.

Hubert, J. *L'art préroman*. 2nd ed. Chartres, 1974.

Iacobini, A. "Il mosaico del Triclinio Lateranense." In *Fragmenta Picta. Affreschi e mosaici staccati del Medioevo romano*, ed. M. Andaloro, 189–96. Rome, 1989.

Joppi, V. "Inventario del tesoro della chiesa patriarcale d'Aquileia fatto tra il 1358 e il 1378." *Arch StorTrieste* 3 (1884–86): 57–71.

———. "Le sacre reliquie della chiesa patriarcale d'Aquileia. Memorie e documenti." *ArchStorTrieste* 3 (1884–86): 195–223.

Jugie, A. M. *La mort et l'assomption de la Sainte Vierge*. Studi e Testi, 114. Vatican, 1944.

Jungmann, J. A. *Missa Sollemnia: Eine Genetische Erklärung der Römischen Messe*. 2 vols. Freiburg, 1958.

Kane, T. *The Jurisdiction of the Patriarchs of the Major Sees in Antiquity and in the Middle Ages*. Canon Law Studies, 276. Washington, D.C., 1949.

Kantorowicz, E. "Ivories and Litanies." *JWCI* 5 (1942): 56–81.

Kartsonis, A. *Anastasis: The Making of an Image*. Princeton, 1986.

Katzenellenbogen, A. *Allegories of the Virtues and Vices in Mediaeval Art*. London, 1939. Rpt. Toronto, 1989.

Kauffmann, C. M. *Romanesque Manuscripts, 1066–1190*. London, 1975.

Kempf, T. "Erläuterungen zum Grundriß der frühchristlichen Doppelanlage." In *Der Trierer Dom*, ed. J. Ronig, 112–116. Neuß, 1980.

Kessler, H. L. *The Illustrated Bibles from Tours*. Princeton, 1977.

———. "Pictorial Narrative and Church Mission in Sixth-Century Gaul." In *Pictorial Narrative in Antiquity and the Middle Ages = Studies in the History of Art* 16 (1985): 75–91.

———. "The Meeting of Peter and Paul in Rome: An Emblematic Narrative of Spiritual Brotherhood." *DOP* 41 (1987): 265–75.

———. "*Caput et Speculum omnium ecclesiarum*: Old St. Peter's and Church Decoration in Mediaeval Latium." In *Italian Church Decoration of the Middle Ages and Early Renaissance*, ed. W. Tronzo, 119–46. Bologna, 1989.

———. "Medieval Art as Argument." In *Iconography at the Crossroads*, ed. B. Cassidy, 59–70. Princeton, 1993.

———. "'Facies bibliothecae revelata': Carolingian Art as Spiritual Seeing." In *Testo e immagine nell'alto Medioevo = Settimane di Studio del Centro Italiano di Studi sull'alto Medioevo* 41 (1994): 533–94.

Kier, H. *Die mittelalterliche Schmuckfussboden*. Düsseldorf, 1970.

Kittel, E. *Siegl*. Braunschweig, 1970.

Kitzinger, E. *The Mosaics of Monreale*. Palermo, 1960.

———. "The Byzantine Contribution to Western Art in the Twelfth Century and Thirteenth Century." *DOP* 20 (1966): 25–47.

———. "The Role of Miniature Painting in Mural Decoration." In *The Place of Book Illustration in Byzantine Art*. Princeton, 1975.

———. *Byzantine Art in the Making*. Cambridge, Mass., 1977.

———. "Reflections on the Feast Cycle in Byzantine Art." *CahArch* 36 (1988): 51–73.

———. *The Mosaics of St. Mary's of the Admiral in Palermo*. DOS, 27. Washington, D.C., 1990.

Klebel, E. "Zur Geschichte der Patriarchen von Aquilieja." *Beiträge zur älteren europäischen Kulturgeschichte*, 1 (= *Festschrift für Rudolf Egger*), 396–422. Klagenfurt, 1952.

Klingender, F. *Animals in Art and Thought to the End of the Middle Ages*. Cambridge, Mass., 1971.

Knotig, K. *Der Sonnenburg im Pustertal*. Bolzano, 1985.

Kölner, H. *Die illuminierten Handschriften der Hessischen Landesbibliothek Fulda*. Stuttgart, 1976.

Kötzsche, D. "Darstellungen Karls des Grossen in der lokalen Verehrung des Mittelalters." In *Karl der Grosse. Lebenswerk und Nachleben*, eds. W. Braunfels and P. E. Schramm, 4: 157–214. 4 vols. Düsseldorf, 1967.

Krautheimer, R. *Rome: Profile of a City, 312–1308*. Princeton, 1980.

Kretschmeyer, H. *Die Geschichte von Venedig*. 3 vols. Gotha, 1905–20. Stuttgart, 1934.

Krinsky, C. "Images of the Temple of Jerusalem before 1500." *JWCI* 33 (1970): 1–19.

Kugler, J. "Die Kryptafresken der Basilika von Aquileia. Studien zu einer Monographie." Ph.D diss., University of Vienna, 1969.

———. "Byzantinisches und Westliches in denKryptafresken von Aquileia." *Wiener Jahrbuch für Kunstgeschichte* 26 (1973): 7–31.

Kupfer, M. "The Lost *Mappamundi* at Chalivoy-Milon." *Speculum* 66 (1991): 540–71.

———. *Romanesque Wall Painting in Central France: The Politics of Narrative*. New Haven, 1993.

Kurth, B. *Die deutschen Bildteppiche des Mittelalters*. Vienna, 1925.

La Basilica di Aquileia. Bologna, 1933.

Ladner, G. *I ritratti dei papi nell'Antichità e nel Medioevo.* 2 vols. Vatican, 1941.

Lanckoronski, Graf K., G. Niemann, and H. Swoboda. *Der Dom von Aquileia. Sein Bau und seine Geschichte.* Vienna, 1906.

Lange, R. *Byzantinische Reliefikone.* Recklingshausen, 1964.

Lanzoni, F. *Le diocesi d'Italia dalle origini al principio del secolo VII.* Studi e Testi, 35. Faenza, 1927.

Lasko, P. *Ars Sacra 800–1200.* Harmondsworth, 1972.

Lazarev, V. *Old Russian Murals and Mosaics from the XI to the XVI Century.* London, 1966.

———. *Storia della pittura bizantina.* Turin, 1967.

Leclercq, J. "L'écriture sainte dans l'hagiographie monastique du haut moyen âge." In *La Bibbia nell'alto Medioevo* = Settimane di studi medievali, 10. Spoleto, 1963.

Le Goff, J. "Ecclesiastical Culture and Folklore in the Middle Ages: Saint Marcellus of Paris and the Dragon." in *Time, Work and Culture in the Middle Ages,* trans. A. Goldhammer, 159–88. Chicago, 1977.

Lejeune, R., and J. Stiennon. *La légende de Roland dans l'art du Moyen-Age.* 2 vols. Brussels, 1966.

Lenel, W. *Venezianisch-Istrische Studien.* Schriften der wissenschaftlichen Gesellschaft in Strassburg, 9. Strasbourg, 1911.

Lexikon der christliche Ikonographie. 8 vols. Freiburg im Breisgau, 1972.

Lubac, Henri de. *Exégèse médiévale. Les quatres sens de l'écriture.* 3 vols. Paris, 1959.

Luca, G. "Il sostrato culturale della cripta di Aquileia." *AntAltAdr* 38 (1992): 231–54.

Luis, A. "Evolutio Historica doctrinae Compassione." *Marianum; Ephemerides mariologiae* 5 (1943): 261–85.

Magnani, L. *Le miniature del Sacramentario d'Ivrea e di altri codici Warmondiani.* Vatican, 1934.

———. *Gli affreschi della Basilica di Aquileia.* Turin, 1960.

Magni, M. "Cryptes du haut moyen-âge en Italie: Problèmes de typologie du IXe jusqu'au début du XIe siècle." *CahArch* 28 (1979): 41–85.

Maguire, H. "The Depiction of Sorrow in Byzantine Art." *DOP* 31 (1977): 123–71.

———. *Art and Eloquence in Byzantium.* Princeton, 1981. Reprint. 1994.

———. *Earth and Ocean.* University Park, Penn., 1987.

———. "Style and Ideology in Byzantine Imperial Art." *Gesta* 28 (1989): 217–31.

———. "Disembodiment and Corporality in Byzantine Images of the Saints" In *Iconography at the Crossroads,* ed. B. Cassidy, 75–90. Princeton, 1993.

Matthiae, G. *Mosaici medioevali delle chiese di Roma.* 2 vols. Rome, 1967.

———. *Pittura Romana del Medioevo.* Vol. 1. 2nd ed. abridged by M. Andaloro. Rome, 1987.

Mauck, M. "The Mosaic of the Triumphal Arch of Sta Prassede: A Liturgical Interpretation." *Speculum* 62 (1987): 813–28.

Mazzotti, M. "Cripte Ravennati." *Felix Ravenna* 74 (1957): 44–47.

McClendon, C. *The Imperial Abbey of Farfa.* New Haven, 1987.

McCulloch, F. *Medieval Latin and French Bestiaries.* 2nd ed. Chapel Hill, 1962.

McCulloh, J. "From Antiquity to the Middle Ages: Continuity and Change in Papal Relic Policy from the Sixth to Eighth Century." In *Pietas: Festschrift für Bernhard Köttig = JbAntChr, Ergänzungsband,* 8 (1980): 311–24.

Meier, T. *Die Gestalt Marias im geistlichen Schauspiel des deutschen Mittelalters.* Berlin, 1959.

Menis, G. C. *La basilica paleocristiana nelle diocesi settentrionali della metropoli d'Aquileia.* Rome, 1958.

———. "La 'Basilica doppia' in un recente volume di 'Atti'." *Rivista di archeologia cristiana* 40 (1964): 123–133.

———. *Storia del Friuli.* Udine, 1969.

Metrović, L. W., and N. Oukenov. "La dormition de la Sainte Vierge dans la peinture médiévale orthodoxe." *Byzantinoslavika* 3 (1931): 134–80.

Mirabella Roberti, M. "Considerazioni sulle aule teodoriane di Aquileia." In *Studi Aquileiesi in onore di G. Brusin,* 209–44. Padua, 1953.

———. *San Giusto.* Trieste, 1970.

Mitchell, J. "The Crypt Reappraised." In *San Vincenzo al Volturno 1: The 1980–86 Excavations,* ed. R. Hodges, Part 1, 75–114. Rome and London, 1993.

Morassi, A. "La pittura e la scultura della basilica." in *La Basilica,* 301–28.

Morgagni Schiffrer, C. "Gli affreschi della cripta di Aquileia." Tesi di laurea, Università degli Studi di Trieste, 1966–67.

———. "Gli affreschi medioevali della Basilica Patriarcale." *AntAltAdr* 1 (1972): 323–48.

Morisani, O. *Gli affreschi di Sant'Angelo in Formis.* Cava dei Tirreni, 1962.

Morrison, K. F. *History as a Visual Art in the Twelfth-Century Renaissance.* Princeton, 1990.

Mouriki, D. *The Mosaics of Nea Moni on Chios.* 2 vols. Athens, 1985.

Nagatsuka, Y. *Descente de Croix.* Tokyo, 1979.

Nebbia, U. "Rinvenimento e restauro dell'antica decorazione absidale dell'abbazia di Summaga." *Bollettino d'arte* 2 (1928): 241–47.

Nelson, R. *The Iconography of Preface and Miniature in the Byzantine Gospel Book.* New York, 1980.

Nickel, H. *Der mittelalterliche Reiterschild des Abendlandes.* Ph.D. diss. Berlin, 1958.

Nicolle, D. *Arms and Armour of the Crusading Era, 1050–1350.* White Plains, N.Y., 1988.

Niero, A. "Il culto di S. Marco (da Alessandria a Venezia)." AntAltAdr 38 (1992): 15–40.

———. "Marco, Evangelista, santo." *Bibliotheca Sanctorum,* VIII, cc. 711–38.

Onians, J. *Bearers of Meaning. The Classical Orders in Antiquity, the Middle Ages, and the Renaissance.* Princeton, 1988.

O'Reilly, J. "Studies in the Iconography of the Vir-

tues and Vices in the Middle Ages." Ph.D. diss., University of Nottingham, 1972; published in *Outstanding Theses in the Fine Arts from British Universities*. New York and London, 1988.

Orlandos, A. *L'architecture et les fresques byzantines du monastère de St. Jean à Patmos*. Athens, 1970.

Ornamenta Ecclesiae. Kunst und Künstler der Romanik in Köln. Exhibition catalogue. 3 vols. Cologne, 1985.

Orselli, A. M. "La città altomedioevale e il suo santo patrono: (ancora una volta) il campione pavese." *RSCI* 32 (1978): 1–69.

Osborne, J. "Textiles and Their Painted Imitations in Early Mediaeval Rome." *PBSR* 60 (1992): 309–51.

Osieczkowska, C. "La mosaïque de la porte royale de Sainte Sophie et la litanie de tous les saints." *Byzantion* 9 (1934): 41–83.

Oswald, F., et al. *Vorromanische Kirchenbauten*. Ausbach, 1966.

Pächt, O. *The Rise of Pictorial Narrative in Twelfth-Century England*. Oxford, 1962.

Pächt, O., and J. J. G. Alexander. *Illuminated Manuscripts in the Bodleian Library*. Oxford, 1973.

Palazzo, E. "Les pratiques liturgiques et dévotionnelles et le décor monumental dans les églises du Moyen Age." In *L'emplacement et la fonction des images dans la peinture murale du Moyen Age = Cahiers du Centre International d'Art Mural* 2 (1993): 45–56.

Panazza, G., and A. Tagliaferri. *La Diocesi di Brescia*. Corpus della Scultura Altomedievale, 3. Spoleto, 1966.

Panofsky, E. "*Imago Pietatis*: Ein Beitrag zur Typengeschichte des *Schmerzenmanns* und der *Maria Mediatrix*." In *Festschrift für Max J. Friedländer zum 60. Geburtstag*, 261–308. Leipzig, 1927.

Panofsky, E., trans. and ed. *Abbot Suger on the Abbey Church of St.-Denis and Its Art Treasures*. 2nd ed. Princeton, 1979.

Paschini, P. "I patriarchi di Aquileia nel secolo XII." *MemStorFor* 10 (1914): 113–81.

———. "Le fasi di una leggenda aquileiese." *RSCI* 8 (1954): 161–68.

Pasi, S. "Osservazioni sui frammenti del mosaico absidale della Basilica Ursiana." *Felix Ravenna* 11–12 (1976): 213–37.

———. "Il mosaico absidale dell'Ursiana: spunti per un inquadramento del problema iconografico." *Felix Ravenna* 13–14 (1977): 219–39.

Pelikanides, S., et al. *The Treasures of Mount Athos*. 3 vols. Athens, 1975.

Peri, V. "Aquileia nella trasformazione storica del titolo patriarcale." *AntAltAdr* 38 (1992): 41–63.

Pertusi, A. "L'impero bizantino nell'alto Adriatico." In *Le origini di Venezia*, 59–93. Florence, 1964. Rpt. in *Saggi Veneto-Bizantini*, 33–65. Civiltà Veneziana, Saggi 37. Venice, 1990.

———. "Quedam regalia insignia: Ricerche sulle insegne del potere ducale a Venezia durante il medioevo." *Studi veneziani* 7 (1965): 3–123.

Picard, Jean-Charles. *Le Souvenir des évêques. Sépultures, listes épiscopales et culte des évêques en Italie du Nord des origines au Xe siècle*. Rome, 1988.

Pickering, E. *Literature and Art in the Middle Ages*. Coral Gables, 1966.

Poeschke, J. *Die Kirche von San Francesco in Assisi und ihre Wandmalereien*. Munich, 1985.

Polacco, R. *La Cattedrale di Torcello*. Venice, 1984.

———. *San Marco, la Basilica d'Oro*. Milan, 1991.

Randall, L. *Images on the Margins of Gothic Manuscripts*. Berkeley and Los Angeles, 1966.

Rasmo, N. *Affreschi medioevali atesini*. Milan, 1971.

Ratkowitsch, C. *Descriptio Picturae. Die literarische Funktion von Kunstwerken in der lateinischen Grossdichtung des 12. Jahrhunderts*. Wiener Studien, Beiheft 15. Vienna, 1991.

Ratkowska, P. "The Iconography of the Deposition without Saint John." *JWCI* 27 (1964): 314–17.

Renaldis, G. de. *Della Pittura Friulana. Saggio Storico di Monsignor Conte Girolamo de Renaldis Canonico della Metropolitana di Udine*. Udine, 1798.

Restle, M. *Byzantine Wall Painting in Asia Minor*. 3 vols. Recklingshausen, 1967.

Reudenbach, B. "Säule und Apostel. Überlegungen zum Verhältnis von Architektur und architekturexegetischer Literatur im Mittelalter." *Frühmittelalterliche Studien* 14 (1980): 310–51.

Rizzardi, C. *Mosaici altoadriatici. Il rapporto artistico Venezia-Bisanzio-Ravenna in età medievale*. Ravenna, 1985.

Rowland, B. *Animals with Human Faces: A Guide to Animal Symbolism*. Knoxville, 1973.

Rutishauser, S. "Genèse et développement de la crypte à salle en Europe du Sud." *Les Cahiers de Saint-Michel de Cuxa* 24 (1993): 37–45.

Sacopoulo, M. *Asinou en 1106 et sa contribution à l'iconographie*. Bibliothèque de Byzantion, 2. Brussels, 1966.

———. *La Théotokos à la mandorle de Lythrankomi*. Paris, 1975.

Sandberg Vavala, E. *La croce dipinta italiana e l'iconografia della Passione*. Verona, 1929.

Sanuto, M. *Itinerario di Marin Sanuto per la Terraferma Veneziana nell'anno MCCCCLXXXIII*. Padua, 1847.

Sauvel, M. T. "Les vices et les vertus d'après les dessins d'un manuscrit de Moissac." *Mémoires de la Société des Antiquaires de France*, ser. 9, 3 (1954): 155–64.

Schapiro, M. "On the Aesthetic Attitude in Romanesque Art." In *Originality in Art and Thought: Issued in Honour of Ananada K. Coomaraswamy*, 130–50. London, 1947. Rpt. in *Romanesque Art*, 1–27. New York, 1977.

———. "Style." In *Anthropology Today: An Encyclopedic Inventory*, ed. A. L. Krober, 287–312. Chicago, 1953. Rpt. in *Theory and Philosophy of Art: Style, Artist and Society*, 51–102. Selected Papers, 4. New York, 1994.

Scheller, R. W. *A Survey of Medieval Model Books*. Harlem, 1963.

Schiller, G. *Iconography of Christian Art*. Vols. 1 and 2. Trans. J. Seligman. New York, 1972.

Schiller, G. *Ikonographie der christlichen Kunst*. Vols. 3 and 4. Gütersloh, 1966 and 1980.

Schmidinger, H. *Patriarch und Landesherr. Die weltliche Herrschaft der Patriarchen von Aquileia bis zum Ende der Staufer.* Graz and Cologne, 1954.

Schneider, C. "Studien zum Ursprung liturgischer Einzelheiten östlicher Liturgien." *Kyrios* (= *Vierteljahresschrift für Kirchen- und Geistesgeschichte*) 1 (1936): 57–73.

Schnitzler, H. *Der Schrein des heilgen Heribert.* Mönchengladbach, 1962.

Schramm, P. E. *Die zeitgenössischen Bildnisse Karls des Grossen.* Hildesheim, 1973.

———. *Die deutschen Kaiser und Könige in Bildern ihrer Zeit, 751–1190.* Munich, 1983.

Schramm, P., and F. Mütherich. *Denkmale der deutschen Könige und Kaiser.* Munich, 1962.

Seidel, L. *Songs of Glory: The Romanesque Façades of Aquitaine.* Chicago, 1981.

Seidler, M. "Schrein des heiligen Heribert." In *Ornamenta Ecclesiae*, 2. Cologne, 1985.

Servières, G. "La Basilique d'Aquilée." *Revue de l'Art Chrétien* 63 (1913): 174–79.

Ševčenko, N. *The Life of Saint Nicholas in Byzantine Art.* Turin, 1983.

Sheingorn, P. *The Book of Sainte Foy.* Philadelphia, 1995.

Simson, O. von. *Sacred Fortress: Byzantine Art and Statecraft in Ravenna.* 2nd ed. Princeton, 1987.

Sinkević, I. "Alexios Angelos Komnenos, A Patron Without History?" *Gesta* 35 (1996): 34–42.

Sinding-Larsen, S. *Christ in the Council Hall: Studies in the Religious Iconography of the Venetian Republic = Acta ad archaeologiam et artium historiam pertinentia* 5. Rome, 1974.

Skawran, K. *The Development of Middle Byzantine Fresco Painting in Greece.* Pretoria, 1982.

Smail, R. C. *Crusading Warfare.* Cambridge, 1956.

Smalley, B. *The Gospel in the Schools, 1100–1280.* London, 1985.

Smith, M. *Prudentius's Psychomachia: A Re-examination.* Princeton, 1976.

Smith, M. Q. "Anagni: An Example of Mediaeval Typological Decoration." *PBSR* 23 (1965): 43–46.

Spatharakis, I. *The Portrait in Byzantine Illuminated Manuscripts.* Leiden, 1976.

Steger, H. *David Rex et Propheta.* Nürnberg, 1961.

Steindorff, L. *Die dalmatischen Städte im 12. Jahrhundert. Studien zu ihrer politischen Stellung und gesellschaftlichen Entwicklung.* Cologne, 1984.

Stenton, F., et al. *The Bayeux Tapestry.* London, 1957.

Stern, H., ed. *Recueil général des mosaïques de la Gaule.* Vol. 1, pt. 1. Paris, 1957.

Sticca, S. *The Latin Passion Play: Its Origins and Development.* Albany, 1970.

———. *The "Planctus Mariae" in the Dramatic Tradition of the Middle Ages.* Trans. J. R. Berrigan. Athens, Ga., and London, 1988.

Stock, B. *The Implications of Literacy: Written Language and Models of Interpretation in the Eleventh and Twelfth Centuries.* Princeton, 1983.

Sureda, Joan. *La pintura románica en España.* Madrid, 1985.

Swarzenski, G. *Die Salzburger Buchmalerei.* Leipzig, 1908–13.

Tagliaferri, A. *Le Diocesi di Aquileia e Grado.* Corpus della Scultura Altomedievale, 10. Spoleto, 1981.

Tavano, Sergio. "Il rivestimento marmoreo al esterno della cripta nella Basilica di Aquileia." *MemStorFor* 42 (1956–7): 139–55.

———. *Storicità dei martiri aquileiesi alla luce di recenti scoperte archeologiche.* Gorizia, 1962.

———. "La cripta deve riaquistare l'antica e originaria funzione." *Voce isontina*, 22 luglio 1969, 2.

———. "L'arte nel Patriarcato di Aquileia." *AqN* 40 (1969): 191–200.

———. "Il culto di San Marco a Grado." *Scritti Storici in Memoria di Paolo Lino Zovatto*, 201–19. Milan, 1972.

———. *Aquileia cristiana.* Udine, 1973 (= *AntAltAdr* 3 [1973]).

———. "Mosaici parietali in Istria." *AntAltAdr* 8 (1975):245–73.

———. "La cripta d'Aquileia e i suoi affreschi." *Arte in Friuli, Arte a Trieste* 2 (1976): 157–70.

———. "Scultura altomedioevale in Aquileia fra Oriente Occidente." *AntAltAdr* 19 (1981): 325–49.

———. *Aquileia e Grado. Storia—Arte—Cultura.* Trieste, 1986.

———. In *Reallexikon für Antike und Christentum. Supplement*- Lierferung, 4, s.v. "Aquileia." Stuttgart, 1986.

———. "San Paolino e la Sede Patriarcale." *Ant AltAdr* 32 (1988): 255–79.

Testi, L. *La storia della pittura veneziana.* Vol. 1, *Le ori-gini.* Bergamo, 1909.

Thümmler, H. "Die Baukunst des XI. Jahrhunderts in Italien." *RJbK* 3 (1939): 141–226.

Toesca, P. "Gli affreschi del Duomo di Aquileia." *Dedalo* 6 (1925): 32–000.

Toubert, H. "Le renouveau paléochrétien à Rome au début du XIIe siècle." *CahArch* 20 (1970): 99–154.

Tramontin, S. "Origini e sviluppi della leggenda marciana." In Le origini della Chiesa di Venezia, ed. F. Tonon, 167–86. Venice, 1987.

Tramontin, S., et al. *Il Culto dei Santi a Venezia.* Venice, 1965.

Tronzo, W. "Moral Hieroglyphs: Chess and Dice at San Savino in Piacenza." *Gesta* 16 (1977): 15–26.

———. "Apse Decoration, the Liturgy, and the Perception of Art in Medieval Rome: S. Maria in Trastevere and S. Maria Maggiore." in *Italian Church Decoration in the Middle Ages and Early Renaissance: Functions, Forms and Regional Traditions*, ed. W. Tronzo, 167–93. Villa Spelman Colloquia, 1. Bologna, 1989.

Vale, G. *I Santi Ermacora e Fortunato nella liturgia.* Udine, 1910.

———. "Contributo per la topografia di Aquileia medioevale." *AqN* 2 (1931): 1–34.

———. "La storia della basilica dopo il secolo IX." In *La Basilica*, 47–105.

———. "Per la topografia di Aquileia medioevale." *AqN* 6 (1935): 3–12.

Valland, R. *Aquilée et les origines Byzantines de la Re-naissance*. Paris, 1963.

Velmans, T. *Le Tetrévangile de la Laurentienne*. Paris, 1971.

Venezia e Bisanzio. Exhibition catalogue, Palazzo Ducale. Venice, 1974.

Verdier, P. *Le couronnement de la Vierge*. Montréal, 1980.

Verkerk, D. H. "Exodus and Easter Vigil in the Ash-burnham Pentateuch." *Art Bulletin* 77 (1995): 94–105.

Verzone, P. *L'architettura religiosa del Medioevo nel Italia settentrionale*. Milan, 1942.

Vio, E. "Cripta o prima cappella ducale?" In E. Vio et al., *Basilica Patriarcale in Venezia. La Cripta, la storia, la consecrazione*, 23–70. Milan, 1992.

von Simson, O., see Simson.

Waetzoldt, S. *Die Kopien des 17. Jahrhunderts nach Mosaiken und Wandmalereien in Rom*. Vienna, 1964.

Wallrath, R. "Zur Bedeutung der mittelalterlichen Krypta (Chorumgang und Marienkapelle)." In *Bei-träge zur Kunst des Mittelalters*, 54–69. Vorträge des ersten deutschen Kunsthistorikertagung auf Schloss Brühl. Berlin, 1951.

Walter, C. "Biographical Scenes of the Three Hier-archs." *REB* 36 (1978): 233–60.

Weerth, E. aus'm. *Der Mosaikboden in St. Gereon zu Köln . . . Mosaikböden Italiens*. Bonn, 1873.

Weitzmann, K. "The Origin of the Threnos." In *De Artibus Opuscula XL. Essays in Honor of Erwin Pan-ofsky*, ed. M. Meiss, 1:476–90. 2 vols. New York, 1961.

———. "Byzantine Miniature and Icon Painting in the Eleventh Century." In *Proceedings of the XIIIth International Congress of Byzantine Studies*, 1966, 207–24. London, 1967. Rpt. in *Studies in Classical and Byzantine Manuscript Illumination*, ed. H. L. Kessler, 271–313. Chicago, 1971.

———. "The Classical in Byzantine Art as a Mode of Individual Expression." Rpt. in *Studies in Classical and Byzantine Manuscript Illumination*, ed. H. L. Kessler, 151–75. Chicago, 1971.

———. "The Ivories of the So-called Grado Chair." *DOP* 26 (1972): 43–91.

———. "Byzantium and the West around the Year 1200." In *The Year 1200: A Symposium*, 53–83. New York, 1975.

———. "Illustrations to the Lives of the Five Mar-tyrs of Sebaste." *DOP* 33 (1979): 97–112.

Welter, J.-T. *L'exemplum dan la littérature religieuse et didactique du Moyen Age*. Paris, 1927.

White, T. H. *The Book of Beasts*. New York, 1984.

Winfield, D. "Middle and Later Byzantine Wall Painting Methods: A Comparative Study." *DOP* 22 (1968): 62–139.

Wittkower, R. "Marvels of the East: A Study in the History of Monsters." *JWCI* 5 (1942): 159–97.

Woodward, D. "Reality, Symbolism, Time, and Space in Medieval World Maps." *Annals of the Association of American Geographers* 74 (1985): 510–21.

Young, K. *The Drama of the Medieval Church*. 2 vols. Rpt. Oxford, 1967.

Zastrow, O. *Affreschi romanici nella provincia di Como*. Lecco, 1984.

Zchomelidse, M.E.N. "Die mittelalterlichen Fresken in Santa Maria dell'Immacolata Concezione in Ceri bei Rom." Ph.D. diss., University of Bern, 1992.

Zovatto, P. L. "Il Battistero di Concordia II." *Arte Veneta* 1 (1947): 243–46.

———. "Il significato della basilica doppia. L'esempio di Aquileia." *RSCI* 18 (1964): 357–98.

INDEX

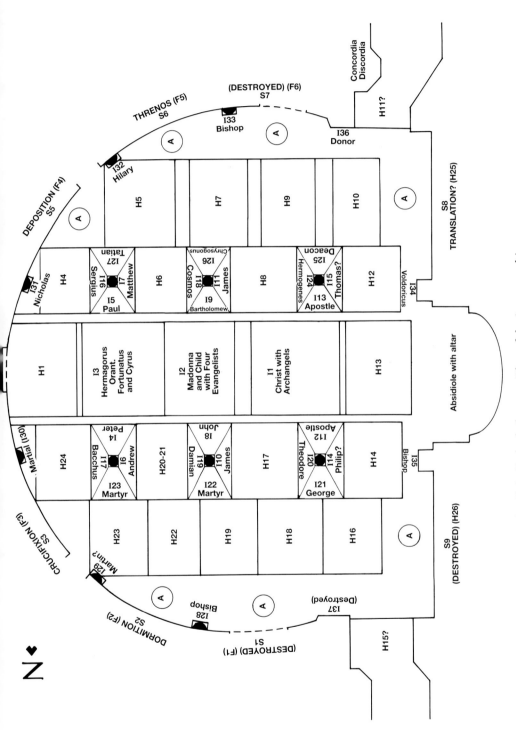

1. Aquileia Cathedral, crypt: Plan of the iconographic program

A = Archangels H = Hagiographic I = Intercessory Hierarchy S = Socle (fictive curtain)
F = Feast Cycle Cycle of the Saints
(Full identification provided in Appendix I)

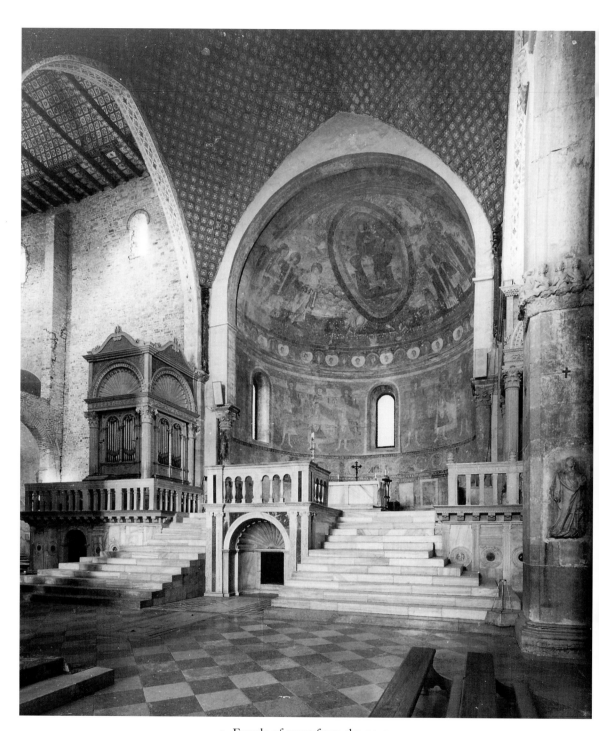

2. Facade of crypt from the nave

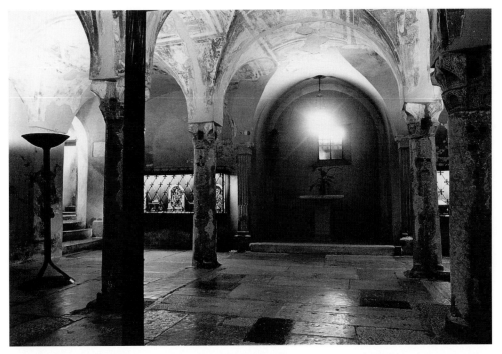

3. General view of crypt to west

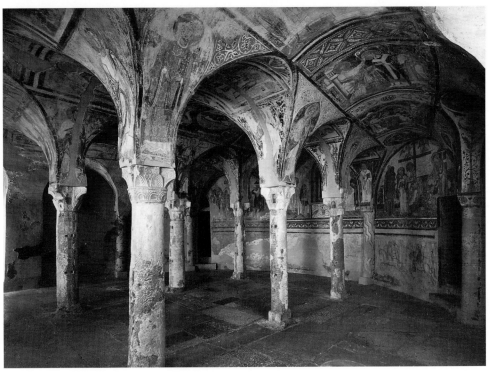

4. General view of crypt to southeast

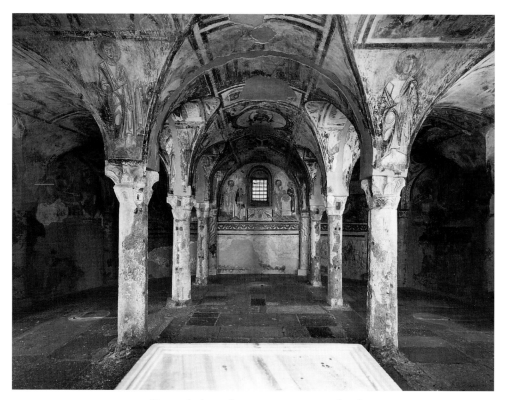

5. General view of crypt to east, central aisle

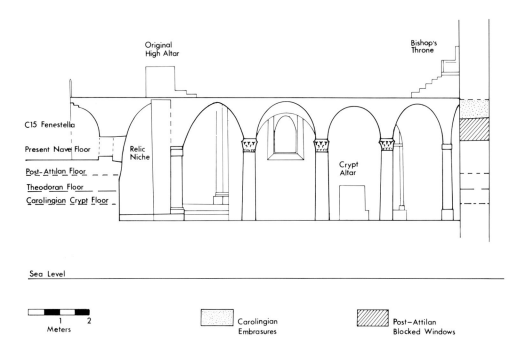

Original
High Altar

Bishop's
Throne

C15 Fenestella

Present Nave Floor

Relic
Niche

Crypt
Altar

Post-Attilan Floor

Theodoran Floor

Carolingian Crypt Floor

Sea Level

1 2
Meters

Carolingian
Embrasures

Post-Attilan
Blocked Windows

6. Longitudinal section of crypt

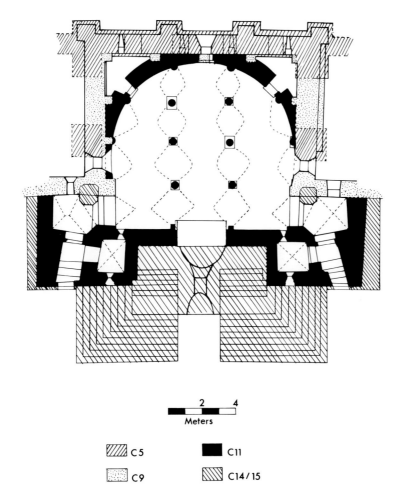

2 4
Meters

C5 C11

C9 C14/15

7. Plan of crypt showing construction phases

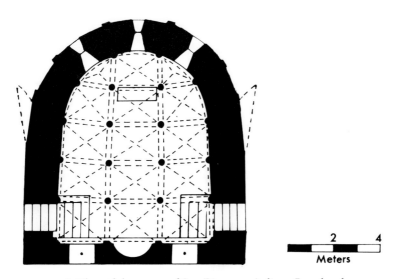

2 4
Meters

8. Plan of the crypt of San Pietro at Agliate, Lombardy

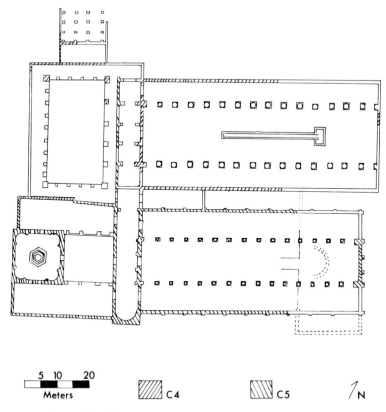

9. Plan of double cathedral complex at Aquileia, 5th century

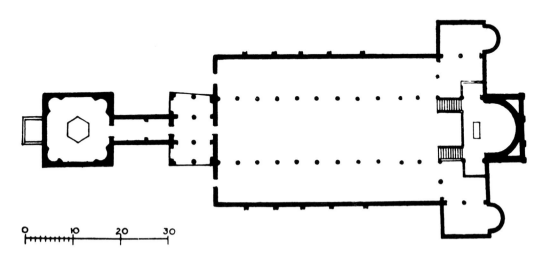

10. Plan of Aquileia Cathedral, 9th–11th centuries

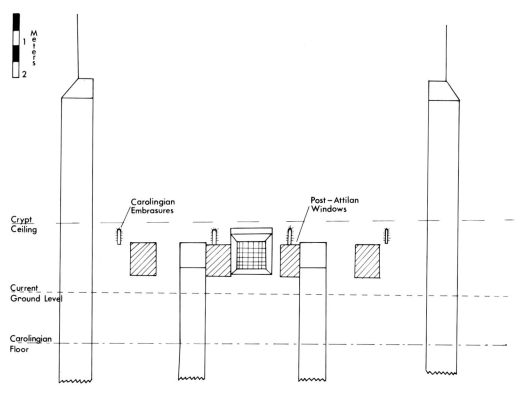

Crypt
Ceiling

Carolingian
Embrasures

Post – Attilan
Windows

Current
Ground Level

Carolingian
Floor

11. Diagram showing construction phases on exterior east wall of crypt

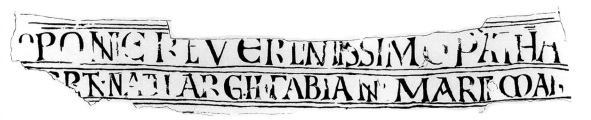

12. Inscription on lower intonaco level

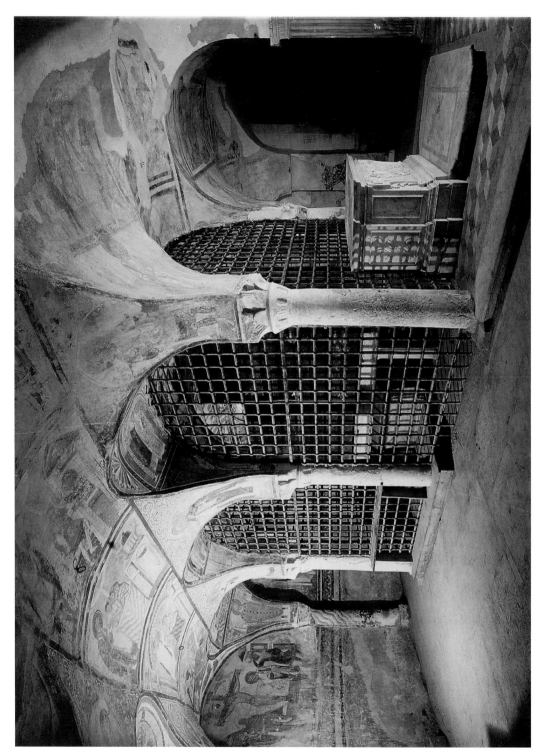

13. Interior of crypt to northeast, showing iron screen

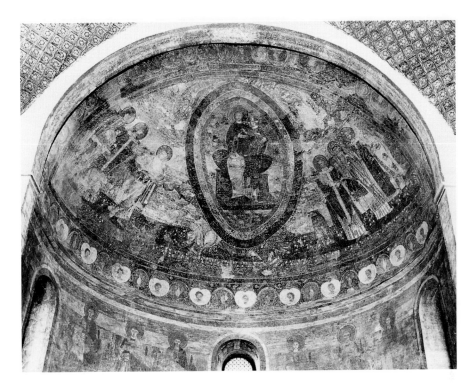

14. Apse of Upper Church: Virgin and Child in Majesty

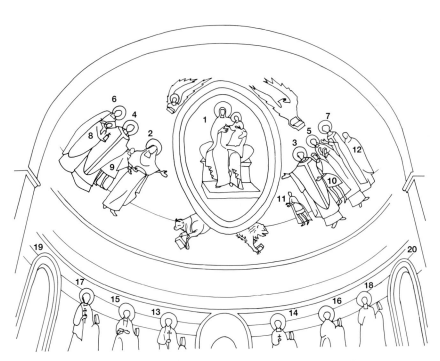

15. Apse of Upper Church: schematic diagram of frescoes in figure 14

CONCH:
1. Madonna and
 Child in Majesty
2. Mark
3. Hermagoras
4. Hilary

5. Fortunatus
6. Tatian
7. Euphemia
8. Patriarch Poppo
9. Emperor Henry II
10. Emperor Conrad II

11. Prince Henry III
12. Empress Gisela
 HEMICYCLE:
13. Felix
14. Fortunatus
15. Largus

16. Dionysius
17. ?
18. Primigenius
19. Chrysogonus
20. Anastasia

16. South entrance bay: Discord trampled by Concord

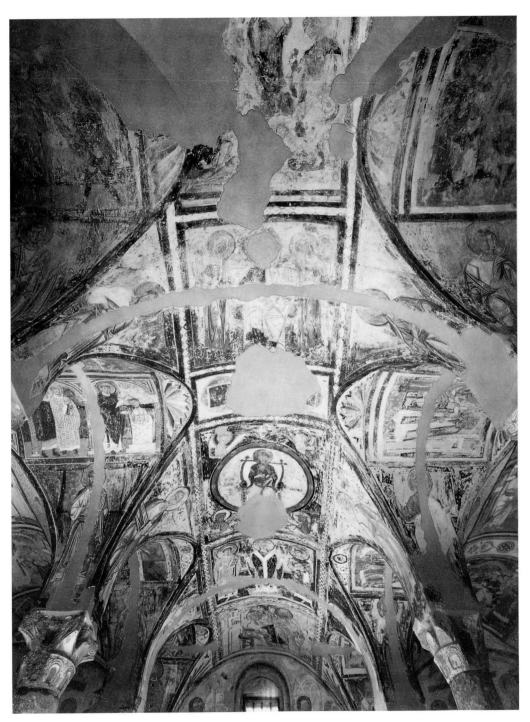

17. Crypt ceiling: general view to east

18. Christ Enthroned with interceding Angels

19. Archangel, over Dormition

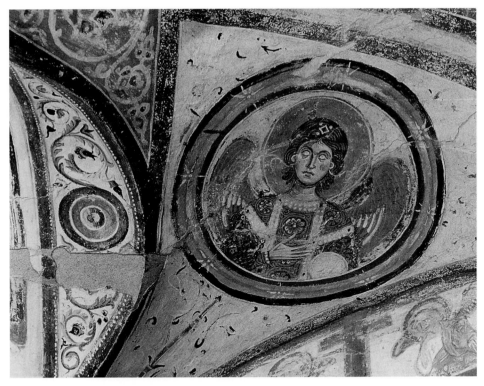

20. Archangel, over Deposition

21. Archangel, over Threnos

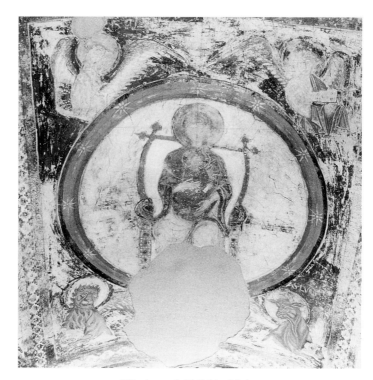

22. Virgin and Child in Majesty

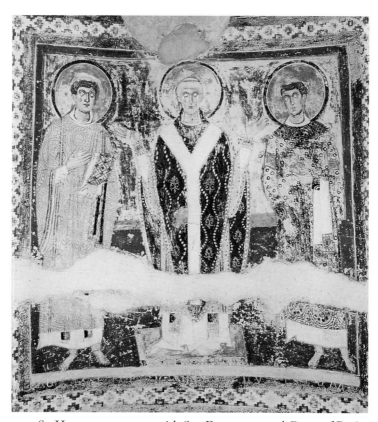

23. St. Hermagoras orans, with Sts. Fortunatus and Cyrus of Pavia

24. St. Peter

25. St. Paul

26. St. Andrew

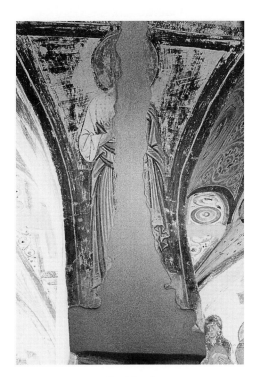

27. St. Matthew

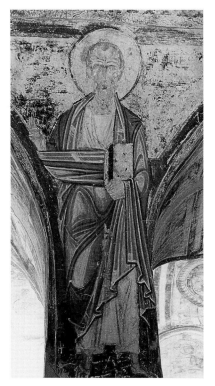

28. St. John

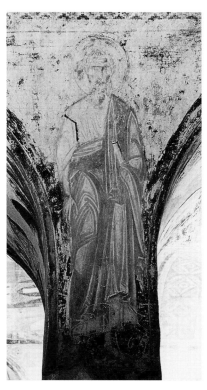

29. St. Bartholomew

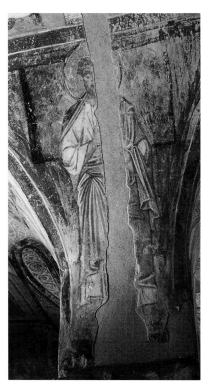

30. St. James the Less

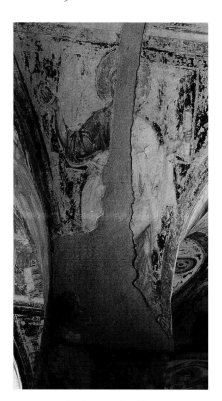

31. St. James the Greater

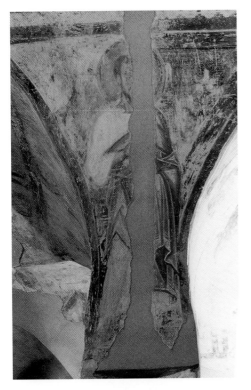

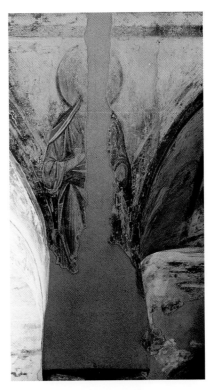

32. St. Simon?

33. St. Matthias?

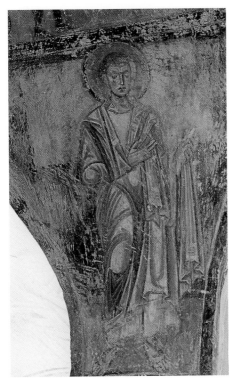

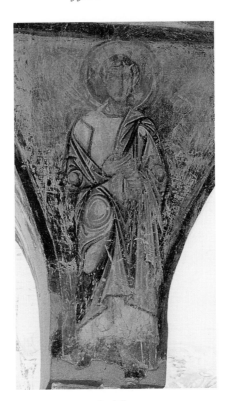

34. St. Philip

35. St. Thomas

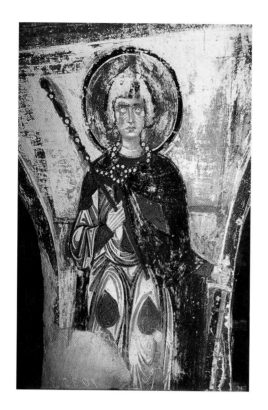

36. St. Sergius

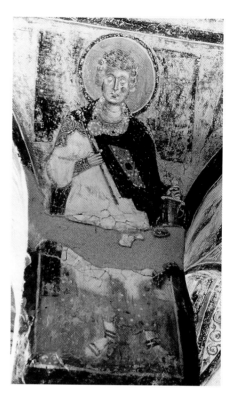

37. St. Bacchus

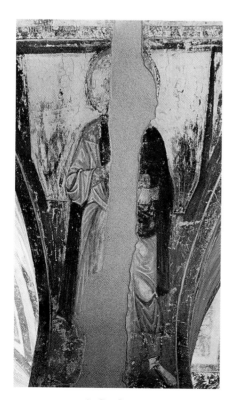

38. St. Cosmas

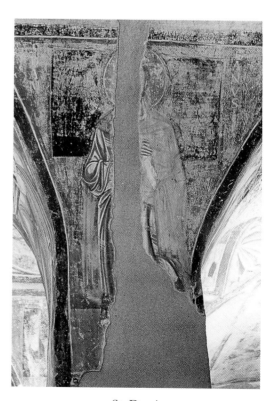

39. St. Damian

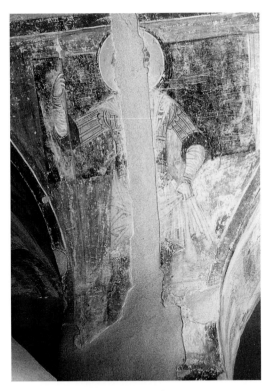

40. St. Theodore

41. St. George

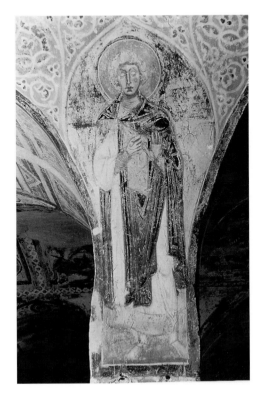

42. St. Vitalis?

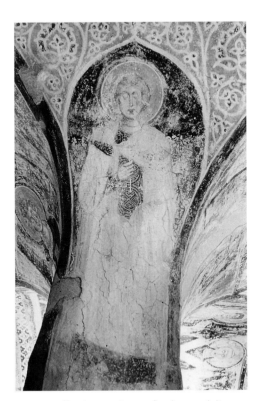

43. St. Anastasius or St. Anastasia?

44. St. Hermogenes

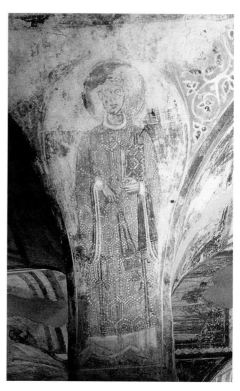

45. St. Fortunatus II?

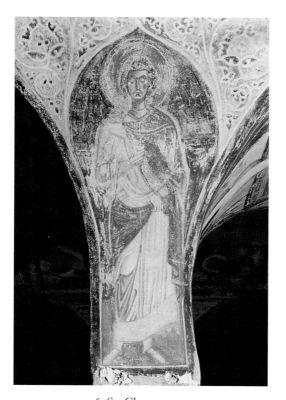

46. St. Chrysogonus

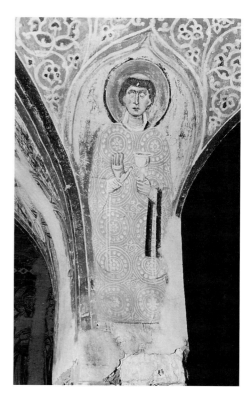

47. St. Tatian

48. Bishop, I28

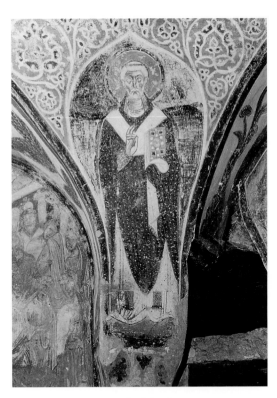

49. St. Martin

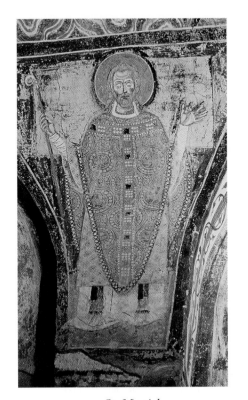

50. St. Martial

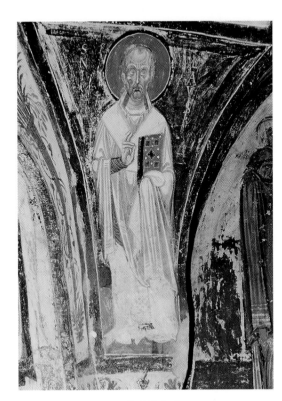

51. St. Nicholas

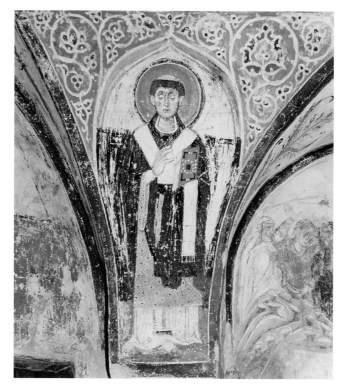

52. St. Hilary of Aquileia

53. Bishop, I33

54. St. Voldoricus?

55. Dedication portrait, Charlemagne? before the Virgin

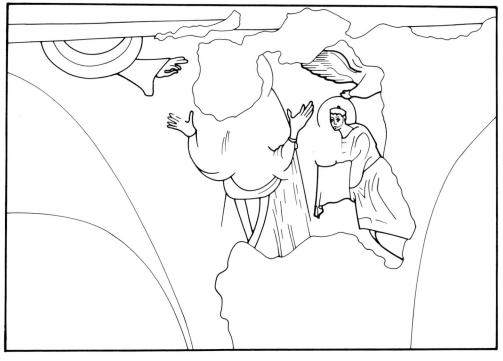

56. Reconstruction drawing of figure 55

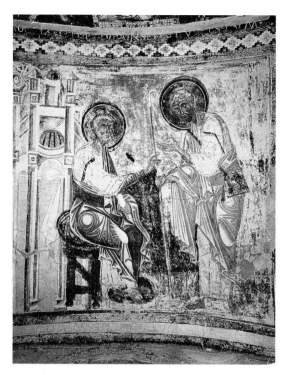

57. Peter commissions Mark as apostle of Aquileia

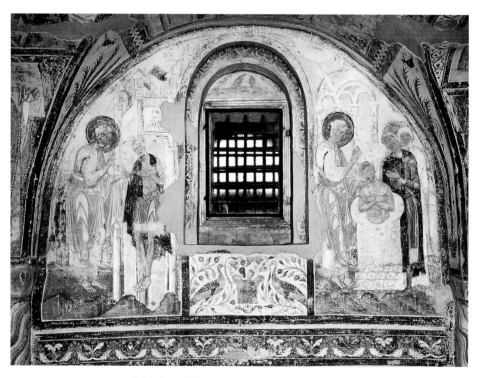

58. Mark heals and baptizes the leper Athaulf at Aquileia

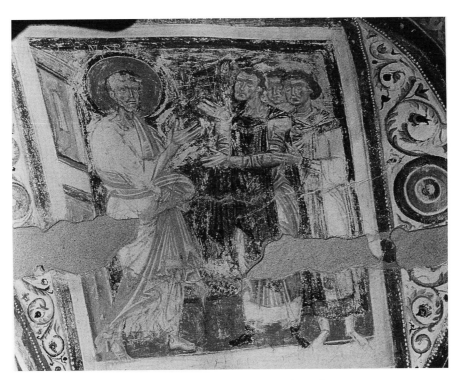

59. Mark confronted by citizens of Aquileia

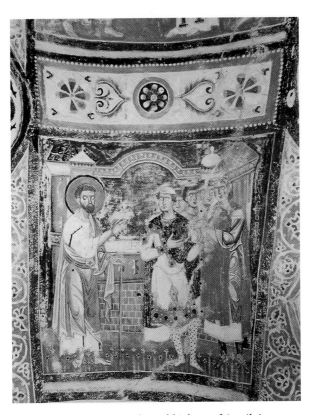

60. Hermagoras elected bishop of Aquileia

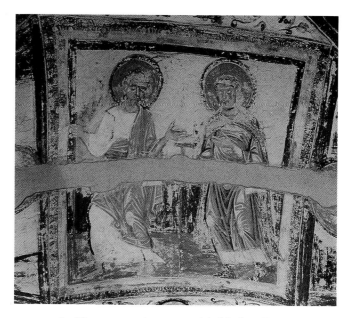

61. Hermagoras journeys with Mark to Rome

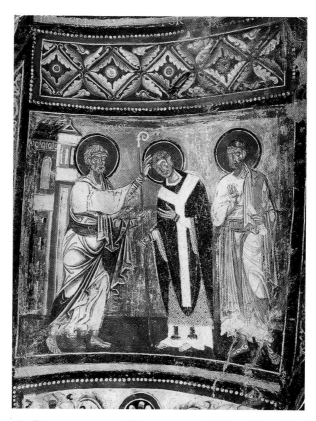

62. Peter consecrates Hermagoras as bishop of Aquileia

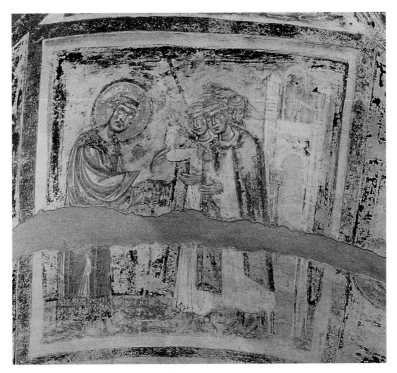

63. Hermagoras is received at the gates of Aquileia

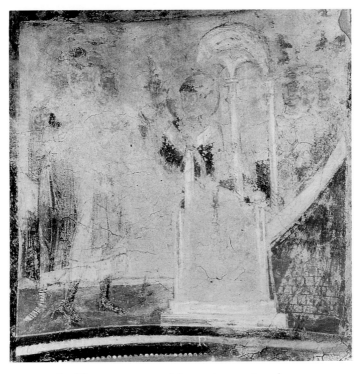

64. Hermagoras preaching or instructing clergy

65. Hermagoras ordaining clergy

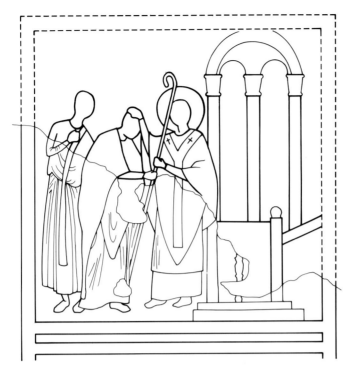

66. Reconstruction drawing of figure 65

67. Reconstruction drawing of damaged panel H11

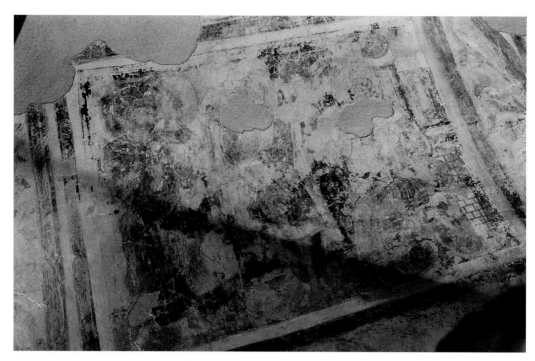

68. Trial of Hermagoras before Sevastus

69. Reconstruction drawing of figure 68

70. Flagellation of Hermagoras

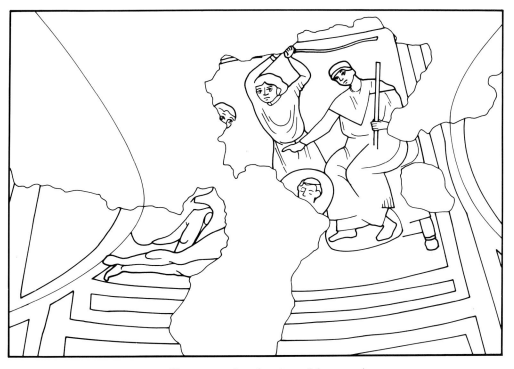

71. Reconstruction drawing of figure 70

72. Hermagoras tortured with claws and lamps

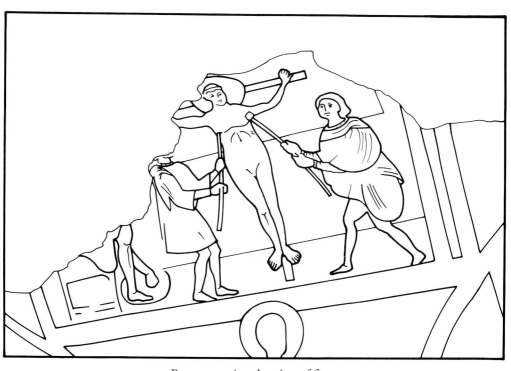

73. Reconstruction drawing of figure 72

74. Hermagoras converts the jailer Pontianus

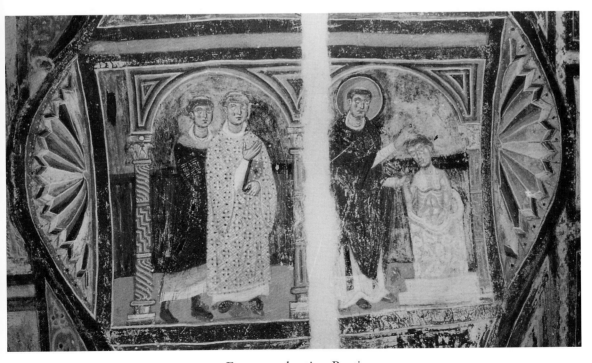

75. Fortunatus baptizes Pontianus

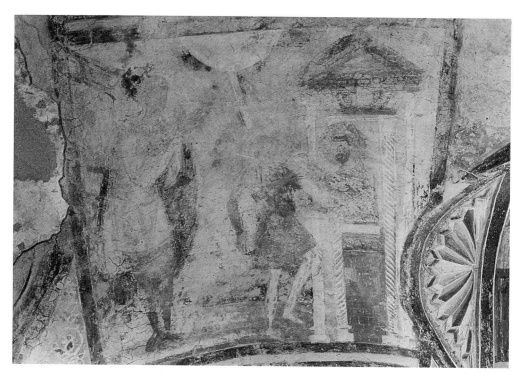

76. Hermagoras heals and converts Gregory's son

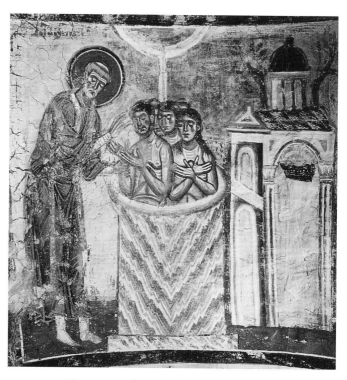

77. Hermagoras baptizes Gregory and his family

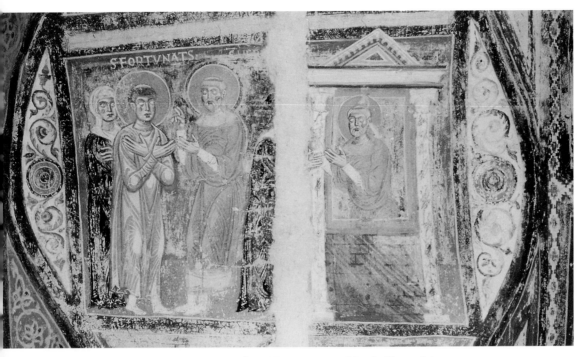

78. Hermagoras ordains Fortunatus and heals Alexandria

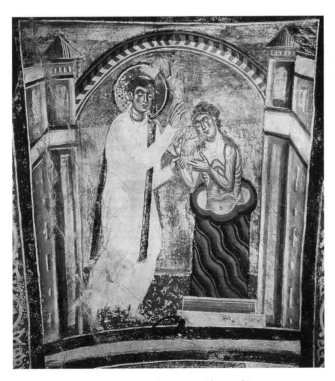

79. Fortunatus baptizes Alexandria

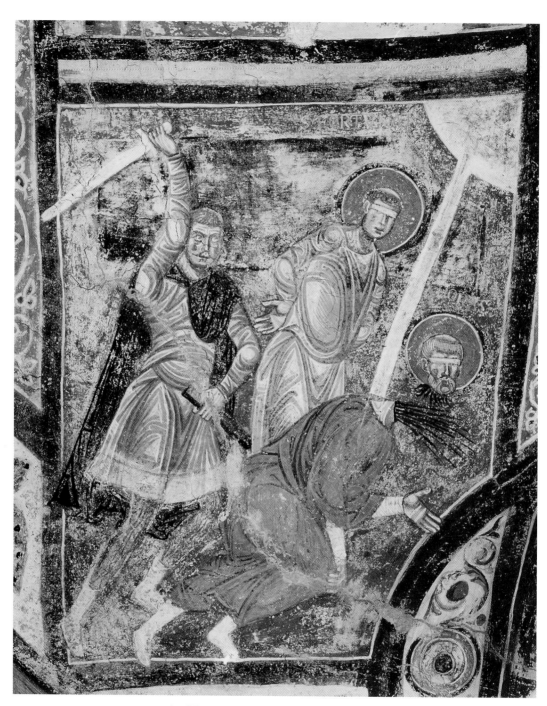

80. Hermagoras and Fortunatus beheaded

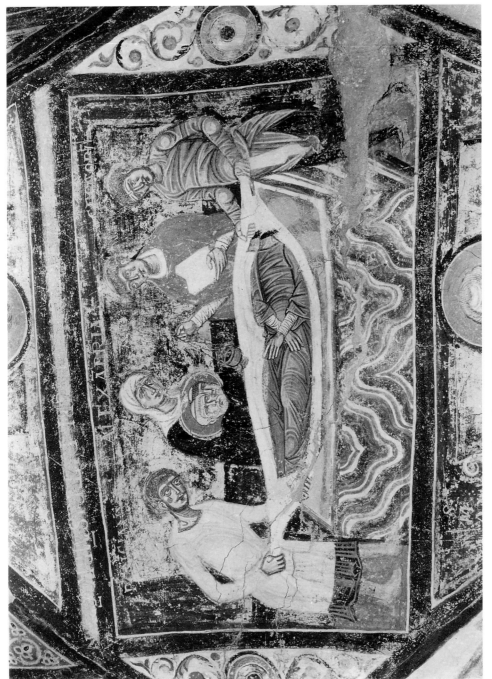

81. Entombment of Hermagoras and Fortunatus

82. Translation of Hermagoras and Fortunatus

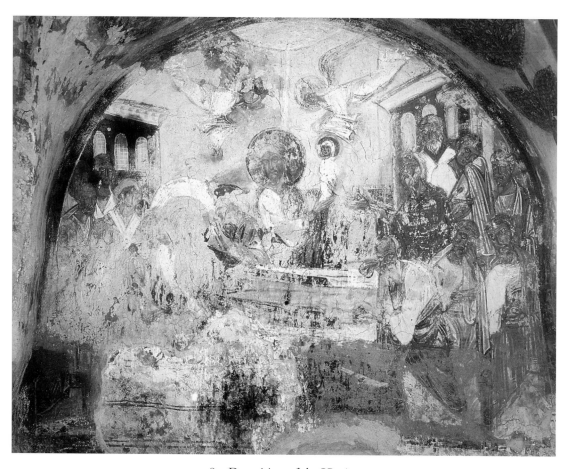

83. Dormition of the Virgin

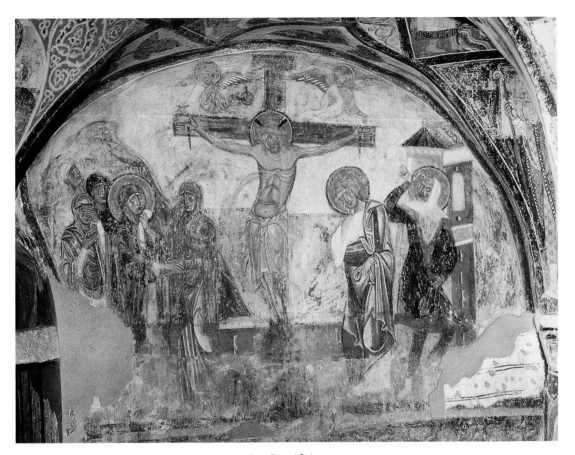

84. Crucifixion

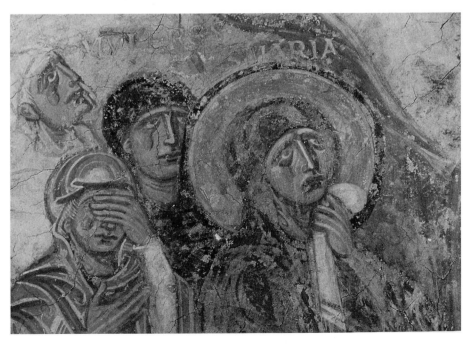

85. Crucifixion, detail of Virgin and grieving women

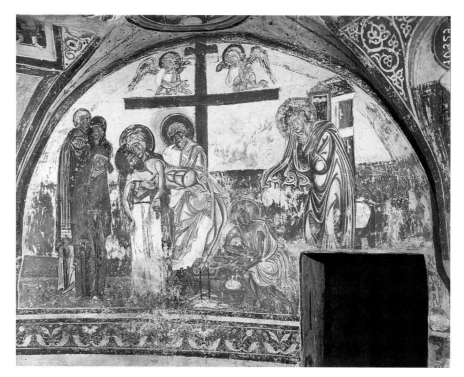

86. Deposition

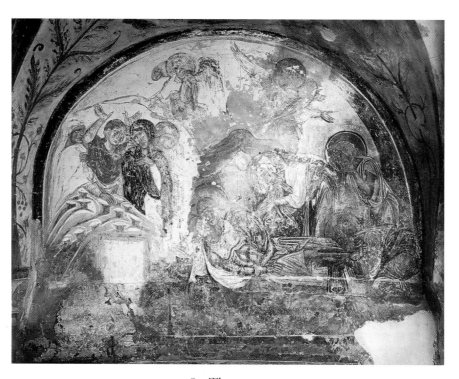

87. Threnos

88. Tiger and panther flanking Tree of Life

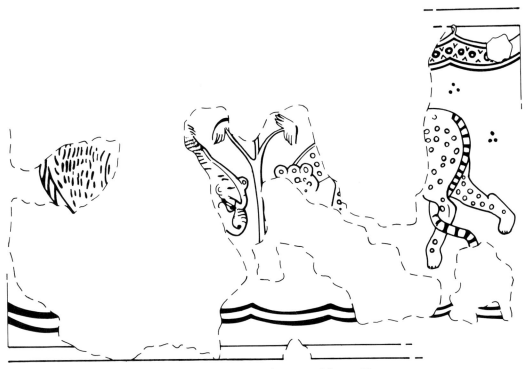

89. Reconstruction drawing of figure 88

90. Superbia and Vices?

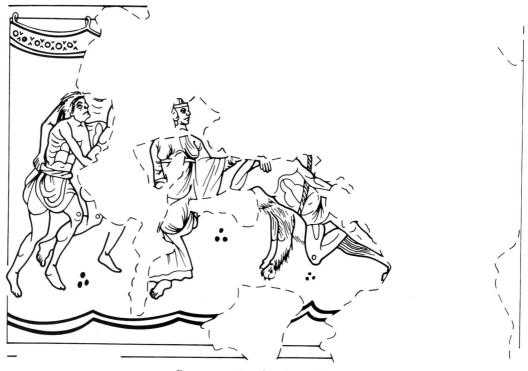

91. Reconstruction drawing of figure 90

92. Detail of figure 90

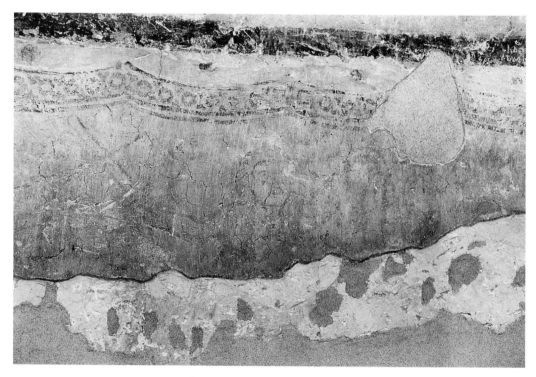

93. St. George and the dragon (detail)

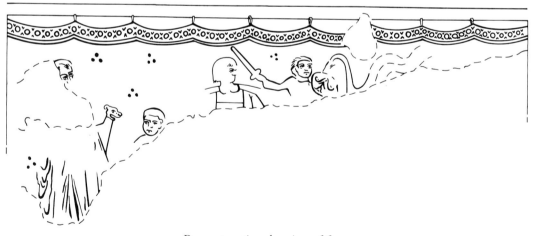

94. Reconstruction drawing of figure 93

95. David playing the lyre (detail)

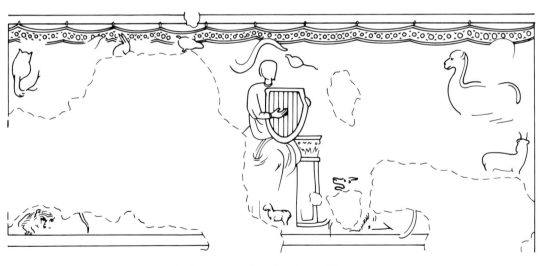

96. Reconstruction drawing of figure 95

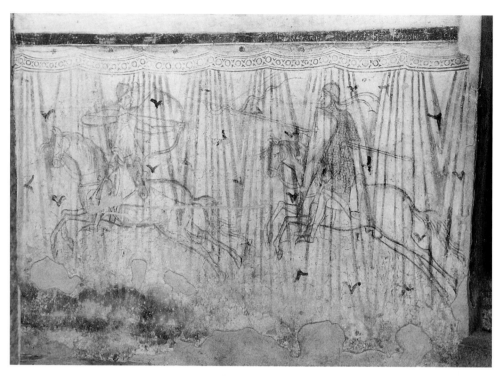

97. Crusader pursuing Saracen

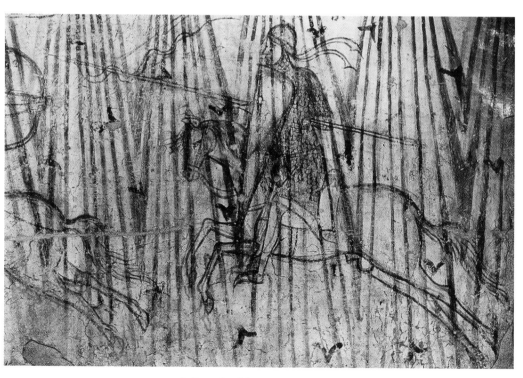

98. Detail of figure 97: Crusader

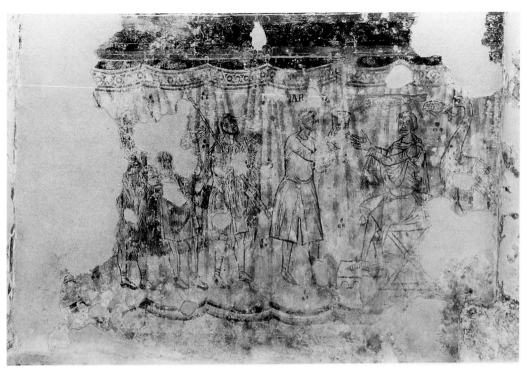

99. Pilgrim scene

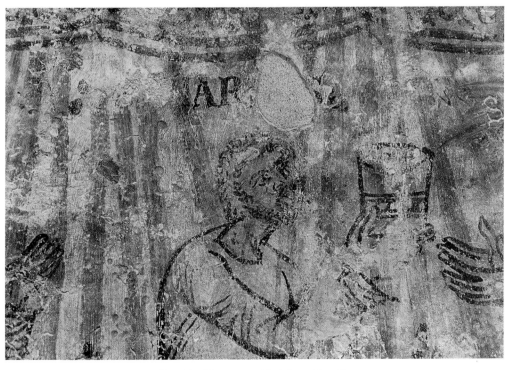

100. Detail of figure 99: Knight with reliquary

101. Battalion of knights

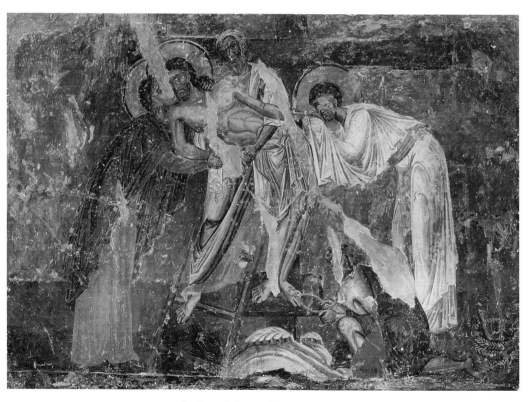

102. St. Panteleimon, Nerezi: Deposition

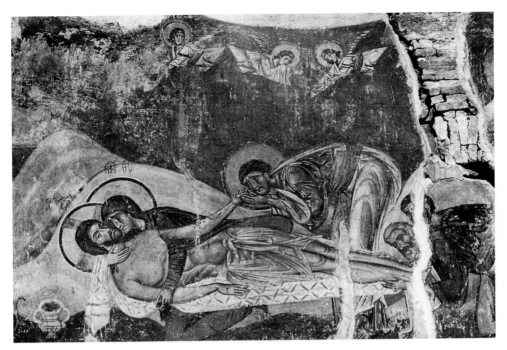

103. St. Panteleimon, Nerezi: Threnos

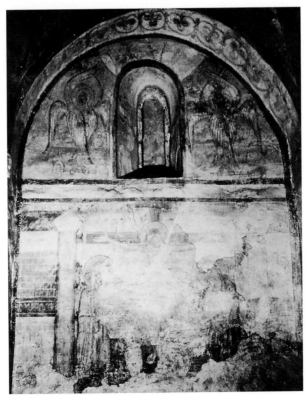

104. Abbey of Sta. Maria, Summaga: General view of sacellum interior to south with Crucifixion

105. Summaga: Detail of Crucifixion

106. Summaga: Detail of Benedictine monks

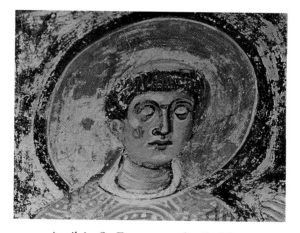

107. Aquileia: St. Fortunatus, detail of figure 23

108. Summaga: Eve

109. Summaga: Abraham

110. Summaga, socle: Samson and the lion; Dragon-slaying

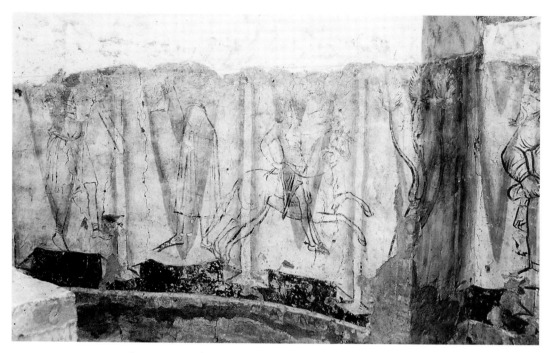

111. Summmaga, socle: David and Goliath?; Falconer on horseback

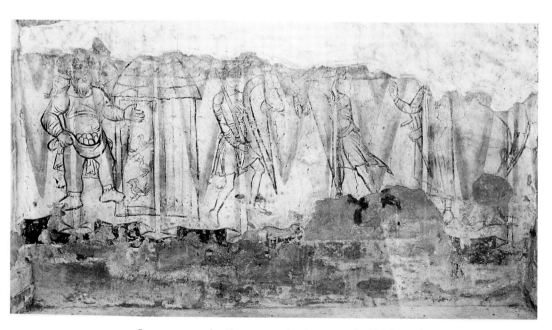

112. Summaga, socle: Fat man gathering eggs; Judicial combat

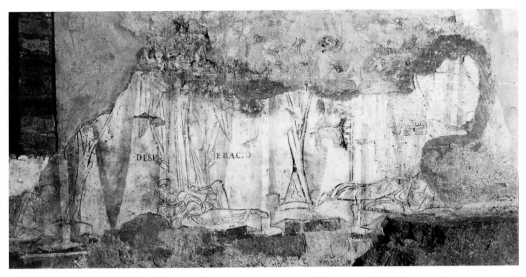

113. Summmaga, socle: Virtues trampling upon Vices

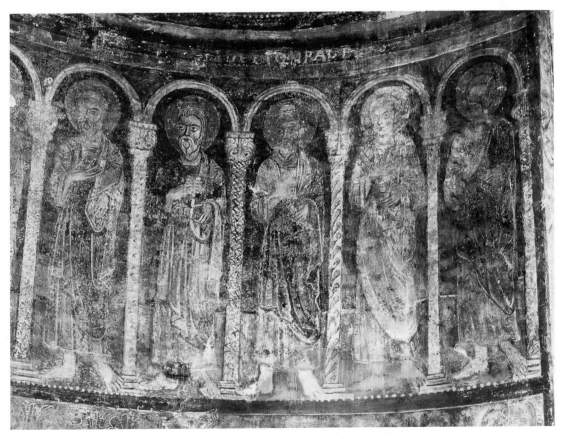

114. Summmaga, central apse: Detail of Apostles

115. Abbey of Sta. Maria in Sylvis, Sesto al Reghena: Archangel Michael

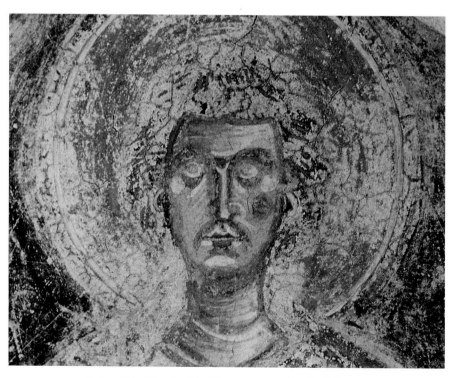

116. Aquileia: Head of St. Chrysogonus, detail of figure 46

117. Former convent of Sonnenburg, crypt: Dolphin on socle

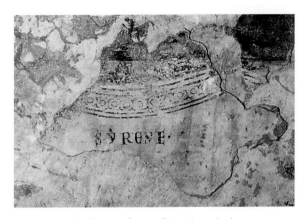

118. Sonnenburg: Siren inscription

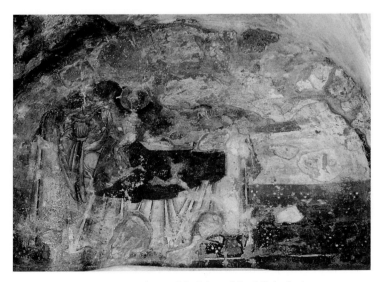

119. Sonnenburg: Nativity of St. Nicholas?

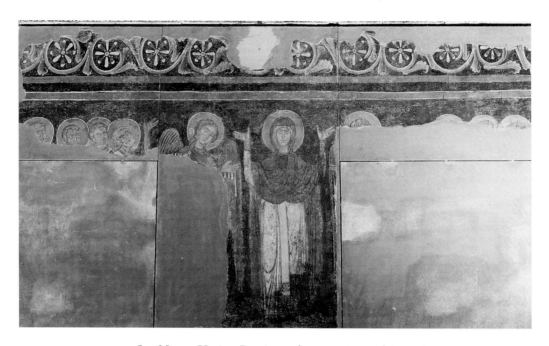

120. San Marco, Venice: Baptistery, lower register of Ascension

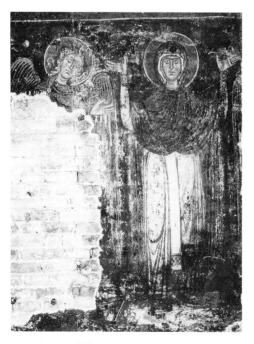

121. The Virgin orant, detail
of figure 120

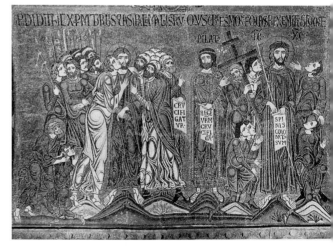

122. San Marco, Venice: Betrayal and
Mocking of Christ

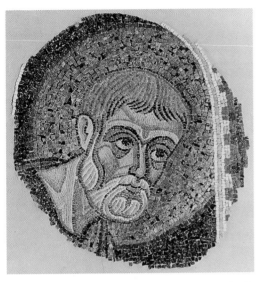

123. Museo Arcivescovile, Ravenna: Head of
St. Peter from Basilica Ursiana

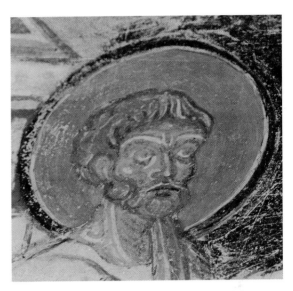

124. Aquileia: Head of St. Peter, detail of figure 62

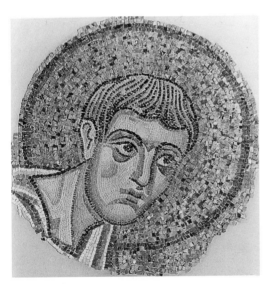

125. Museo Arcivescovile, Ravenna: Head of
St. John from Basilica Ursiana

126. Aquileia: Head of Pontianus, detail
of figure 81

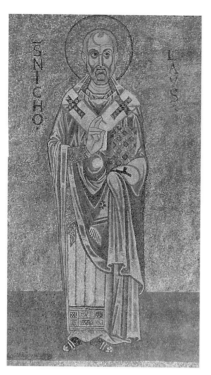

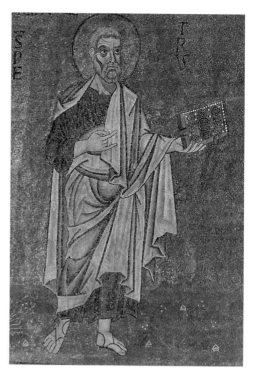

127. San Marco, Venice, central apse: Detail of St. Nicholas

129. San Marco, Venice: St. Peter, detail of figure 128

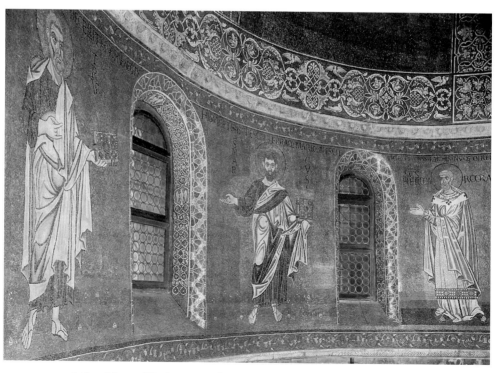

128. San Marco, Venice, central apse: Sts. Peter, Mark, and Hermagoras

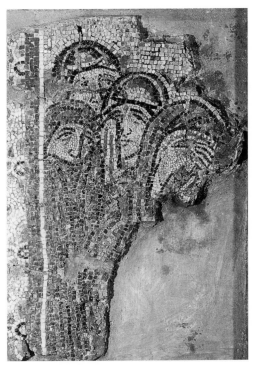

130. Museo di San Marco, Venice:
"Pie Donne" from the Deposition

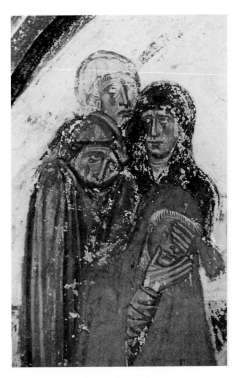

131. Aquileia: Mourning women,
detail of figure 86

132. San Marco, Venice: Angels
from the Deposition

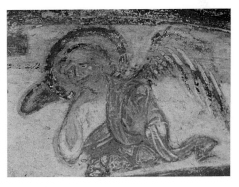

133. Aquileia: Pensive angel,
detail of figure 86

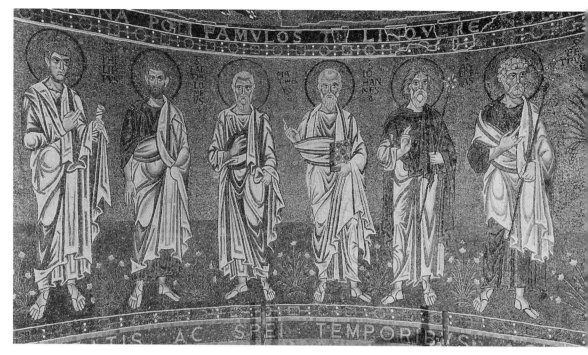

134. San Giusto, Trieste, north apse hemicycle (left): Apostles

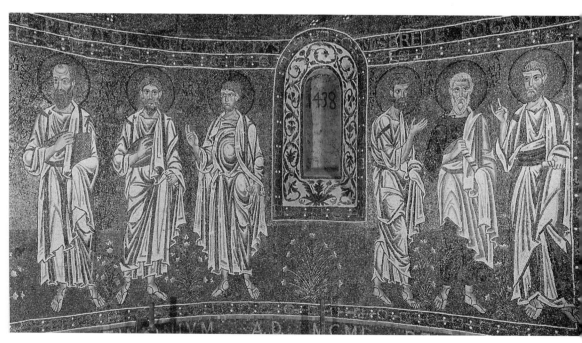

135. San Giusto, Trieste, north apse hemicycle (right): Apostles

136. San Marco, Venice, Treasury, Pala d'Oro: Diagram of the Mark Cycle reconstructed as a frieze

1. Peter commissions Mark as apostle of Aquileia
2. Mark baptizes Hermagoras (?)
3. Mark conducts Hermagoras to Peter in Rome
4. Mark destroys idol in Pentapolis
5. Mark heals Anianus in Alexandria

6. Mark captured by pagans at Easter Mass in Alexandria
7. Mark's vision of Christ in prison at Alexandria
8. Invention of Mark's relics by Venetians outside Alexandria
9. Translation of relics to Venice
10. Reception of relics in Venice

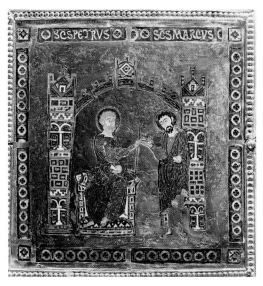

137. Pala d'Oro: Peter commissions Mark as
apostle of Aquileia

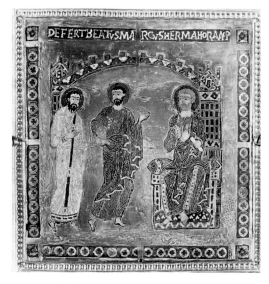

138. Pala d'Oro: Hermagoras brought before
Peter in Rome

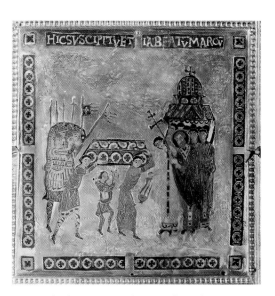

139. Pala d'Oro: Translation of Mark to Venice

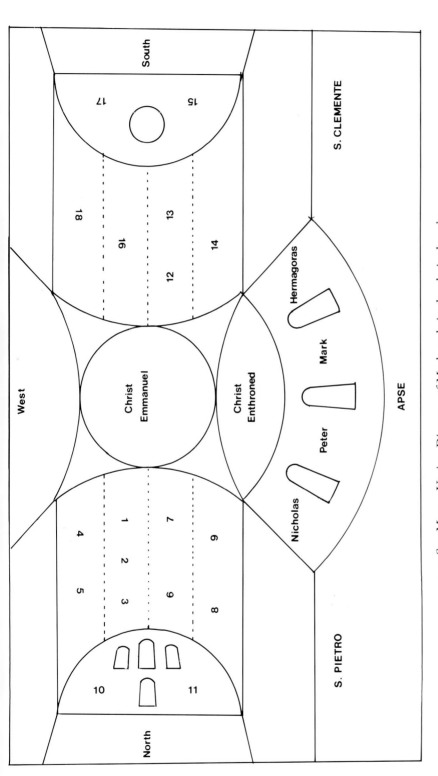

140. San Marco, Venice: Diagram of Mark cycle in the choir chapels

1. Peter consecrates Mark as patriarch of Aquileia
2. Mark heals Athaulf at Aquileia
3. Mark baptizes Athaulf at Aquileia
4. Peter consecrates Hermagoras as patriarch of Aquileia
5. Hermagoras baptizing in Aquileia
6. Mark preaching in Pentapolis
7. Mark baptizing in Pentapolis
8. Mark warned by angel; journeys to Alexandria
9. Mark heals Anianus in Alexandria
10. Mark captured by pagans at Easter Mass in Alexandria
11. Entombment of Mark in Alexandria
12. Venetians remove Mark's relics from tomb in Alexandria
13. Venetians carry off relics in baskets of pork
14. Moslem officials inspect Venetian ship
15. Ship with Mark's relics departs for Venice
16. Mark saves Venetians from shipwreck
17. Arrival of relic ship in Venice
18. Reception of relics by the doge and the patriarch of Grado

141. San Marco, Venice: Mark's mission to Aquileia

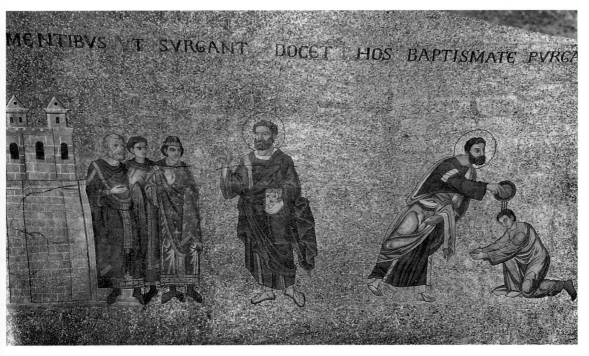

MENTIBVS VT SVRGANT DOCET HOS BAPTISMATE PVRGA

142. San Marco, Venice: Mark's mission to Pentapolis

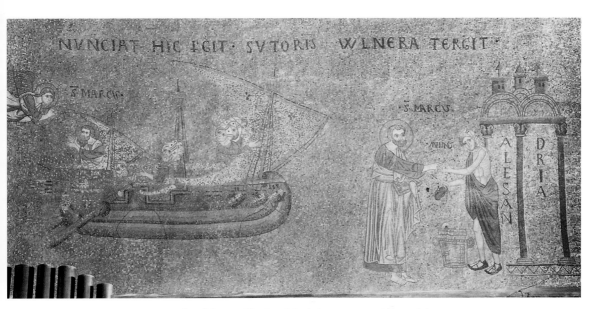

NVNCIAT HIC EGIT · SVTORIS · WLNERA TERGIT ·

S MARCVS

S MARCVS

ALESAN DRIA

143. San Marco, Venice: Mark journeys to Alexandria

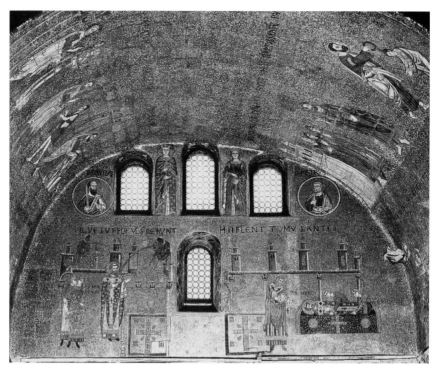

144. San Marco, Venice: Martyrdom and entombment of Mark in Alexandria

145. San Marco, Venice: Pope Pelagius

146. San Marco, Venice: Patriarch Helias

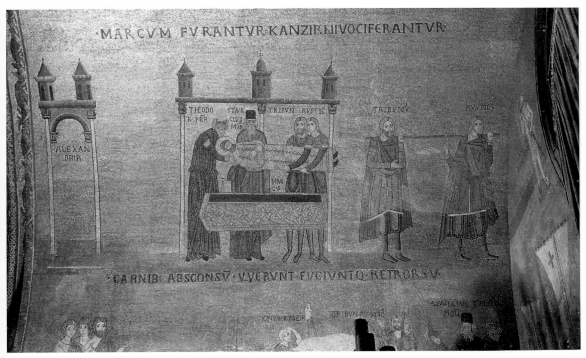

147. San Marco, Venice: Venetians remove Mark's relics from tomb in Alexandria

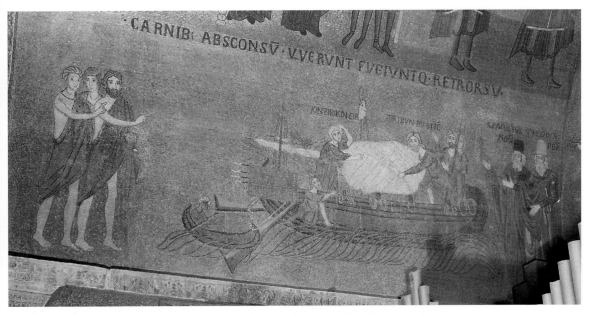

148. San Marco, Venice: Venetians load Mark's relics aboard their ship

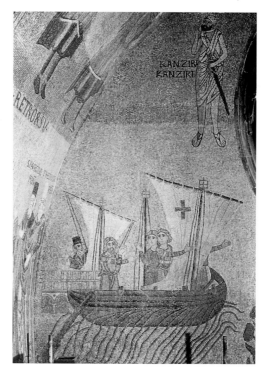

149. San Marco, Venice: Ship departs from Alexandria

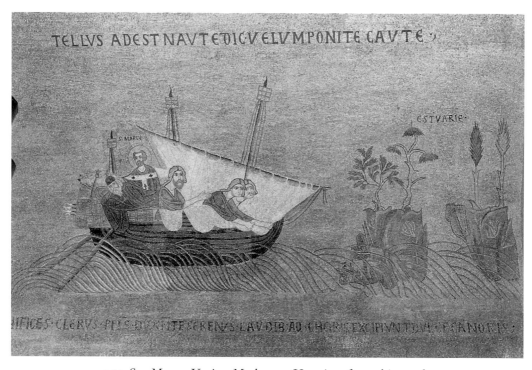

150. San Marco, Venice: Mark saves Venetians from shipwreck

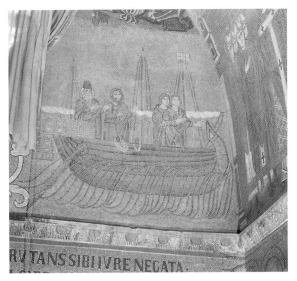

151. San Marco, Venice: Ship with relics arrives in Venice

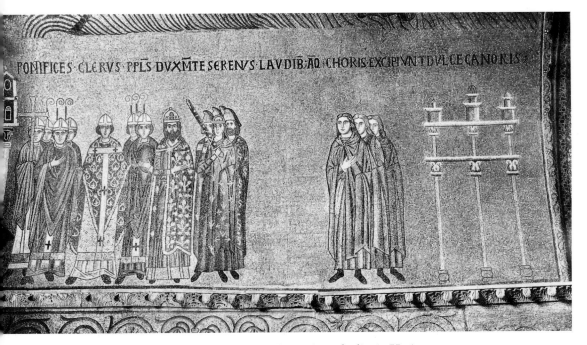

152. San Marco, Venice: Reception of relics in Venice

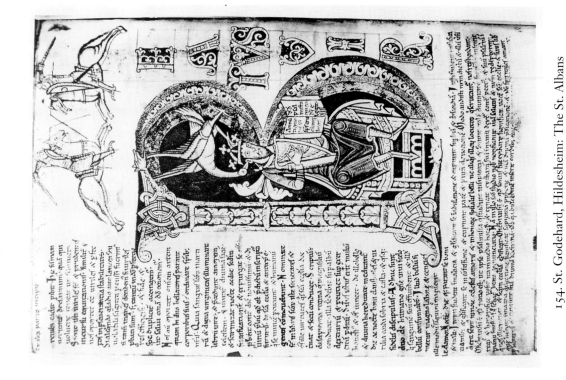

154. St. Godehard, Hildesheim: The St. Albans
Psalter, Beatus Page

153. Paris, Bibliothèque Nationale, cod. lat. 2077,
fol. 163: Superbia and the Vices

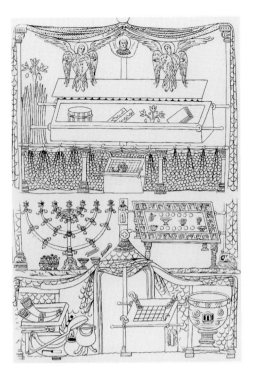

155. *Hortus Deliciarum*, fol. 45v: The Temple in Jerusalem

156. Aquileia, crypt: Vase with acanthus

157. Aquileia, crypt: Acanthus arranged as candelabrum

158. Aquileia, crypt: Inhabited vine scroll

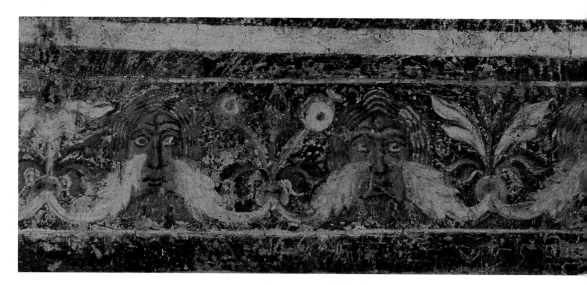

159. Aquileia, crypt: Mask frieze

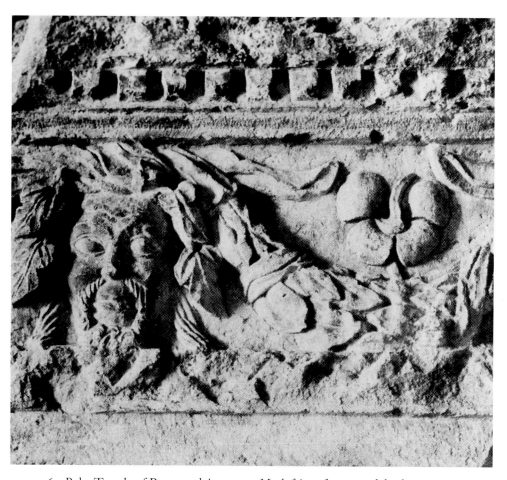

160. Pola, Temple of Roma and Augustus: Mask frieze from sepulchral monument